HOUSE PROUD

NINETEENTH-CENTURY WATERCOLOR INTERIORS
FROM THE THAW COLLECTION

NINETEENTH-CENTURY

WATERCOLOR INTERIORS FROM THE

THAW COLLECTION

HOUSE

GAIL S. DAVIDSON

FLORAMAE McCARRON-CATES

CHARLOTTE GERE

PROUD

 Smithsonian
Cooper-Hewitt, National Design Museum
NEW YORK

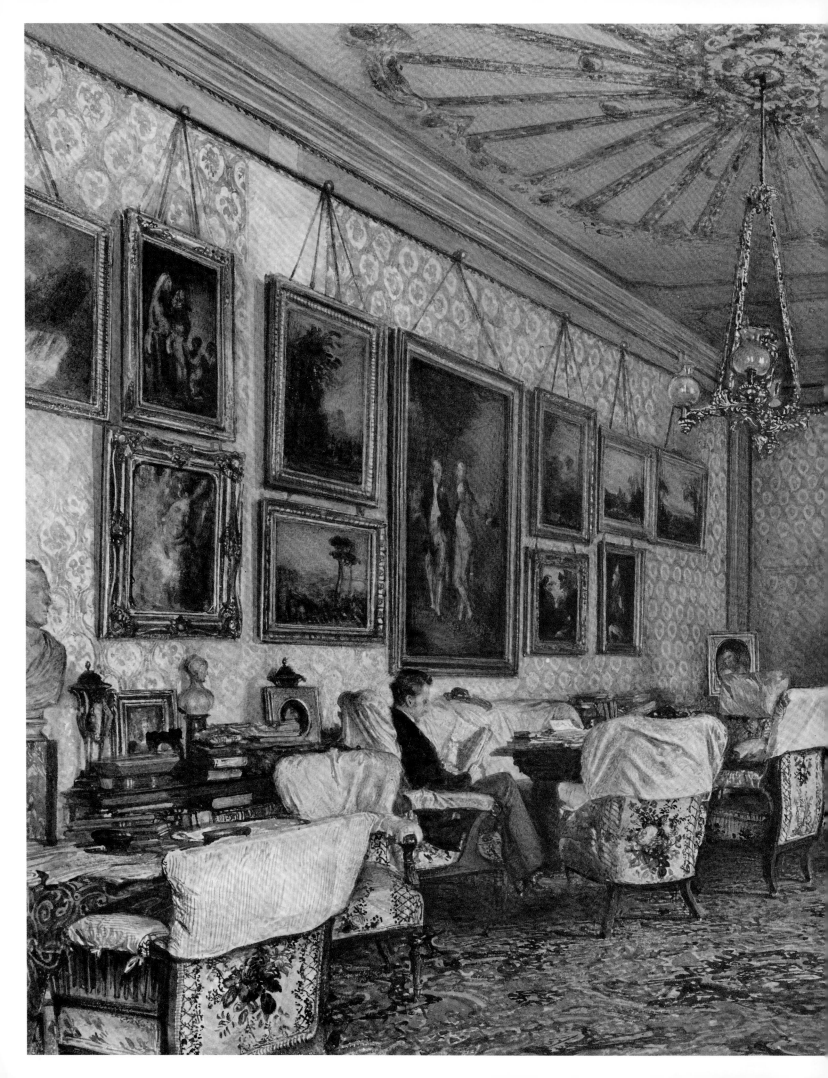

CONTENTS

FOREWORD

PAUL WARWICK THOMPSON

Eugene and Clare Thaw are most readily identified with the world of Old Master drawings and paintings and, of course, the spectacular collection of Native American artifacts they donated to the Fenimore Art Museum in Cooperstown, New York. But Gene Thaw's collecting also extends into the world of decorative arts, where his expert eye has not always settled on the most obvious of objects. Gene's love of faience ware, for example, demonstrates a preference for earthy character and charm over the glamour and allure of porcelain. In 2007, Cooper-Hewitt became the beneficiary of the Thaws' collection of faience ware from Moustiers, and of their remarkable collection of staircase models, masterpieces of woodworking which illustrate design process and practice in French COMPAGNONNAGE woodworking guilds. Wonderful flights of fancy, they are also highly instructive essays in the story of craft apprenticeships and cabinetry skills in eighteenth- and nineteenth-century Europe.

This year, we celebrate yet another donation of works from the Thaws' collection to Cooper-Hewitt, National Design Museum. On this occasion, their gift represents the single most significant acquisition for our Drawings, Prints, and Graphic Design department in thirty years: eighty-five nineteenth-century watercolors of interiors—an outstanding record of taste, decoration, and domestic pride, which encompasses palaces, lodges, and townhouses from Potsdam to London to St. Petersburg.

These drawings have been part of the Thaws' lives for many years, and, through their act of great generosity, these works may now be researched by countless design scholars and enjoyed by the many thousands of us fascinated by the ways in which the residents of such houses chose to record their homes and document their design tastes. We thank Clare and Gene Thaw, once again, for donating this treasure trove to Cooper-Hewitt and dedicate this book to both of them.

I wish to thank Cooper-Hewitt's curators of the HOUSE PROUD exhibition, Gail S. Davidson, Curator and Head of the Drawings, Prints, and Graphic Design department, and Floramae McCarron-Cates, Associate Curator of Drawings, Prints, and Graphic Design, for the terrific job they have done of articulating the many reasons, both obvious and subtle, as to why the Thaw watercolors complement Cooper-Hewitt's collection as well as why this Museum is the perfect place for them to reside. Much gratitude goes also to decorative-arts scholar Charlotte Gere, who has generously shared with us the excellent research she has accumulated for well over a decade on this collection of watercolors.

With deep appreciation, I acknowledge the lenders to this landmark exhibition, as well as the Arthur Ross Foundation, whose generosity has helped make this exhibition possible. Support is provided by the Esme Usdan Exhibition Endowment Fund, Jan and Warren Adelson, Jamie Drake, The Felicia Fund, Albert Hadley, Inc., and Mr. and Mrs. Frederic A. Sharf. Additional support is provided by Barbara R. Munves, Oceanic Graphic Printing (USA), Inc., and the Fifth Floor Foundation. As always, this publication is made possible in part by The Andrew W. Mellon Foundation.

Special thanks to Patty Tang; and, at Cooper-Hewitt: Cara McCarty, Curatorial Director, for her leadership throughout the preparation and execution of this exhibition and book; Sarah Coffin, Curator of Seventeenth- and Eighteenth-century Decorative Arts; Jocelyn Groom, Head of Exhibitions; and Chul R. Kim, Director of Publications. And finally, many thanks and congratulations to exhibition designers Leven Betts Studio and exhibition graphics and catalogue designers Tsang Seymour Design, who have again delivered a splendid installation and book design.

Paul Warwick Thompson, Director
Cooper-Hewitt, National Design Museum

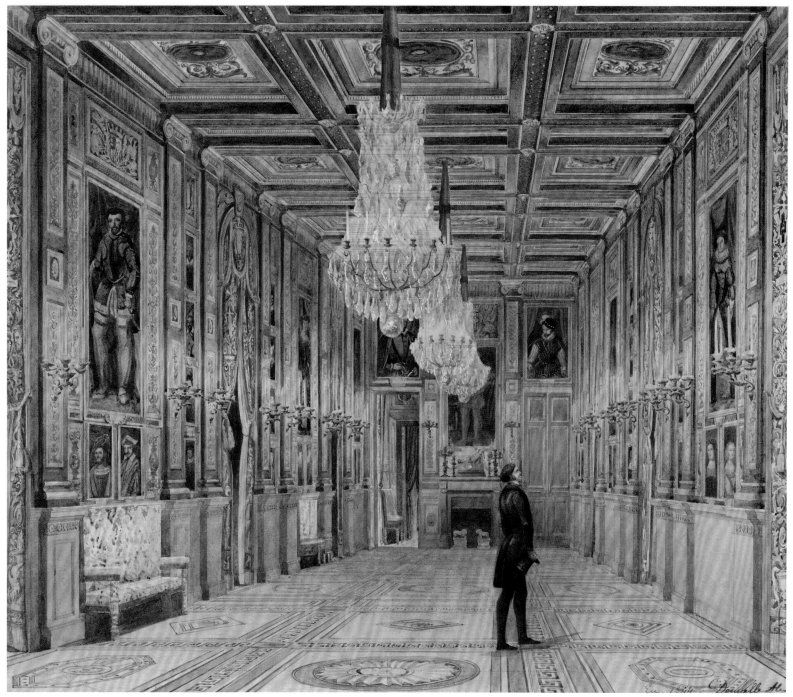

THE INSIDE STORY

PRINTS AND DRAWINGS OF INTERIORS IN COOPER-HEWITT'S COLLECTION

GAIL S. DAVIDSON

FIG. 1

In February 2008, the NEW YORK TIMES published an article entitled "Picture, Picture on the Wall…Whose is the Fairest House of All?" The story focused on proud homeowners who hired photographers to document their houses "much in the way you might have portraits of your children taken." One photographer prepared bound albums of his photos and his clients' comments for them to display on coffee tables. Summing up this "new" phenomenon, another professional stated, "We fetishize homes now, in a way that we never used to."[1] Yet documenting houses in albums is not a recent fashion. From the late eighteenth through the nineteenth century, consumption and luxury were a condition of the money economy. People lavished attention and funds on their homes, treating them as sources of self-esteem, comfort, convenience, and privacy. The fashion for commissioning watercolors of domestic interiors accompanied these developments.

These nineteenth-century watercolors reveal much about the period's culture, manners, and practices. In the beginning of the century, domestic interiors were relatively uniform, and rooms did not generally serve specific functions. During the course of the century, however, rooms evolved into private, gender-specific, and activity-based spaces, filled with decorative objects and mementos—what literary critic Walter Benjamin called "traces"—which defined these interiors as "portraits" of their inhabitants.[2]

Cooper-Hewitt, National Design Museum's collection of works on paper, which spans the history of design from the late Gothic period to contemporary times, is uniquely positioned to illustrate the evolution of the domestic interior. The gift from Eugene V. and Clare E. Thaw of eighty-five nineteenth-century watercolors depicting English, Continental European, Russian, and American interiors has enhanced the Museum's prestige enormously in this field. These works constitute arguably the largest group of individual nineteenth-century interiors in a public or private collection in the United States. The Metropolitan Museum of Art in New York owns a rare intact album of interiors of the Hofburg palace in Vienna, executed from 1826 by Johann Stephan Decker (1784–1844), painter to the Austrian court, and there are isolated examples in other American public and private collections. The tradition of commissioning and preserving watercolor interiors for display in albums was more common in Europe than in America, and many of these albums, some in their original leather bindings, still reside in royal or noble collections and in state museums.[3]

One of the most ardent admirers of interior views was Queen Victoria, who commissioned and collected watercolor interiors of her royal palaces, including Buckingham Palace, Windsor, Frogmore, Balmoral, and Osborne, as well as palaces she visited. Her interiors form part of the Queen's Collection at Windsor Palace. Among the European palaces Victoria and her husband Prince Albert visited was the Château d'Eu in Normandy, the favored summer residence of King Louis-Philippe. In an effort to consolidate his position as monarch, Louis-Philippe sought an alliance with England and formed close ties with the English royal family. Queen Victoria and he exchanged visits in the 1840s, and the French king and queen were guests of Victoria during their periods of exile from France. In 1844, Louis-Philippe presented Victoria an album of views of the residence by the French painter Eugène Lamy and other artists as a souvenir of her September 1843 visit. One of the Thaw collection drawings shows the Château d'Eu's picture gallery, which is related to images of the same room in Victoria's album.[4] (FIG. 1) On April 13, 1855, while awaiting a visit at Windsor of Louis-Philippe's widow, Queen Marie-Amélie, who had been living with her husband at Claremont House in Surrey since the Revolution of 1848, Victoria wrote in her journal, "The contrast was painful in the extreme. I have been looking over my beautiful Album d'Eu which brought the past vividly back to my memory."[5] This entry illustrates the importance these albums of interiors held for their owners in reconnecting with treasured sentiments and experiences.

The Thaw Collection of watercolor interiors, the most important gift to Cooper-Hewitt's Drawings, Prints, and Graphic Design department in almost thirty-five years, strengthens the existing collection significantly. Moreover, Cooper-Hewitt is an exceedingly appropriate repository for these exceptional drawings. The Museum possesses major drawings and prints of interiors from the sixteenth, seventeenth, and eighteenth centuries. They are not room portraits per se, since domestic interiors were rarely the subject of drawings in these centuries.[6] For the most part, interiors from the late fifteenth through the seventeenth centuries served as backgrounds for moralizing genre scenes. In the eighteenth century, interior drawings served as architectural elevations or building sections for presentation to clients; to advertise designers' skills for future commissions; or for instruction to craftsmen. An engraving by German printmaker Israhel van Meckenem (1440/45–1503), COUPLE SEATED ON A BED, includes a late fourteenth- to early fifteenth-century bedroom, or perhaps a bedroom alcove in a larger public space (FIG. 2). This print belongs to an engaging series known as SCENES OF DAILY LIFE, a satirical comment on married and unmarried couples from different classes in various activities relating to sex.[7] Six of the twelve scenes take place in interiors. In the Cooper-Hewitt print, a young dandy sporting a cloak, ostrich feathers, and POULAINS,

or pointed shoes, embraces a woman who is heavily clothed, looking askance at him as she holds her hands over her pregnant (or soon-to-be pregnant) belly. The keys and pouch she wears around her waist and the knife jammed into the bolt of the door are visual puns on virginity and the man's sexual intentions. At the same time, we are given interesting access to the couple's life. The bedroom interior suggests that they are not impoverished. The couple sits on a chest at the foot of a bed with a wooden headboard decorated with linen-fold paneling. Raised on a dais for protection against rodents, dirt, and the cold, the bed is surrounded by a canopy on a wood or metal hanging system with draperies that can be drawn around the four sides to keep out the cold and provide privacy. A covered wooden candle stand doubles as a night table and possibly also as a dining table.

The bourgeois bedroom developed significantly in France by the seventeenth century as revealed in an etching by Abraham Bosse (1602–1676). The Calvinist printmaker thoroughly documented bourgeois life, both public and private, in the city and in the country, within an oeuvre comprising around 1,500 prints. He depicted the newly wealthy displaying their status through their clothing, possessions, homes, and furnishings. In several of Bosse's print series, domestic interiors provide the settings for daily activities, accompanied by a verse commenting on the scene depicted.[8] One plate from the six-part series MARIAGE À LA VILLE [MARRIAGE IN THE CITY], published in 1633, is the RETOUR DU BAPTESME [RETURN FROM BAPTISM] (FIG. 3). Following the service, a mother receives her newborn girl from the arms of the wet nurse while family, friends, and the cat look on. The upper-middle-class French Protestant interior features a four-poster bed with finials of ostrich feathers in urns popular from 1625 to 1675, and the impaneled hangings and bedcover are en suite with the chair at the end of the bed. The tapestries covering the walls serve an allegorical and decorative as well as functional purpose. The hanging on the back wall conflates two roles of Daphne as goddess of chastity—represented by her metamorphosis into a laurel tree—and protectress of childbirth. What is possibly a looking glass tied to a ribbon hangs on a nail driven straight through the wall hanging. A row of low-backed, upholstered "farthingale" chairs, whose backs and seats are separated by a gap, lines the room's back wall. The chairs, which accommodated women's full-skirted dresses, have no arms. On the right, a table is laden with tarts and fruits to celebrate the child's survival to baptism.

The most significant feature of the scene is the room's public function. In contrast to today's usage, seventeenth- and eighteenth-century French bedrooms, especially formal state bedrooms in royal or noble residences, were settings for public occasions and rituals. The French system of royal apartments exemplifies the role bedchambers played in

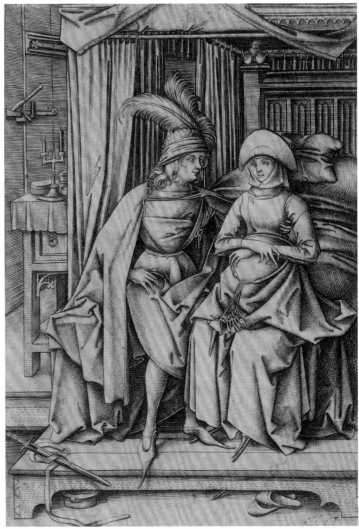

FIG. 2

the customs of the social elite. In general, there were three suites of apartments, each of which had a bedroom; the APPARTEMENT DE PARADE, the state apartment used for formal purposes such as receiving ambassadors and the like; the APPARTEMENT DE SOCIÉTÉ, the suite used for general entertaining; and the APPARTEMENT COMMODITÉ, or private apartment.[9] Formal state bedrooms in the time of Louis XIV typically had a box-shaped, richly draped and embroidered four-poster bed, separated from the larger bedroom space by a low marble balustrade, which served both as protection for the king and to delineate status. An officer stood guard behind, while in front, members of the court paid obeisance to the king by observing his daily rituals.

After the death of the Sun King in 1715, royal and aristocratic lifestyle became more informal and intimate. The Prince Regent, Philippe d'Orléans, lived in the Palais Royal in Paris, redecorated by his favored architect, Gilles-Marie Oppenord (1672–1742). His BED ALCOVE FOR THE DUC D'ORLÉANS, in the Museum's collection, probably illustrates the scheme for the prince regent's informal private apartment (FIG. 4). Its

2. ISRAHEL VAN MECKENEM (German, before 1440/45–1503)
A Couple Seated on a Bed, 1495–1503. Engraving on white laid paper.
6 ¾ x 4 ½ in. (171 x 114 mm). Cooper-Hewitt, National Design Museum,
Smithsonian Institution, Gift of Mrs. Leo Wallerstein, 1959-72-1

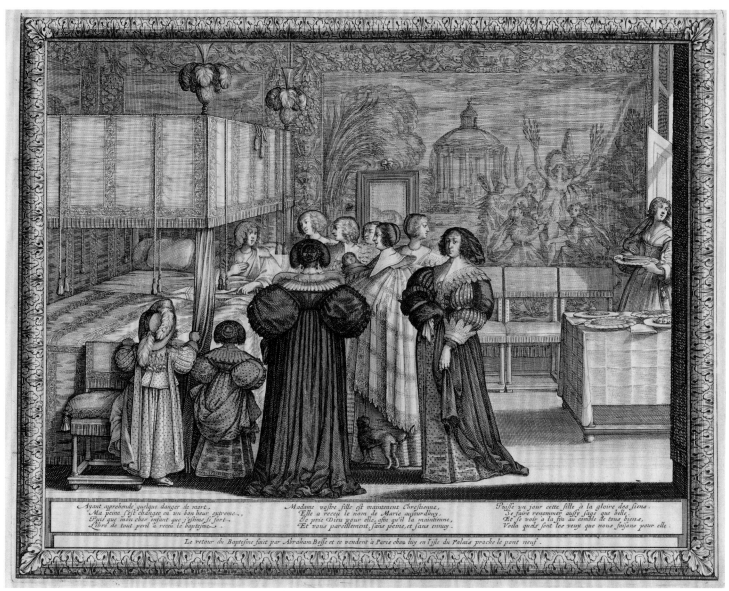

FIG. 3

arrangement is a simplified version of the more extravagant state bed-room. The bed À LA DUCHESSE (with a raised headboard but no foot-board, and with a canopy suspended from the ceiling) placed at right angles to the crimson silk-covered wall, behind and between two gilded columns fixed to a balustrade, creates a protected alcove at one end of the room.[10] The remainder of the room opens into a reception area surrounded by paneled walls, with seating furniture created to visually lock into the wood paneling, or BOISERIE.

Approximately twenty years later, the formal bedchamber for the Prince de Rohan in the Hôtel de Soubise, as shown in Cooper-Hewitt's WALL ELEVATION (1735–36) after a design by Germain Boffrand

3. ABRAHAM BOSSE (French, 1602–1676)
Le Retour du Baptesme (Return from the Baptism), state I/II,
plate VI in *Mariage à la Ville (Marriage in the City)*, 1633. Etching with engraving
on thin white laid paper. 11 ¾ x 15 ³⁄₁₆ in. (299 x 386 mm).
Cooper-Hewitt, National Design Museum, Smithsonian Institution,
Museum purchase from Smithsonian Institution Collections Acquisition Program
and Eleanor G. Hewitt Funds, 1996-33-1

(1667–1754) (FIG. 5), shows, from the side, a bed with a "flying" canopy or tester à la duchesse. The bed is placed between columns, creating a bed alcove, although it lacks the traditional balustrade. By this time, the columns served as symbols of status rather than as protection for the noble occupant.[11] Like the Oppenord bedchamber, the walls are paneled, but the severe, rectangular boiserie in the earlier elevation is softened by sinuous contours and richly carved decorative ornament. Paintings set into frames blend harmoniously with the wall decoration. Generally, this room interior has given up the static, severe character of the French classical baroque or early Regency, and has acquired the lighter, more organic concordance of rococo style. In the room's reception area, seating furniture would have been lined up against the walls when not in use, and brought into the room for women while men conducted their affairs standing.

The French-born Huguenot Daniel Marot (1661–1752), who became court designer for Prince William of Orange at The Hague, introduced his own version of the baroque style of Louis XIV, which he later brought to England in 1694 when the Dutch leader became William III

FIG. 4

FIG. 5

4. **GILLES-MARIE OPPENORD** (French, 1672–1742)
Bed Alcove for the Duc d'Orléans, Palais Royal, Paris, ca. 1720.
Pen and black ink, brush and gray, violet and rose wash on white laid paper.
8 ⅜ x 14 ³⁄₁₆ in. (212 x 360 mm).
Cooper-Hewitt, National Design Museum, Smithsonian Institution,
Purchased for the Museum by the Advisory Council, 1911-28-81

5. **AFTER GERMAIN BOFFRAND** (French, 1667–1754)
Wall Elevation of the Bedroom for the Prince de Rohan, Hôtel de Soubise, Paris, 1735–36.
Pen and black and gray ink, brush and gray wash, gouache, graphite on three joined
sheets of white laid paper, incised for transfer. 11 ⁷⁄₁₆ x 20 ⅝ in. (290 x 524 mm).
Cooper-Hewitt, National Design Museum, Smithsonian Institution,
Purchased for the Museum by the Advisory Council, 1911-28-5

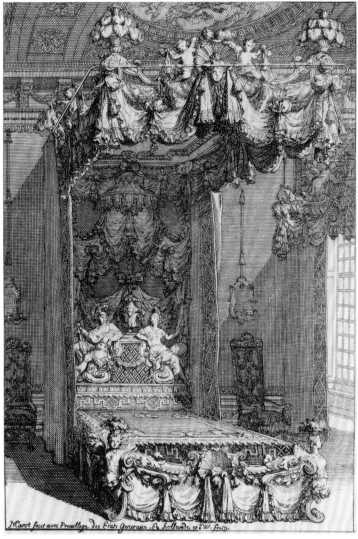

FIG. 6

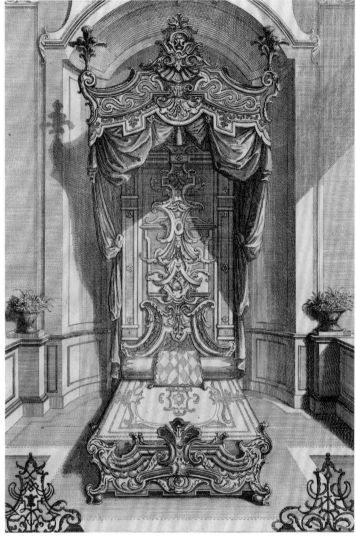

FIG. 7

6. **DANIEL MAROT** (French, active England and the Netherlands, 1661–1752)
Design for a State Bedchamber, from *Second Livre d'Appartements* (*Second Series of Interiors*), ca. 1702, Etching with engraving on white laid paper. 13 5/16 x 8 ¾ in. (338 x 222 mm). Cooper-Hewitt, National Design Museum, Smithsonian Institution, Museum purchase from General Acquisitions Endowment Fund, 1988-4-53

7. **JOHANN JAKOB SCHÜBLER** (German, 1689–1741)
Design for Bed Alcove, plate 6 in *Erste Augabe Seines Vorhabenden Wercks* (*First Issue of Works*), 1728–31. Engraved by Johann August Corvinus (German, 1683–1738). Published by Jeremias Wolff (German, 1663–1724). Engraving on cream laid paper. 14 15/16 x 9 11/16 in. (380 x 246 mm). Cooper-Hewitt, National Design Museum, Smithsonian Institution, Museum purchase from Sarah Cooper-Hewitt Fund, 1997-22-13

of England. Prints documenting Marot's designs (1702; a second, larger edition published in 1712) disseminated Marot's interior furnishing designs in the Netherlands, England, and parts of Germany.[12] Marot lavished the greatest attention on the state bed, since the bedroom was usually the final and most important room in individual apartments—the place where the rank and wealth of the owner were made explicit. He published a series of fanciful bed designs featuring flamboyant flying testers and four posts. One such design for a *lit d'ange* shows an elaborate tester, head and footboards of figural ornament in stucco, and opulent festooned draperies made by highly skilled French Huguenot textile upholsterers (FIG. 6). This particular example includes a rod going around the entire bed, supported by the tester, which hangs from the ceiling, and on which draperies could be pulled for privacy. To reiterate the status of the client, a reduced matching canopy is suspended above the door of the room. On the rear wall, sconces with mirror backs hang above two tall-backed "farthingale" armchairs with matching upholstery. Jakob Schübler (1689–1741), a mathematician and furniture designer from Nuremberg, created a number of elaborate state beds inspired by those of Marot (FIG. 7), which were published with other fur-

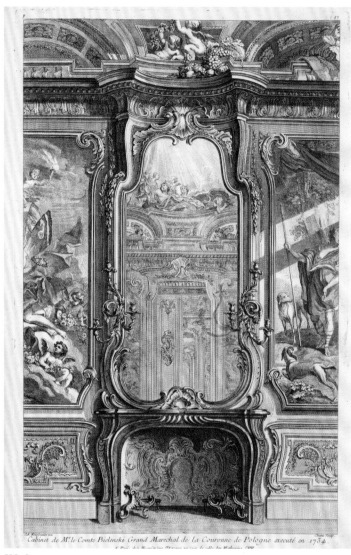

Cabinet de M.^r le Comte Bielenski Grand Marechal de la Couronne de Pologne executé en 1734

FIG. 8

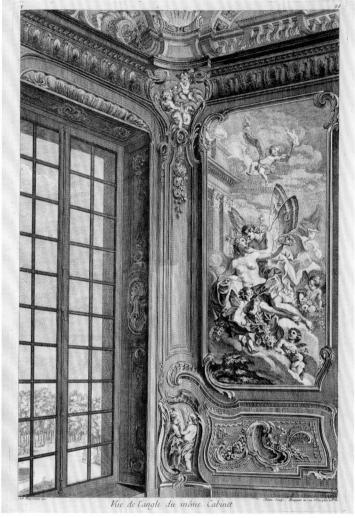

Vue de l'angle du même Cabinet

FIG. 9

niture designs in the 1720s or 1730s by the Augsburg publisher and print dealer Jeremiah Wolff and his heirs.[13]

Contemporary with Boffrand's interiors for the Paris Hôtel de Soubise, Juste-Aurèle Meissonnier, in a burst of creative genius, designed one of the earliest fully rococo interiors, a small 20-by-20-foot room [CABINET] for the Warsaw palace of Count François Bielinski, grand marshal of the Polish crown. While the room no longer exists, its interior decoration was recorded in the designer's OEUVRE (1748).[14] Typical of the time, the room appears not in perspective view, but rather as separate elevations (three walls and a ceiling), with the fourth wall reflected in the mirrored over-mantel on the fireplace wall (FIG. 8, 9). In comparison with Boffrand's design, these images express a totally new, dynamic interior—more extreme than would have been acceptable in contemporary Paris—in which richly carved boiserie, marble-topped fireplace,

8. **JUSTE-AURÈLE MEISSONNIER** (French, 1695–1750)
Cabinet de Mr. le Comte Bielenski [sic] Grand Marechal de la Couronne de Pologne executé en 1734, plate 87 in Oeuvre de Juste-Aurèle Meissonnier (The Cabinet of Count Bielinski, Grand Marshall of Poland, executed in 1734), 1742–48 (designed 1734).
Engraved by Pierre Chenu (French, 1718–after 1767). Engraving on white laid paper. 23 13/16 x 17 5/8 in. (605 x 448 mm).
Cooper-Hewitt, National Design Museum, Smithsonian Institution
Purchased for the Museum by the Advisory Council, 1921-6-212-45

9. **JUSTE-AURÈLE MEISSONNIER** (French, 1695–1750)
Vue de l'angle du même Cabinet (View of Same [Count Bielinski's] Cabinet), plate 89 in Oeuvre de Juste-Aurèle Meissonnier, 1742–48 (designed 1734). Engraved by Pierre Chenu (French, 1718–after 1767). Engraving on white laid paper. 23 13/16 x 17 5/8 in. (605 x 448 mm).
Cooper-Hewitt, National Design Museum, Smithsonian Institution,
Purchased for the Museum by the Advisory Council, 1921-6-212-46

10. **PIERRE RANSON** (French, 1736–1786)
Wall Elevation of a Bedroom Alcove, ca. 1780. Pen and brown ink, brush and watercolor, white gouache, graphite on white laid paper. 11 1/16 x 28 3/8 in. (281 x 720 mm).
Cooper-Hewitt, National Design Museum, Smithsonian Institution,
Purchased for the Museum by the Advisory Council, 1911-28-261

FIG. 10

gilt-bronze ornaments, and lighting combine with wall and ceiling paintings in an exuberant, rhythmic display of serpentine lines and organic, sculptural decoration.

But the rebellious, anticlassical spirit of rococo could not last long in France. Even before 1750, the pendulum began to swing back to a decorative style rooted in classicism, inspired by scholarly interest in the discoveries of Herculaneum and Pompeii, by the prints and drawings of French followers of Giovanni Battista Piranesi, and by the taste of Marie-Antoinette, among other forces. Two wall elevations in the neoclassical style from Cooper-Hewitt's celebrated Léon Decloux collection of ornament prints and drawings illustrate variations on the theme.[15] The first is an elevation for a cabinet with a daybed in a niche by Pierre Ranson from the late 1770s.[16] (FIG. 10) The bed with draped tester, supported by four curving rods (known as a LIT À LA POLONAISE, or bed in the Polish style) and painted wall ornament of flowers, garlands, and heart-decorated medallions tied up with blue bows (suggesting a love tryst), represents an interior concept for an intimate room in a late eighteenth-century Parisian HÔTEL. Another interior elevation, in a more austere, antique style applicable for more formal rooms, WALL ELEVATION FOR AN ANTECHAMBER OR SALON (ca. 1785) by Louis-Gustave Taraval, shows three rectangular niches with built-in sofas below large mirrors framed by swaged draperies caught back by rosettes. (FIG. 11). A severe, classical frieze decorated with waterleaf ornament is supported by two piers adorned with wreathed portrait medallions above two elaborate candelabra upheld by pairs of putti standing on round, garlanded bases.[17]

From the middle of the eighteenth century, a new type of interior-design drawing gained popularity in addition to the wall elevation or the building section. This drawing type, described as the "developed-surface" view, comprised four elevations folded-out around a room plan, as in an engraving of a drawing-room design by Thomas Sheraton, which shows all the furniture traditionally placed against the four walls around a floor plan.[18] (FIG. 12) By depicting an interior in this fashion, it became possible for a designer to fold up the wall elevations into the center to achieve a quasi-three-dimensional model, which enabled a client to visualize standing in the midst of a completed interior. Later in the century, as furniture moved onto the floor, individual, freestanding pieces appeared as contour diagrams on the plan. For instance, in DESIGN FOR THE WEST DRAWING ROOM AT STOKE EDITH, Charles Heathcote Tatham showed an arrangement of two sofas with sofa tables and side chairs in the central space around the fireplace.[19] (FIG. 13)

In the first decade of the nineteenth century, true perspective views of residential interiors became more common, probably because they were more easily understood by untrained consumers than room elevations or developed-surface views. More important, they illustrated prized personal possessions and captured the emotional associations of homeowners to the spaces they inhabited. Additional forces encouraged the production and collecting of this new variety of interior drawing, such as the publication of books on interior decoration during the early decades of the nineteenth century in England, France, Germany, and Italy.[20] Thomas Hope's HOUSEHOLD FURNITURE AND INTERIOR DECORATION (1807), directed to an aristocratic clientele, and George

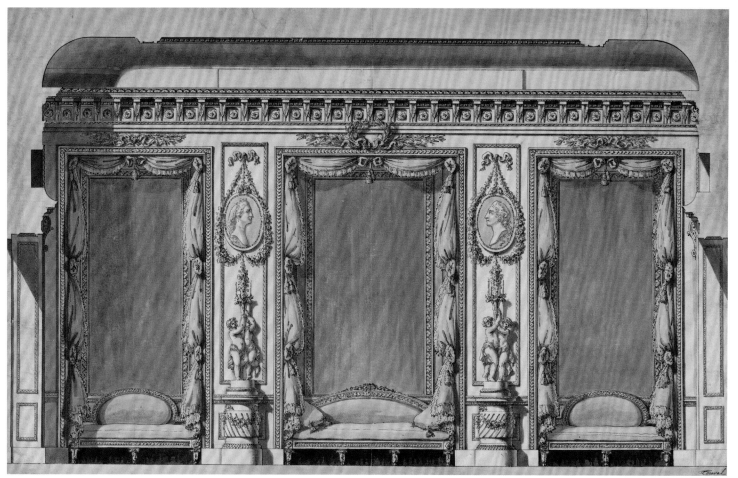

FIG. 11

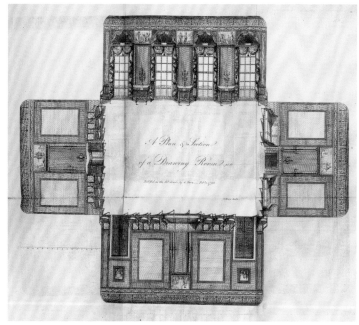

FIG. 12

In the introduction to his book, Hope acknowledged the influence of his predecessor and colleague Charles Percier, whose publication with Pierre-François-Léonard Fontaine, RECUEIL DE DÉCORATIONS INTÉRIEURES COMPRENANT TOUT CE QUI A RAPPORT A L'ORNEMENT (1801–12), was a potent force in disseminating the Empire style throughout Europe and America. Like Hope's and Smith's volumes, the plates in the RECUEIL were executed as crisp, black-and-white contour prints whose controlled line paralleled the classical ornament depicted. Plate 37 (FIG. 14) shows a wall elevation for a lady's bedchamber, ornamented with paintings and tapestries in the so-called Etruscan style. It relates to an earlier design in the Thaw Collection for two alternative wall dec-

Smith's A COLLECTION OF HOUSEHOLD FURNITURE AND INTERIOR DECORATION (1809), written for an upper-middle-class audience, contained perspective drawings visualizing the new, severe brand of neoclassicism that became known in England as the Regency—after Edward, Prince Regent, later George IV—and in continental Europe as Empire, after that of Napoleon Bonaparte.

11. **LOUIS-GUSTAVE TARAVAL** (French, 1738–1794)
Wall Elevation for an Antechamber or Salon, ca. 1785. Pen and black ink,
brush and watercolor, black chalk on laid paper. 17 ¹⁵/₁₆ x 24 ⅞ in. (455 x 632 mm).
Cooper-Hewitt, National Design Museum, Smithsonian Institution,
Purchased for the Museum by the Advisory Council, 1911-28-281

12. **THOMAS SHERATON** (English, 1751–1806)
A Plan and Section of a Drawing Room, plate 61 in *The Cabinet-maker and Upholsterer's
Drawing-Book* (3rd edition, revised), 1802. Engraved by Garnet Terry
(English, active ca. 1780–96). Published by T. Bensley (first published 1793).
Engraving on white paper. 17 ⅜ x 19 ¹³/₁₆ (442 x 504 mm).
The Metropolitan Museum of Art, Rogers Fund, 1952, 52.519.25

13. **CHARLES HEATHCOATE TATHAM** (English, 1772–1842)
Proposal for the West Drawing Room at Stoke Edith, 1800.
Brush and watercolor, graphite on paper. 15 ⁷/₁₆ x 9 ⁵/₁₆ (392 x 236 mm).
Victoria and Albert Museum, E1311.1-272.2001

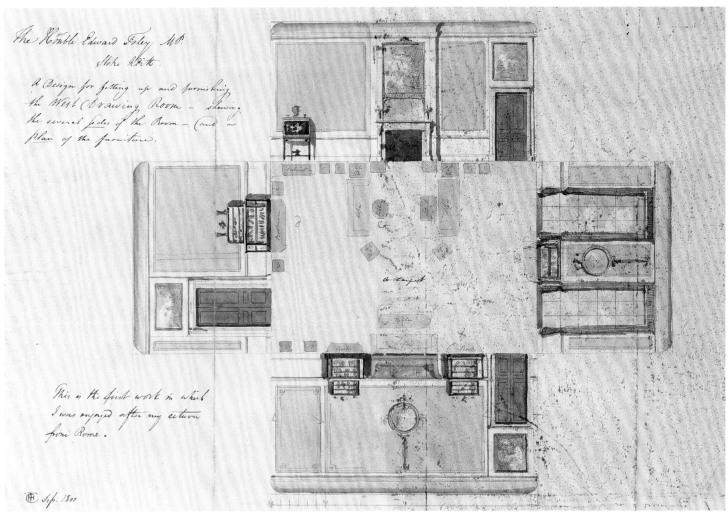

The Honble Edward Foley MP.
Stoke Edith.
A Design for fitting up and furnishing
the West Drawing Room — Shewing
the several sides of the Room — (and a
Plan of the furniture.

This is the first work in which
I was engaged after my return
from Rome.

Sep. 1800

FIG. 13

orations for a music room (1790–1805), possibly from the studio of François-Joseph Belanger, one of the premier decorators adapting the neoclassical inventions of Piranesi for interiors, directly preceding Percier and Fontaine.[21] (FIG. 15) The RECUEIL also featured the application of textiles as decorative unifiers, as exemplified in the tented Council Room and the "continuous drapery" (repeating valence) concept used in Malmaison. These decorative themes also characterized the boudoir interior of Napoleon's stepdaughter and sister-in-law Hortense de Beauharnais, known as Queen Hortense of Holland, as depicted in Auguste-Siméon Garneray's charming 1811 watercolor.[22] (FIG. 16)

Percier and Fontaine's and other French decorative ideas, percolating through English sources, also informed interiors in the Prince of Wales's London home, Carlton House, and in his summer residence, the Brighton Pavilion, both designed by Henry Holland. With each project, the prince had an enthusiastic, if not meddlesome, hands-on relationship with his decorators, who had to endure his impulsive, frequent changes of mind. Cooper-Hewitt's rich and deep archive of drawings by Frederick Crace (1779-1859) documents several phases of Brighton's interior renovations. An early Crace scheme for the prince's ground-floor bedroom suite, DESIGN FOR BED IN TENTED ALCOVE (FIG. 17), looks to French tented interiors from the late 1770s onwards, including those of Percier and Fontaine.[23] A calico-covered daybed sits beneath a large

convex mirror (permitting a wide-angled view of the Steine River) framed by radiating gold-pleated fabric (or perhaps lengths of satinwood), with matching sun ray–pleated calico textile on the ceiling and festooned around the room. Decorative fringes and tassels throughout complete the regal effect of this Regency-style interior.[24]

A second Crace perspective drawing for Brighton's central saloon embodies the almost concurrent fashion for chinoiserie, which characterized subsequent decorative campaigns for other rooms in the summer palace (FIG. 18). This watercolor records the circular room as it was designed in 1802, with blue and silver Chinese (perhaps) paper handpainted with trees and collaged birds on the walls to simulate a garden arbor. Chinese-style fretwork motifs in red and blue create the dado and frieze, while a trompe-l'oeil bamboo fretwork balcony encircles the ceiling. It has been suggested that this drawing was executed just prior to the room's next face-lift by Robert Jones in 1822, when the simulated sky was stripped of its paint and the draperies removed from the windows. An exotic water-lily chandelier sketched in graphite on a separate piece of paper (similar to the chandeliers designed for the music room around 1815) was collaged onto the watercolor, perhaps to illustrate the fixture proposed for the new renovation.[25]

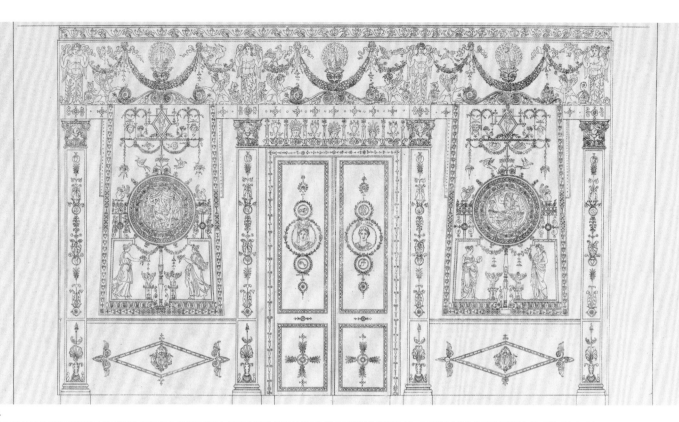

FIG. 14

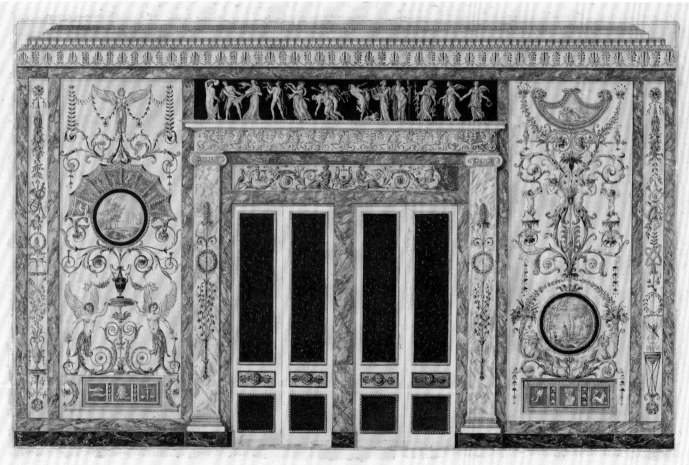

FIG. 15

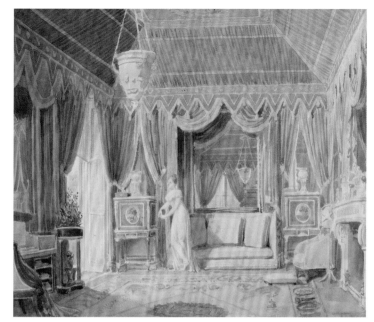

FIG. 16

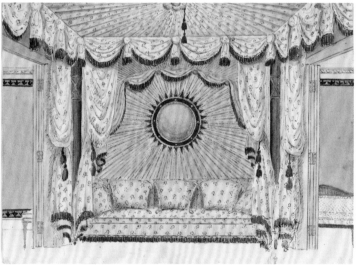

FIG. 17

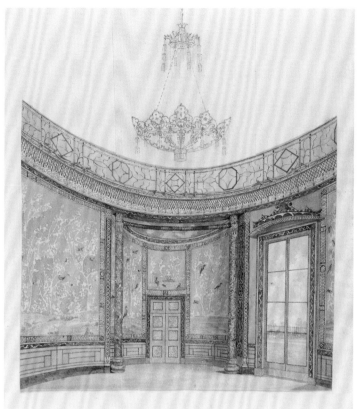

FIG. 18

14. **CHARLES PERCIER** (French, 1764–1838) and **PIERRE-FRANÇOIS-LÉONARD FONTAINE** (French, 1762–1853). *L'Une des Faces de la Chambre à Coucher de Mme G. à Paris* (*Wall Elevation for the Bedroom of Madame G., Paris*), plate 37 in *Recueil des décorations intérieures*, 1812. Published by P. Didot l'aîné. Etching on cream wove paper. 17 ¼ x 11 5⁄16 in. (438 x 288 mm). Cooper-Hewitt, National Design Museum, Smithsonian Institution, Purchased for the Museum by the Advisory Council, 1921-6-377-1

15. **CIRCLE OF FRANÇOIS-JOSEPH BÉLANGER** (French, 1744–1818) *Projet pour un salon de musique* (*Design for a Wall Elevation in a Music Room*), Paris, 1790–1802. Pen and black ink, brush and watercolor, gouache on off-white laid paper. 13 ⅛ x 20 15⁄16 in. (333 x 532 mm). Cooper-Hewitt, National Design Museum, Smithsonian Institution, Thaw Collection, 2007-27-14

16. **AUGUSTE-SIMÉON GARNERAY** (French, 1785–1824) *View of Queen Hortense's Boudoir, rue Cerutti, Paris*, 1811. Brush and watercolor on laid paper. 11 7⁄16 x 13 ⅜ in. (290 x 340 mm). Private collection, Paris, France, inv. n° 374

17. **FREDERICK CRACE** (English, 1779–1859) *Design for Bed in Tented Alcove, probably for the Prince of Wales's Bedroom or Boudoir, Royal Pavilion, Brighton*, 1801–04. Pen and black ink, brush and watercolor on white wove paper. 8 x 11 in. (203 x 279 mm). Cooper-Hewitt, National Design Museum, Smithsonian Institution, Museum purchase through gift of Mrs. John Innes Kane, 1948-40-26

18. **FREDERICK CRACE** (English, 1779–1859) *Design for the Decoration of the Saloon, Royal Pavilion, Brighton*, ca. 1815. Brush and watercolor, graphite on white wove paper. 20 ¾ x 13 ⅝ in. (527 x 346 mm). Cooper-Hewitt, National Design Museum, Smithsonian Institution, Museum purchase through gift of Mrs. John Innes Kane, 1948-40-25-a/b

In Crace's designs from about 1817 for the sumptuous music room, chinoiserie fantasies burst forth in a no-holds-barred "opium dream manner."[26] (FIG. 19) This room and its counterpart in the pavilion's western block, the banquet room, came into being during the 1815 renovation by John Nash, when the prince regent decided he no longer admired the "perverted...simplicity which is the charm of...Greek Temples."[27] He chose to transform the original neoclassical building into an all-encompassing Asian-style extravaganza. Using a color palette at once strident and striking, Crace filled three walls with paintings of Chinese landscapes, in scarlet, yellow, and metallic gold based on images from William Alexander's VIEWS OF CHINA (1805). Snarling dragons and griffins and colonettes with entwined snakes capped and framed the paintings. Pagoda-topped doors and chimney mirror and a ceiling cove of faux-painted bamboo bundles on two walls heightened the theatricality. DESIGN FOR THE WEST WALL (FIG. 20) contains two variants for the painted glass eyebrow windows, which were backlit to produce an opalescent glow. An aquatint of the completed room in John Nash's VIEWS OF THE ROYAL PAVILION, BRIGHTON (1826), based on a watercolor by Augustus Charles Pugin, shows the nine suspended gaslit water-lily chandeliers that illuminated the space and the continuous blue and pink drapery along the room's window wall (FIG. 21). The whole effect has been likened to "an immense Oriental lacquered cabinet."[28]

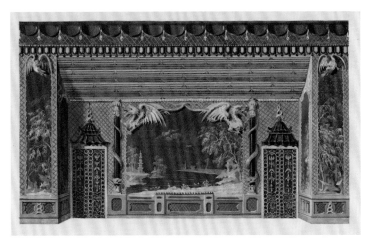

The Brighton Pavilion's extravagance, which far exceeded any noble or upper-middle-class interiors of the time, influenced many English country houses starting in the 1830s, probably by way of Nash's VIEWS. Examples can be seen in watercolors from the Thaw Collection by William Alfred Delamotte, incorporating chinoiserie decorative motifs (See Gere and McCarron-Cates, FIGS. 22, 23). On the Continent, references to the Empire style of Percier and Fontaine and the publications that followed appear in a drawing from the Thaw collection, SALON INTERIOR IN THE EMPIRE TASTE by Hilaire Thierry (see Gere and Mc-Carron-Cates, FIG. 20), and on a much more modest level in the Museum's VIEW OF A MORNING ROOM INTERIOR, coming from the bequest of Erskine Hewitt, brother of the Hewitt sisters, founders of the Museum (FIG. 22). This watercolor looks into a tall, wood-paneled interior with two full-height windows. A woman in a white gown sits before a mirrored dressing table, while another woman (probably a servant) wearing mourning costume sits beside the fireplace preparing her mistress's fashion accessories, as indicated by the work basket on the floor. A round pedestal table on a tripod base, covered with assorted knickknacks, occupies the center of the room. Other furniture includes a Louis XVI commode with a toilette/dressing case on top between the windows, a desk and rush-seat chair by the rear left window, and a matching chair holding the door ajar. The tall, straight-backed settee with loose tasseled cushions against either arm, the mahogany fire screen, and dressing table (COIFFEUSE) are all Empire style pieces, as is the layered window treatment, which can be compared with the draperies depicted in the music-room interior on a gilt-bronze, enamel, and glass mantel clock by Antoine-André Ravrio (1759–1814), in Cooper-Hewitt's collection.[29] (FIG. 23)

Additional works in the Museum's permanent collection help elucidate individual furniture pieces and complement other objects included in the Thaw Collection drawings. For example, Dominique Hagen's 1851 watercolor AN INTERIOR IN MOSCOW (FIG. 24) shows an opulent salon chock-full of sculpture, paintings, porcelain, lamps, and other objects. The furniture is an eclectic mix of mainly French period or revival pieces, reflecting the Russians' love affair with French culture dating back to Catherine the Great in the 1700s and continuing into the following century. Along with a variety of seating forms, including FAU-TEUILS, or armchairs; BERGÈRES, upholstered armchairs with exposed wooden frames; a TÊTE-À-TÊTE, intended to seat two persons facing each other; and a chimneypiece and over-mantel mirror, all in rococo-revival style, the drawing also records several showy Louis XVI or Boulle-style pieces. The tall, ormolu-mounted cabinet along the right rear wall corresponds to an exquisitely drawn Louis XVI-style cabinet design from the Decloux collection (FIG. 25). The bronze-mounted porcelain lighting fixtures placed in many locations throughout the room are quite similar to a Renaissance-revival fixture depicted in DE-SIGN FOR AN OIL LAMP AND CANDELABRUM (FIG. 26) from about 1850 by an unknown French lighting firm; comparable fixtures can be seen in many of the Thaw Collection drawings.

Also from the mid-nineteenth century is a DESIGN FOR A BOURGEOIS BIEDERMEIER INTERIOR in Cooper-Hewitt's permanent collection, possibly by R. Haes, recording an 1853/58 interior from the German town of Coblenz (today Koblenz).[30] (FIG. 27) Coblenz's location on the Rhine with its picturesque ruined castles drew visitors from all parts of the world. Friedrich Wilhelm IV (1795–1861) and Queen Elisabeth Ludovika of Bavaria (1801–1873) took up summer residence nearby in the renovated Schloss Stolzenfels, where Queen Victoria and Albert paid them a two-day visit during a trip through Germany in 1845.[31] The Coblenz watercolor likely documents a room in an upper- middle-class

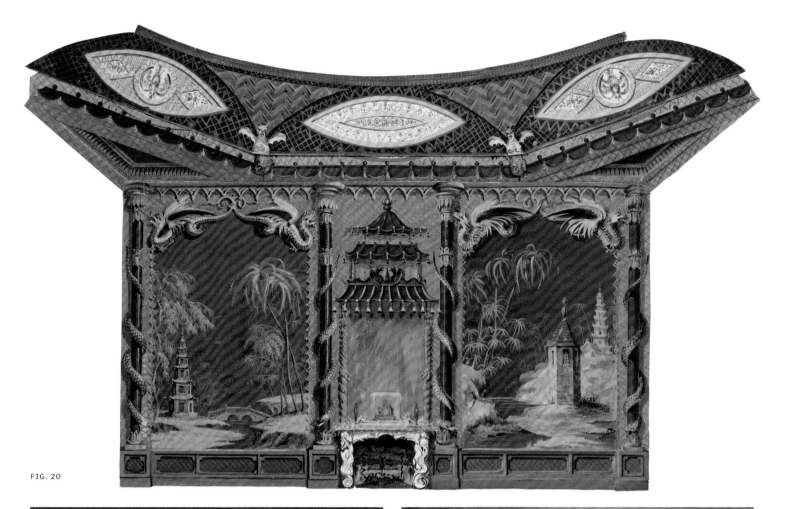

FIG. 20

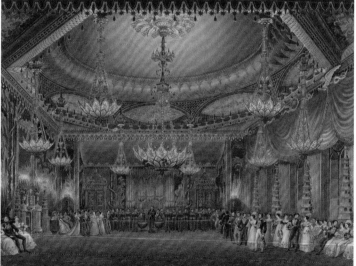

FIG. 21

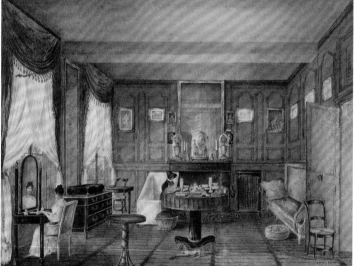

FIG. 22

townhouse shortly after the Schloss Stolzenfels renovation by Karl Friedrich Schinkel in 1842. The furnishings in the drawing appear to date from the 1840s. The sofa follows the rococo-revival style popular around this time; the round table, klismos-type chairs, and side chair are typical late Biedermeier pieces,[32] while the white ceramic stove fea-

22. *View of a Morning Room Interior*
France, 1820–25. Pen and brown and gray ink, brush and watercolor,
white gouache, graphite on white laid paper. 8 x 10 ⅝ in. (203 x 270 mm).
Cooper-Hewitt, National Design Museum, Smithsonian Institution,
Bequest of Erskine Hewitt, 1938-57-66

tures bands of decorated tiles with Schinkel style classical motifs. The fashionable gray flat-patterned wallpaper, with contrasting red Gothic pelmet band beneath the upper molding and a similar band above the baseboard, is comparable to an Austrian Biedermeier wallpaper design in the Museum's permanent collection (FIG. 28). Other Biedermeier patterns in the collection can be paired with wallpapers in several of the Thaw Collection drawings.

Schloss Stolzenfels was one of the royal couple's favored residences, along with Sanssouci in Potsdam—whose spectacular concert room is

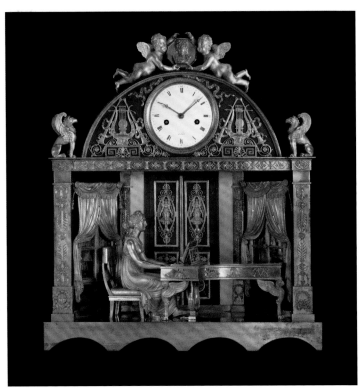

FIG. 23

FIG. 24

FIG. 25

recorded in a Thaw collection drawing by Eduard Gaertner (FIG. 29)—and Charlottenburg Palace, their official Berlin residence after Friedrich was named king in 1842. Charlottenburg's original seventeenth-century building by Johann Arnold Nering was expanded by Johann Friedrich Eosander in 1706–13; Friedrich's apartments were in the western extension, and Elisabeth's apartments occupied the eastern extension. An exquisite 1864 watercolor and gouache drawing in Cooper-Hewitt's collection by the accomplished but little-known artist Elizabeth Pochhamer (active Berlin, 1864–80) documents a portion of the queen's apartments, the library and the adjacent study and breakfast room, visible through two arched openings (FIG. 30). This view must have been especially appreciated, as it was documented about twenty years earlier in two other drawings by the painter Carl Friedrich Wilhelm Klose (1804–after 1863), whose watercolor interiors are also represented in the Thaw Collection, and in another watercolor by Carl Graeb (1816–1884) from the Hesse collection.[33] (FIGS. 31, 32)

What is striking about the apartment's interiors, especially in comparison with the sparsely appointed, rather sedate Coblenz watercolor above, is its feminine character and profusion of densely packed, plush upholstered seating and other furnishings in an eclectic mixture of styles. Some of the furniture may have come from a group of pieces the king had transferred from the palace where his parents had lived. Additional baroque and rococo pieces were pulled from storage, and oth-

23. **ANTOINE-ANDRÉ RAVRIO** (French, 1759–1814)
Clock, Paris, France, 1805–10.
Fire-gilt bronze, blackened bronze, enamel, glass.
22 ¹⁄₁₆ x 19 ⁹⁄₁₆ x 7 ⁵⁄₁₆ in. (560 x 497 x 185 mm). Cooper-Hewitt, National Design Museum,
Smithsonian Institution, Gift of the Estate of Carl M. Loeb, 1955-82-1

24. **DOMINIQUE HAGEN** (possibly Russian, active second half of 19th century)
An Interior in Moscow (detail), 1851. Brush and gray wash, watercolor, pen and black ink
on off-white wove paper. 10 ¹³⁄₁₆ x 14 in. (275 x 355 mm). Cooper-Hewitt,
National Design Museum, Smithsonian Institution, Thaw Collection, 2007-27-50

25. *Design for Cabinet in the Louis XIV style*, France, 1850–60.
Pen and brown ink, brush and wash, gold paint, gouache on
tracing paper, lined. 5 ⁵⁄₁₆ x 6 ¹⁵⁄₁₆ in. (135 x 177 mm).
Cooper-Hewitt, National Design Museum, Smithsonian Institution,
Purchased for the Museum by the Advisory Council, 1911-28-131

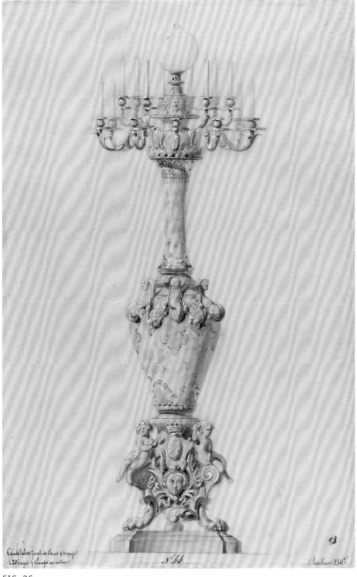

FIG. 26

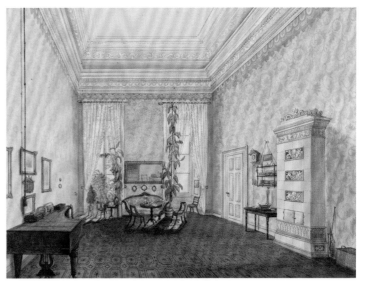

FIG. 27

FIG. 28

ers were newly fabricated to blend with them. By the mid-century, mixing styles would have been considered more varied and interesting than using one style throughout, and also would have encouraged historical and personal associations.[34] The metal rod suspended in the two arched openings allowed portiere draperies to close off the study and breakfast rooms for privacy—a functional addition for daily use.

26. *Design for an Oil Lamp and Candelabrum*
France, 1850–60, Brush and watercolor, gouache, pen and blue ink, graphite on tracing paper. 17 ⅛ x 10 ¾ in. (435 x 273 mm).
Cooper-Hewitt, National Design Museum, Smithsonian Institution, Museum purchase from Pauline Riggs Noyes Fund, 1953-206-4

27. Possibly **R. HAES** (active Germany or Austria, mid 19th century)
Design for a Bourgeois Biedermeier Interior, Coblenz, Germany, 1853 or 1858
Brush and watercolor, pen and black ink, white gouache on wove paper. 8 ½ x 11 ¼ in. (216 x 286 mm). Cooper-Hewitt, National Design Museum, Smithsonian Institution, Museum purchase through gift of Sarah Cooper Hewitt, 1954-157-2

28. *Wallpaper Design.* Austria, 1835–40.
Brush and watercolor, gouache, graphite on heavy white wove paper. 9 ¹¹⁄₁₆ x 13 ¼ in. (246 x 336 mm). Cooper-Hewitt, National Design Museum, Smithsonian Institution, Museum purchase through gift of Mary Hearn Greims, 1940-120-4

By around 1864, as revealed in the Pochhammer drawing, the stucco ceiling ornament has been gilded, a colorful rococo-revival carpet has been laid in the three rooms, and a small selection of Charlottenburg's famous oriental porcelains is grouped in front of the pier table and on either side of the library mirror, making both spaces more comfortable, cluttered, and intimate. In the Graeb drawing, the furniture in the rear two rooms has been stripped and gilded, more souvenirs have been added on the library console table, and new, unrelated carpets (perhaps temporary) have replaced the continuous red rococo patterned

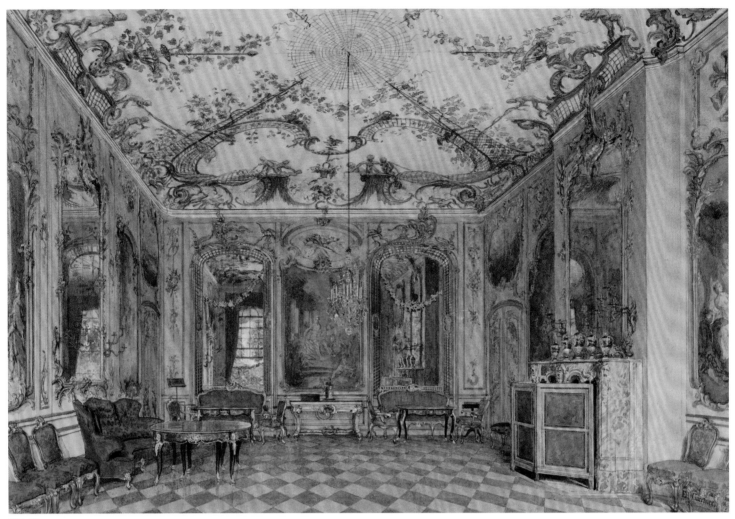

FIG. 29

carpet in the Pochhammer drawing.[35] Clearly, the queen, like other affluent consumers in this period, preferred physical and emotional comfort over pomp and ceremony or aesthetic harmony. But what nineteenth-century society found so warm and endearing was considered horrifying by subsequent Art Nouveau architects and designers such as Hector Guimard in Paris, who sought to eliminate clutter and historical styles and establish a new organic, unified style of decoration, commonly known by the German term GESAMTKUNST.

When Adeline Guimard chose to place the portion of her husband's archive the couple had brought from Paris to New York City in 1938, she divided the material among four institutions: the Museum of Modern Art, the New York Public Library, Columbia University's Avery Library, and Cooper-Hewitt. Included in the Museum's Guimard holdings are rare vintage photographs dating from about 1910 of interiors in the Hôtel Guimard, located in Paris's sixteenth arrondissement at the intersection of the avenue Mozart and the villa Flore. Guimard deliberately selected this corner lot as he could place the load-bearing walls on the building's exterior, and thus vary the interior spaces from floor to floor. The architect's offices occupied the first floor, the entertainment rooms filled the second level, and the couple's bedrooms and anterooms comprised the fourth floor. For the dining room (FIG. 33), Guimard chose a rococo inspired oval plan, filling the interior with sinuous furnishings that had a decidedly feminine presence, perhaps in

homage to his new American wife. He designed everything, down to the table linens and silk curtains. The square dining table—one wonders why it was not round—which appears to sprout from the carpet, the chairs (one of which was given to Cooper-Hewitt), the undulating sideboard and storage cabinets built into the room's curving walls, and the nature-inspired plaster ornament above were integrated into a

29. **EDUARD GAERTNER** (German, 1801–1877)
Concert Room, Sanssouci Palace, Potsdam, Germany, 1852.
Brush and gouache, watercolor, graphite on white wove paper.
6 15/16 x 10 3/8 in. (177 x 264 mm). Cooper-Hewitt, National Design Museum,
Smithsonian Institution, Thaw Collection, 2007-27-51

30. **ELIZABETH POCHHAMMER** (German, 1864–1880)
Apartments of Queen Elizabeth of Prussia, Charlottenburg Palace, Berlin, 1864.
Brush and watercolor, white gouache, gold paint,
graphite on thick white wove paper. 9 9/16 x 12 1/16 in. (243 x 306 mm).
Cooper-Hewitt, National Design Museum, Smithsonian Institution, Museum purchase
through gift of the Estate of David Wolfe Bishop, 1957-98-2

31. **CARL FRIEDRICH WILHELM KLOSE** (German, 1804–after 1863)
Library of the Queen in Charlottenburg Palace, Berlin, 1840s. Brush and watercolor
on wove paper. 8 7/16 x 12 3/16 in. (214 x 309 mm). Stiftung Preußische Schlösser
und Gärten Berlin-Brandenburg, Aquarellsammlung Nr. 1757

32. **CARL GRAEB** (German, 1816–1884)
*Apartments of Queen Elizabeth of Prussia, View from the Library into the Breakfast Room
and Study, Charlottenburg Palace, Berlin*, after 1862.
Brush and watercolor on paper. 12 9/16 x 16 5/8 in. (320 x 402 mm).
Hessische Hausstiftung/Kronberg, StAD D23.

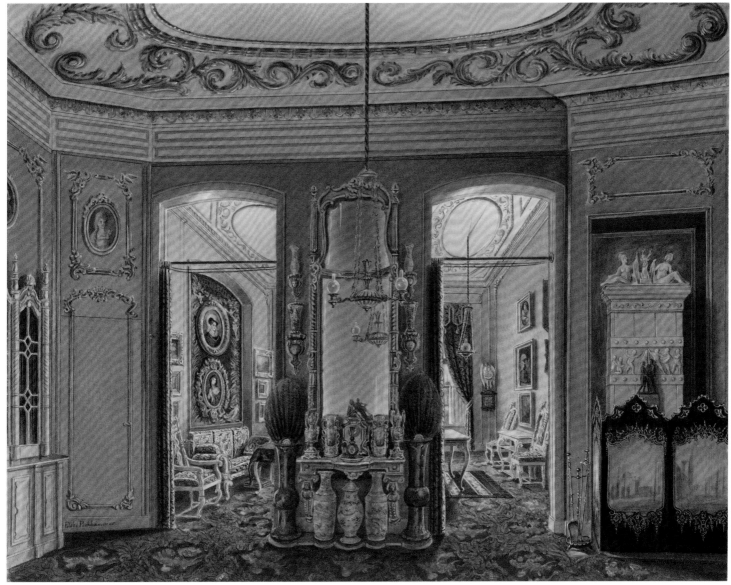

FIG. 30

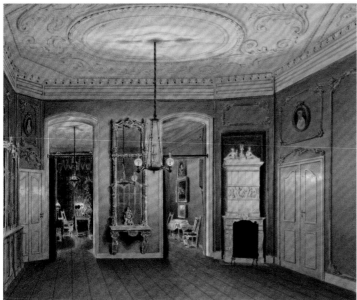

FIG. 31

FIG. 32

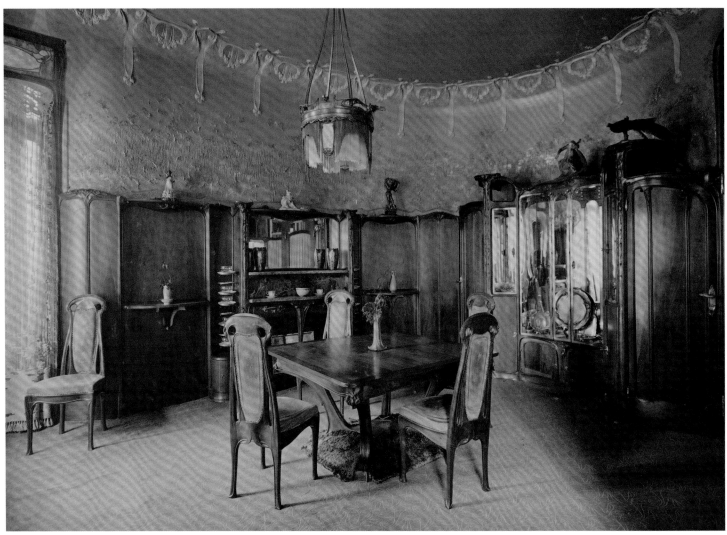

FIG. 33

unified ensemble. Even the medium-toned pearwood used for the furniture lent its curvilinear graining to the whole.[36]

The interior photographs of the Guimard townhouse count among the final examples of turn-of-the-twentieth-century interior design in the Museum's permanent collection. They illustrate the fate of the watercolor interior portrait by the close of the nineteenth century, when the camera lens increasingly replaced the painter's hand in capturing the intimate and individual personalities of domestic interiors. These photographs and the drawings and prints discussed above demonstrate how intimately the Thaw watercolors connect to the Museum's hold-

ings. In the years ahead, these drawings will be featured in many exhibitions and ignite the imaginations of many viewers. In addition, the intimate worlds they show us will attract the students of Cooper-Hewitt and Parsons The New School for Design's Master's program in the History of Decorative Arts, whose research promises to increase our knowledge and appreciation of these wonderful images.

33. HECTOR GUIMARD (French, 1867–1942)
Dining Room, Hôtel Guimard, Rue Mozart, Paris, ca. 1910.
Gelatin-silver print, toned, 8 ½ x 11 ⅟₁₆ in. (216 x 281 mm).
Cooper-Hewitt, National Design Museum, Smithsonian Institution,
Gift of Madame Guimard, 1956-78-11

NOTES

1. Kimberly Stevens, "Picture, Picture on the Wall...Whose is the Fairest House of All?" In *The New York Times*, 2/21/2008, sec. F, House & Home.

2. "The interior is not just the universe but also the etui of the private individual. To dwell means to leave traces. In the interior; these are accentuated. Coverlets and antimacassars, cases and containers are devised in abundance; in these the traces of the most ordinary objects of use are imprinted. In just the same way, the graces of the inhabitant are imprinted in the interior." Walter Benjamin, *The Arcades Project*, trans. Howard Eiland and Kevin McLaughlin (Cambridge, MA: The Belknap Press, 1999): 9.

3. Among the earliest of these albums is a series of twelve Château Malmaison views, commissioned probably by the Empress Josephine in 1812, from the French painter Auguste-Siméon Garneray (1725–1824), and today in the Musée National des Châteaux de Malmaison et Bois-Préau, Reuil-Malmaison. Among the existing European collections is a group of Bavarian interiors, known as the Witellsbach Album, after the royal family name, comprising watercolor interiors of Bavarian royal dwellings including the Alte Residenz and Nymphenburg Palace, dating from 1820-50, today in the Wittelsbacher Ausgleichsfonds, Munich. See Hans Ottomeyer, *Das Wittelsbacher Album: Interieurs Königlicher Wohn-und Festräume 1799-1848* (Munich: Prestel, 1979). In northern Germany, the Hesse family collection of interiors (versions of some Hesse drawings are included in the Thaw Collection), is held by the Schloss Museum, Darmstadt, and the Museum Schloss Fasanerie, Eichenzell. Additional German interiors of Charlottenburg and Sanssouci palaces exist in the collections of the Stiftung Preußische Schlösser und Gärten Berlin-Brandenburg, Aquarellsammlung. The interiors collection known as the Wittgenstein Album, documenting domestic interiors related to the Wittgenstein princes, is presently with the family. In the Czech Republic, a group of palace interiors by Carl Robert Croll (1800-1863), belonging to the noble Lobkowicz family, is deposited at Nelahozeves Castle, near Prague. In Russia, palace interiors are kept in the collection of the various palaces, such as the Hermitage and Pavlovsk in Saint Petersburg. See Emmanuel Ducamp et al., *Imperial Palaces in the Vicinity of St. Petersburg: Watercolors, Paintings, and Engravings from the XVIIIth and XIXth Centuries*, 4 vols. (Paris: Alain de Gourcoff, 1992); and Emmanuel Ducamp et al., *The Winter Palace, Saint Petersburg* (State Hermitage Museum, 1995). In addition, pockets of individual aristocratic and middle-class interiors can be found in such institutions as the Victoria and Albert Museum in London; the Musée des Arts Décoratifs and the Musée Carnevalet in Paris; as well as historical museums in Germany and Austria. Finally, the private collection of interiors belonging to Mario Praz, the father of European domestic interior studies, is preserved at the Mario Praz Museo in the Palazzo Primoli in Rome, part of the Galleriea Nazionale d'Arte Moderna.

4. Delia Millar, *The Victorian Watercolours and Drawings in the Collection of Her Majesty the Queen*, vol. 1 (London: Phillip Wilson, 1995): 509-10, nos. 3136, 3138. These watercolor and gouache drawings by Eugène Lamy depict *Presentations to Queen Victoria in the Galerie des Guises* and *Concert in the Galerie des Guises*. While the Thaw drawing is similarly sized as others in the Queen's album, Denuelle is not represented by any other work in the Queen's Collection. The Thaw watercolor was probably commissioned by Louis-Philippe or another member of the Queen's party as a souvenir of the château.

5. Victoria, Queen of Great Britain, and Raymond Mortimer, *Leaves from a Journal: A Record of the Visit of the Emperor and Empress of the French to the Queen and of the Visit of the Queen and HRH the Prince Consort to the Emperor of the French, 1855* (London: Andre Deutsch, 1961): 25. I am grateful to Charlotte Gere for this reference.

6. Some of the exceptions include two Dutch (or English) room interiors from the 1690s, which seem to be a painter's experiments with perspective devices like the camera obscura or peepshow boxes rather than interior documents. See Peter Thornton, *Authentic Décor: The Domestic Interior, 1620-1920* (New York: Viking, 1984): 76-77, nos. 90-92; and David Dewing, ed., *Home and Garden: Paintings and drawings of English, Middle-Class, Urban Domestic Spaces, 1675 to 1914*, exh. cat. (London: Geffrye Museum, 2003): 91; and two views of Samuel Pepys's Library, ca. 1693, in Magdalene College, Cambridge, resulting from similar trials with perspective tools (Thornton., p. 77, no. 92, and Dewing, p. 91). Pepys had much admired the perspective painting experiments of the Dutch painter Samuel van Hoogstraten in the collection of Thomas Povey, London; see Jane Campbell Hutchison, review of Celeste Brusati, *Artifice and Illusion: The Art and Writing of Samuel van Hoogstraten*, in *Sixteenth Century Journal* 28, no. 3 (1997): 1040-41; watercolors commissioned by Horace Walpole of his home Strawberry Hill, 1788, Lewis Walpole Library, Yale University (Thornton, *Authentic Décor*, pp. 174-75, nos. 220-21); and watercolors commissioned by Sir John Soane of his house and office at 12 Lincoln's Inn Fields, 1798, (see Dewing, p. 102, no. 42).

7. Fritz Koreny, comp., and Tilman Falk, ed., *Hollstein's German Engravings, Etchings and Woodcuts, 1400-1700*, vols. XXIV and XXIVA, *Israhel van Meckenem* (Blaricum, the Netherlands: A. L. Van Gendt, 1986): XXIV, p. 192, nos. 499-510; XXIVA, pp. 203-08.

8. On Bosse's genre prints, see Carl Goldstein, "Looking in the Mirror of Abraham Bosse," in Sue Welsh Reed, *French Prints from the Age of the Musketeers* (Boston: Museum of Fine Arts, 1998): 21-27.

9. Katie Scott, *The Rococo Interior: Decoration and Social Spaces in Early Eighteenth-Century Paris* (New Haven: Yale University Press, 1995): 104-05.

10. According to the description of the room by Le Rouge, *Les curiositez de Paris, de Versailles...* (Paris: Chez Saugrain, 1723): 147, as quoted in Franck Folliot, "Le Palais Royal (1692-1770)," in *Le Palais Royal*, exh. cat. (Paris: Musée Carnavalet, 1988): 74: "L'alcôve qui renferme un lit superbe [et qui] est soutenue de deux colonnes dorées, d'ordre composite et fermée d'une balustrade du même goût" ["The alcove which encloses a superb bed [and which] is supported by two gilded columns of the composite order is closed off [from the rest of the room] by a balustrade of the same style"].

11. Reproduced as a print by Joseph Lucas and published in Germain Boffrand's *Livre d'Architecture* (Paris: Chez Guillaume Cavelier, 1745): pl. 61. On Boffrand's decorations for the Hôtel de Soubise and the Cooper-Hewitt drawing in particular, see Albert France-Lanord et al., *Germain Boffrand, 1667-1754: l'aventure d'architecte indépendant* (Paris: Herscher, 1986): 231-33; and Fiske Kimball, *The Creation of the Rococo* (Philadelphia: Philadelphia Museum of Art, 1943): 179, fig. 235.

12. On Daniel Marot's designs for interiors, see Reinier Baarsen, "The Court Style in Holland," in *Courts and Colonies: The William and Mary Style in Holland, England, and America*, exh. cat. (New York: Cooper-Hewitt Museum, 1988): 15-21.

13. On Schübler, see Thornton, p. 114, pl. 136. Some of Schübler's more ingenious inventions using mechanical devices included compartmentalized writing desks, dumbwaiters, and collapsible beds; see Timothy Clifford, *Designs of Desire: Architectural and Ornament Prints and Drawings, 1500–1800*, exh. cat. (Edinburgh: National Galleries of Scotland, 1999): 187, no. 86.

14. On Meissonnier's Bielinski cabinet, see Peter Fuhring, *Un Génie de Rococo: Juste-Aurèle Meissonnier, 1695-1750*, 2. vols. (Turin: Umberto Allemandi, 1999): vol. 1, p. 41; vol. 2, . 213-14, no. 48.

15. On Cooper-Hewitt's Léon Decloux collection, see Gail S. Davidson, "Ornament of Bizarre Imagination," in Sarah Coffin et al., *Rococo: The Continuing Curve 1730-2008*, exh. cat. (New York: Cooper-Hewitt, National Design Museum, 2008): 43-46.

16. Cooper-Hewitt has three additional Ranson interior elevations from the first and second *Cahier de Décorations d'appartements...(1911-28-262,263,264)* which were engraved by Jacques Juillet and published in 1780.

17. This discussion of eighteenth-century interiors has, due to the nature of Cooper-Hewitt's collection, dealt with a limited number of room types, such as bedchambers, salons, and cabinets. However, during this period, the increasing demand for privacy generated new types of rooms, such as the woman's boudoir; see Ed Lilley, "The Name of the Boudoir," in *Journal of the Society of Architectural Historians* 53, no. 2 (June 1994): 193-98.

18. Robin Evans, "The Developed Surface, An Enquiry into the Brief Life of an Eighteenth-century Drawing Technique," in Robin Evans, *Translations from Drawing to Building* (Cambridge, MA: MIT Press, 1997): 194-231.

19. Thornton, p. 148, pl. 186.

20. Thornton, pp. 141-45; Charlotte Gere, "The Art of the Interior: Interior Decoration in the Nineteenth Century," in Charlotte Gere, *An Album of Nineteenth-Century Interiors, Watercolors from Two Private Collections*, ed. Joseph Focarino, exh. cat. (New York: The Frick Collection, 1992): 13-18.

21. On Bélanger, see Jean Stern, *A l'Ombre de Sophie Arnould: François-Joseph Bélanger, Architecte des Menus Plaisirs, Premier Architecte du Comte d'Artois*, 2 vols. (Paris: Plon, 1930); and, most recently, Peter Fuhring, *François-Joseph Belanger, 1744-1818* (Paris: De Bayser, 2006): 5-14.

22. After her marriage to Napoleon's brother Louis Bonaparte (King of Holland) disintegrated, Hortense was given the hôtel on the rue Cerutti that her husband acquired in 1805; see Pierre-François-Léonard Fontaine: *Journal 1799-1853*, vol. 1 (Paris: Ecole Nationale Supérieure des Beaux-Arts, Institut Français d'Architecture, Société de l'Histoire de l'Art Français, 1987): 243, n. 248]. While Hortense complained of frequent illness, she conducted receptions which, if we believe her account, altered the social custom of the time as well as the design of the interior. She claimed to be the first hostess to pull a table into the interior of the salon and to encourage men to sit while socializing, thus enabling women, who were seated, to more easily interact in conversation with men. See Hortense, Queen Consort of Louis, King of Holland, *The Memoirs of Queen Hortense*, vol. 2 , ed. Jean Hanoteau, trans. Arthur K. Griggs (New York: Cosmopolitan Book Corporation, 1927): 15-16; 325, n. 6.

23. For example, Bélanger designed (ca. 1778) a tented bedroom for Charles-Philippe, Count d'Artois, in the Bagatelle; see Jean-Jacques Gautier, "Le Goût du Prince, Part III, Décor et Ameublement de Bagatelle," in Daniel Alcouffe et al., *La Folie d'Artois*, exh. cat. (Levallois-Perret, France: L'Objet d'Art, 1988): 131-34, figs. 16-20.

24. The drawing's scheme corresponds to a description of the bedchamber in the *London Chronicle* of 1802, quoted in Megan Aldrich, "The Georgian Craces, c. 1768 to 1830," in Megan Aldrich ed., *The Craces: Royal Decorators, 1768-1899*, exh. cat. (London: Murray, 1990): 22; on this drawing, see also John Morley, "Early Chinoiserie Interiors at Brighton," in *Apollo* 116, no. 247 (September 1982): 156; and John Morley, *The Making of the Royal Pavilion Brighton, Designs and Drawings* (London: Sotheby Publications., 1984): 220-23.

25. Morley, "Chinoiserie Interiors," pp. 157-58; Morley, *Brighton*, pp. 88-91.

26. Morley, *Brighton*, p. 200.

27. Ibid, p. 68.

28. Clifford Musgrave, "The Royal Pavilion, Brighton, Part 1, The Building and Its Decoration," in *The Magazine Antiques*, vol. 90 (July 1966): 78. In contrast to Crace's earlier neoclassical watercolor designs for Brighton from 1801-02, the gouache drawings for the music room (ca. 1817) show greater skill and sophistication in paint handling.

29. 1955-82-1; from the collection of Princess Beloselsky-Branitzka, née Radziwill; von Damm, Berlin; Carl M. Loeb. A clock of the same model was in the collection of Prince Napoléon, (Napoléon Joseph Charles Paul Bonaparte, 1822–91), son of Jérôme Bonaparte and Catherine of Württemberg), ill. Armand Dayot, *Napoleon I in Bild und Wort* (Leipzig: H. Schmidt & C. Günther, 1897): 387.

30. The term Biedermeier refers to a period following the Napoleonic wars, dated generally 1815 to 1848, in northern and central Europe, characterized by simple, functional, abstract, or geometric forms and an emphasis on natural woods with no surface ornament. The style has been associated generally (though not exclusively) with the emerging bourgeoisie.

31. Victoria made her first trip to Germany in response to Friedrich Wilhelm IV's visit to England in 1842 to attend the christening of his god-child Prince Albert Edward (later King Edward VII). As a souvenir of her German visit, Friedrich Wilhelm commissioned a set of watercolors, known as the Rhine album, consisting of nine views of Stolzenfels Palace by Carl Georg Anton Graeb (1816-1864) and Georg Osterwald (1803-1884); fourteen views of Schloss Brühl by Adolf Wegelin (1810-1881) and Osterwald; and one of Cologne Cathedral by Osterwald. See Millar, vol. 1, pp. 370-71, nos. 2177-82, vol. 2, p. 670, nos. 4205-08; pp. 916-17, nos. 5778-90. On May 1, 1847, Victoria wrote, "how delighted I am with the Rhine album which recalls to me all the charming places that we visited in 1845 and our delightful meeting at the time." See Victoria, Queen of Great Britain, *Further Letters of Queen Victoria, from the Archives of the House of Brandenburg-Prussia*, ed. Hector Bolitho, trans. J. Pudney and Arthur Paul John Charles James Gore Sudley, Viscount (London: T. Butterworth, 1938):10, cited in Millar, vol. 1, p. 35.

32. For comparable sofa designs, see *Album of Furniture Designs* (1924-124-25-9 and -13) from the firm of Wilhelm Kimbel in Cooper-Hewitt's collection.

33. Graeb made another version of this interior with a slightly wider perspective; see Andreas Dobler, *Interieurs der Biedermeierzeit: Zimmeraquarelle aus Fürstlichen Schlössern im Besitz des Houses Hessen*, exh. cat. (Petersberg, Germany: M. Imhof; Eichenzell, Germany: Hessische Hausstiftung Museum Schloss Fasanerie, 2004): 100.

34. The same mixture of styles characterized the interiors of Friederick Wilhelm's apartment; see Margarete Kühn, *Schloss Charlottenburg* (Berlin: Deutscher Verein für Kunstwissenschaft, 1955): 104-05, pl. 69.

35. The large black fans made of bustard and peacock feathers with carved ivory handles stuck inside the red lacquer vases on either side of the library console table were said to be presents by Prince Friedrich Wilhelm Waldemar of Prussia (1817-1849), who had traveled to India in 1844-46 and brought back loads of souvenirs for relatives. The three Chinese vases under the table were presents to the Queen, perhaps from her husband; see Dobler, p. 100.

36. The dining-room furnishings were donated by Mme Guimard to the Petit Palais, Musée des Beaux-Arts de la Ville de Paris; see George Vigne, *Hector Guimard: Architect Designer, 1867–1942* (New York: Delano Greenidge Editions, 2003): 262-71.

FRANZ XAVER NACHTMANN (German, 1799–1846)
The Dressing Room of King Ludwig I at the Munich Residenz (detail), 1836.
Brush and gouache, gold paint, pen and black ink, graphite on white wove paper.
8 11/16 x 11 1/4 in. (221 x 286 mm). Cooper-Hewitt, National Design Museum,
Smithsonian Institution, Thaw Collection, 2007-27-18

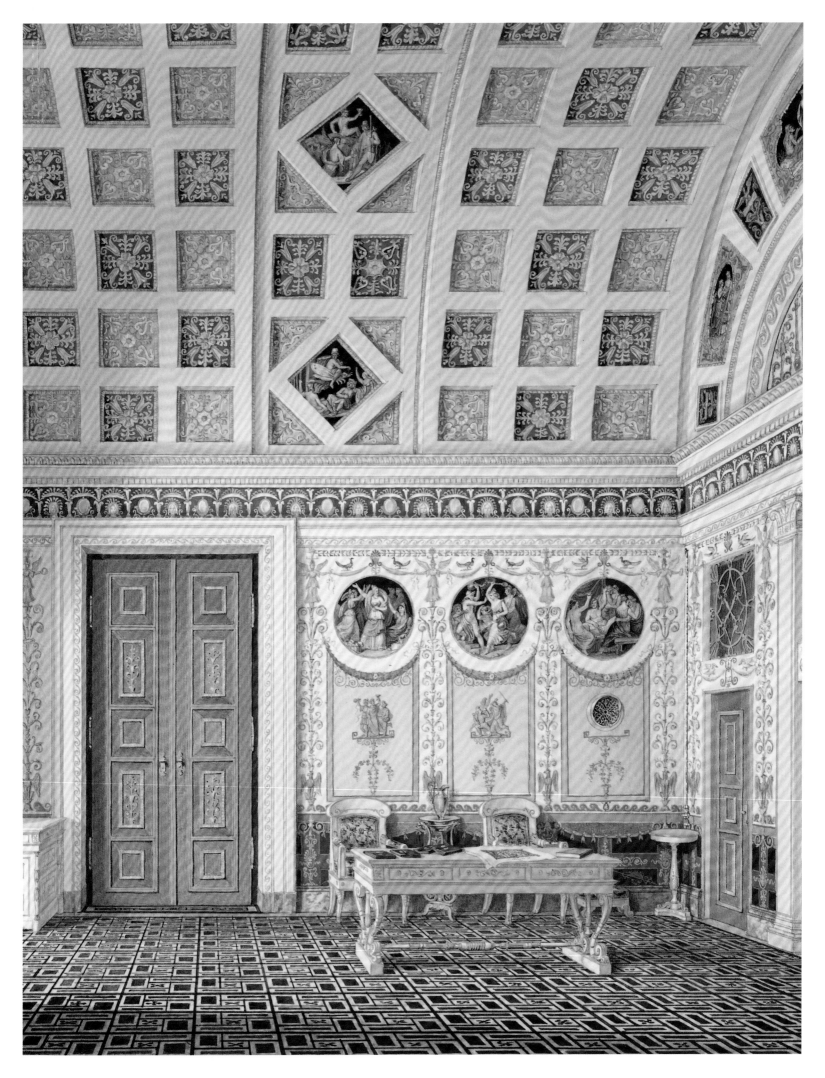

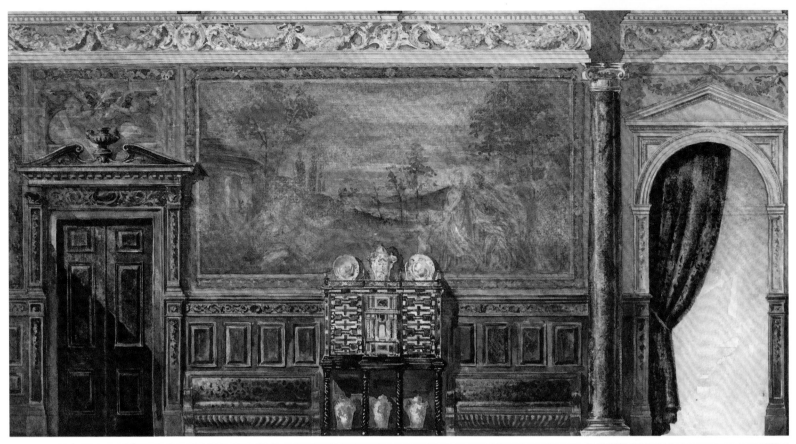

HOUSE PROUD

FROM AMATEUR TO PROFESSIONAL AND FROM
GRAND TO COMFORTABLE

CHARLOTTE GERE AND FLORAMAE McCARRON-CATES

FIG. 1

In nineteenth-century Europe, the artistic tradition of depicting private interiors in watercolors followed a trajectory. The earliest endeavors, often produced by family members or friends with little or no formal art training, were earnest attempts to document personal spaces and objects which held significant meaning. As the century progressed, the interest in possessing a pictorial record of living spaces took a greater hold. Professionally trained artists were commissioned by the aristocracy and wealthy bourgeoisie to record, often in astounding detail, the layouts of rooms filled with art, furniture, and other material possessions which attested to the social status of the occupants. After 1870, this particular tradition of watercolor interiors declined, replaced by photography and a shift in artistic style from tight, architecturally delineated images to a more relaxed treatment of space, light, and color.

While their function was ostensibly to record, these renderings serve an additional purpose for the modern viewer. They provide a perspective on the social mores, cultural customs, and personal spaces that presaged the modern home. With great curiosity we peer into these records of the past, recognizing the sophistication of the arranged interiors and their impact on our understanding of ourselves as social beings. What we buy and display projects whom we wish others to see. As heirs of the Victorian legacy of conspicuous consumption, these rooms—regal and spare, cluttered and overstuffed—remind us that our purchases may come back to haunt us.

In the eighteenth century, drawings of interior spaces were usually rendered by architects, primarily as elevations. They functioned as construction documents rather than subjective depictions, although the ornamentation of overdoors, chimneypieces, and wall paneling was rendered in exquisite detail. Watercolor interiors did not attempt to document a room architecturally; rather, they continued a tradition, begun by the seventeenth-century Bibiena family and their followers in the eighteenth century, of painted renditions of theater and stage designs. The drawings share a perspectival viewpoint, as opposed to the flat wall elevations of architecture. In the earliest watercolors by less formally trained artists, the reliance on perspective can be distracting, but also lends a sense of intimacy. For example, the

1. UNKNOWN ENGLISH ARTIST
Buscot Park, Elevation, 1890. Brush and watercolor, gouache, graphite on off-white wove paper. 7 ½ x 14 ⅜ in. (191 x 365 mm).
Cooper-Hewitt, National Design Museum, Smithsonian Institution,
Thaw Collection, 2007-27-3

2. FRANZ HEINRICH (German, 1802–1890)
Sala del Thorvaldsen, Rome, 1845. Pen and brown ink, brush and watercolor, white gouache, graphite on white paper. 10 ¹³⁄₁₆ x 13 ³⁄₁₆ in. (275 x 335 mm).
Cooper-Hewitt, National Design Museum, Smithsonian Institution,
Thaw Collection, 2007-27-36

FIG. 2

wall elevation of a formal hall at Buscot Park follows the traditional elevation style of architectural draftsmen while employing a more fluid brushwork that reflects the looser handling of the watercolor medium at the end of the nineteenth century (FIG. 1). This Palladian-style home surrounded by formal gardens was originally built for Edward Loveden Townsend between 1780 and 1783. After it was acquired by Alexander Hamilton, a prominent financier and art collector, in 1889, the building underwent an extensive renovation under the direction of architects Ernest George and Harold Peto. Elements found in this drawing, including the porphyry scagliola column and Ionic capital, are still visible at Buscot Park today.

In examining the Thaw Collection watercolors as a group, one discerns a second thread develop, a movement away from the formal public spaces of palaces and manor houses toward more personal spaces. Rooms initially designed for ceremonial presentations and state visits took on different functions. By the nineteenth century, the rigid formalities which governed such spaces evolved along with social and cultural mores. Halls and salons became social spaces where the elite met to dine and dance. These in turn evolved further into more intimate salons, drawing rooms, and sitting rooms—the ancestors of the modern living room. The Quirinal Palace, built in 1573 on the Quirinal, one of the Seven Hills of Rome, was a summer palace for Pope Gregory XIII. The German painter Franz Heinrich, about whom we know very little, painted a view of a room once called LA SALA DELLE UDIENZE [audience chamber], essentially a throne room, where those granted audience with the pope were presented (FIG. 2). In 1812, Napoleon commissioned the celebrated neoclassical sculptor Bertel Thorvaldsen (ca.

FIG. 3

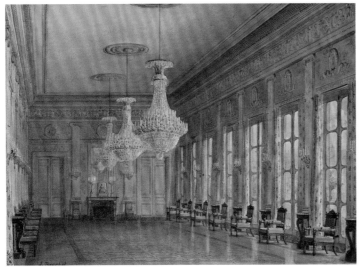

FIG. 4

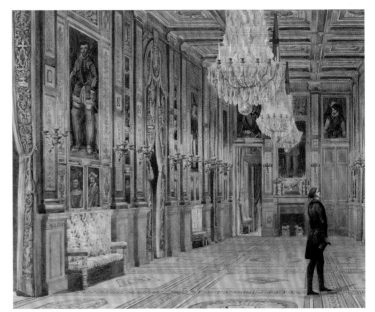

FIG. 5

1770–1844) to create TRIUMPH OF ALEXANDER, a plaster frieze which runs around the ceiling. The majestic and formal room is shown with very little comfortable furniture, which is entirely in keeping with the function of the room. The pope's throne sat on a dais at the end of the room; those in audience usually stood in his presence.

In Jules-Frédéric Bouchet's (1799–1860) views of two salons in the Montpensier wing of the Palais Royal (FIGS. 3, 4) in Paris, the highly ornate rooms follow the interior design of sixteenth- and seventeenth-century palaces.[1] The original structure, built by Cardinal Richelieu, became the living quarters of King Louis-Philippe (r. 1830–48). The long row of large pier-glasses, reflective surface of the parquet floor, and elaborate crystal chandeliers create a sense of opulence and grandeur. Another of Louis-Philippe's homes, the Château d'Eu, was depicted by Alexandre-Dominique Denuelle (FIG. 5), showing the Galerie des Guises. Conspicuous in this view are the chandeliers and parquet floors admired by the likes of Queen Victoria, whom Louis-Philippe received in September 1843. He in turn was received by the queen at Windsor Castle in October 1844. The French king commissioned a number of watercolor interiors as souvenirs of his visit, and presented many of them as gifts to Queen Victoria. The drawings, exe-

cuted by Eugène Lami (1800–1890) and a number of lesser-known French and English artists, were bound in a large album. The Galerie des Guises features in the album twice, as the site of presentations to Queen Victoria and the venue for a concert.

The Chateau d'Eu as it survives today, with its high-pitched roofs and brick and stone construction, is only one wing of the vast palace in the form of a U proposed in 1578. The existing structure was enlarged from 1821 by Pierre Fontaine (SEE DAVIDSON, FIG. 1) for the Orléans family. As he noted, the intention was to retain the character of the time when the château belonged to the dukes of Guise and of its most celebrated former inhabitant, Mademoiselle de Montpensier.[2] Restored and redecorated by Eugéne-Victor Viollet-le-Duc for the Comte de Paris in the 1870s, and almost destroyed by fire in 1902, the castle saw its

3. JULES-FRÉDÉRIC BOUCHET (French, 1799–1860)
A Small Salon in the Montpensier Wing, Palais Royal, 1830.
Brush and watercolor, white gouache, graphite on white wove paper.
7 ³/₁₆ x 9 ⁵/₈ in. (182 x 244 mm). Cooper-Hewitt, National Design Museum,
Smithsonian Institution, Thaw Collection, 2007-27-10

4. JULES-FRÉDÉRIC BOUCHET (French, 1799–1860)
The Salon in the Montpensier Wing, Palais Royal, ca. 1830. Brush and watercolor, white
gouache, graphite on white wove paper. 6 ½ x 9 ¹/₁₆ in. (165 x 230 mm).
Cooper-Hewitt, National Design Museum, Smithsonian Institution,
Thaw Collection, 2007-27-11

5. ALEXANDRE-DOMINIQUE DENUELLE (French, 1818–1879)
Vue de la galerie au Château d'Eu (detail), 1844. Brush and watercolor,
white gouache, graphite on white wove paper. 14 ³/₁₆ x 17 ¹/₁₆ in. (360 x 434 mm).
Cooper-Hewitt, National Design Museum,
Smithsonian Institution, Thaw Collection, 2007-27-34

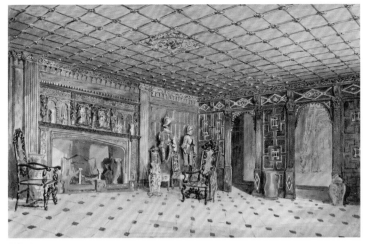

FIG. 6

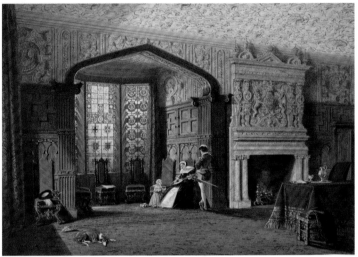

FIG. 7

East Sutton Place was the family seat of Sir Edmund Filmer, Bt, MP, to whom Richardson dedicated the second volume of his four-volume STUDIES FROM OLD ENGLISH MANSIONS (1841–48). This entrance hall[3] relates directly to a printed image in that volume, and the accompanying text explains that the hall "is a very ancient building, some portions as early as the reign of Henry VIII. The entrance hall contains a screen bearing the date 1570, which is a very interesting specimen of carved woodwork, and there is a handsome dining-room of the style of Elizabeth's reign."

The craze for gothic-style furniture in the nineteenth century was inspired by halls such as this and others in historic Tudor homes all over Britain. As the middle class searched for status objects to reinforce real or imagined pedigrees, furniture, ceramics, and textiles that referenced the Elizabethan past became the rage. The monthly magazine ACKERMAN'S REPOSITORY quickly capitalized on this trend by publishing small sections on fine furniture; it devoted nearly all of 1827 to furniture in the gothic style. In issue no. LVI, published August 1 of that year, the unknown author commented that there was a dearth of furniture extant from the Elizabethan period, and "the decorator must rely on architectural remains and from combinations which unite fitness with truth of character" to produce enough furniture to satisfy his clients.[4] By the time issue no. LVIII appeared in October, the gothic style warranted its own heading in the REPOSITORY's index, and the full-color plate showing "Pugin's Gothic Furniture" was accompanied by the commentary, "The Gothic style, which we have shown to be so well adapted to domestic arrangements and decorations, is becoming much more general that it was a few years since." Additionally, the writer reported that, due to the continued popularity of the gothic style, a separate volume was in preparation "as well to upholsterers and other professional persons, as to the admirers of the gothic style by whom they are employed."[5]

Gothic formal halls, whether in private homes or universities, symbolized a link to a history of erudition and nobility. Joseph Nash (1808–1878), who studied with A. W. N. Pugin (1812–1852), painted AN ELIZABETHAN ROOM AT LYME HALL, CHESHIRE (FIG. 7) as late as 1872. Although the work was originally composed in the 1840s, increased interest in "Olde English" architecture would have made it even more relevant to contemporary taste. The room contains many of the elements that characterized the style: carved paneling and heavily molded plasterwork on the walls and ceiling; the over-mantel, with its armorial cartouche; the deep window embrasure, or recess, reached through a pointed and paneled arch; and the bay window, with its panes of armorial stained and painted glass.

restoration completed in 1973 by the town of Eu. It is now a museum devoted to the reign of Louis-Philippe and to Montpensier, who started the collection of portraits in the Galerie des Guises in 1663.

In England, formal entrance halls in stately homes were devoid of furniture and often lacked warmth. In Tudor times, armorial suitings were kept there, and furnishings consisted of a few chairs pushed against the walls. Often dominated by an oversized fireplace, halls of this type relied on the hearth for light and heat. As the mansions were passed down through the generations, additional decorative objects were often incorporated, sometimes causing a clash of styles. In Charles James Richardson's (1806–1871) THE ENTRANCE HALL, EAST SUTTON PLACE, KENT (FIG. 6), suits of armor hang on the wall, and Chinese jars and a huge leather jug, or "jack," eagerly sought by collectors later in the nineteenth century, occupy the floor.

6. **CHARLES JAMES RICHARDSON** (English, 1806–1871)
The Entrance Hall, East Sutton Place, Kent, 1844. Brush and watercolor, graphite on white wove paper. 7 11/16 x 12 1/16 in. (195 x 306 mm). Cooper-Hewitt, National Design Museum, Smithsonian Institution, Thaw Collection, 2007-27-33

7. **JOSEPH NASH, SR.** (English, 1808–1878)
An Elizabethan Room at Lyme Hall, Cheshire, 1872. Brush and watercolor, gouache, graphite on white wove paper. 13 1/8 x 19 1/6 in. (333 x 484 mm). Cooper-Hewitt, National Design Museum, Smithsonian Institution, Thaw Collection, 2007-27-67

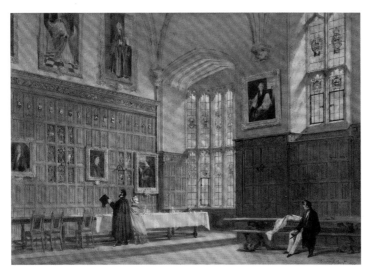

FIG. 8

The subjects covered in the four volumes of Nash's MANSIONS OF ENGLAND IN THE OLDEN TIMES can be broadly described as Tudor and Elizabethan, periods to which Victorian historicism was most strongly drawn. Nash called it "an era most prolific of splendor and originality of style, stimulated by the advance of national prosperity and greatness, and when the arts may be said in this country to have first begun to flourish," unconsciously emphasizing the nationalist bias of this choice of model. The Tudor house at Lyme was built in the mid-sixteenth century by Sir Piers Legh, and successive generations extended it in the eighteenth and nineteenth centuries. When Nash made his drawing of Lyme in 1844, the architect Lewis William Wyatt (ca. 1778–1853) had already added his Victorian version of Tudor to the house. In 1856, Nash rendered the dining hall in Magdalen College, Oxford (FIG. 8). The Tudor style is reflected in the linen-fold paneled walls, carved with scenes from the life of Mary Magdalene; vaulted plaster ceiling; and leaded stained-glass windows. Portraits of Cardinal Thomas Wolsey and Magdalen College founder William Waynflete hang in their original positions, joined by portraits of others associated with the college.

Other styles also proliferated in nineteenth-century England. Chinoiserie, most often associated with the eighteenth century, survived into the nineteenth in new ways, with designers drawing on other Asian and Middle Eastern decorative motifs, all filtered through a European eye. With Chinese porcelains flooding the market in Europe, designers invented elaborate schemes which evoked an exotic ambiance. Inspired by the example of Brighton Pavilion, George, Prince of Wales's pleasure palace built by John Nash (1752–1835) on the existing structure originally designed by Henry Holland (1745–1806), wealthy members of English, German, and Viennese society decorated their homes with

birds and dragons, bamboo, and wicker. The pavilion, in particular its music room, begun about 1817 and decorated by Frederick Crace (1779–1859) and Robert Jones (active 1815–23), is a sumptuous creation of Chinese-inspired details. In 1827, Nash documented room by room the elaborate color schemes and decorative elements of the pleasure palace in his publication VIEWS OF THE ROYAL PAVILION, BRIGHTON, whose influence extended from London to Berlin and beyond.

In 1826, Karl Friedrich Schinkel (1781–1841) was commissioned to renovate part of the seventeenth-century Royal Palace in Berlin; by the 1850s, the palace was used only for official receptions. Eduard Gaertner's views of the state apartments are a valuable record of royal taste and patronage in the 1820s and 1830s.[6] The Chinese Room (FIG. 9) is lined above the paneled chair rail with large pieces of painted Chinese paper, framed by wide blue borders and decorated with Chinese characters in gold. A suite of black lacquered sofa and side chairs upholstered in brilliant yellow silk, a curving banquette by Birckenholtz in deep blue damask which fills the end wall, and two seventeenth-century-style chairs covered with rose-pink velvet make up the formal furnishings of the room, which also houses an impressive collection of Asian porcelain and black and gold lacquered cabinets.[7] A small island of intimacy and sociability has been created in the far corner, with upholstered chairs around a large table.

Gaertner painted his views in the 1840s and 1850s, before the rooms were abandoned. Visiting the palace in 1858, Queen Victoria remarked, "We went across an open gallery (very cold and inconvenient in winter) to the King's apartments - strange, dark, vaulted, dull rooms, left just as he used them, full of pictures of interiors of churches, - then to the Queen's rooms, fine and large but very cold - full of family pictures and busts."[8] The state rooms were also part of the tour, but the queen described only the "Red" and "Black" rooms and the celebrated "Ritter Saal," all in "the richest Renaissance style, with painted ceilings, splendid furniture, &c -, really one of the finest things I have ever seen."[9] Gaertner also recorded these rooms between 1844 and 1852. The Emperor Wilhelm II (succeeded 1888) made the Royal Palace once again the sovereign residence and initiated a new period of building

8. **JOSEPH NASH, SR.** (English, 1808–1878)
View of the Dining Hall in Magdalen College, Oxford, 1856. Brush and watercolor, white gouache, gray wash, pen and black ink, graphite on off-white wove paper. 13 ¼ x 19 ⅛ in. (337 x 485 mm). Cooper-Hewitt, National Design Museum, Smithsonian Institution, Thaw Collection, 2007-27-59

9. **EDUARD GAERTNER** (German, 1801–1877)
The Chinese Room in the Royal Palace, Berlin, 1850. Brush and watercolor, gouache, graphite on white wove paper. 10 ¹¹⁄₁₆ x 14 ⁵⁄₁₆ in. (272 x 363 mm). Cooper-Hewitt, National Design Museum, Smithsonian Institution, Thaw Collection, 2007-27-48

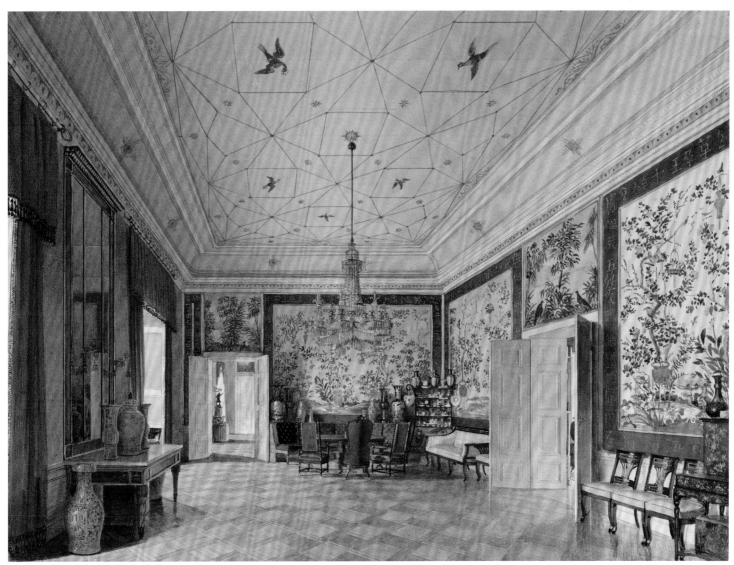

FIG. 9

activity. However, the persistent cold was never solved; even after the transformation of the palace into a museum, many of the rooms were closed in winter. The palace was demolished after World War II.

Albums of interiors served as reminders of a beloved home for family members who married and moved away. This view of the Chinese Room is a replica of the one Gaertner made in the same year, now in the Hesse collection in Darmstadt. The views of the Chinese Room and other apartments in the Berlin palace of Prince Wilhelm of Prussia and his wife Marianne of Hesse-Homburg (d. 1846) were made for their daughter Elizabeth, who in 1836 married Prince Charles of Hesse; the drawings are now in the Schlossmuseum in Darmstadt.

A Viennese interpretation of Chinese and Japanese motifs, Rudolph von Alt's THE JAPANESE SALON, VILLA HÜGEL, HIETZING (FIG. 10) shows how little Europeans of this period understood of the respective cultures of China and Japan. This watercolor, described as Japanese, is more a fantasy than a document of Japanese art and design—hardly surprising, as for two centuries, Japan had refused all contact with the West, except for a handful of Dutch traders, until Commodore Matthew Perry reopened trade relations with Japan in 1854,[10] and the nuances of Japanese design were unknown at the time the villa was constructed.[11] Relying on scant evidence gleaned from imported porcelains and secondhand reports, decorators invented exotic forms and termed them "Japanese."[12] The decorator responsible for this elaborate pastiche incorporated examples of Asian porcelain, Chinese lamps, and large ceramic figures that sit between the French windows (FIG. 10A). Papier-mâché tables and chairs embellished with mother-of-pearl stand in front of a mantelpiece decorated with Chinese fretwork directly inspired by Crace's designs at Brighton. Curiously, the seated figure that dominates the room underscores the ambiguity. Is she a woman or a porcelain doll? The artifice is complete.

Foremost among stylistic influences in the nineteenth century was French neoclassicism, evident in many of these watercolor paintings. The French held unequaled sway over European tastes from the seventeenth century through the Regency and the Second Empire. Classical balance and symmetrical form created a counterpoint to the excesses of the rococo period in the eighteenth century, which was responsible for chinoiserie.

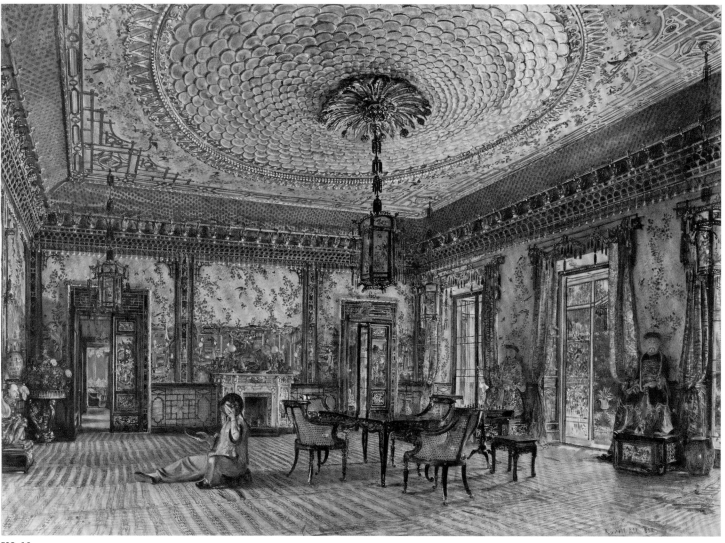

FIG. 10

FIG. 10A

In 1783, Carlton House, a neoclassical masterpiece designed by John Nash, in Pall Mall was presented to the twenty-one-year-old George, Prince of Wales and later King George IV, as his London residence, and George immediately set out to turn it into one of the most fashionable in Europe. The prince lavished huge sums of money on its decoration, embellishing ceaselessly in his quest for perfection. After barely forty years, during which it was altered beyond recognition, the house was abandoned and demolished. Nothing remains of the "perfect palace" except the columns from the screen between the front courtyard and the street, which survive as the portico of the National Gallery in London's Trafalgar Square.

10. **RUDOLF VON ALT** (Austrian, 1812–1905)
The Japanese Salon, Villa Hügel, Heitzing, Vienna, 1855. Brush and watercolor, gouache, graphite on white wove paper. 15 ⅛ x 20 ¹⁵/₁₆ in. (384 x 532 mm).
Cooper-Hewitt, National Design Museum, Smithsonian Institution, Thaw Collection, 2007-27-56

10A. *Chinoiserie figure on pedestal*. France, 19th century. Terra-cotta. 5 ft 4 in. x 18 in. x 18 in. (162.6 x 45.7 x 45.7 cm). Cooper-Hewitt, National Design Museum, Smithsonian Institution, Gift of Mr. and Mrs. Albert C. Bostwick, 1971-93-2-a,b

11. **CHARLES WILD** (English, 1781–1835)
The Circular Dining Room at Carlton House, London, 1819. Brush and watercolor, gouache on white wove paper. 18 ⅛ x 15 in. (461 x 381 mm).
Cooper-Hewitt, National Design Museum, Smithsonian Institution, Thaw Collection, 2007-27-2

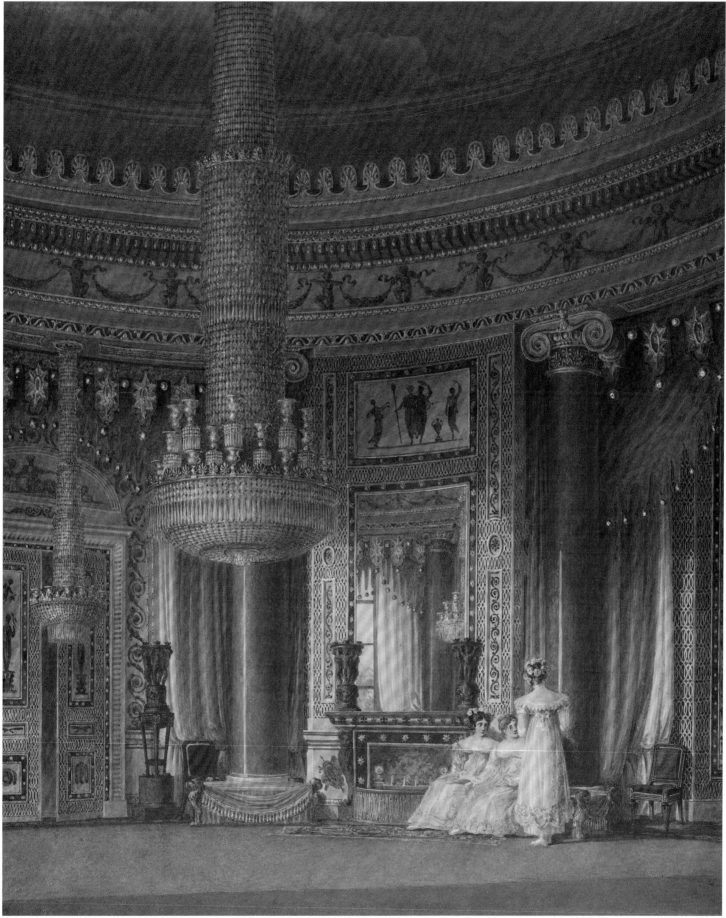

FIG. 11

The problem with Carlton House was that it was too small for the extravagant George, especially after he succeeded his father in 1820. The prince's architect Henry Holland used the site as well as he could, but it offered little scope for expansion and was inconveniently close to the public street. In addition, it landed the prince with mountains of debt. Furnishings and fabrics were ordered and never used; marble chimney-pieces were torn out and replaced; chairs and tables were no sooner installed than sent down to Brighton for the Pavilion, his exotic palace by the sea. When George moved into the larger, more secluded Buckingham Palace (on which he proceeded to spend even greater sums of money), Carlton House became redundant. Its maintenance would have been an unjustifiable extravagance; but its destruction was an incalculable loss to British architecture and decoration and to the urban landscape of London.

This view shows the Carlton House's circular room on the principal floor. Originally the music room, then in the 1790s the second drawing room, it was converted into a dining room in 1804 (FIG. 11). This watercolor is on a much larger scale, with more prominent figures, than the drawings made of the room by Charles Wild for William Henry Pyne's HISTORY OF THE ROYAL RESIDENCES, but it shows the room at the same point in its complex decorative history.[13] The giant porphyry-colored columns of scagliola, or imitation marble, with bronze capitals survived the first decade of alterations under Henry Holland, as did the ceiling painted to simulate a cloudy sky. The completed scheme was predominantly orange, pale blue, red, silver, black, and green. The reddish columns supported a stucco frieze of bronze-colored putti holding swags of foliage and a cornice of silvered anthemion or floral decoration on a lavender ground. The light blue silk curtains and pelmets were ornamented with cut-glass stars. The chairs were upholstered with orange leather and the ottomans covered in blue silk, swagged and edged with silver fringe to match the curtains. Pyne described the enormous cut-glass chandeliers in the Rose Satin Drawing Room as the finest in Europe.[14]

COMFORT ARRIVES IN THE FORMAL SALON

As the nineteenth century progressed, aristocratic families and the wealthy upper-class bourgeoisie were influenced by contemporary trends in furnishings, and the grand salon was redesigned to be more accommodating and comfortable. While the dimensions of the room remained palatial, a new style emerged out of the excesses of the rococo century. As Witold Rybczynsk observed, one of the hallmarks of French rococo style was the idea of comfort that the furniture projected.[15] Merging the comfort of rococo with the desire for manufactured goods, designers and decorators looked to progressive models

that had their origin in the pattern books of Thomas Chippendale (1718–1799), G. Hepplewhite (d. 1786), and Thomas Sheraton (1751–1806). Of primary importance was Chippendale's THE GENTLEMAN AND CABINET-MAKER'S DIRECTOR, first published in London in 1754, a compendium of up-to-date designs in neoclassical, neo-gothic, and "Chinese" styles for chairs, tables, bookcases, and other household furnishings used by decorators in England and abroad. The influence of the DIRECTOR was widespread, and copies of it could be found in many private libraries throughout Europe.[16] By the early nineteenth century, the Chippendale style, referred to as "the English Taste," became, with Georgian, Regency, and neo-gothic, the standard for durable, well-built, comfortable furniture. In 1815, a new style, Biedermeier, named (somewhat later) after a fictional character in a work by Ludwig Eichrodt, became popular in Germany, Austria, and Scandinavia. Biedermeier furniture featured the formal lines of neoclassical design, but without the excessive ornamentation associated with it. Sleek pieces in polished wood, unadorned by swags, wreaths, or trophies, resembled the merchants and businessmen who purchased them, and the style came to embody the German bourgeoisie. For Madame Candide, the unknown inhabitant of this room in the Palazzo Satriano (FIG. 12), the elegant, light, modern furniture and the terracotta tiled floor must have mitigated some of the effects of the Neapolitan summer. The seventeenth-century palace was the ancestral home of General Carlo Filangieri di Satriano, Premier of the Two Sicilies, the son of Goethe's friend, the "noble but impoverished" philosopher and writer Gaetano Filangieri. Situated on the fashionable promenade at Chiaia, overlooking the eighteenth-century pleasure gardens of the Villa Nazionale with the sea beyond, the palace was enlarged in the eighteenth century under the direction of Ferdinando Sanfelice (1675–1748). The neoclassical interiors were the work of Gaetano Genovese (1795–1860), described as "the finest Neoclassical architect working in Naples." As was usual in Italy, the salon is furnished and decorated plainly, with minimal upholstery and hangings. A marble (or marbleized) dado topped by a floral wallpaper border in the French taste runs round the walls, which are painted pale green up to a frieze of swags on a grey ground picked out in white. The striking border to the green painted ceiling, done either in plaster or trompe-l'oeil, simulates fabric, a popular device in nineteenth-century decoration. The next room in the long enfilade visible through the open door is papered in wide stripes of green and white, in harmony with the first room. A toilet table can be seen in the room at the end of the vista, probably a bedroom and the last in a suite of rooms comprising the living quarters of "Mdme Candide."

The summer custom of dressing windows with muslin draperies has been followed here; the polished tile floor is bare of rugs. The chairs are

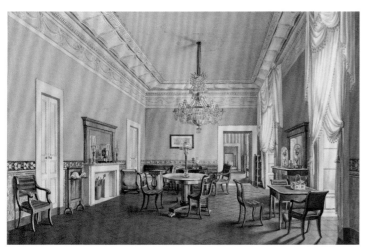

FIG. 12

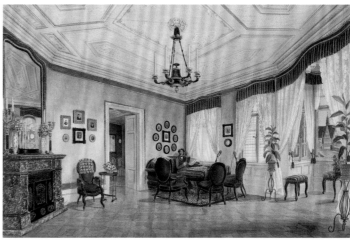

FIG. 13

of pale wood upholstered in blue stripes to match the built-in banquette on the end wall. Like much of the furniture, the sewing table, with its deep well of silk and its lyre-shaped supports, is in the English style, popularized in Naples through the influence of the British ambassador Sir William Hamilton. The console with mirror above and the circular marble topped table in the center of the room are in the French taste, and French-style candelabra in gilt and patinated bronze flank the large clock under a glass dome on the mantelshelf, a novelty in the form of a windmill whose sails were doubtless operated by the clockwork mechanism.

By contrast, the oddly shaped room in this view (FIG. 13), with its geometric ceiling decoration and old-fashioned casement windows above eighteenth-century paneled skirting, was updated to nineteenth-century tastes by means of a carefully coordinated scheme. The severity of the plasterwork and paneling is mitigated by the arching top of the over-mantel. Plain and gilt wooden pelmets, edged with long fringes and hung with lace curtains and inner muslin blinds, occupy the whole of the right wall, ingeniously uniting window openings of different sizes. Two rococo-style armchairs are trimmed with the same blue fringing as the pelmets and tasseled tiebacks; the upholstered seats of the stools in the bay window match the tablecloth. Through the door-

way one sees chairs in the adjacent room pushed against the wall, in contrast to the comfortable seating arrangement near the windows, where a gentleman is engrossed in reading. Chairs and furniture groupings provide comfort and function in the "Second Empire" style. Championed by Empress Eugénie, wife of Napoleon III, the style prevailed between 1852 and 1870. It combined rococo-revival curvature with the balance and symmetry of the neoclassical French style made popular by Charles Percier and Pierre-François-Léonard Fontaine in the early 1800s. Often using dark and heavy wood, and featuring an abundance of tassels, Second Empire furniture was often over-upholstered, overstuffed, and oversized. In reality an eclectic mishmash of conflicting tastes, the style contributed to a comfortable interior that encouraged relaxation rather than formality.

The view through the open window hints at the character of the urban landscape, with old houses and a church spire. Just visible in the window bay, flanked by a handsome pair of foliage plants in green wrought-iron plant stands, is a flower-filled wooden jardinière-table, which forms part of the suite of rococo-revival furniture. Under the table, a patterned square rug, probably of needlework, breaks the expanse of polished parquet. Groups of monochrome miniature portraits are carefully arranged on the walls; it is tempting to suppose that the oval frames arranged in a circle above the settee and possibly some others may contain portrait photographs, a prized novelty. The circular object hanging between the windows is an aneroid barometer. To judge from the costume of the man on the sofa, this view cannot be much earlier than the 1850s. The room is surprisingly uncluttered for that date, though there is more than a suggestion of splendor in the heavy marble chimneypiece, the over-mantel mirror, the fine French gilt-bronze clock under a glass dome, and four-branch candelabra and six-branch central chandelier in gilt and patinated bronze. For all its

12. **L. IELY** (possibly French, active 1820s–30s)
A Salon in the Palazzo Satriano, Naples, 1829. Brush and watercolor, graphite on white wove paper. 9 ½ x 14 9/16 in. (241 x 370 mm).
Cooper-Hewitt, National Design Museum, Smithsonian Institution, Thaw Collection, 2007-27-9

13. **CASPAR OBACH** (German, 1807–1868)
A Salon, probably in Stuttgart, 1850s. Brush and watercolor, gold paint, graphite on white wove paper. 10 x 15 ⅛ in. (254 x 384 mm).
Cooper-Hewitt, National Design Museum, Smithsonian Institution, Thaw Collection, 2007-27-45

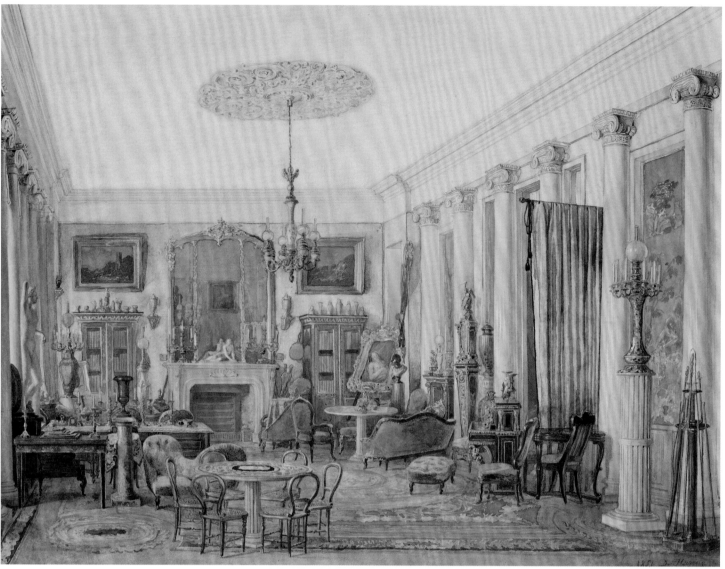

FIG. 14

air of understated bourgeois comfort, this room was likely part of a grand residence.

Dominik Hagen's view of a grand colonnaded room in Moscow (FIG. 14) bears all the marks of nineteenth-century Russia's predilection for opulence and show. It is difficult to tell to which class the owner belonged, as many wealthy merchants lived in townhouses as grand as those of the nobility. The room's scheme is dominated by the profusion of "Boulle" furniture—pieces with ormolu-mounted and brass-inlaid marquetry inspired by the master cabinetmaker André-Charles Boulle (1642–1732)—a taste much demonstrated in the imperial palaces of the Romanovs since the time of Catherine II (the Great). On the mantelshelf, there is a reduced copy of Charles-Antoine Coysevox's NYMPHE Á LA COQUILLE from Versailles. The room would be a typical example of a wealthy Moscow interior, except for its association with Rachel Félix, the great French actress renowned for her scandalous private life, whose response to the plea of a presumed lover is recorded on the mount.[17] Rachel was on tour in Moscow in 1853 and the implied rendezvous may have happened on that occasion; she subsequently owned the watercolor.

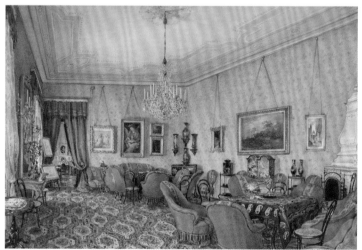

FIG. 15

14. **DOMINIQUE HAGEN** (German or Russian, active second half of 19th century)
An Interior in Moscow, 1851. Brush and gray wash, watercolor, pen and black ink on off-white wove paper. 10 13/16 x 14 in. (275 x 355 mm). Cooper-Hewitt, National Design Museum, Smithsonian Institution, Thaw Collection, 2007-27-50

15. **FRANZ ALT** (Austrian, 1821–1914)
A Salon in Vienna, 1872. Brush and watercolor, gouache, graphite on white wove paper. 8 3/4 x 12 5/8 in. (223 x 320 mm). Cooper-Hewitt, National Design Museum, Smithsonian Institution, Thaw Collection, 2007-27-66

Franz Alt's 1872 A SALON IN VIENNA (FIG. 15) shows a formal salon covered with paintings in heavy gold frames (including a watercolor of a popular subject, the Scaliger tomb in Verona), and two drawings on a double easel by the window. Next to the curtained doorway at the end of the room is a watercolor copy of Raphael's CALLING THE APOSTLES; directly under the picture, on the gilded rococo-revival pedestal table by the door, is a miniature version of Etienne-Maurice Falconet's THE BRONZE HORSEMAN, the iconic equestrian statue of Peter the Great in St. Petersburg. Portraits are massed above a writing desk in the adjoining room. In this carefully coordinated scheme, both rooms feature pale walls that set off the rich blue of the upholstery and curtains. The painted ceiling is delicately tinted, in keeping with the cream wallpaper patterned in grey with swags and flowers.

Even without an inscribed date, one can easily discern that the rooms were decorated and furnished in the 1870s. The taste for black and gold Japanese lacquer and black-ground FAMILLE NOIRE porcelain vases is characteristic of the period, as is the round table in the near window set with a panel of Chinese embroidered silk bordered with a crocheted fringe in deep blue and cherry red. What may be a pair to it is on the table in the center of the farther conversation group. On the nearer square table is a paisley-bordered cloth, also of embroidered silk. In the center of the table is a brocade-pattern covered cup mounted in gilt metal. The Louis XV–style white and gold console table between the windows supports a pair of many-branched candelabra whose lights would have been reflected and enhanced by the tall mirror. They are of Louis XV inspiration, like the central chandelier and the three-branched girandoles flanking the mirror, which may have come from the French Baccarat factory. The three-tiered whatnots with cabriole legs, supporting respectively a pair of vases and a black-and-gold lacquer canister, are inspired by a Louis XVI table à café—a taste for the French eighteenth century was another characteristic of 1870s interiors.

The suite of spoon-back easy chairs, side chairs with cabriole legs, and sofas is upholstered in blue velvet, with a central band of floral needlepoint embroidery and contrasting piping and fringed edging that pick up the colors of the flowers and the velvet. In the 1870s, this upholstery treatment replaced the ubiquitous buttoning popular during the Second Empire. The theme of the upholstery is repeated in the heavy portiere and the window pelmets. The season must be summer, as sunlight floods the room and the only curtains are of filmy patterned lace. The floral motifs in the upholstery panels are echoed in the repeating lozenges patterning the carpet, which covers the floor and continues into the room beyond. The lacy black and gold Gothic frame of the fire screen in front of the BOMBÉ ceramic stove is earlier in taste,

but this intricate carving remained popular in Austria and Germany until well into the 1880s. The mass-produced bentwood chairs with cane seats, one of the earliest designs (ca. 1855) manufactured by the Viennese firm of Thonet, are an unexpected detail in this salon. In 1869, the patent on this model ran out, and other firms seized the opportunity to fill the demand for these popular chairs. Their inclusion suggests that the room hosted some entertainments for which even the extensive suite of upholstered furniture was insufficient.[18]

Rudolf von Alt's SALON IN THE APARTMENT OF COUNT LANCKORONSKI IN VIENNA displays the rarefied cultural environment of the royal Lanckoronski family (FIG. 16), and also underscores the change from a formal space to a comfortable room of repose. The upholstered chairs are covered with simple white cloth covers at the armrests and backs, lending a casual air. The chairs, sofa, and desk cluster close to walls papered, in typical Biedermeier fashion, with repeating pale scrolls on a colored ground. In contrast, the room's artworks and the elegant ceiling fixture suspended above the Oriental carpet tell of its formal past. The Polish Lanckoronski family assembled a major collection of old-master paintings and German, French, Dutch, and Italian decorative-arts objects. The portrait in the center on the left-hand wall, by Anton von Maron (1733–1808), shows the brothers Rzewuski in Rome. The portrait bust of Friedrich von Schiller on the table at left is by Joann Heinrich Dannecker. The landscapes can be identified as by Ruisdael, Waldmüller, Gainsborough, and Claude.

LARGE SALON WITH ORGAN, an accomplished, and possibly amateur, watercolor (FIG. 17), is not signed and bears no inscription; however, from the costumes worn by the figures, one seated at the organ and the other at a table in the window, it can be dated to the 1830s. Certain clues in the furniture and decoration point to an English country house. The incongruity of a neoclassical barrel-vaulted ceiling with a Gothic-style organ and Jacobean-revival window bay suggests that the exterior of the house underwent a transformation at a later date than the decoration of the interior. The chimneypiece, probably dating from the 1770s, is reminiscent of Robert Adam, but the ornate tasseled window draperies supported on huge cloak pins and caught up in the claws of a bird with widespread wings are in the Regency style, and may be contemporary with the installation of the window. Henry Holland used this device of swags with a deep edging of fringe in a contrasting color caught in the beak or claws of a bird (usually an eagle) at Southill, the house he designed for Samuel Whitbread, and in the Rose Satin drawing room at Carlton House. The same motif also features in ACKERMANN'S REPOSITORY, where it was credited to the upholsterer John Stafford, a successful provincial decorator.

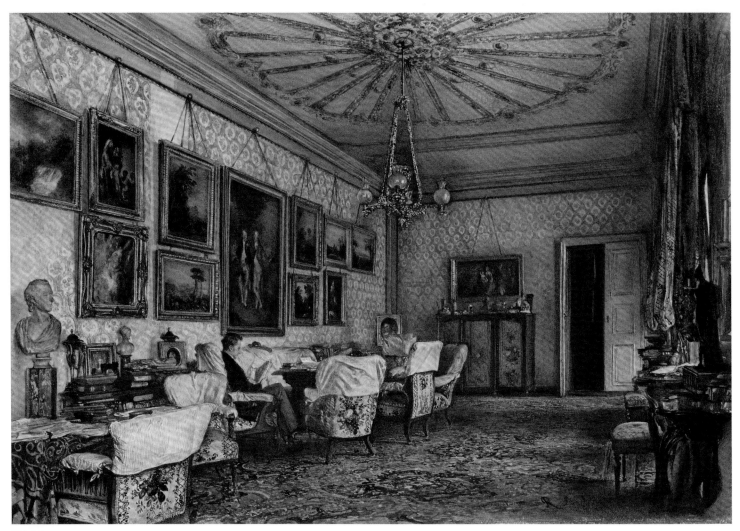

FIG. 16

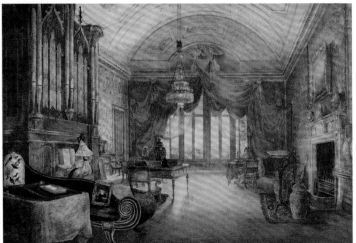

FIG. 17

Although this is architecturally a formal salon, it functions as music room, library, and drawing room. In this interior view, the watercolor serves less as a document of style and more a record of lives lived. The furniture, which covers a period of about sixty years from the 1770s to the 1830s, reflects a practical approach to the interior rather than a planned scheme by a professional decorator. The crystal and ormolu chandelier is hung with a counterweighted mechanism for lowering and raising it. In the foreground, a conspicuously stylish, Grecian-style library couch has a black and gold frame exaggeratedly coiled at one

end. The sofa table has a glass dome covering brilliantly colored stuffed birds on a branch and a portable writing desk open with paper and inkwell ready for use, suggesting that one of the room's inhabitants might be about to draw the birds. By the chimneypiece stand two large Chinese porcelain jars and a rustic tripod, probably imported from China, supporting a great porcelain dish. Another jar and a dish stand on the French-style BUREAU PLAT, or writing table, in the center of the room. The chairs are also in the French taste, similar to those made for Southill by Georges Jacob in about 1800.[19]

THE RISE OF THE WATERCOLORIST

In watercolor painting, transparent pigments are applied in thin, over-lapping washes, which create great depth of tone while retaining a lightness unlike any other medium. True watercolor painting relies on

16. **RUDOLF VON ALT** (Austrian, 1812–1905)
The Salon in the Apartment of Count Lanckoronski in Vienna, 1881. Brush and watercolor, white gouache on white wove paper. 10 7/16 x 15 3/8 in. (265 x 391 mm). Cooper-Hewitt, National Design Museum, Smithsonian Institution, Thaw Collection, 2007-27-71

17. **UNKNOWN ENGLISH ARTIST**
A Large Salon with Organ, 1830. Brush and watercolor, gouache, graphite on white wove paper. 11 7/16 x 16 15/16 in. (291 x 431 mm). Cooper-Hewitt, National Design Museum, Smithsonian Institution, Thaw Collection, 2007-27-12

the whiteness of the paper, not opaque pigments or white paint, for highlights. (Gouache, by contrast, is opaque, and gouache paintings can be built up following the same system used in oils.) Watercolors were initially used in the late eighteenth century by highly skilled draftsmen, who produced survey drawings for architectural firms or topographers. They used thinly applied washes to add substance to architectural renderings, which were often remarkably detailed. It was rare for fine artists to work in the medium, which lacked the standing and substance of oil paint—the primary medium for creating large history paintings and official portraits. According to Marjorie Cohn, the rise of amateur watercolor painting was aided by the publication around 1800 of numerous manuals explaining the techniques, as well as by the new profession of the "artist's colorman"—who not only sold brushes, paper, and mounting boards to artists, but also prepared the pigments for them.[20] This was a crucial step for amateurs, as grinding the raw pigments with gum arabic to create a malleable substance was tedious and, unless practiced, produced uneven results. As early as the 1780s, a British colorman named William Reeves invented the dry-cake watercolor, an important development in watercolor art. The firm of Winsor & Newton, which manufactured watercolor paints from 1832, selling the watercolors in round tins, began putting them in standard tubes in 1846. And, in 1780, the Briton James Whatman invented a paper with no discernable grid lines,[21] known as wove paper, which also contributed to the rise of watercolor as a viable artistic medium. Previously, laid paper, with its marks of manufacture, created a rough and uneven surface unsuitable for the transparency of watercolor washes. Whatman's paper was so smooth that the fluidity of the wash could be used to greatest effect.

In the early nineteenth century, young women from upper-middle-class families were encouraged to cultivate their sensibilities through the arts, and tutors instructed them in music and painting. These women often chose to depict the interiors of their homes, recording with great care the minutiae of their lives. In the 1815 work THE ARTIST'S DRAWING ROOM ON LAKE CONSTANCE (FIG. 18), Louise Cochelet, a lady-in-waiting, and LECTRICE [reader], and close confidant to Queen Hortense, stepdaughter of Napoleon and wife of Louis Bonaparte, King of Holland and Napoleon's younger brother, rendered her sparsely furnished "petit Salon," or drawing room, in brown wash grisaille, a popular technique at the time. The drawing reflects the efforts of an accomplished watercolor painter, who relied on tonalities

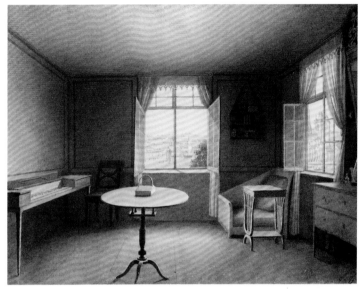

FIG. 18

rather than a range of color. This interior's charming atmosphere—the serene, orderly arrangement, the beautiful view—conveys something of Constance's climate, which is mild, consistent, and dry. The windows overlooking the lake are open and dressed for summer with transparent curtains, probably of muslin. Although spare, the furnishings are very much in the French fashion: the asymmetrical chair to the right of the window, a favorite of Napoleon, and later called a "Napoleon chair"; the suspended bookshelves; the center table with its tripod support, and on the table, a workbox with two sloping lids on either side of the handle, likely fitted inside as a NÉCESSAIRE with sewing implements and thread; and a small, square piano. In the immediate environs of the old cathedral city of Constance,[22] just visible through the windows, are a number of ancient churches, buildings, and castles. In the immediate area were the ruined castle of Neuberg and Arenenburg Castle, which later became Hortense's residence in exile.[23] (Cochelet's four-volume MÉMOIRS OF QUEEN HORTENSE AND THE IMPERIAL FAMILY contains much information on her years of exile in Switzerland.)

By the early nineteenth century, the drawing room replaced the formal salon as the receiving room for important visitors. In the homes of the nobility, the drawing room still maintained elements of formality, but a sense of intimacy began to prevail. This can be seen not only in Cochelet's salon, but also in more formal depictions such as William Henry Hunt's THE GREEN DRAWING ROOM OF THE EARL OF ESSEX AT CASSIOBURY (FIG. 19). The elaborate gilded frames, rich color scheme, and placement of the furniture belie the stately formality of a receiving room for visitors. However, the woman at the piano and the tiny dog suggest a relaxed air. Hunt perfected a technique of minutely detailed

18. LOUISE COCHELET (French, 1785–1835)
The Artist's Drawing Room on Lake Constance, 1816.
Brush and brown wash, graphite on white wove paper. 7 ⁹/₁₆ x 10 ¹/₁₆ in. (192 x 255 mm).
Cooper-Hewitt, National Design Museum,
Smithsonian Institution, Thaw Collection, 2007-27-1

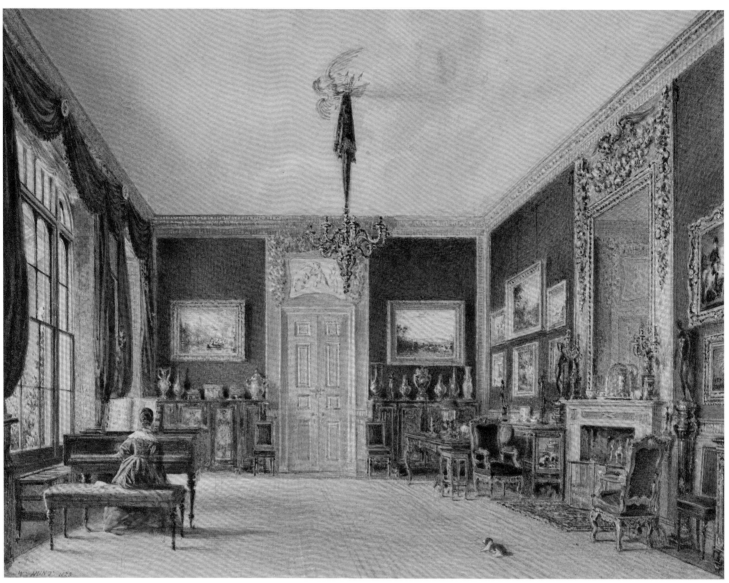

FIG. 19

and highly finished watercolor particularly suited to interior views. Cassiobury (or Cashiobury) Park, home of the Capel family, Earls of Essex, in Hertfordshire, was an Elizabethan house that was demolished in the 1920s; its magnificent carved staircase, by Grinling Gibbons, is now in the Metropolitan Museum of Art. Much of the room's contents are identifiable, including the magnificent paintings by J. M. W. Turner on either side of the door. The one to the right, THE THAMES AT WALTON BRIDGE, is now in the collection of the National Gallery of Melbourne in Australia. This room, overlooking the park, was in the newest part of the house, a gothic-style wing by James Wyatt, ornamented with gilded carvings by Gibbons. It has a fashionable "sky" ceiling and green curtains matching the wallcovering. The trompe-l'oeil eagle holding the chandelier is an unusual device.[24]

H. Thierry's A SALON IN THE EMPIRE TASTE (FIG. 20) is particularly remarkable for its atmospheric light, which brings out the accents of gold, white, and silver and the transparency of glass and muslin. The blue-and-buff color scheme, which continues in the adjoining room, emphasizes the bas-reliefs above the doorcase and the over-mantel mirror. Among the closely hung collection of pictures is a moonlit seascape by

Claude-Joseph Vernet (or one of his many imitators) and a couple of interiors in heavy gold frames. One pedestal, in the far right corner of the room, carries a reduced replica of the APOLLO BELVEDERE; another in the near right corner seems to await a companion piece.

There are many parallels here with French imperial taste: The candelabra on the chimneypiece resemble those included in Percier and Fontaine's decorations for Napoleon at Malmaison and Fontainebleau in the form of a winged Victory; and the gilt and patinated bronze chandelier is similar to Percier and Fontaine's for Josephine's music room at Malmaison. Gilt-bronze objects with clean neoclassical lines were popular in the Napoleonic era, notably those by Pierre-Philippe Thomire (1751–1843). Drawing on Percier and Fontaine's interpretations of antiquity, Thomire created metalwork of various types for palaces throughout Europe.[25] (FIG. 20A) The two cut-glass bowls in the tea

19. **WILLIAM HENRY HUNT** (English, 1790–1864)
The Green Drawing Room of the Earl of Essex at Cassiobury, 1823.
Brush and watercolor, gouache, graphite on white wove paper.
9 ⅛ x 11 ⁷⁄₁₆ in. (231 x 290 mm). Cooper-Hewitt, National Design Museum,
Smithsonian Institution, Thaw Collection, 2007-27-4

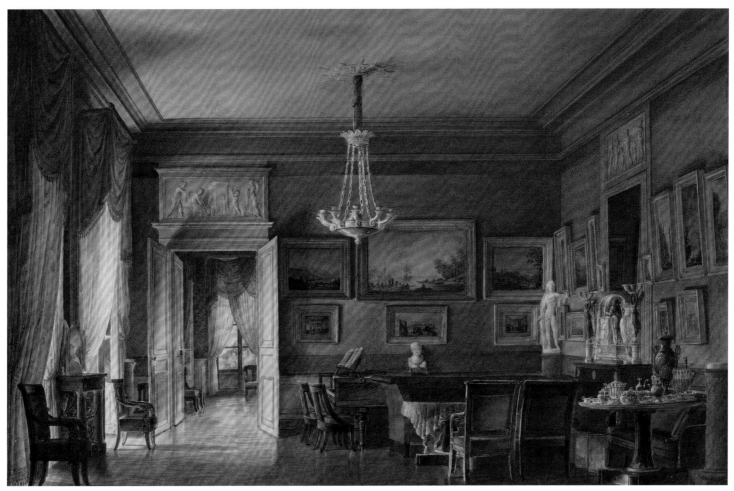

FIG. 20

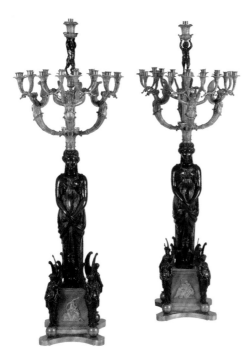

FIG. 20A

20. **HILAIRE THIERRY** (French, active first half 19th century)
A Salon in the Empire Taste, 1820–30. Brush and watercolor, gouache on white
wove paper. 11 x 16 ¹⁵/₁₆ in. (279 x 431 mm). Cooper-Hewitt, National Design Museum,
Smithsonian Institution, Thaw Collection, 2007-27-6

20A. **PIERRE-PHILIPPE THOMIRE** (French, 1751–1843)
Pair of Candelabra. Paris, France. 1815–25. Patinated and gilded bronze.
61 ⅝ h x 21 ⅝ dia. in. (156.5 h x 55 dia. cm). Cooper-Hewitt, National Design Museum,
Smithsonian Institution, Gift of Anne-May Hegeman, 1999-15-1,2

equipage, surrounded by rings holding silver-gilt spoons and knives, respectively for sugar and butter, are like a set made for Empress Josephine by master silversmiths such as Odiot and Biennais, who specialized in table services including glass liners in mounts of chased silver-gilt like these. Both the round table and the console between the windows are in the Empire style, but the chairs are in a later style, probably after the Bourbon Restoration in 1814.

On a practical note, the heavily swagged blue silk pelmets are made deep enough to allow for the fact that the French windows open inwards. The deep blue velvet upholstery of the chairs and the sofa to the right of the fireplace matches the gold-bordered cloth on the central table and the fabric concealing the chain of the chandelier. The black sofa in front of the pianoforte may be covered with horsehair. The floor is of polished parquet without coverings of any kind. The highly accomplished artist of this drawing could well have benefited from the incomparable training in the technique of watercolor acquired from hand-coloring lithographs and aquatints.[26]

Eduard Petrovich Hau's PETIT CABINET DE MAMAN DANS LE COTTAGE (FIG. 21) shows how pervasive the English neo-Gothic style was in other countries. This charming study in the Cottage Palace, commissioned by Nicholas I for his wife and built in 1826–29 by Adam Menelaws (ca. 1750–1831), contains screens ornamented with pointed arches, stained glass in quatrefoil patterns, and architectural tracery derived from ecclesiastic sources. The chandelier and wastebasket,

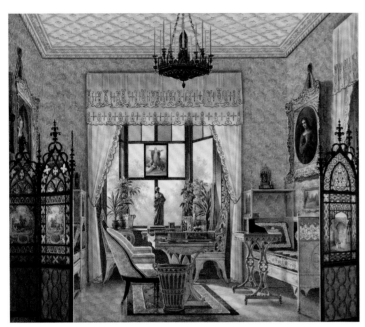

FIG. 21

The elaborate swagged portière framing the entrance to the conservatory is a conspicuous example of the Pavilion influence, being a reduced version of the swagged pelmet and curving reveals in the Music Room there. The delicate chinoiserie panes in the transom are either painted glass or oiled paper transparencies. There are near replicas of both these views by Delamotte. Essentially the views are the same, but there are a number of different details, and in this view of the fireplace wall more of the room is shown. Delamotte illustrated topographical books, particularly about Oxford, which may account for his duplication.

THE INFORMAL SALON

In the informal salon, the usage of rooms changed with the needs, comfort, and interests of the household. Comfort became the focal point of these rooms, and, like the drawing room, they often took on the characteristics of their owners. These semiprivate rooms functioned as family rooms do today, where families could converse, play cards, or listen to music. Furniture was no longer lined up around the walls, and instead was brought into the center of the room or arranged in clusters in the corners.

The winter garden, also called a conservatory, was a hallmark of the well-appointed home in the nineteenth and early twentieth centuries. It was not a greenhouse in the traditional sense, but a room, encased in glass, where the garden could be integrated with the rest of the home. The winter garden, often adorned with towering plants and marble sculptures, was reserved for reading; small, informal parties, balls, or dances for entertaining special guests; and contemplation, unbounded by the regulations of the drawing room—a room in which sensibilities, and not really plants, were cultivated. A RUSSIAN WINTER GARDEN depicts a beautiful Russian example dating from the mid-1830s.[29] (FIG. 24) It was common in grand Russian houses to hold parties in their large winter gardens, and this winter garden has a tiled floor, with large squares of polished parquet, installed in prepara-

which reference the room's function, are in the style of Pugin: the small tables, desk, and chair are likely by Peter Gambs (1802–1871). While neo-gothic style enjoyed great popularity among the aristocracy, particularly those who had converted to Orthodox Christianity, others found the style overbearing.[27]

Two views from 1839 of the drawing room at Middleton Park, Oxfordshire, by William Alfred Delamotte (FIGS. 22, 23) reflect the continuing interest in chinoiserie. Middleton was a plain neoclassical building remodeled between 1806 and 1810 by Thomas Cundy, Sr. (1765–1825), for the fifth Earl of Jersey.[28] Cundy was no innovator, and this riotous scheme was probably the work of deft amateur decorators, perhaps from among the earl's family or other members of the household, inspired by George IV's Brighton Pavilion. Delamotte heightened the gilded details of the interior with gold paint, a device used among continental professionals, and an idea that may have come from porcelain decoration, as a number of them had been trained in porcelain factories. Interior views reached the height of their popularity around 1840. Albums were kept to be handed round after dinner, and must have inspired the many amateurs who made interiors their specialty. Significantly, five albums feature in these views, leaning against stools and chairs in the foreground.

As at Brighton, there was lavish use of bamboo in the furniture at Middleton—sitting uneasily among the plain Regency library chairs and cabinets—and in the edging of the bright blue frieze decorated with crudely simplified Chinese characters (a device reminiscent of the bordered paper panels in the Chinese Room at the Berlin Royal Palace).

21. **EDUARD PETROVICH HAU** (Estonian, active Russia, 1807–1887)
Petit cabinet de Maman dans le Cottage, 1830–35.
Brush and watercolor on white wove paper. 8 ⅜ x 9 ⅝ in. (212 x 244 mm).
Cooper-Hewitt, National Design Museum, Smithsonian Institution,
Thaw Collection, 2007-27-22

22. **WILLIAM ALFRED DELAMOTTE** (English, 1775–1863)
The Drawing Room at Middleton Park, Oxfordshire, 1839.
Brush and watercolor, gouache, gold paint, graphite on white wove paper.
11 ⅜ x 14 ¹⁵⁄₁₆ in. (289 x 380 mm). Cooper-Hewitt, National Design Museum,
Smithsonian Institution, Thaw Collection, 2007-27-26

23. **WILLIAM ALFRED DELAMOTTE** (English, 1775–1863)
The Chinese Drawing Room, Looking towards the Conservatory, Middleton Park, Oxfordshire,
1840. Brush and watercolor, gouache, gold paint, graphite on white
wove paper. 9 ⅝ x 12 ⅝ in. (245 x 313 mm). Cooper-Hewitt, National Design Museum,
Smithsonian Institution, Thaw Collection, 2007-27-27

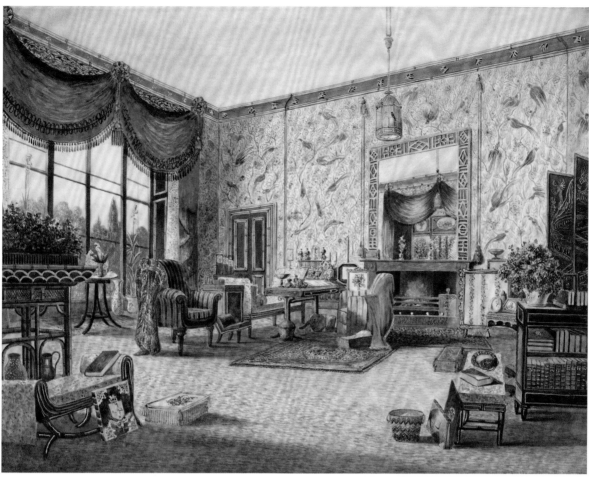

FIG. 22

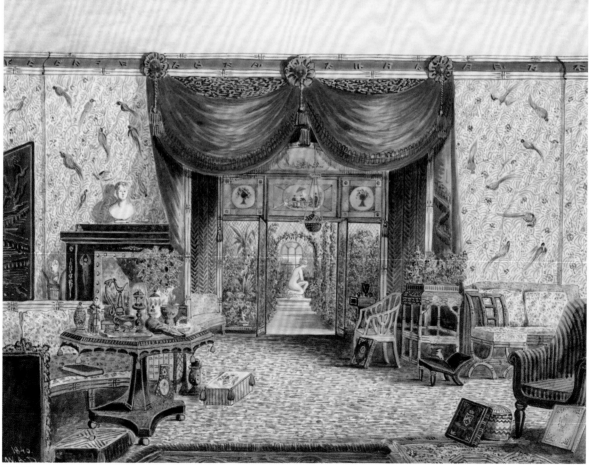

FIG. 23

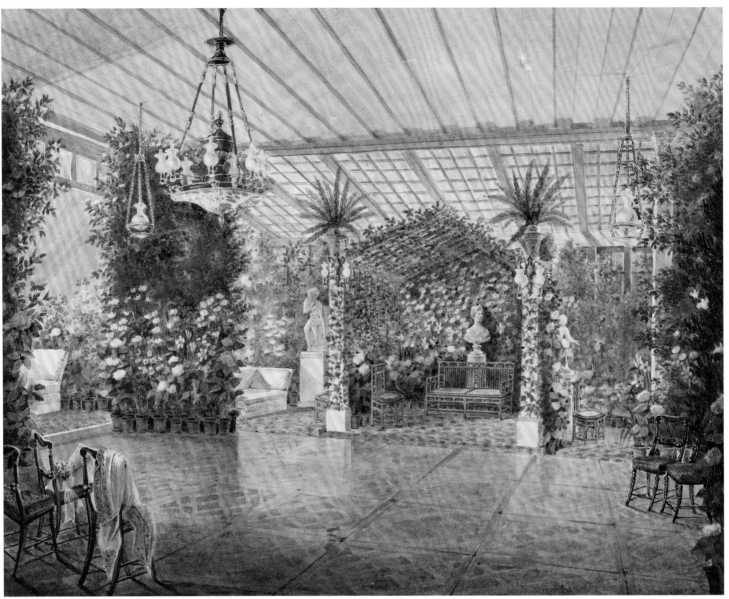

FIG. 24

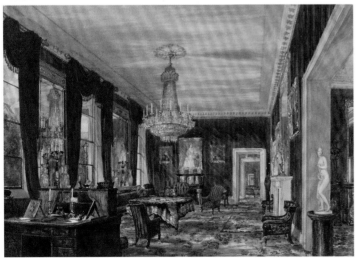

FIG. 25

Emma Roberts's gracious SECOND EMPIRE SALON (FIG. 25) *points to a royal or aristocratic owner. The statue in the right foreground may be a reduced version of Canova's* VENUS ITALICA *or* HOPE VENUS.[30] *Neither the position of the hands nor the drapery is correct, but the style is very similar to the original. The spectacular chandelier seems to reference a time when the room hosted much grander functions. The upholstered chairs, circular table, and even the writing desk seem in conflict with the formal portraits in gilt frames and the large reflecting mirrors.*

In Vladislav Dmochowski's 1840 INTÉRIEUR DE SALON (FIG. 26), *the rooftops visible through the round window to the left show that this*

24. Attributed to **VASILY SEMENOVIC SADOVNIKOV** (Russian, 1800–1879)
A Russian Winter Garden, 1835–38.
Brush and watercolor, gouache, graphite on white wove paper.
9 7/16 x 11 3/4 in. (239 x 299 mm). Cooper-Hewitt, National Design Museum,
Smithsonian Institution, Thaw Collection, 2007-27-23

25. **UNKNOWN FRENCH ARTIST**
A Second Empire Salon, 1850–60. Brush and watercolor, gouache, graphite on white wove
paper. 14 9/16 x 20 3/4 in. (370 x 527 mm). Cooper-Hewitt, National Design Museum,
Smithsonian Institution, Thaw Collection, 2007-27-24

tion for a ball. An alcove furnished with a white covered sofa is en-closed by an awning outside the French windows. On the occasional chairs in the left foreground are a small bouquet of flowers and a cashmere shawl, highly prized in Russia.

FIG. 26

FIG. 27

curiously shaped room is high up in a northern European townhouse or palace. The motif on the ceiling suggests that it may have been a music room, now used for other purposes. From the fringed muslin curtains and abundant greenery, one discerns that it is summer. Although the contents of the room are impressively detailed, there is little to pinpoint its geographic location. The arrangements of plants in the windows hint that we may be in Russia or Poland or Lithuania,

26. **VLADISLAV DMOCHOWSKI** (Lithuanian, active Poland mid-19th century)
Intérieur de salon, 1840. Brush and watercolor, gouache on white wove paper.
8 ⅛ x 12 ¹¹/₁₆ in. (206 x 322 mm). Cooper-Hewitt, National Design Museum,
Smithsonian Institution, Thaw Collection, 2007-27-29

27. **CARL FRIEDRICH WILHELM KLOSE** (German, 1804– after 1863)
The Red Room, Schloss Fischbach, ca. 1846.
Brush and watercolor, graphite on white wove paper. 6 ½ x 8 ¹³/₁₆ in. (165 x 224 mm).
Cooper-Hewitt, National Design Museum, Smithsonian Institution,
Thaw Collection, 2007-27-38

Dmochowski's country of origin. The furniture is modern, yet difficult to assign to any one designer or manufacturer. The mechanical chair and stand, a number of what appear to be optical instruments on the adjoining table, and the oversize window point to the possibility that this room may be as a photographer's studio. Frenchman Louis-Jacques-Mandé Daguerre invented the daguerreotype in 1839, one year before this drawing was made; the novelty of the invention, which spread like wildfire throughout Europe and America, may have been the reason Dmochowski depicted this room. If this is the case, this is likely a commercial salon, not a private one. The chair and accompanying metal bracket could be a device to help sitters stay still during the long exposure times. The furniture throughout the room resembles stock furniture used by commercial photographers in the 1840s, and the unusual number of potted plants could have been used for props. One puzzling detail is the large, urn-shaped woven basket by the low sofa in the foreground, which strongly resembles the basket prominently shown in the study at St. Polten (SEE FIG. 49), which is a wastepaper basket. The use of the basket in this room is not clear, and it is in an odd position.

Friedrich Wilhelm Klose's RED ROOM and BLUE ROOM of the Schloss Fischbach depict two rooms in what was the summer residence of Prince Wilhelm of Prussia and his wife Princess Marianne of Hesse-Homburg. The Schloss Buchwald in Silesia (now part of Poland), built by Carl Gotthard Langhans, best known for the Brandenburg Gate in Berlin; Erdmannsdorf, where King Friedrich Wilhelm III of Prussia spent the summer months; Schildau, bought by Friedrich for his daughter Luisa; Radziwill Castle, in Ruhberg; and Schloss Fischbach were the center of a lively social life for the Prussian aristocracy. The Red Room (FIG. 27) has a masculine air due to the prominent neo-Gothic chandeliers and the rigid, symmetrical placement of heavy, dark wooden furniture. Only the patterned woven carpet and the spinet and guitar at left relieve the somber tone. The sparkling glass displayed in the tiered cabinet at right features a vase of red Bohemian cut glass, which was heavily exported after the 1840s, when the demand for English lead glass outstripped the market for Bavarian crystal.

There are many "English" touches in the Blue Room (FIG. 28), such as the heraldic painted glass in the upper panes of the window and the English-style chairs (which were quite likely made in Germany). This room projects a more feminine personality: Bunches of flowers adorn the long table at left and the side tables, and they are echoed in the embroidered pillows in the alcove beneath the window and along the border of the carpet. Shellflower bouquets were often assembled in tall glass domes and placed on mantels or in freestanding cases. They acted as substitutes for real flowers in Victorian parlors (FIG. 28A). While

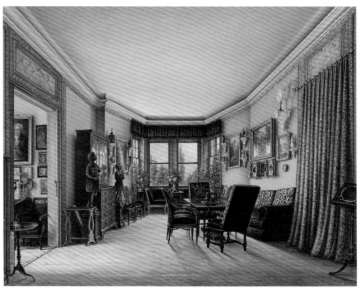

FIG. 29

FIG. 28

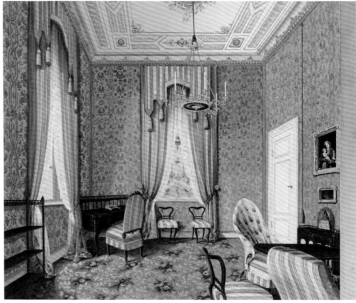

FIG. 30

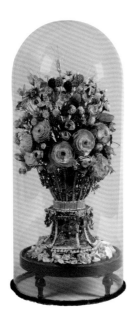

over-doors of marbled panels, is furnished in the English style, a mix-ture of the fashionable Jacobean and the Sheraton manner, named after furniture maker Thomas Sheraton. The bureau-bookcase, the tri-pod table in the foreground, the nesting table by the entrance at left,

the decorator of this room adopted identical pelmets in both rooms, he chose a more contemporary style of ceiling fixture for the Red Room, in keeping with its use as an informal sitting room.

This view of a *wohnzimmer*, or living room in the Schloss Buchwald (**FIG. 29**) is probably from the same date, and even possibly part of the same commission, as the two views of the Schloss Fischbach rooms. Although it is not signed, it can be attributed with confidence to the same artist as well. The three drawings share many qualities, notably the exaggerated receding perspective. The view depicts the room in summer, with the planked floor bare and no curtains, only a pleated pelmet over green blinds. The window embrasure is filled with flowers in two oval jardinières framing a view of trees and distant mountains. The room, with its green wallcovering bordered by a gold fillet and its

28. **CARL FRIEDRICH WILHELM KLOSE** (German, 1804–after 1863)
The Blue Room, Schloss Fischbach, 1846.
Brush and watercolor, graphite on white wove paper. 6 9/16 x 9 in. (166 x 228 mm).
Cooper-Hewitt, National Design Museum, Smithsonian Institution,
Thaw Collection, 2007-27-39

29. Attributed to **CARL FRIEDRICH WILHELM KLOSE** (German, 1804–after 1863)
A Room in Schloss Buchwald, 1840–45.
Brush and watercolor, gouache on paper. 9 1/16 x 11 7/8 in. (230 x 301 mm).
Cooper-Hewitt, National Design Museum, Smithsonian Institution,
Thaw Collection, 2007-27-31

30. Attributed to **M. SEKIM** (active Austria and Russia, 1840s)
A Room, possibly in the Governor's Residence, Hermannstadt, ca. 1840.
Brush and watercolor, gouache, gold paint, gum arabic on white wove paper.
13 1/8 x 16 1/8 in. (334 x 409 mm). Cooper-Hewitt, National Design Museum,
Smithsonian Institution, Thaw Collection, 2007-27-43

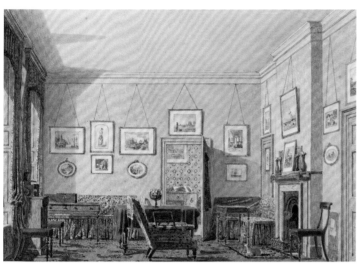

FIG. 31

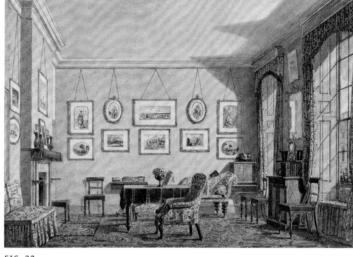

FIG. 32

and the shield-back chairs are probably inspired by pattern books like Sheraton's DRAWING-BOOK, which was published in German in 1794. The sofa and matching chairs with embroidered backs and ebonized turned woodwork were inspired by Henry Shaw's influential SPECIMENS OF ANCIENT FURNITURE (1836). The chair with curving arms facing the sofa resembles one designed by Karl Schinkel after his visit to England in 1826. Small sculptures, caskets, antique vases, and a large Venetian glass goblet are arranged round the walls on decorative brackets set among watercolors of Italian landscapes in gold frames. The figures of boys on pedestals flanking the bureau-bookcase, one holding a Bible and the other praying, derive from the 1825 sculpture by Christian Daniel Rauch of the theologian and educational philanthropist August Hermann Francke.

From the late eighteenth century onward, Brukenthal Palace, in Hermannstadt (now Sibiu, in Romania), a handsome building in the Viennese baroque style, served as the governor's residence. This palatial room's opulent scheme of decoration (FIG. 30) is consistent with the main reception areas of the palace. The cabriole-legged occasional chairs may have been supplied by a Viennese furniture retailer, rather than custom-made. This formal reception room has an unused air— there is an inkstand but no paper on the writing desk, and the shelves

are empty of books or ornaments. The imposing curtains have boldly shaped pelmets and large silk tassels, and match the upholstery on the chairs. There are lace inner curtains; and, visible in the window on the far wall, is a painted blind, a popular novelty of the time. The scene on the blind of a dancing figure in a shaped panel goes with the tentative rococo curves of the chairs and writing table. (Louis XV style reemerged in the 1840s and endured for another half century.) The gold fillet edging the walls under the ceiling cove, above the baseboards, and in the corners suggests that fabric has been used here, rather than wallpaper. The damask pattern in rose-red and gold is partnered by a fitted, red and gold carpet—the ultimate in luxury— with a pattern of foliage on which are scattered bouquets of roses. The geometric decoration of the ceiling and the fine chandelier of ormolu and ruby glass have the appearance of belonging to a more severe scheme, and may have survived from an earlier decorative era.

While the term "drawing room" may conjure images of overstuffed jewel-box rooms of middle-class Victorians, it also performed other functions. For young men living away from home, the drawing room often served as a less formal visiting room. These two views of a room in an Oxford college, presumably Christ Church, belong with a fairly numerous group of similar interiors done by George Pyne in the 1850s (FIGS. 31, 32). This pair is unique for having retained the identity of the occupant.[31] This room bears such a strong likeness to other rooms depicted by Pyne that it is tempting to speculate whether one furnisher and decorator was responsible for all of the Oxford undergraduate rooms. They each have a collection of watercolors; tables with sturdy cloths; and fitted, patterned carpets; and most of the rooms have doors, window shutters, and skirtings grained in the same way as here, possibly because varnished graining was more hard-wearing than

31. GEORGE PYNE (English, 1800/01–1884)
George James Drummond's Room at Oxford, 1853. Brush and watercolor, white gouache, graphite on white wove paper. 8 3/16 x 11 15/16 in. (208 x 303 mm).
Cooper-Hewitt, National Design Museum, Smithsonian Institution, Thaw Collection, 2007-27-53

32. GEORGE PYNE (English, 1800/01–1884)
George James Drummond's Room at Oxford, 1853. Brush and watercolor, gouache, graphite on white wove paper. 8 7/16 x 12 1/8 in (215 x 308 mm). Cooper-Hewitt, National Design Museum, Smithsonian Institution, Thaw Collection, 2007-27-54

FIG. 33

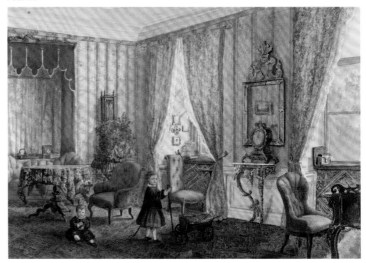

FIG. 34

paint. The seating is a mixture of conventional household taste with upholstered benches or ottomans against the walls. A fashionable "Turkish corner" has been contrived by cutting off the second door in the fireplace wall with a corner ottoman. The minutely detailed depiction of art, furnishing and fabrics, and ornaments and accessories gives the viewer a glimpse of the conventional tastes of a particular moment in the Victorian era.[32]

For members of the militia, living quarters were smaller and less private, and rooms served multiple functions, just as for young men in college. The green and red jacket hung over the chair back, plumed helmet, red and white sword belt, three swords, and red and green peaked forage cap on the stand beside the chair indicate that these are the quarters of a Prussian cavalry officer in the early years of the nineteenth century (FIG. 33). It is possible that this view was executed by the inhabitant, as army officers were taught the use of watercolor as part of their training in mapmaking. Their techniques in pen and ink and wash were often of professional standard, and served them well for landscape. However, interior views posed different challenges. Though this drawing is carefully executed, the faulty understanding of perspective and light betrays the amateur. Pictures and portraits of various kinds add a personal note.

Although far from luxurious, the outer room is furnished, with comfortable and practical Biedermeier-style furniture. Trellis-pattern wallpaper panels are edged with wide blue borders. Plain white curtains held back by cloak pins mask blue roller blinds that match the wallpaper borders. The cloth on the table in front of the sofa is embroidered to complement the bold grey-and-pink pattern of the upholstery. A red document case, partly hidden by the white glass shade of a lamp, hangs on the wall above the chest of drawers. The room is equipped with a writing table with a superstructure of shelves for books. Just visible in the inner room—which may have been where the officer slept—is a bookcase also filled with books. By the doorframe is a wall clock, possibly a cuckoo clock, worked by counterweights and pendulum. A zither lies on the table, and foils and masks for fencing hang on the fire screen.

Siebleben, now a suburb of Gotha, in Thuringia, Germany, was the estate of the Löwenstein-Werthein-Freudenburg family. Prinz Wilhelm, friend and confidant of Albert, Prince of Saxe-Coburg-Gotha and husband of Queen Victoria, from his time at the University of Bonn, married Olga Gräfin von Schönburg-Glauchau in 1852. Their first son, Ernst, was born in September 1854 and their second, Alfred, in October 1855 at Siebleben. It seems quite possible that the two little boys shown in this view by Countess Schoenberg (FIG. 34) could be the sons, aged two and one, respectively. There is a watercolor view of Siebleben attributed to Heinrich Brückner in Queen Victoria's album of views of Saxe-Coburg-Gotha.

As the dominant feminine sphere within the home, the drawing room reflected the taste of the woman of the house. Middle-class women purchased chairs, stools, elaborate wallcoverings, and window treatments that emphasized the status of their husbands and their family. It is interesting to compare them with the nobility in this respect. The comfort of the nobility is what the middle classes emulated. The bohemian glass and bric-a-brac on fragile tables, placed for display in the middle-class drawing room at mid-century, were references to a wealth that had been reserved for the aristocracy until the Industrial Revolution. The aristocracy, however, did not merely purchase expensive, one-of-a-kind objects for display. While the middle-class nineteenth-century drawing room has been compared to a museum, the wealthy members of the upper class did not hesitate to enjoy their possessions.

33. **UNKNOWN GERMAN ARTIST**
A Prussian Officer's Quarters, 1830.
Brush and watercolor, pen and ink, graphite on white wove paper.
5 7/8 x 10 7/8 in. (149 x 277 mm). Cooper-Hewitt, National Design Museum,
Smithsonian Institution, Thaw Collection, 2007-27-13

34. **COUNTESS SCHOENBERG** (German, active 1850s)
A Room at Siebleben, Gotha, 1856. Brush and watercolor on white wove paper.
6 3/4 x 9 13/16 in. (172 x 249 mm). Cooper-Hewitt, National Design Museum,
Smithsonian Institution, Thaw Collection, 2007-27-60

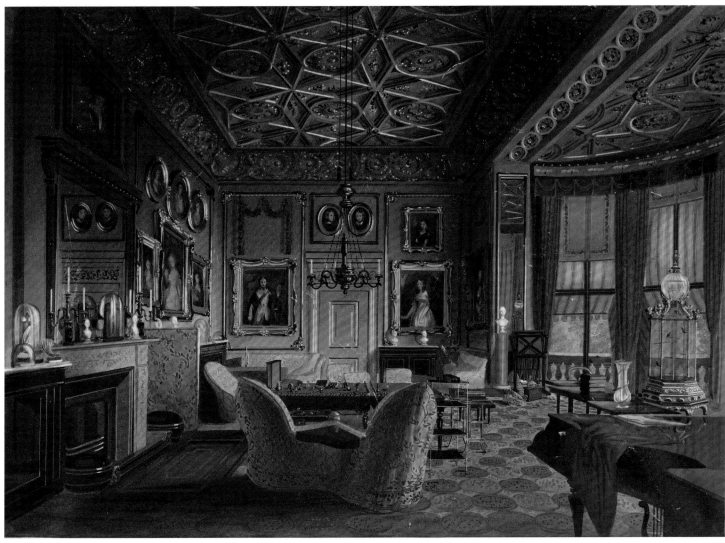

FIG. 35

THE PHOTOGRAPHER AND THE WATERCOLORIST

Concurrent with the proliferation of professional watercolor painting were the invention of photography and the rise of professional photographers. It was inevitable that the two professions would overlap. A good example of the merger of watercolorist and photographer is James Roberts, a drawing teacher who produced numerous watercolor interiors for Queen Victoria and Prince Albert. From his arrival in England from Paris in 1848 through the 1850s, he painted many of the royal residences, including Frogmore, Buckingham Palace, and New Balmoral Castle, in Scotland. He also hand-colored photographs of interiors taken by George Washington Wilson of the bedrooms, sitting rooms, and library at Balmoral. It appears that Queen Victoria had an obsession for these interior views—records of poignant or emotional milestones of her life, which were included in her souvenir albums or given to members of the royal family.[33] In some instances, details of rooms' corners were captured. One such work in the Royal Collection,

THE DUCHESS OF KENT'S SITTING ROOM WITH HER CHAIR IN WHICH SHE SAT WHEN SHE WAS TAKEN ILL, 15TH MARCH 1861, FROGMORE HOUSE, relates to the death of Victoria's mother, to whom she gave this beautiful house adjacent to Windsor Castle in 1841.

An early interior view of a salon or sitting room at Buckingham Palace, painted by Roberts shortly after his arrival in London, demonstrates his working style (FIG. 35). The cheerful room is intimate and well lived in, with a semicircular alcove at right with slip-covered furniture and simple wooden tables. French windows shaded by striped awnings lead to a balcony. A tête-à-tête in the English style is prominently displayed, and other seating areas are tucked into corners. The left and back walls are hung with portraits in elaborate gilt frames; to the left of the door is a portrait of Prince Albert by John Partridge (1798–1872), commissioned by the queen. The portrait of Victoire, Duchesse de Nemours, in the Royal Collection was painted by Franz Xaver Winterhalter (1805–1875) in 1840.[34] A six-armed chandelier is suspended from the ceiling, which is coffered in an intricate interlace design. Tables, divans, and chairs are arranged on a carpet patterned in green and gold ovals on a blue field. There are striking objets d'art, including numerous glass-covered figurines and classical marble busts. Especially touching

35. JAMES ROBERTS (English, ca.1800–1867)
Salon Particulier de la Reine au Palais de Buckingham (The Queen's Sitting Room at Buckingham Palace), August 1848. Brush and watercolor, gouache, gum arabic, graphite on white wove paper. 10 ¾ x 15 ³⁄₁₆ in. (273 x 385 mm).
Cooper-Hewitt, National Design Museum,
Smithsonian Institution, Thaw Collection, 2007-27-85

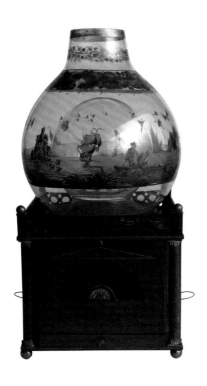

FIG. 35A

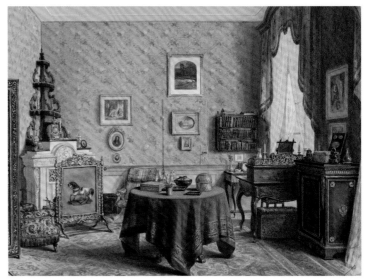

FIG. 36

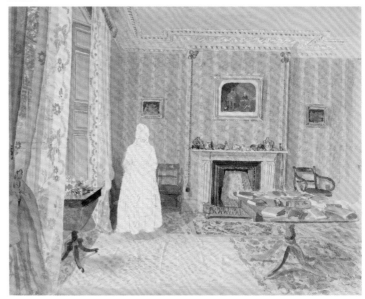

FIG. 37

is the cluster of children's toys. The nineteenth century's fascination with nature is well documented, and actual birds and fish were commonly found in elaborate constructions such as this birdcage fishbowl combination (FIG. 35A). A similar gilt example is shown in the alcove.

Wilhelm Amandus Beer's A SITTING ROOM WITH A WRITING TABLE (FIG. 36) depicts an interior that is small and plain in its architectural details yet very stylish and modern in its furnishings. At an angle to the window is a desk in the fashionable rococo-revival style, partnered by a table with elegant cabriole legs. The round center table is covered with a rust-colored plush cloth, its wide, patterned border almost brushing the floor. The chair is covered in a striped material from North Africa, then much in vogue for upholstery and hangings. The armchair on the other side of the fireplace is upholstered in luxurious cut velvet with a double row of contrasting piping finished with a thick fringe. The heavy ormolu-mounted, ebonized cabinet with scrolling gilt ornament is partnered by a black and gold folding screen at the far left. The ornate fireplace set across the corner of the room is surmounted by angled shelves in the same rococo style as the desk and table; the variety of precious ornaments displayed include a fine clock of ormolu and rock crystal with an urn-shaped finial. The curving shelves are edged with crimson silk fringe secured by a gold fillet.

The most conspicuous object in the room, which may hold the clue to its owner, is the carved fire screen inset with an embroidered panel of a white horse in parade trappings on a background of brilliant green. The boldly patterned carpet and scattered ornaments show evidence of orientalist tastes. On the walls are mainly engravings after contemporary paintings, including Paul Delaroche's popular DEATH OF A

CHRISTIAN MARTYR. It hangs over an inconspicuous jib door in the center of the wall, so cleverly incorporated into the wallcovering and paneled dado as to be almost invisible. In a sophisticated decorative arrangement, a fabric matching the curtains covers the walls and the upper part of the jib door, including the surface of the lock. The edges of the fabric under the ceiling molding and above the dado are finished with a gold fillet in the eighteenth-century manner.

35A. Birdcage with fishbowl. The Netherlands, early 19th century.
Wood, glass, gilded brass, metal wire. Overall: 24 ½ x 12 ½ x 12 ½ in. (62.2 x 31.8 x 31.8 cm).
Cooper-Hewitt, National Design Museum, Smithsonian Institution,
Gift of Channing Hare, 1971-17-1

36. **WILHELM AMANDUS BEER** (German, 1837–1907)
A Sitting Room with a Writing Table, 1867. Brush and watercolor, gold paint, graphite on white wove paper. 11 ⅝ x 14 ¾ in. (295 x 375 mm).
Cooper-Hewitt, National Design Museum, Smithsonian Institution,
Thaw Collection, 2007-27-64

37. **RICHARD PARMINTER CUFF** (English, 1819/20–1876 or later)
Sitting Room at 7 Owen's Row, Islington, 1855. Brush and watercolor, gray wash, graphite on white wove paper. 11 x 13 ⁹⁄₁₆ in. (280 x 345 mm). Cooper-Hewitt,
National Design Museum, Smithsonian Institution, Thaw Collection, 2007-27-57

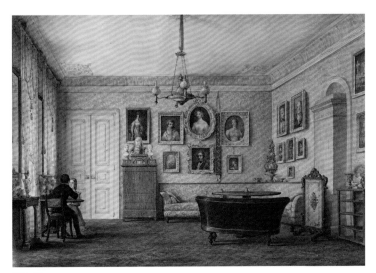

FIG. 38

Richard Parminter Cuff drew a simple domestic scene at the Owen's Row (FIG. 37) house in North London, which belonged to John Peacock, a Baptist minister, and his wife Deborah. Parminter Cuff, an architect and engraver, and his brother William, a bookseller, shared lodgings in the house. The ghostly female figure in the drawing suggests that by 1855 one of them had married. There is also a study on the reverse of this drawing for the head of a young woman, possibly the subject of the unfinished portrait, wearing a hat decorated with a fern-leaf.[35]

This sitting room is, as per the usual standard terrace-house plan, at the front, on the first floor.[36] The elegant eighteenth-century marble fireplace and the striped and flowered wallpaper suit the plain architecture. The restrictive nature of rented quarters obliged the occupant to eat in the sitting room, and the same is plainly true here, where the heavy damask crumbcloth is still spread over the patterned carpet in readiness for the next meal, when the table is lifted onto it and the books are removed. The ample window has a view of trees, and the artlessly arranged vase of flowers on the sewing table adds a rural touch. The room's formal arrangement is from an earlier era. Barely anything in the room is less than thirty years old; the drop-leaf pedestal table, chairs, sewing table with its pleated silk well, flowered needlework hearth rug, japanned hand screens (for shielding the face from the fire) at each end of the mantelshelf, and little ornaments all date from the first two decades of the nineteenth century. Only the engravings in their gold frames are a later addition.

38. OTTO WAGNER (German, 1803–1861)
A Salon in a Residence of the Duke of Leuchtenberg, 1850.
Brush and watercolor, gouache on white wove paper. 9 ⅛ x 12 ¹⁵⁄₁₆ in. (231 x 329 mm).
Cooper-Hewitt, National Design Museum, Smithsonian Institution,
Thaw Collection, 2007-27-49

The clue to the ownership of the room in Otto Wagner's A SALON IN A RESIDENCE OF THE DUKE OF LEUCHTENBERG (FIG. 38) is the portrait, second from left in the upper row on the far wall. The mustachioed man wears the ceremonial costume devised by Napoleon for family members whom he raised to royal status. It appears to be the emperor's stepson Eugene de Beauharnais (1781–1824), to whom he gave the rank of Imperial Highness and the title Prince Eugène Napoléon de France. Napoleon and his brothers were all clean-shaven, but Beauharnais, a cavalryman, usually wore a mustache. (He removed it temporarily to please his mother, the Empress Josephine, on the occasion of his marriage in 1806 to Princess Augusta Amelia of Bavaria.) The portrait to the left could be of his wife, and the oval portrait on the far right probably represents his sister Hortense, Queen of Holland and, after the Restoration, Comtesse de St. Leu.

Following the defeat and abdication of Napoleon in 1814, Beauharnais retired to Munich, where he died in 1824, having been created Duke of Leuchtenberg in 1817 by his father-in-law, the King of Bavaria. That same year, the duke commissioned the king's architect Leo von Klenze to build a palace for him in Munich, which was completed in 1821. The room's architectural details offer few hints as to the character of the building. Whether it is one of the 263 rooms in the Palais Leuchtenberg or one of his several more modest country houses cannot be determined. Though the room is quite large—there is clearly a third window at the viewer's level—the decoration is quite plain. In 1816, Klenze had restored and redecorated Schloss Ismaning on Tegernsee, a summer retreat for the Leuchtenberg family; the curved banquette with upholstery matching the wallcovering in the corner of the room is a characteristic Klenze device, derived ultimately from his master, Karl Friedrich Schinkel. Between the banquette and the door is a typical Biedermeier-style blond wood secretaire, on top of which sits an eighteenth-century French lyre-shaped gilt clock under a glass dome, flanked by two marble busts. Empire consoles are backed by looking glasses reaching almost to the ceiling, which reflect fine glass and porcelain garnitures dating from approximately 1830 to 1840. The curved black horsehair sofa and needlework screen in front of the great porcelain stove are later in style, likely almost contemporary with the view. One of the inhabitants of the room, by the far window, with his back to the viewer, could be Leuchtenberg's second son Maximilian, who became duke in 1835 and married Grand Duchess Maria of Russia, daughter of Nicholas I, in 1839.

In 1871–74, the English architect George Devey (1820–1886) was working on a number of smaller buildings in and around Leigh, including Hall Place, a mansion purchased by Samuel Morley in 1871. The owner was a businessman—his fortune came from the manufacture of

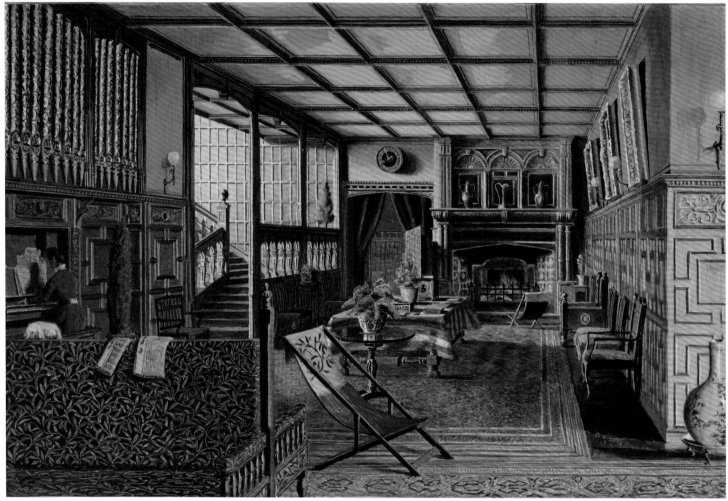

FIG. 39

hosiery—as well as a Liberal politician, philanthropist, and a total abstainer. A Member of Parliament from 1865 onward, he worked tirelessly for the Non-Conformist cause. At Hall Place, he built a completely new house, an enormous building consisting of a range of gabled bays broken by two square towers. The ground floor consisted of an entrance porch leading to a rather cramped anteroom, which opened out into the Oak Parlour with stairs straight ahead. The library and drawing room were to the left, the dining room and study to the right.[37] In the view by Henry Robertson (FIG. 39), the Oak Parlour is informally furnished with pieces of mixed styles and periods, oriental rugs, and Eastern curiosities. The organ to the left is a reminder of Morley's only recreation, which was singing with his family; he disliked classical music.

THE LIBRARY

Alberto Manguel wrote that a library is "a room determined by artificial categories"—a room that implies a logical and structured world.[38] The classification of libraries was often extremely subjective until the establishment of library science in the late nineteenth century. In the private home, designated rooms set aside for books and reading were places for solitude and repose, as opposed to the study, a room used as a work space. Home libraries were the offspring of the great national and university libraries that originated in the sixteenth century, after innovations in printing technology revolutionized book production.

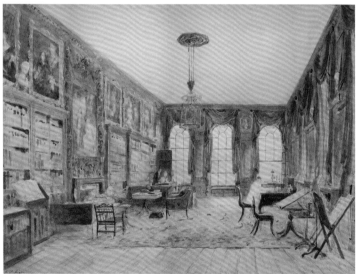

FIG. 40

39. **HENRY ROBERT ROBERTSON** (English, 1839–1921)
The Interior of Hall Place at Leigh, near Tonbridge, Kent, 1879. Brush and watercolor, gouache, graphite on off-white wove paper. 11 3/16 x 16 3/4 in. (284 x 426 mm). Cooper-Hewitt, National Design Museum, Smithsonian Institution, Thaw Collection, 2007-27-69

40. **AUGUSTUS CHARLES PUGIN** (French, active England, ca. 1762–1832)
The Library at Cassiobury, before 1816. Brush and watercolor, graphite on white wove paper. 14 13/16 x 20 3/8 in. (376 x 517 mm). Cooper-Hewitt, National Design Museum, Smithsonian Institution, Thaw Collection, 2007-27-20

FIG. 41

Western Europe's transition from written manuscript to printed page began in Mainz, Germany, with Johann Gutenberg, who presented sheets of his forty-two-line Bible printed from movable type at the Frankfurt Trade Fair in 1455.[39] By the seventeenth century, book collecting became commonplace among wealthy businessmen and tradesmen. The practice of displaying books in shelves surrounding a room, with the books' spines pointing out, supposedly began with the private library of Jacques-Auguste de Thou, a French lawyer and historian who died in 1617.[40] As private libraries became widespread, scholars interested in promoting themselves sought out owners of rare books. Private collectors, whose interests were often eccentric and esoteric, purchased volumes dedicated to their individual interests. The in-depth nature of these collections made them indispensable to scholars of like interests. Many private collections were bequeathed to universities and national libraries; a noted example is the library of Samuel Pepys, which was given to Magdalen College at Cambridge. For nineteenth-century Europe's consumer culture, books connoted social status. The titles lining the library shelves quietly implied erudition, the embossed and gilded bindings signified wealth.

Augustus Charles Pugin's watercolor depiction of THE LIBRARY AT CASSIOBURY (FIG. 40) is a preliminary sketch that shows the decorations incorporated into the seventeenth-century room by James Wyatt around 1800. The vast room, 54 by 23 feet, led into three subsidiary libraries. It was hung with a selection of the family portraits, which included Joshua Reynolds's 1768 GEORGE CAPEL, VISCOUNT MALDEN

41. William Henry Fox Talbot (English, 1800–1877)
A Scene in a Library, before March 22, 1844. Salt print from a calotype negative.
5 x 7 in. (13.2 x 18.0 cm). Courtesy of Hans P. Kraus, Jr., New York

AND HIS SISTER LADY ELIZABETH—a double portrait, now in the Metropolitan Museum of Art, of the children of the 4th Earl of Essex—above the fireplace, along with works by Peter Paul Rubens, Anthony van Dyck, Cornelius Jansen, Peter Lely, and Godfrey Kneller. The Reynolds is hung within a magnificent carved frame by Grinling Gibbons, part of the original Baroque decoration of the room. The new arch-topped windows are hung with the elaborately swagged and fringed draperies then in fashion. Between them, narrow pier glasses accentuate the length of the room. The magnificent center lantern is supplemented by an oil lamp on the writing table. The later, more finished, watercolor and print views show candelabra on the chests beneath the pier glasses and a geometric-patterned and bordered carpet, rather than the rumpled rug shown here. Pugin's sketch includes a larger number of figures, imparting an air of greater activity than the two figures in the more formal versions, in which the liveliness is supplied by three playful dogs in the foreground.

The importance of the library to the aristocratic Englishman is acknowledged by William Henry Fox Talbot's 1845 documentary calotype, or photographic print produced from a paper negative, of two shelves of his library (FIG. 41). The actual library would have been dark to allow for the recording of these shelves by the calotype process. Talbot most likely constructed a portable bookshelf and transported his books outdoors, into the light, to document in facsimilie a portion of his library. The books are organized by standard sizes and similar bindings, yet stand and fall like representatives of conflicting cultures. The imperative behind the taking of this image was the immobility of the books, but embedded in the picture is the identity of their owner. How often do we look at someone's bookshelves in order to understand whom we are dealing with? What you read is who you are.

The following two libraries show two particularly British temperaments: the man of letters, and the aristocratic upholder of tradition. INTERIOR OF A LIBRARY, painted by an unknown artist (FIG. 42), shows a comfortable room lined with books that opens onto a beautiful garden. The window treatments and furniture arrangement place it in the late Regency style, perhaps the late 1830s or early 1840s. The open cabinet door at left, the stack of books on the floor by the desk, and the books on the settee imply that the reader has just stepped out. The desk at right implies a writer, and many of the books on the shelves have similar bindings, as if they were part of a series. THE LIBRARY IN THE GOTHIC STYLE by Charles James Richardson (FIG. 43), painted in about 1860, shows a repository and nothing more. Essentially a book vault, this room has no other furniture except the built-in shelving units trimmed in elaborate Gothic taste. As if in response to Pugin's "Gothic Furniture," advertised in ACKERMAN'S REPOSITORY three decades

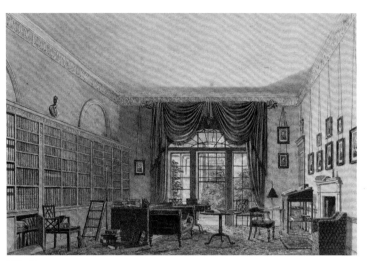

FIG. 42

FIG. 42A

earlier, this hall exemplifies the nineteenth-century English fascination with heritage. In spite of the massive hearth surmounted with a painting flanked by elongated figures, the room exudes a chilly air, in contrast to the Regency library painted twenty years earlier.

Charlotte Bosanquet's (1790–1852) loosely painted interior of the library at Dingestow (FIG. 44) presents books within a heavy Tudor framework. It is lined with bookshelves, and has few ornaments or works of art. The square Corinthian columns and pilasters enclosing the shelves, the frieze with classical busts above them, the paneled over-mantel, and the compartmented ceiling with plasterwork ornaments in high relief are inspired by the English Renaissance style of the period of Henry VIII. The owners did not complement the recently completed Tudor Revival scheme with pedantically correct furnishings, preferring instead a comfortable and useful room with comfortable Victorian chairs and sturdy tables. The red-and-white-striped slipcovers on the chairs and sofas give some semblance of unity. The windows are curtained in red, with heavy wooden poles and rings, but the glazed double doors leading out into the garden in the pedimented embrasure at the end of the room have neither curtains nor shutters.

Dingestow Court, in Monmouthshire, the home of Bosanquet's cousin Samuel, is said to have been built in 1623 on the site of an earlier house. The rooms the artist painted reflect the life of the educated upper middle class. Alterations in the eighteenth century included the enclosing of the Jacobean front with a Georgian façade. In 1843, the house was extensively renovated by Lewis Vulliamy, who restored it to a style approximating the original date or earlier. Bosanquet was an amateur painter, as evidenced in her handling of perspective and her unschooled application of the watercolor washes. The arrangement of the furniture seems to have presented difficulties for her. The chairs

barely seem anchored to the carpet, and the attempt to explain the skirts of the chairs result in a feeling that the chairs are about to run off. The view's quirky handling leads us to speculate that the artist was a good-natured woman with a sense of humor.

An entirely different personality emerges in one of the most impressive watercolors in the Thaw collection, the 1884 painting of SIR LAWRENCE ALMA-TADEMA'S LIBRARY IN TOWNSHEND HOUSE, LONDON (FIG. 45), executed by his daughter Anna (FIG. 46) when she was only sixteen or seventeen years old.[41] The decoration is a good example of an eclectic "Aesthetic" interior, owing as much, or more, to Japan and seventeenth-century Holland as to ancient Rome. Where possible, arched openings replaced conventional doorways; and the journalist Mrs. Haweis noted "the Dutch fondness for nooks and crannies, little rooms opening into other little rooms, with unexpected glimpses of further rooms in effective sequence."[42] The massive wall enclosing the fireplace must have originally been on the exterior of the house, and the room beyond added later, thus creating the nooks and crannies. Another room was entirely paneled with the remains of a collection of seventeenth-century Dutch cabinets.

In a report in THE MAGAZINE OF ART, this library, on the ground floor leading out of the hall on the right-hand side, was described as "Gothic," but the furniture of the room is practical rather than self-

42. **UNKNOWN ENGLISH ARTIST**
Interior of a Library, 1830s–40s. Brush and watercolor, graphite on off-white wove paper. 8 ⅜ x 12 ⁷⁄₁₆ in. (213 x 316 mm). Cooper-Hewitt, National Design Museum, Smithsonian Institution, Thaw Collection, 2007-27-28

42A. Metamorphic library table-steps. England, ca. 1795. Mahogany, brass, felt. Cooper-Hewitt, National Design Museum, Smithsonian Institution, Gift of Anonymous Donor, 1967-45-28

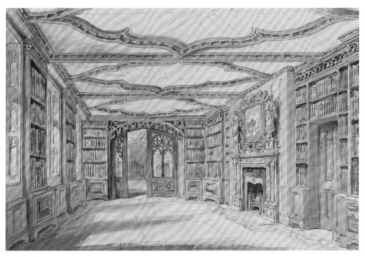

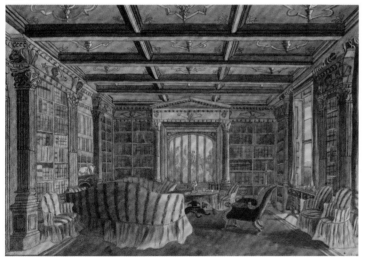

consciously revivalist, and the bentwood chair behind the writing table is positively utilitarian.[43] The fur-covered couch under the window and the bronze chandelier, with its blue candles echoing the color of the architrave and the door panels, were both designed by Alma-Tadema himself. The floor is covered with Japanese tatami matting, used elsewhere in the house for dadoes; the fabric covering the dado here looks like batik, a resist-dyed cotton from Southeast Asia, especially the

43. **CHARLES JAMES RICHARDSON** (English, 1806–1871)
A Library in the Gothic Style, ca. 1860. Brush and watercolor, pen and brown ink, graphite on white wove paper. 10 13/16 x 15 11/16 in. (274 x 398 mm). Cooper-Hewitt, National Design Museum, Smithsonian Institution, Thaw Collection, 2007-27-63

44. **CHARLOTTE BOSANQUET** (British, 1790–1852)
The Library at Dingestow, 1840s. Brush and watercolor, pen and black ink, graphite on white wove paper. 7 3/4 x 10 3/4 in. (195 x 274 mm). Cooper-Hewitt, National Design Museum, Smithsonian Institution, Thaw Collection, 2007-27-42

Dutch East Indies. (Mrs. Haweis describes another dado in the house as being of dark brown batiste, fine cambric that would have been entirely unsuitable for the purpose, but this may have been due to a mishearing of the word batik.) On the panels flanking the window hang what seems to be a pair of German framed and glazed drawings representing obelisks with coats of arms, the uppermost one on the left panel surmounted by a crown. The object suspended from the ceiling of the room to the left, whose purpose is unknown, may be a Japanese parasol or a large, flattened paper lantern.

Two more views, this time of a library owned by an American businessman dating from the early 1880s and another by a Polish nobleman, reveal much about the rooms' occupants. THE LIBRARY OF COUNT LANCKORONSKI, painted by Rudolf von Alt in 1881 (FIG. 47), depicts a sanctuary filled with symbols of culture and refinement. The room's arrangement can be read as a portrait: Every object has been selected and placed to convey a specific ambiance. The green leather chairs, Persian carpets, and dark wood suggest a masculine temperament; the leather-bound volumes and brass chandelier above the table suggest late nights spent investigating esoteric texts. Karl, Count Lanckoronski (1848–1933) was a writer, archeologist, trader, and art collector from an ancient noble family of great wealth and taste. He studied art history and law as a young man, later became interested in archeology, and amassed an enormous collection of antique sculpture. A generous patron, he supported a number of artists and promoted writers such as Hugo von Hofmannstal and Rainer Maria Rilke. He admired the art of Arnold Böcklin, Hans Makert, Anselm Feuerbach, Hans Thoma, and Auguste Rodin. He eventually owned the most valuable private collection in Vienna, with works by Tintoretto, Rembrandt, Canaletto, and Jan van Goyen. Von Alt's painting shows the count's collection before the construction of the great neo-Baroque Palais Lanckoronski in Vienna in 1894–95.

As the only American watercolor in the collection, Edward Lamson Henry's view of the interior of a private New York library is an insightful document of nineteenth-century American tastes (FIG. 48). Conservative to a fault, this library displays almost none of the Gothic-, rococo-, and Elizabethan-revival styles nor of the Aesthetic movement popular at the time; indeed, if the scheme were unattributed, it would be difficult to place.[44] There is a distinct Northern European or Baltic look, even in the arrangement of the furniture, with everything lined up at right angles suggesting a rigid spirit.[45]

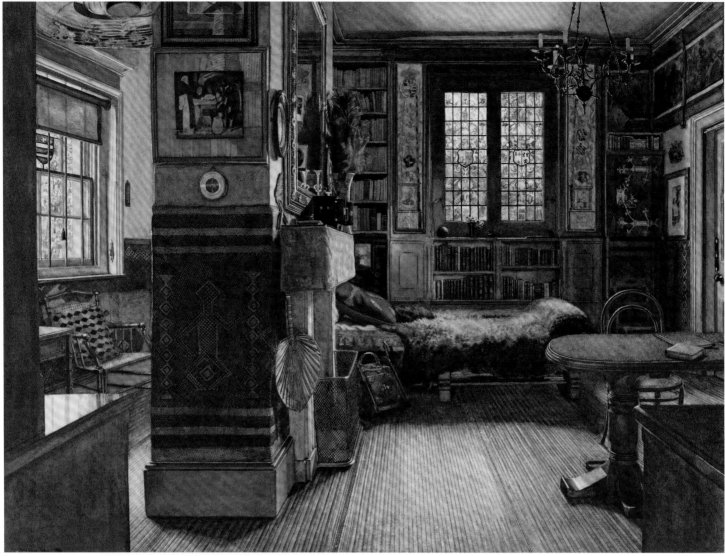

FIG. 45

THE STUDY

An offshoot of the formal library, the study merged public and private spaces in the nineteenth-century aristocratic or upper-middle-class home. The study was a sort of home office, less an enclave for learning than for business. Studies often contained books, but they were more likely to be account books, ledgers, and other volumes related to household finances. The study's usage is illustrated in A STUDY AT ST.

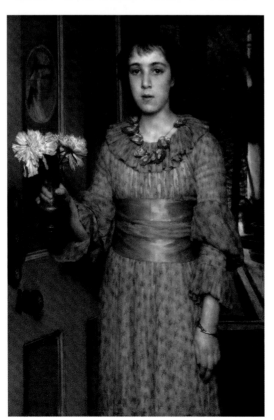

FIG. 46

45. ANNA ALMA-TADEMA (English, 1865–1943)
Sir Lawrence Alma-Tadema's Library in Townshend House, London, 1884. Brush and water-
color, pen and brown and black ink on white wove paper.
13 x 17 ¹¹⁄₁₆ in. (330 x 450 mm). Cooper-Hewitt, National Design Museum,
Smithsonian Institution, Thaw Collection, 2007-27-72

46. SIR LAWRENCE ALMA-TADEMA, R.A. (Dutch, 1836–1912)
Miss Anna Alma-Tadema, 1883. Oil on canvas. 44.5 x 31 in. (1130 x 785 mm).
Royal Academy of Arts, London, Purchased from Miss Anna Alma-Tadema 03/908

47. RUDOLF VON ALT (Austrian, 1812–1905)
The Library in the Apartment of Count Lanckoronski in Vienna, Riemergasse 8, 1881.
Brush and watercolor, gouache, graphite on white wove paper. 12 ⅜ x 17 ⅜ in.
(315 x 442 mm). Cooper-Hewitt, National Design Museum, Smithsonian Institution,
Thaw Collection, 2007-27-70

48. EDWARD LAMSON HENRY (American, 1841–1919)
A Library Interior, 1890–1905. Brush and watercolor, gouache on white wove paper.
11 ¾ x 15 ¾ in. (298 x 400 mm). Cooper-Hewitt, National Design Museum,
Smithsonian Institution, Thaw Collection, 2007-27-65

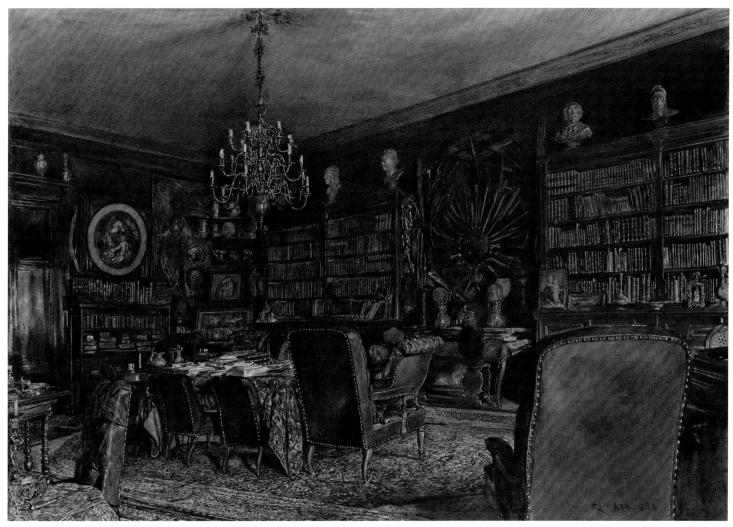

FIG. 47

FIG. 48

POLTEN, *painted in 1837 by Matthäus Kern.*[46] *(FIG. 49) The sparsely furnished, masculine room (note the rack of pipes by the door and the large desk) is devoid of books; instead, it holds large, oval portraits that date from the Napoleonic era and a few smaller portraits that seem to date from the 1820s or 1830s. The framed paintings of architectural ruins on the opposite wall imply the occupant is a learned man, presumably someone who had traveled on the Grand Tour to Italy.*

The plain room has an air of grandeur, nonetheless, being furnished and decorated in the trendy Biedermeier style. The curtains are oddly spare in comparison with the ample folds of the ones in the adjoining room, just visible through the open door. A striking feature of the room is the oversize woven wastebasket that dominates the front right corner of the painting; similar large baskets appear in other northern European and Russian rooms of this period.

The lack of bookshelves in this view of King Louis-Philippe's study at Neuilly (FIG. 50) reinforces the distinction between the library and the study in nineteenth-century domestic interiors. It is a portrait of solitude, and it is instructive to compare it with the watercolors showing formal, unpopulated, palatial reception rooms at two of his other residences, the Palais Royal in Paris and the Chateau d'Eu in Normandy (see figs. 3–5). The sitter's identity renders the interior special; in other respects, it is typical, with comfortable chairs, a businesslike writing table, and neat piles of documents. Louis-Philippe showed himself to be true to his reputation as the "Citizen-King" with this unremarkable, almost middle-class room. The only distinctive touch is the unusually large number of paintings lining the walls.[47]

By contrast, the elegant study of Prince Karl of Prussia is a masterpiece by the great neoclassical architect Karl Friedrich Schinkel (FIG. 51). The Ordnungs-Palais, erected in 1747 on the Wilhelmsplatz in Berlin, was given to Prince Karl when he married Princess Maria of Saxe-Weimar.

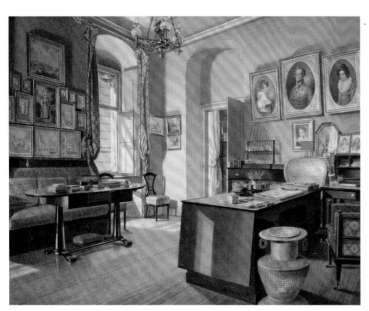

FIG. 49

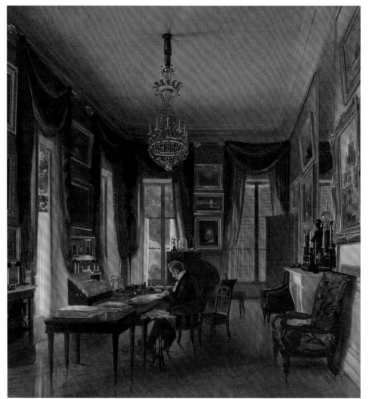

FIG. 50

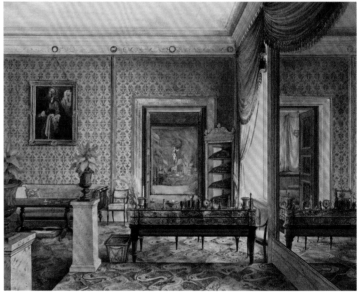

FIG. 51

Schinkel remodeled it in 1827–28 and, as he was under great pressure to complete the work, kept many of the building's original structural elements. Nevertheless, the architect achieved an impressive result: an Italianate building combining antique and Renaissance features, and rooms richly decorated with furniture and fittings. A good example of the architect's refined yet utilitarian taste is the large galleried writing table in the foreground. It is inset with panels of amber-colored, molded glass with a scrolled pattern, similar to a motif Schinkel used on a desk he designed for Princess Augusta, who was married to Wilhelm, Prince Karl's brother. While Schinkel specified the exact placement of each piece of furniture he designed for the room, the Prince individualized the study with various memorabilia and personal mementos. On the top rail of the desk sits an assortment of treasures, such as vases of malachite that may have been Russian imperial presents and diamond parures in the corner cabinet, whose mirrored sides enhanced the glittering jewels. Most of the Schinkel furniture shown is preserved in the Charlottenburg Palace in Berlin, including the corner cabinet; the suite of japanned and gilded side chairs and sofa inspired by Schinkel's travels in England, modeled on examples in Lord Lansdowne's London house in Berkeley Square; and the matching black and gold sofa table, a version of one designed for the boudoir of Crown Princess Elizabeth in the Berlin Royal Palace.[48]

In Eduard Gaertner's view of Prince Karl's study, the viewpoint is from a low platform, on which stand two yellow marble plinths supporting plant-filled, polished stone vases.[49] *To the right, a large mirror reflects part of a room lined with draped hangings and Moresque cushioned banquettes, visible through the open door in the far wall. At the end*

49. **MATTHÄUS KERN** (Austrian, 1801–1852)
A Study at St. Polten, 1837. Brush and watercolor on white wove paper.
9 ¹¹/₁₆ x 12 ³/₈ in. (246 x 314 mm). Cooper-Hewitt, National Design Museum,
Smithsonian Institution, Thaw Collection, 2007-27-19

50. **JAMES ROBERTS** (English, ca.1800–1867)
The Study of King Louis-Philippe at Neuilly, 1845. Brush and watercolor, gouache on white
wove paper. 13 ¼ x 12 ⅛ in. (336 x 308 mm). Cooper-Hewitt,
National Design Museum, Smithsonian Institution, Thaw Collection, 2007-27-37

51. **EDUARD GAERTNER** (German, 1801–1877)
The Study of Prince Karl of Prussia, 1848. Brush and watercolor, graphite on white wove
paper. 6 ¹⁵/₁₆ x 8 ¾ in. (177 x 222 mm). Cooper-Hewitt, National Design Museum,
Smithsonian Institution, Thaw Collection, 2007-27-40

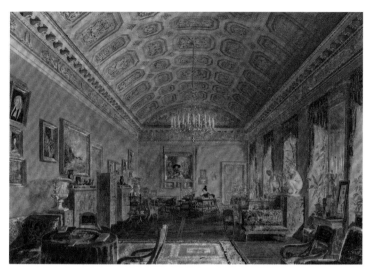

FIG. 52

of the vista is a plant-filled conservatory. The window to the left of the mirror is dressed with a deep-fringed pelmet, which continues across the mirror and must have been symmetrically matched to the right. The formal Gothic-revival motif of Schinkel's textile wallcovering is discreet, unlike the boldly patterned and colored carpet. On the far wall, in a frame designed by Schinkel, is a version of Cristofano Allori's celebrated JUDITH WITH THE HEAD OF HOLOFERNES, in Florence's Pitti Palace. This drawing belongs with the series of Prussian royal interiors done in the 1840s and 1850s; remarkably, the room has been left exactly as Schinkel had designed it more than twenty years earlier.

If it is tempting to consider the study as a masculine domain, two examples of studies that belonged to women level the balance. Josef Sotira's 1835 STUDY OF CZARINA ALEXANDRA FEODOROVNA (FIG. 52) depicts a large, magnificently appointed room, likely from the Winter Palace at St. Petersburg, the official residence of the imperial family since the time of Catherine the Great. (It is not possible to verify this, since the palace was devastated by fire in 1837 and completely rebuilt in 1837–39.) The study, with its coffered barrel vault and fine collection of paintings, owes a considerable debt to French taste, although most of the furniture is from 1820s and 1830s Russia. The magnificent ormolu chandelier and flowered carpet also represent fine Russian workmanship. The large suite of banquettes and armchairs of pale wood—possibly birch, a popular native wood—with figured blue upholstery is in the elegant style introduced in the 1820s. The chairs' open scrolling arms

52. **JOSEF SOTIRA** (Austrian, active in Austria and Russia, 1830–1840)
The Study of Czarina Alexandra Feodorovna, Russia, 1835. Brush and gray wash, watercolor, gouache, pen and black ink on off-white wove paper. 10 ¹³⁄₁₆ x 16 in. (274 x 407 mm).
Cooper-Hewitt, National Design Museum,
Smithsonian Institution, Thaw Collection, 2007-27-16

are like an example in Karelian birch designed by the architect Vasily Petrovitch Stasov (1769–1848), a distinguished Russian neoclassicist, for the Catherine Palace at Tsarskoe Selo. The painting on the back wall appears to be a version of REMBRANDT WITH HIS WIFE SASKIA.

Flanking the central window are two marble sculptures of the CROUCHING VENUS. The window embrasures are filled with plants and framed by delicate muslin inner curtains. There are no heavy outer curtains, suggesting summer; in fact, since there is no heat source visible, neither stove nor grate, the room may have been inhabited only in summer. Between the outer pairs of windows are consoles with ceiling-high looking glasses that would have reflected and diffused the light from the ormolu Winged Victory candelabra. The five windows, with their diagonal pelmet arrangement centered on the middle window, is mirrored in the symmetrical furniture placement on either side of the door on the facing wall. Two corner banquettes form conversation groups with the scroll-armed chairs; and before them are round tables covered with embroidered velvet cloths and littered with books and albums. Two great classical marble vases on pedestals, echoing the marble sculptures opposite, flank the cupboards, the tops of which are crowded with Greek and Etruscan antiquities. The screen masks the door in the center of the wall.

Czarina Alexandra Feodorovna is seated at a plain writing table at the far end of the room, surrounded by a cluster of work tables and occasional chairs, which relieve the formality of the room. Frederica Louisa Charlotte Wilhelmine, daughter of King Friedrich Wilhelm III of Prussia, was born in 1798. In 1817, she married Nicholas Pavlovitch, son of Czar Paul I. Following imperial custom, she converted to the Orthodox faith and took the Russian names of Alexandra Feodorovna. Nicholas succeeded his brother Czar Alexander I in 1825. He died in 1855 and was succeeded by his son Alexander II; Alexandra Feodorovna died in 1860.[50]

The second study belonged to Cecilia von Oldenburg (1807–1844), third wife of Grand Duke Paul Friedrich Augustus (1783–1853), hereditary ruler of the Duchy of Oldenburg in Schleswig-Holstein. Part of the Federation of the Rhine in 1808, Oldenburg was annexed by the French in 1811 and recovered by Duke Peter Friedrich Ludwig of Oldenburg, who was given the title of grand duke by the Congress of Vienna in 1814. Cecilia was the daughter of Gustavus IV Adolphus, King of Sweden, who was deposed and exiled in 1809 following Sweden's defeat in the war with Russia of 1808–09. She died four days after the birth of her only child, Duke Elimar von Oldenburg.[51] Cecilia's study (FIG. 53), from the Oldenburg family album of interior views, was painted by Ernst Christian Anton von Lautzow in 1839. It is dominated by a life-size portrait of a man, almost certainly her husband, in mili-

tary uniform. The bronze figure of Psyche with gilded wings, which stands to the right of the portrait, is reflected in the looking glass that rises almost to the ceiling on the far wall, making the serene pair of landscapes flanking it look almost insignificant.

The fine suite of Biedermeier furniture is evidence of the important patronage of the dukes of Oldenburg; some of their furniture survives in the Oldenburg Landesmuseum, including a Greek-revival sofa and a sofa table in the English style. The room is decorated with typical Biedermeier delicacy and a lightness of color particularly associated with Scandinavia. The pale yellow walls with trails of flowers are matched by the cream-ground needlework carpet embroidered in squares with flowers. The ceiling is painted a dusty pink, with the discreet plasterwork picked out in white and finished by a grey molding. The suite of mahogany furniture includes a heavy desk with ormolu mounts as well as a more feminine secrétaire à abattant, whose gilded black-leather writing slope is open. The sofa table is placed before the upholstered sofa, rather than behind it, as is so often—incorrectly—the case nowadays. The four dramatic curved-back armchairs, reminiscent of antique models, are supplemented by a comfortable reclining chair drawn up to the writing table. A leather document case on the chair beside the writing table awaits attention once a place can be cleared among the clutter of portraits and views. The large, two-handled gilt vases decorated with oval medallions of roses on a dark ground appear to be Russian—perhaps from the Imperial Porcelain Manufactory, of which the Czar was justly proud. The small tables placed about the room include a round sewing box on a tripod support and two popular English-style quartetto tables that could be nested together.

The artist was a fairly accomplished amateur, possibly a member of the family. Much of the furniture is rendered too small, the sculptures and portrait too large. The little paintings on the desk seem to include interior views, perhaps scenes of other rooms in the Oldenburg Palace that eventually helped form the family album.

BEDROOMS

The bedroom was not always the most intimate room of the house. Prior to the nineteenth century, bedrooms served more of a public purpose, often doubling as a sitting room. Heads of state regularly received international visitors in their bedrooms; indeed, the state bed in the seventeenth century was often the most expensive piece of furniture in the house.[52] In general, though, nineteenth-century bedrooms combined quite a few functions—dressing rooms, morning rooms, and places where a woman could arrange her toilet. By mid-century, bedrooms were decorated in the same manner as sitting rooms or morning rooms, with a great deal of attention given to furniture and fabrics.

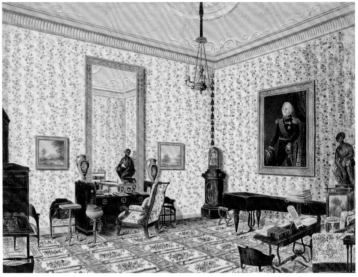

FIG. 53

Beds were usually constructed of two posts at the foot and a large headboard, often with hanging fabric to keep out drafts. In England, beds were placed with the headboard against the wall, while the French style allowed for the side of the bed to be against the wall. Furniture tended to be mahogany, and, in addition to the bed and a washstand, there would also be a cupboard for clothes called a chiffonier, and occasionally a chaise and other comfortable chairs. While in many middle-class homes the bedroom furniture was older furniture from downstairs rooms, moved upstairs when new furnishings were purchased, in the bedrooms discussed here, the furnishings were no doubt purchased specifically for these rooms.[53]

By the mid-nineteenth century, bedrooms were considered private spaces and located on upper floors, away from the public spaces. In the suite arrangement—almost unknown in England, but a common feature of apartment buildings in Paris and Vienna—the bedroom served as an extension to the drawing room, and company could be entertained in it once the bed was concealed behind a curtain. The toilet apparatus would have been in the adjoining dressing room. Cesar Daly remarked in 1852 that "as a result of a certain ease of manners, the absence of prudishness, and the intense love of company, the modesty of fortunes and the diminutiveness of lodgings in Paris, the bedroom of the mistress of the house often serves to supplement the drawing room."[54]

53. ERNST CHRISTIAN ANTON VON LAUTZOW (German, active 1835–45)
The Study of Grand Duchess Cecilia von Oldenberg, 1839.
Brush and watercolor, gouache, gold paint on white wove paper.
10 13/16 x 14 in. (275 x 355 mm). Cooper-Hewitt, National Design Museum,
Smithsonian Institution, Thaw Collection, 2007-27-21

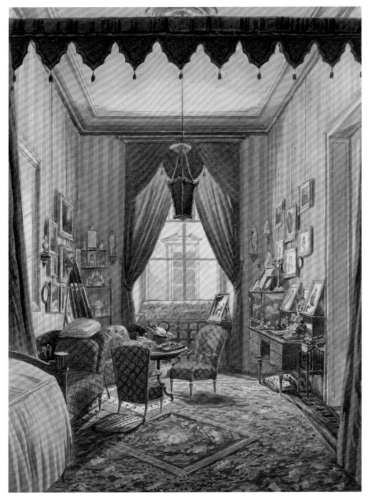

alcove suggests that there was access to a dressing room behind the spectator, thus suggesting an en suite arrangement. The artist very successfully accomplished the complex perspective of this tall, narrow room. While the Biedermeier style is evident, the general Victorian style of European décor in the 1850s has all but eliminated its nationalistic features. In fact, this room resembles the Parisian apartment style that became popular in Vienna at that time. The use of half of the bedroom for writing, sewing, gossiping, and displaying pictures and bibelots speaks to its informal character. This boudoir is decorated and furnished for the reception of company, even if not for formal entertaining, with an elaborate curtain and pelmet arrangement framing the tall window, wide-striped mauve and white wallpaper, and a luxurious patterned carpet covering the whole floor of the room. The walls are densely hung with pictures; and portraits cover every available surface on the writing table and the gold and black lacquer cabinet in the corner.

Ferdinand Le Feubure's painting of the bedroom of Pedro I, Emperor of Brazil, is a commemorative document, and as such is unique in the Thaw watercolor collection (FIG. 55). Dom Pedro was instrumental in securing Brazilian independence in 1822, and in 1824, he became the constitutional emperor. In 1826, he succeeded his father as king of Portugal; but in 1831, he abdicated in favor of his fifteen-year-old daughter Maria da Gloria, while his six-year-old son became Pedro II of Brazil. Dom Pedro died three years later, in 1834, in the very room where he had been born, the Don Quixote Room in the Queluz Palace, outside Lisbon, among the most remarkable extant examples of rococo style in Portugal.[56] The circular bedroom was decorated by Manoel da Costa (1755–after 1811) with episodes from the story of DON QUIXOTE.[57] Da Costa was a fervent admirer of the French rococo decorator Jean-Baptiste Pillement (1708–1808), and his delicate scenes in the ceiling cove and on the over-doors have a lightness absent from the conventional renderings of Apollo and the Muses on the ceiling.

The king's bedroom was sparsely furnished, as was the usual practice in Portugal. The necessary furniture was conveyed from one palace to another as the royal family moved from Lisbon to the ancient royal palace at Cintra and on to the great Germanic castle at Mafra. Queluz, a convenient staging post, eventually became their preferred summer residence. The bed and bedside table in Dom Pedro's room are in the French taste, but the rest of the furniture looks English. Britain was a longstanding ally and trading partner, and much fine English furniture made its way to Portugal. The boldly radiating patterned floor is probably of Brazilian hardwood.

While dressing rooms were usually small and used as an adjoining room to the bedroom, the elaborate dressing room in Franz Xaver

The room in AN INTERIOR WITH A CURTAINED BED ALCOVE (FIG. 54) is deceptive. Its crowded appearance, profusion of bric-a-brac and family mementos, and bed hint at somewhat restricted living quarters. However, urban apartments, even palaces, in Europe of this period often contained a series of rooms ending in a narrow boudoir with a bed behind a curtain.[55] The centrally placed door in the right-hand wall and the mirror opposite, which would have reflected the vista through the door, suggest that this is such a bedroom-boudoir. The view through the window, so close to another large building, gives the impression that one is in the city. The bed alcove is created by a pair of curtains and a pelmet in the Moorish taste across one end of the room, not attached to the ceiling. The bed's position on one side of the

54. UNKNOWN AUSTRIAN ARTIST
An Interior with a Curtained Bed Alcove, ca. 1853.
Brush and watercolor, gouache, gum arabic, graphite on Whatman paper.
11 5/16 x 8 7/16 in. (288 x 215 mm). Cooper-Hewitt, National Design Museum,
Smithsonian Institution, Thaw Collection, 2007-27-52

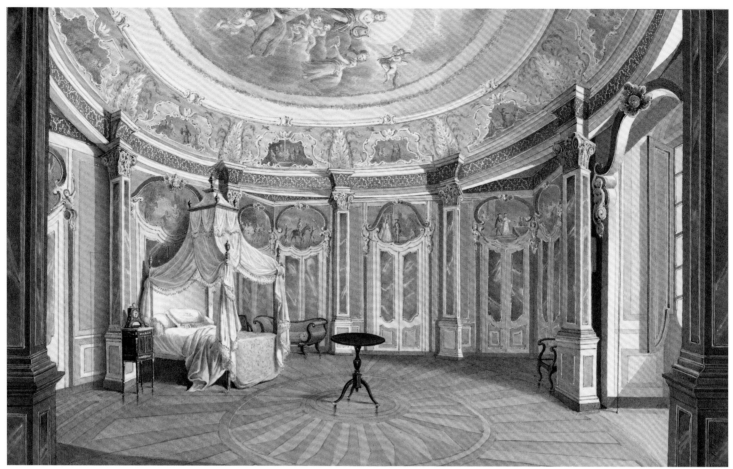

FIG. 55

Nachtmann's (1799–1846) THE DRESSING ROOM OF KING LUDWIG I AT THE MUNICH RESIDENCE PALACE stands out as an example of classically motivated extravagance (FIG. 56). Ludwig I of Bavaria (1786–1868) succeeded his father, Max I Joseph, in 1825, having already embarked upon the transformation of his capital, Munich, more than ten years earlier. Profoundly inspired by his Grand Tour of Italy in 1804–05, he immediately began accumulating antique treasures for his planned Glyptothek, or sculpture building. The first of architect Leo von Klenze's many buildings for Ludwig and his family, the Glyptothek gave Munich a classical character unrivaled in any other German town. Nachtmann's highly detailed rendering shows a room in the Konigs-Bau, a new wing on the Max-Joseph-Platz built by Klenze in 1826–35, in imitation of the Palazzo Pitti in Florence.[58] Ludwig's vaulted and coffered, elaborately decorated dressing room had a companion in Queen Therese's equally sumptuous vaulted study. Ludwig's dressing room was painted with scenes from classical literature and poetry; Queen Therese's study celebrated German Romantic literature. The style of painted decoration in both these rooms derived ultimately from Raphael's Vatican Loggie, a fruitful source of inspiration for much Renaissance-revival decoration in the nineteenth century.

Von Klenze attended to every detail, making drawings for the furniture of marmoreal white and gold, for the tabourets and consoles, for thrones and suites of settees and chairs, and even for the candelabra and mirror frames. The designs, many executed in simplified form, were based on ancient Greek models. The Festsaal-Bau, another new wing on the Hofgarten side, was built in the Renaissance-revival style for Ludwig by Klenze in 1832–42. A surviving project drawing for the decoration of this room, by the architect himself, exhibited in London in 2000, is in the same technique as Nachtmann's drawing, of watercolor with gold heightening; but it appears to show the opposite wall of the room, since the subjects in the roundels and lozenges are different from those shown in Nachtmann's view of the room. The latter was one of the first German professionals to paint interiors for the royal albums that proliferated in the 1830s and 1840s. He was involved from the early 1820s with building up the Wittelsbach album for Queen Caroline of Bavaria, and made replicas of some of these views for the Hesse family album at Darmstadt. A series of views of rooms occupied by Princess Elizabeth of Bavaria in Munich and at Tergensee Castle is preserved at Potsdam.

The legacy of Ludwig's building mania was bequeathed to his grandson, Ludwig II, born in 1845 on his grandfather's birthday, at exactly

55. **FERDINAND LE FEUBURE** (German, 1815–1898)
The Bedroom of the Emperor Dom Pedro I of Brazil, Palace of Queluz, 1850.
Brush and watercolor, gum arabic, graphite on white wove paper.
7 ⅞ x 12 ⅝ in. (200 x 320 mm). Cooper-Hewitt, National Design Museum,
Smithsonian Institution, Thaw Collection, 2007-27-47

56. **FRANZ XAVER NACHTMANN** (German, 1799–1846)
The Dressing Room of King Ludwig I at the Munich Residenz, 1836. Brush and gouache,
gold paint, pen and black ink, graphite on white wove paper.
8 ¹¹⁄₁₆ x 11 ¼ in. (221 x 286 mm). Cooper-Hewitt, National Design Museum,
Smithsonian Institution, Thaw Collection, 2007-27-18

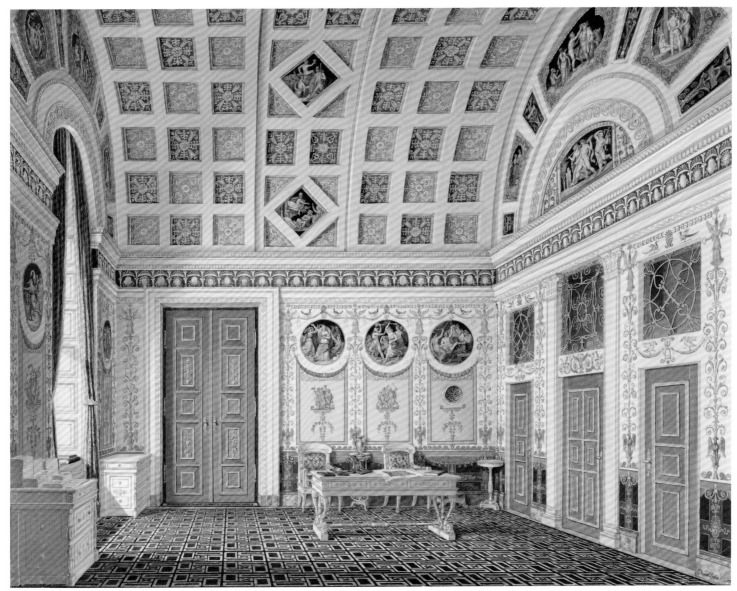

FIG. 56

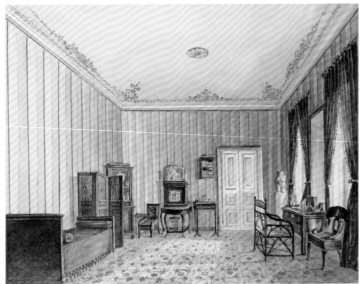

FIG. 57

57. UNKNOWN RUSSIAN ARTIST
Bedroom in a Country Dacha, 1839.
Brush and watercolor, pen and blue ink, graphite on white wove paper.
7 3/16 x 9 9/16 in. (183 x 243 mm). Cooper-Hewitt, National Design Museum,
Smithsonian Institution, Thaw Collection, 2007-27-25

the same hour. Inspired not by the classical world but by myth and symbolism, the younger Ludwig left a more eccentric heritage than his grandfather.[59]

Two remarkable Russian drawings, one from early in the nineteenth century, the other from the very end, reiterate the progression from amateur watercolorist to professional artist. The early drawing is by an unidentified artist who, though not incompetent, was not sufficiently accomplished to be a professional. As the taste for interior paintings grew, many amateurs tried their hand at painting them. Their names are now almost always irretrievable. The inscription on the mount of this painting (FIG. 57) identifies a room in the dacha, a single-story wooden country house, of the Kishkovsky family. Though not opulently furnished, it is by no means unsophisticated. The decoration on the coved ceiling is picked out in blue; the walls are papered with an elegant wide stripe in blue and yellow; the floor is close-carpeted; and the curtains match the daytime covers of the bed-divan, with its bolsters made to form arms at each end. The bed in the French style was a considerable luxury in a country where even the czar sometimes slept on a folding campaign bed in his study. The writing table be-

tween the windows is furnished with a pair of candlesticks, and a tall looking glass fills the wall in front of it. Books occupy a small set of hanging shelves on the wall by the door, and next to the shelves, on top of a cabinet, is a mysterious mechanical device under a glass cover, possibly a musical automaton. The door of the cabinet is mounted with a flowered porcelain panel.

Inconspicuously placed in the far corner of the room is a sculpture of a kneeling boy, a popular model in the manner of Lorenzo Bartolini. The chairs are fine examples of late neoclassical taste. The writing chair, a considerable curiosity, seems to be made of metal, possibly steel and gilt bronze, with the seat of gilt-bronze woven mesh.[60]

Alexander Benois's (1870–1960) THE BEDROOM OF CZARINA MARIA ALEXANDROVNA, GATCHINA PALACE, ST. PETERSBURG (FIG. 58) shows how new painting methods infiltrated the discipline of painted interiors. The estate at Gatchina was a country retreat of the Russian imperial family. While the public rooms of the palace were sumptuously appointed, the private spaces were decorated in a far from regal manner. This bedroom is decorated in typical Victorian style, with floral-patterned walls, upholstery, and bed drapery. The highly polished rococo-revival furniture, a floral carpet, blue and gold Venetian glass central chandelier, and portraits in a gilded frame hung over the sofa complete the decorative scheme.[61] While this is no doubt a comfortable room, it is remarkable that the wealthiest family in Europe would reside in rooms that so closely resembled those of any fairly well-off member of the bourgeoisie.[62]

Of note is the treatment of watercolor in the execution of this interior. The loose, undefined patches of color that slither and stain the paper reflect the tendencies of contemporary French Post-Impressionist painters like Edouard Vuillard and Pierre Bonnard. As curator of Princess Maria Tenisheva's collection of modern art and a founding member of the Russian avant-garde exhibiting society World of Art, Benois was familiar with French experimental painting. The rooms rely on an atmospheric infusion of color, and the spatial relationships of furniture and interior space are convincingly explained. There is a noticeable difference in the rendering of the perspective of the two drawings. Rendered in simple one-point perspective, the space in the country dacha tilts radically upward, with the furniture gingerly perched on the floor. Benois's superior handling of two-point perspective allows for a more convincing description of the room with the furniture nestled into the space. This is a complicated room to render, with the commingled floral patterns, curving furniture, and curtained bed.

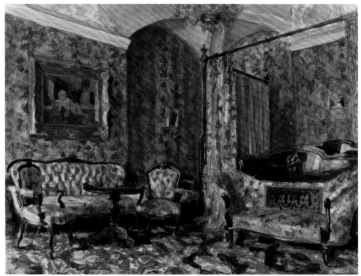

FIG. 58

CONCLUSION

The watercolor interiors in the Thaw Collection document the evolution of nineteenth-century rooms and houses; more important, they illustrate the changes their inhabitants experienced over the course of the century. As the bourgeoisie settled more and more into typical middle-class life, the rooms themselves underwent a transformation. In the early twentieth century, sitting rooms and informal parlors evolved into what eventually came to be called the living room. And with the relaxed definitions for each room, different activities were practiced in them.

This important record shows the music room of the composer and musician Fanny Hensel (née Mendelssohn Bartholdy, 1805–1847) (FIG. 59), the older sister of the famous composer Felix Mendelssohn Bartholdy (1809–1847). The Mendelssohns were a wealthy Jewish family, educated and cultivated members of the Hamburg haute bourgeoisie. Their ancestry boasted the Enlightenment philosopher Moses Mendelssohn (known as the "German Socrates"), the man who led the German Jews out of the ghetto and into society. On Fanny's mother's side were the court banker Isaac Daniel Itzig, one of the wealthiest men in Berlin, and the musical Salomon family, whose connections extended into the Viennese nobility. It was Fanny's father, the banker Abraham Mendelssohn, who changed the family name to Mendelssohn Bartholdy and had his children baptized in the Protestant faith to ease their future careers.

Fanny Mendelssohn is now recognized as a fine composer, whose reputation suffered from the restrictions put on women professionals and from her well-to-do background, which absolutely proscribed gainful employment. Although her family supported her musical ambitions and training in theory, few of her compositions were published during her

58. ALEXANDRE BENOIS (Russian, 1870–1960)
The Bedroom of Czarina Maria Alexandrovna, Gatchina Palace, St. Petersburg, ca. 1900.
Brush and watercolor, gouache, graphite, red chalk on white wove paper.
12 3/8 x 16 3/4 in. (315 x 425 mm). Cooper-Hewitt, National Design Museum,
Smithsonian Institution, Thaw Collection, 2007-27-76

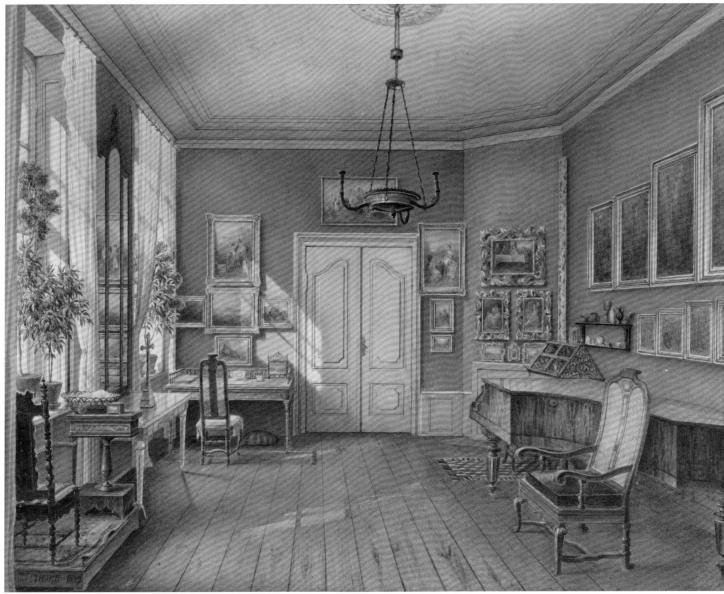

FIG. 59

lifetime, save for some songs under her brother's name. She married, after a long courtship, the court painter Wilhelm Hensel (1794–1861) in 1829, and they moved into the garden house of the Mendelssohns' Berlin residence at no. 3 Leipzigerstrasse. The Hensels' music room was the center of much musical and artistic entertaining.

This watercolor, reproduced many times in biographical studies of Fanny, was painted two years after Fanny's death—Felix died in the same year, his failing health aggravated by his grief at her death— and by an artist other than her husband. This is surprising, as Hensel always sketched during the evening entertainments and kept an album of portraits of their circle of friends and acquaintances. It can be speculated that, although he was a productive artist, busy with portraits and teaching, he never recovered from the blow of her death.

59. **JULIUS EDUARD WILHELM HELFFT** (German, 1818–1894)
The Music Room of Fanny Hensel (née Mendelssohn), 1849.
Brush and watercolor, graphite on white wove paper. 9 3/16 x 11 13/16 in. (234 x 300 mm).
Cooper-Hewitt, National Design Museum, Smithsonian Institution,
Thaw Collection, Gift of Eugene Victor Thaw Art Foundation, 2007-27-41

The room is dominated by a beautiful piano, and hung with a collection of paintings, including, above the fireplace, a reduced copy of Titian's SUPPER AT EMMAUS from the Louvre. The desk and sewing table, both positioned to take advantage of the light, have the look of being frozen in time, as if they remained untouched since the death of their owner. The flowering shrubs, probably oleanders, are well tended and in bloom. A table, apparently of glass and bearing a large cross, is positioned like an altar in front of the three-section pier glass, turning the room into a shrine. A little-known aspect of interior view painting is that they sometimes posthumously recorded the subject's most characteristic or intimate sphere of activity.

Looking at Julie Bayer's AN ARTIST'S STUDIO (FIG. 60), it is tempting to imagine that this is the artist's own studio, and the figure shown reading on the sofa is a self-portrait. In spite of the evidence of traditional feminine occupation in this room—a pincushion and scissors; a miniature chest of drawers for trinkets; the small portable writing desk on the table at the left; and a cluster of ornaments on the carved bracket under the portrait on the far wall—the room shows signs that the

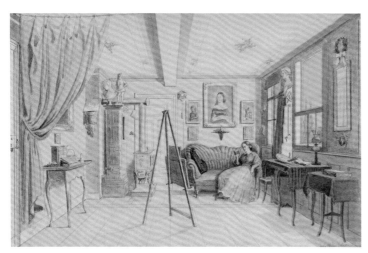

FIG. 60

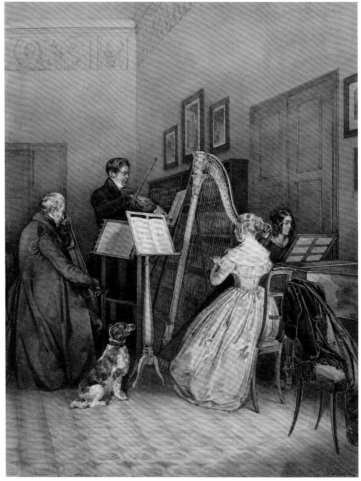

FIG. 61

artist is a serious one. The small panel propped up above the canvas on the easel is no doubt a sketch being transferred to a larger format. Casts of a medieval standing figure and an antique bust are stored on the unused stove, and there is another bust on top of the shelves between the windows. Disembodied pairs of hands hang on the wall beyond the second window. A palette and brushes have been set down beside an open book on the largest table, and drawing instruments hang on the side of the shelves, which are covered with a protective green curtain. The brown curtain roughly strung on a wire across the room must have been intended to obtain some privacy for sleeping quarters at one end, or perhaps a place for a model to disrobe. Though far from being a Bohemian loft, this room is stark in comparison to the elaborate studios of the most famous and influential painters of the time. While not outfitted with massive amounts of historical props to dazzle clients, this studio's earnestness and humility are a telling record of a dedicated artist.

In many of the drawings depicted here, figures sit in silence reading quietly at windows or gossip together over their sewing baskets. A hint of the festivities and entertainments the mid-nineteenth-century homeowner participated in can be found in the predominance of musical instruments in the drawings. From elaborate organs to zithers and guitars, they prove that these rooms were filled with song and music. Well-appointed drawing rooms sometimes included harps as well as pianos, and wealthy homes featured music rooms adorned with trophies (FIGS. 61, 62). Professional musicians and vocal artists entertained evening guests. It was also common for young women to perform duets at the piano to entertain the family, and upper-class women were taught to read and play music and to sing. While many of the artists included here were male professional artists, trained as topographers or china painters or miniaturists, many were also women, and

it is a testament to their collective ability, as well as the generosity of the Thaws, that Cooper-Hewitt's visitors are able to glimpse, in astounding detail, the nineteenth-century home.

60. JULIE BAYER (German, active 1850)
An Artist's Studio, ca. 1850. Brush and watercolor, graphite on white wove paper. 7 3/8 x 11 5/16 in. (188 x 287 mm). Cooper-Hewitt, National Design Museum, Smithsonian Institution, Thaw Collection, 2007-27-44

61. L. ROSSI (active Germany and France, ca. 1850)
The Music Party, ca. 1850. Brush and watercolor, white gouache, graphite on white wove paper. 12 1/8 x 9 5/16 in. (308 x 236 mm). Cooper-Hewitt, National Design Museum, Smithsonian Institution, Thaw Collection, 2007-27-46

62. Possibly ACHILLE-LOUIS MARTINET (French, 1806–1877)
Salon Interior with Gabriel d'Arjuzon Playing the Violin and Pascalie d'Hosten, Comtesse d'Arjuzon, Playing Guitar, 1840s. Brush and watercolor on white wove paper. 4 5/8 x 4 3/16 in. (117 x 107 mm). Cooper-Hewitt, National Design Museum, Smithsonian Institution, Thaw Collection, 2007-27-83

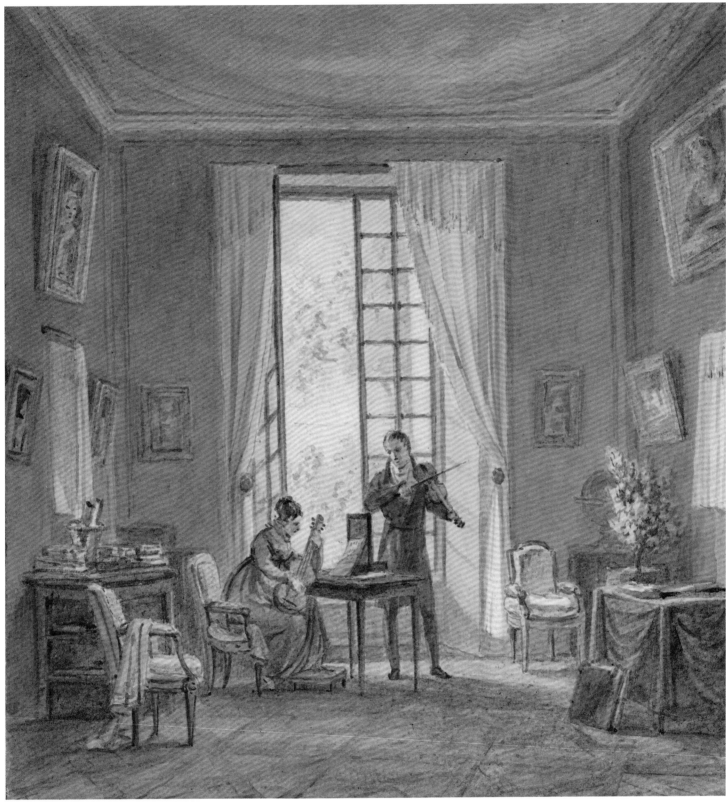

FIG. 62

NOTES

1. Beginning in 1832, the Palais Royal underwent restoration by Fontaine. Bouchet collaborated with Fontaine on a history of the royal residence of the Orléans family, *Histoire du Palais-Royal* (Paris, 1834), for which he produced engraved illustrations. The watercolors here were presumably produced for the engravings.

2. Pierre-François-Léonard Fontaine, *Journal 1799-1853*, vol. 2, *1824-1853* (Paris: Ecole Nationale Supérieure des Beaux-Arts; Institut Français d'Architecture; Société de l'Histoire de l'Art Français, 1987): 725.

3. *The Entrance Hall, East Sutton Place, Kent* (1844) appears in the third volume (1844), in which the empty room is occupied by a fanciful Elizabethan father and mother, two girls, a boy, and a large dog.

4. *Ackerman's Repository, The Third Series,* August 1, 1827, vol. X, no. LVI, *Fashionable Furniture,* p. 119.

5. *Ackerman's Repository, The Third Series,* October 1, 1827, vol. X, no. LVIII, *Gothic Furniture,* p. 295.

6. See Irmgard Wirth, *Eduard Gaertner* (1978) for illustrations of fifteen of the rooms in the palace.

7. For a description and inventory, see Helmut Borsch Supan, *Marmorsaal und Blaueszimmer* (1976), no. 29.

8. Quoted by David Duff, *Victoria Travels* (London, 1970): 167.

9. Quote from Queen Victoria's unpublished diaries in the Royal Library at Windsor Castle, with the gracious permission of H. M. The Queen.

10. The Treaty of Kanagawa (now part of Yokohama) is also known as the Perry Convention. This was the first trade agreement between Japan and the West.

11. The designation "Japanese" may have been due to the recent reopening of Japan to European markets and the craze for Japanese goods. The Villa Hügel was built by Karl Alexander Anselm Freiherr von Hügel (1796–1870), an imperial officer familiar with India, Kashmir, and the Far East. His garden at Hietzing was renowned for botanical specimens collected on his journeys. The Villa was acquired by August Ludwig Wilhelm Duke of Braunschweig-Wolfenbüttel in 1854. See, Gerhard Weissenbacher, *In Hietzing gebaut. Architektur und Geschichte eines Wiener Bezirkes*, vol. II (Vienna, 1998): 17–19.

12. It is significant that in Owen Jones's publication *The Grammar of Ornament* (Day & Sons, London, 1856), there was no category listed as "Japanese" ornament. Actually, much of the fretwork that adorns the mantelpiece and other furniture can be traced to that publication under examples of "Chinese" ornament.

13. The twenty-four minutely detailed plates devoted to Carlton House in William Henry Pyne's *The History of Royal Residences* (1819) constitute a record of exceptional importance in the history of Regency decoration.

14. The history of Carlton House and its decoration is described in detail in the catalogue of the exhibition *Carlton House: The Past Glories of George IV's Palace,* held at The Queen's Gallery in Buckingham Palace, 1991 (see pp. 214–16, no. 93, for the Circular Dining Room).

15. Witold Rybczynski, *Home: A Short History of an Idea* (New York, Penguin Books, 1986): 98.

16. Included in the publication is a list of subscribers, which included not only fine furniture makers but also significant clients including the Earl of Chesterfield, the Duke of Kingston, and the Duke of Portland. The publication was dedicated to the Earl of Northumberland.

17. The inscription on the right in a masculine hand indicates that the presentation of this drawing was to remind Mme. Felix of fond memories of the rooms and an invitation to return soon. Her curt response, written hastily at left indicates

that, in effect, she would not advise her former lover to hold his breath.

18. Charlotte Gere, *Nineteenth-Century Decoration: The Art of the Interior* (London: Weidenfeld and Nicholson, 1989): pl. 55.

19. It is interesting to speculate on the musical life that centered on the splendid organ in this room. Though by no means commonplace, organs were found in a number of private houses, particularly if there was a family chapel. Old organs survive at Knole and Hatfield, and Handel himself played on the Legh family instrument at Adlington Hall in Cheshire. The Gothic Revival organ in the present drawing probably dates from the late eighteenth century, since the drawing itself is clearly earlier than the great surge of Gothic initiated by Pugin in the 1840s.

20. Marjorie B. Cohn, *Wash and Gouache: A Study of the Development of the Materials of Watercolor* (Cambridge: The Center for Conservation and Technical Studies, Fogg Art Museum, Harvard University, 1977): 12.

21. Ibid., p. 16.

22. The old cathedral city of Constance (or Konstanz) is at the westernmost end of the southern shore of Lake Constance, the vast lake from which the Rhine emerges, on the borders of the Thurgau Canton of Switzerland, Southern Germany, and Austria. The border between Switzerland and Germany runs through the lake, and Constance was a contested territory, once subject to Austrian rule, then Swiss, and from 1805 part of the Duchy of Baden as a result of the Treaty of Pressburg.

23. Napoleon's step-daughter Hortense (Duchesse de St-Leu),was exiled to Switzerland who died there in 1837.

24. In the posthumous sale of Hunt's studio in 1864, there were eleven of the Cassiobury drawings, but not this one. Most of the furniture in this room was sold by Christie's in 1893.

25. Tracey Albainy, Thomire catalogue entry in Odile Nouvel-Kammerer et al., *Symbols of Power : Napoleon and the Art of the Empire Style, 1800-1815* (New York: American Federation of the Arts/Abrams; Paris: Musée des Arts Décoratifs, 2007): 316.

26. Gere, pl. 204.

27. There are two more views of rooms in the Alexandria Cottage by Hau (the drawing room and the Tsar's study) and a view of the exterior by Charlemagne in the "Peterhof" volume from the four-volume set of *Imperial Palaces in the Vicinity of St. Petersburg*, published by Alain de Gourcoff. The watercolors of the rooms are dated 1855; the exterior to circa 1850.

28. In 1934, it was demolished to make way for a new house designed by Sir Edwin Lutyens.

29. The plants covering the pergola and climbing up the columns seem to have grown since the same view was painted for the Wittgenstein family by Carl Kollman in 1834. This drawing may date from the following year, when the Viennese artist Sotira was working at Pavlino; or from 1838, when other views there were made by Sotira and by the Russian artist Vasily Semenovic Sadovnikov, who is likely to be the author of this watercolor. This site remained unidentified because the winter garden was not one of those illustrated by Mario Praz when he published the rest of the Wittgenstein interiors in his *Illustrated History of Interior Decoration*.

30. See Hugh Honour, "Canova's Statues of Venus," in *The Burlington Magazine* CXIV (1972): 662–66.

31. The Victoria & Albert Museum has three similar interiors, again with a pair showing two aspects of the same room. There was one example in the 1981 *Interiors* exhibition at Hazlitt, Gooden and Fox; and there is one other, reproduced in Gere, pl. 348), in a private collection. All three V&A interiors are reproduced in Susan Lasdun, *Victorians at Home* (London: Weidenfeld and Nicolson, 1981). There has been one or two at auction since 1981.

32. See also Christie's, July 9, 1991, for a pair of watercolors by Pyne showing two views of a room at Christ Church. N.B. Huntington Library, William Turner of Oxford, Interior of a room at Oxford (actually by George Pyne) shows a flower pot with a rose in it that also appears in another interior from this group (Gere, p. 348), suggesting that many of the contents could be hired from the decorator, even perhaps the works of art.

33. Other watercolorists were also employed by Queen Victoria to record the interior views. James Giles was one such artist, who also painted interiors of Old Balmoral castle. See Delia Millar, *Queen Victoria's Life in the Scottish Highlands Depicted by Her Watercolor Artists* (London: Philip Wilson Publishers Limited, 1985): 60–63.

34. Delia Millar cites a version of *The Queen's Sitting Room* which is inscribed on the mount in French and includes a portrait of Prince Arthur on the end wall. As of 1995, the publication date of Millar's book, that watercolor, purchased in Vienna in 1921, was in a private collection in Florida. It may be the one purchased by Eugene V. Thaw, and which he donated to Cooper-Hewitt in 2007.

35. A companion drawing of the other half of this room shows that William conducted his book-dealing business on the premises. Books fill every available shelf, and a wire hook suspended by the fireplace and stuffed with documents, presumably bills and receipts, suggests a busy commercial operation. In that drawing, a young woman is shown seated at a table with her folding writing desk, attending to correspondence and bills. It is possible that she is the same woman indicated in the sitting room.

36. Owen's Row is a modest street in north London. It was developed in 1773 by Thomas Rawstone, an Islington bricklayer, and runs between St. John Street and Goswell Road. In 1940, during World War II, a bombing raid destroyed all but four of the fifteen houses in the row. Tall, narrow terraced houses of the type built in Owen's Row were standard all over London, varying little except in scale from one street to the next.

37. For a detailed account of Devey's life and achievements, see Jill Allibone, *George Devey, Architect 1820-1886* (Cambridge: Lutterworth Press, 1991).

38. Alberto Manguel, *A History of Reading* (New York: Viking, 1996): 198. It is interesting to compare Jorge Luis Borges's satire on this concept of the ordered library in his story "La Bibliotecca de Babel," in *Ficciones* (Buenos Aires, 1944).

39. Manguel, p. 133.

40. John Foskett Douglas, *The New Encyclopaedia Britannica*, vol. 22, 15th edition (Chicago: The University of Chicago, 1989): 971.

41. Sir Lawrence Alma-Tadema was a preeminent painter of classical subjects. Attention to detail and the rendering of textures, especially marble, were his specialties. Anna, her father's pupil, was listed as thirteen years old in the 1881 census.

42. Mrs. Haweis, *Beautiful Houses; Being a Description of Certain Well-Known Artistic Houses* (1882); cited in Charlotte Gere, *An Album of Nineteenth-Century Interiors: Watercolors from Two Private Collections*, exh. cat., edited by Joseph Focarino (New York: The Frick Collection, 1992): 96.

43. This drawing has in the past been misidentified as a view of the Gold Room, on the first floor of the house, of which Anna Alma-Tadema exhibited a painting at the Royal Academy in 1885 (fig. 13; Gere 1989, pl. 27). Since the exhibition at the Frick in 1992, Alma-Tadema's residences (he lived at Townsend House from 1870 to 1886) have been discussed in great detail by Julian Treuherz in the catalogue of the Alma-Tadema exhibition held in Amsterdam and Liverpool, 1996–97. Treuherz was not able to add much to the detailed description of the room in the Frick catalogue, but it is very interesting to see it in the context of the other rooms, and to understand how it fit into the plan of the house.

44. The verso of the drawing has an inscription that this watercolor records an interior on East 93rd Street in Manhattan. City records from this time do not support this attribution. It is possible that the inscription refers to an address in another New York borough location.

45. In 1872, Henry painted a view of the parlor in the house on Brooklyn Heights belonging to Mr. and Mrs. John Bullard (oil on panel; in the Manoogian Collection). The house is clearly furnished and decorated in a very similar style to the scheme shown in the Cooper-Hewitt watercolor, and it could be that he was also responsible for designing the Bullard house.

46. The ancient cathedral city of St. Polten is the capital of what is now the Federal Republic of Lower Austria. The baroque character of the city today was established in the late seventeenth century under the architect Jacob Prandtauer. When Napoleon marched on Vienna for the second time in 1809, it was occupied by French troops.

47. The Château de Neuilly, in the vast Parc de Neuilly to the north of the Bois de Boulogne in Paris, was built for Louis xv's Secretary of War, the Comte d'Argenson, in the decade between 1741 and 1751 on the site of an earlier structure dating from the mid-sixteenth century. After the French Revolution, it had a number of celebrated occupants, who entertained lavishly and added to the existing château, among them Talleyrand and Napoleon's marshall and brother-in-law, Joachim Murat, who bought it in 1804. Murat became King of Naples in 1808, and was succeeded at Neuilly by Napoleon's sister, Pauline Borghese. In 1814, the château was restored to the French crown, and, in 1819, it was acquired by the Duc d'Orléans, future King Louis-Philippe. He commissioned Pierre-Francois-Léonard Fontaine to transform the building yet again. During the revolution of 1848, which brought Louis-Philippe's reign to a close, the mob pillaged and burned the château, leaving only the wing built by Murat. Neuilly is now entirely built over and absorbed into suburban Paris.

48. A similar desk made for Princess Augusta, wife of Karl's brother Wilhelm, is smaller, but has many of the same details, inlaid legs, and frieze under the writing top.

49. The function of the platform is unclear, particularly since the entrance to the room is in the corner, to the spectator's left. In Schinkel's hurried transformation of the palace, this may have been an improvised, and not altogether satisfactory, expedient for concealing a change in the floor level.

50. There is a near replica of this interior view, also dated 1835, in the archive of the Princely Clary family at Teplitz Castle in Bohemia. The occupant of the room in the case of the Clary watercolor is Elisalex Ficquelmont, who married Count Edmund Clary. Elisalex was the great-granddaughter of Field Marshall Kutusov, savior of Moscow in 1812. Kutusov's daughter married Count Ferdinand Tiesenhausen: they had two daughters, one of whom married

Count Carl Ficquelmont. The other was seduced by one of the imperial princes and taken under the protection of the Empress Alexandra Feodorovna, so it is perfectly possible for her niece to have been portrayed in the study of the empress. However, it is assumed that this version shows a Ficquelmont residence in St. Petersburg.

51. Oldenburg was developed as a modern, enlightened city on neoclassical lines by the progressive and cultivated grand ducal family in the 1820s and 1830s. Carl Heinrich Slevogt, the court architect responsible for the additions to the grand ducal palace, spent his formative years in Berlin and was much influenced by Karl Friedrich Schinkel. Slevogt died in 1832 and was succeeded by Heinrich Strack, a pupil of the Dane C. F. Hansen.

52. Peter Thornton, *Authentic Décor, The Domestic Interior, 1620-1920* (New York: Viking, 1984): 58.

53. Judith Flanders, *Inside the Victorian Home, A Portrait of Domestic Life in Victorian England* (New York: Norton, 2003): 42.

54. Quoted in Donald J. Olsen, *The City as a Work of Art, London, Paris, Vienna* (New Haven: Yale University Press, 1986): 123.

55. Flanders, p. 43.

56. It was built for the Infante Dom Pedro (grandfather of Pedro IV) in 1747–52 by Mateus Vicente de Oliveira (1706–1786), in homage to Versailles. The debt is particularly apparent in the entrance courtyard and the celebrated gardens. In 1934, the interior of Queluz was devastated by fire, badly damaging the Hall of the Ambassadors. Many imposing state rooms survived, including the Throne Room decorated by Antoine Collin and Silvestre de Faria Lobo (d. 1769); the richly gilded oval Hall of Mirrors (another salute to Versailles); the sophisticated Hall of Tiles (without which no palace in Portugal could be considered complete); the Council Room, with its fine floor of Brazilian hardwood; and the mirrored Queen's Dressing Room (1774–76).

57. The inscription identifying this memorial drawing was written by Princess Maria Amelia, daughter of Pedro and his second wife, Amelia Augusta von Leuchtenberg (married 1829). Maria Amelia, who was only three at the time of her father's death, revisited the Queluz Palace for the

first time seventeen years later, in 1851. She found the room unchanged.

58. The Alte Residenz at Munich was built between 1598 and 1616 for Elector Maximilian I, and occupies a long frontage on the Residenzstrasse between the Hofgarten and the Max-JosephPlatz.

59. Ludwig II of Bavaria (1845–1886), heir to the Wittelsbach family, is noted for the eccentric design of Neuschwanstein Castle, begun in 187, and a royal hunting estate, Linderhof. Both palaces were heavily influenced by the operatic work of German composer Richard Wagner (1813–1883).

60. Steel and gilt furniture produced at the Tula armory works in the eighteenth century was prized in Russia, though it was almost unknown elsewhere. The manufacture of furniture and ornaments at Tula was forbidden by law at the time of the Napoleonic wars, and the prohibition was never rescinded. However, other factories must have been supplying metal furniture in the nineteenth century, as a suite of chairs in a boudoir at the Hermitage was depicted as late as 1871.

61. The painting of a child in the bedroom is by Josef Karl Stiler, of one of the Princes of Leuchtenberg.

62. The rooms on the Armory Square in the vast Gatchina Palace were left unchanged after the death of Alexander II in 1881, as can be seen from views painted during Alexander's lifetime by E. P. Hau in 1862 and 1878. The czar's study was hung with battle scenes and studies of military uniforms.

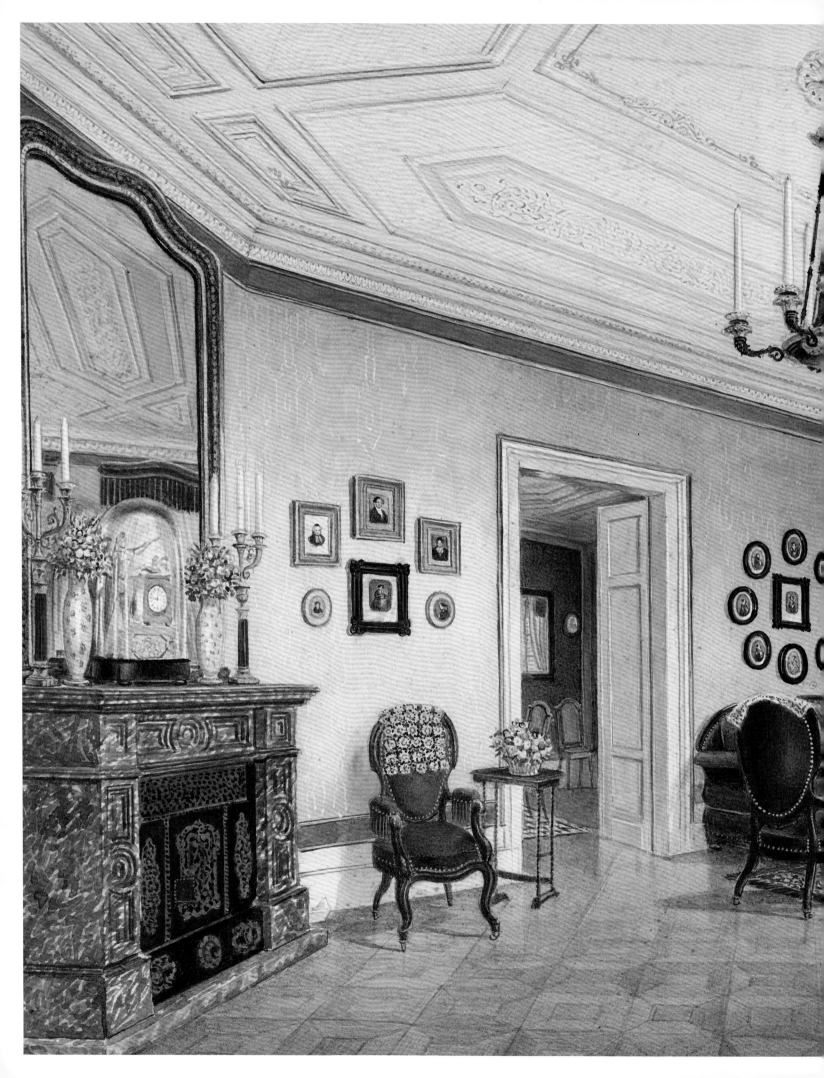

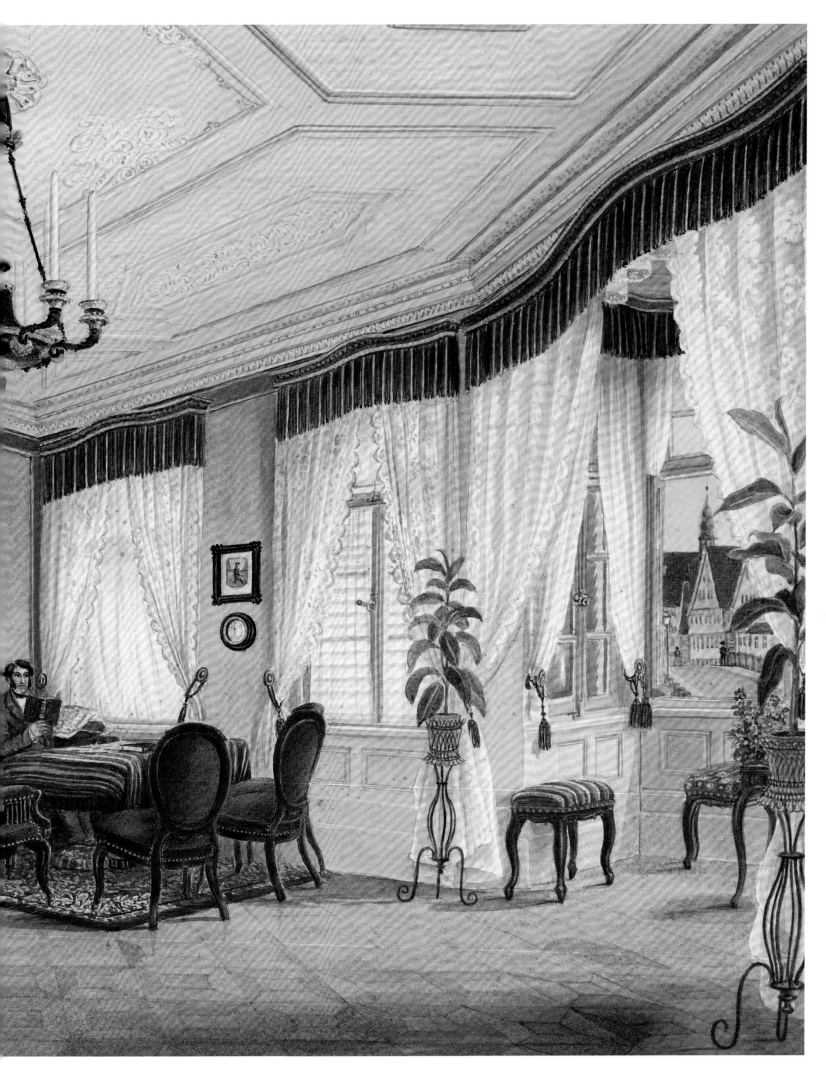

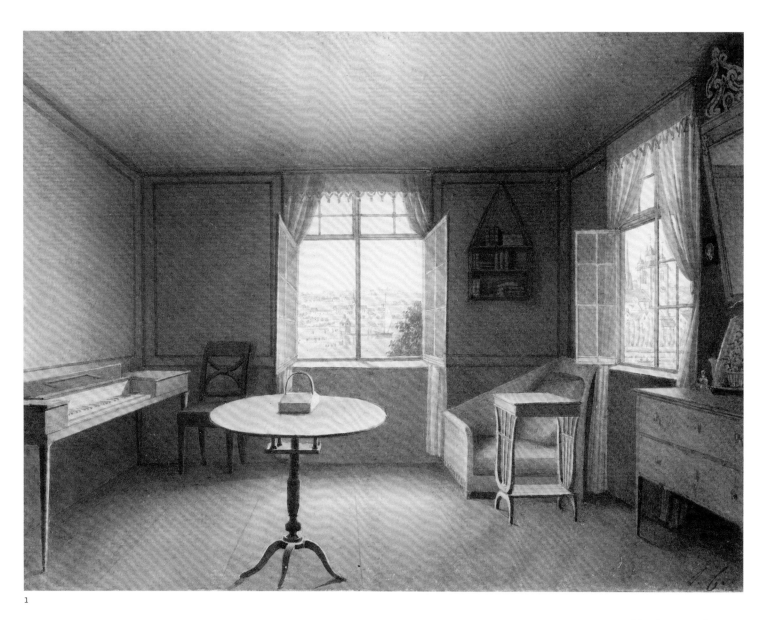

1

1. **LOUISE COCHELET** (French, 1785–1835)
The Artist's Drawing Room on Lake Constance, 1816
Brush and brown wash, graphite on white wove paper
7 9/16 x 10 1/16 in. (192 x 255 mm)
Cooper-Hewitt, National Design Museum
Smithsonian Institution
Thaw Collection, 2007-27-1

2. **CHARLES WILD** (English, 1781–1835)
The Circular Dining Room at Carlton House, London, 1819
Brush and watercolor, gouache on white wove paper
18 1/8 x 15 in. (461 x 381 mm)
Cooper-Hewitt, National Design Museum
Smithsonian Institution
Thaw Collection, 2007-27-2

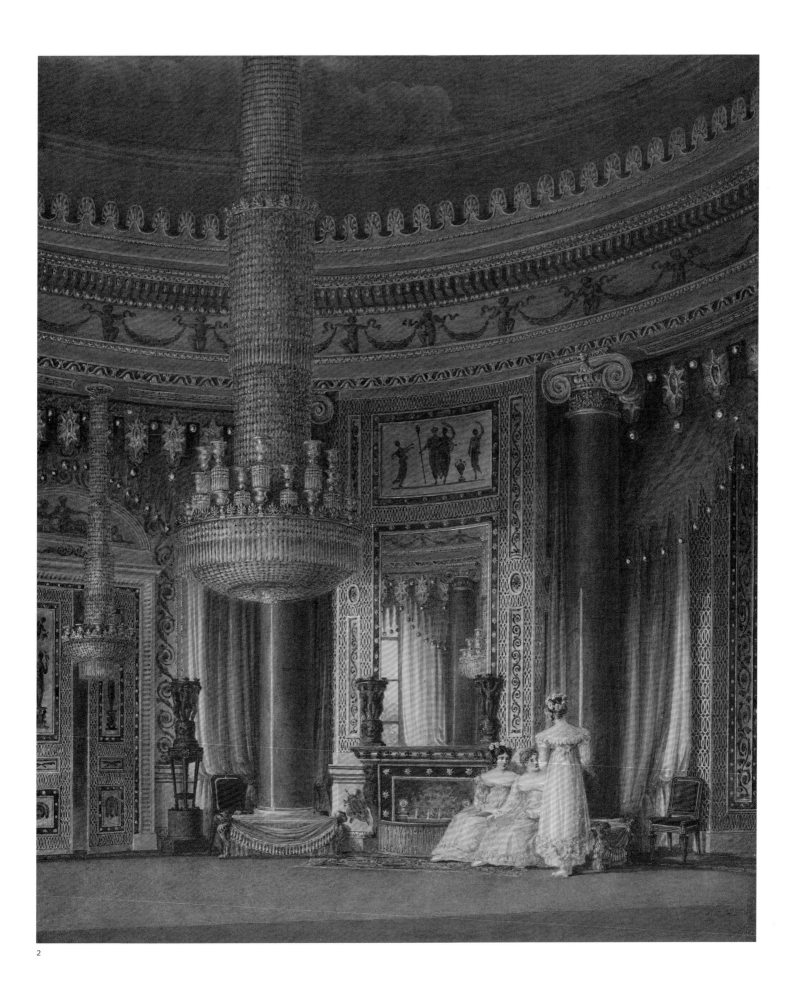

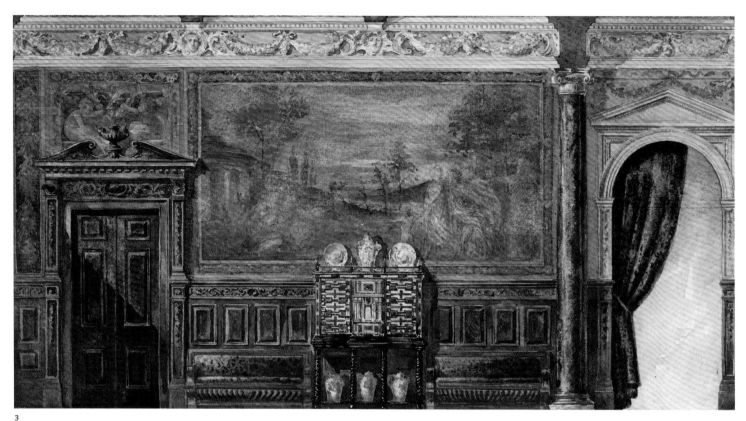

3

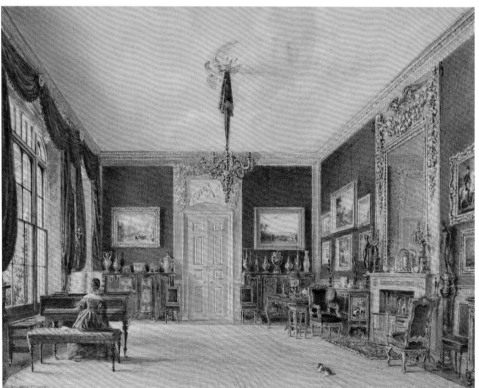

4

3. **UNKNOWN ENGLISH ARTIST**
Buscot Park, Elevation, 1890
Brush and watercolor, gouache, graphite on
off-white wove paper
7 ½ x 14 ⅜ in. (191 x 365 mm)
Cooper-Hewitt, National Design Museum
Smithsonian Institution
Thaw Collection, 2007-27-3

4. **WILLIAM HENRY HUNT** (English, 1790–1864)
*The Green Drawing Room
of the Earl of Essex at Cassiobury*, 1823
Brush and watercolor, gouache, graphite
on white wove paper
9 ⅛ x 11 ⁷⁄₁₆ in. (231 x 290 mm)
Cooper-Hewitt, National Design Museum
Smithsonian Institution
Thaw Collection, 2007-27-4

5. **BOUILHET** (French, active first half of 19th century)
A French Restoration Bedroom, 1823
Brush and watercolor, graphite on white wove paper
Cooper-Hewitt, National Design Museum
Smithsonian Institution
Thaw Collection, 2007-27-5

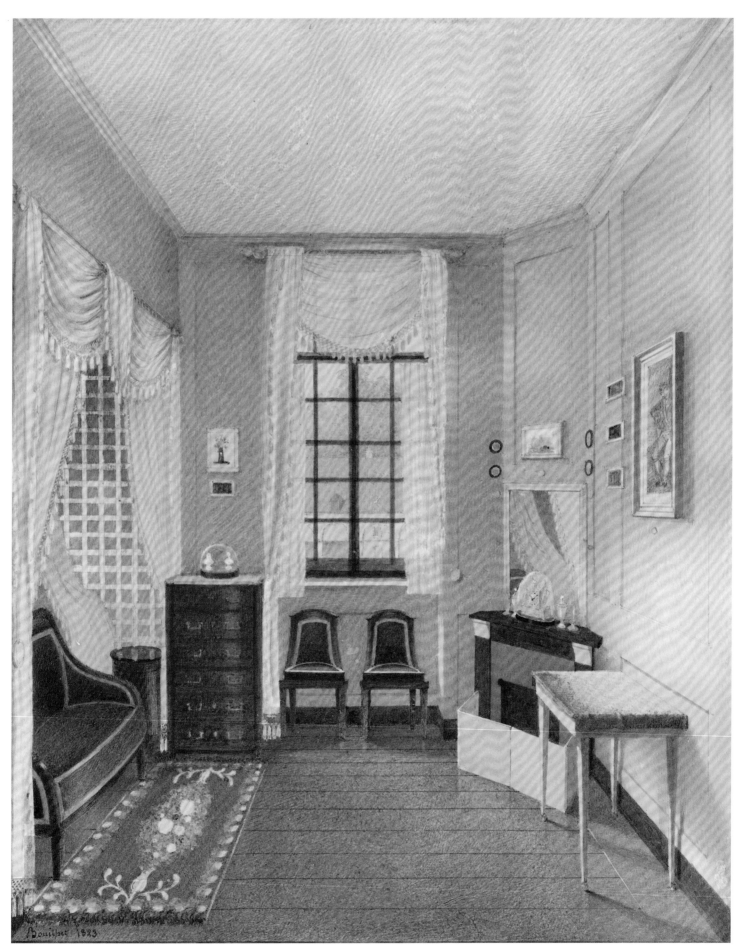

5

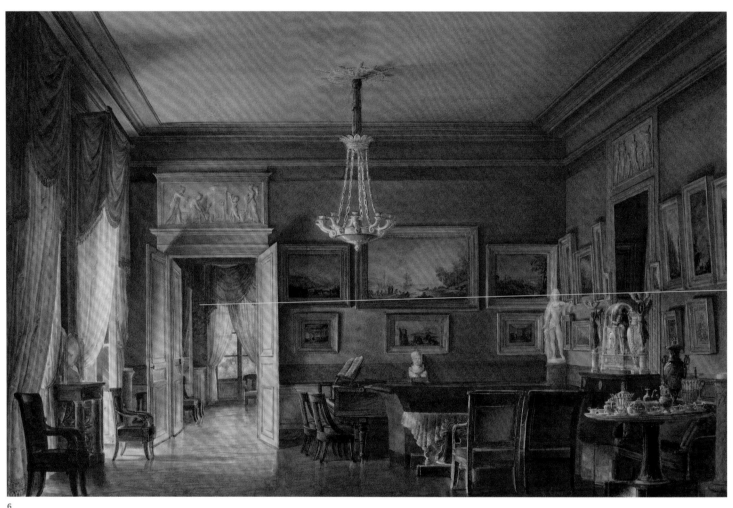

6

6. **HILAIRE THIERRY**
(French, active first half of 19th century)
A Salon in the Empire Taste, 1820–30
Brush and watercolor, gouache on white wove paper
11 x 16 ¹⁵⁄₁₆ in. (279 x 431 mm)
Cooper-Hewitt, National Design Museum
Smithsonian Institution
Thaw Collection, 2007-27-6

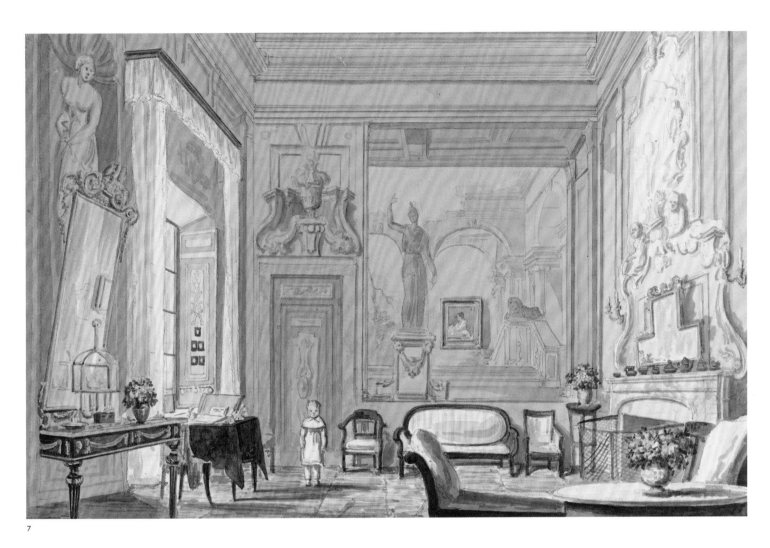

7

7. **UNKNOWN ITALIAN ARTIST**
A Room in a Florentine Palace, 1824
Brush and watercolor, gouache, graphite on
white wove paper
7 x 11 in. (178 x 279 mm)
Cooper-Hewitt, National Design Museum
Smithsonian Institution
Thaw Collection, 2007-27-7

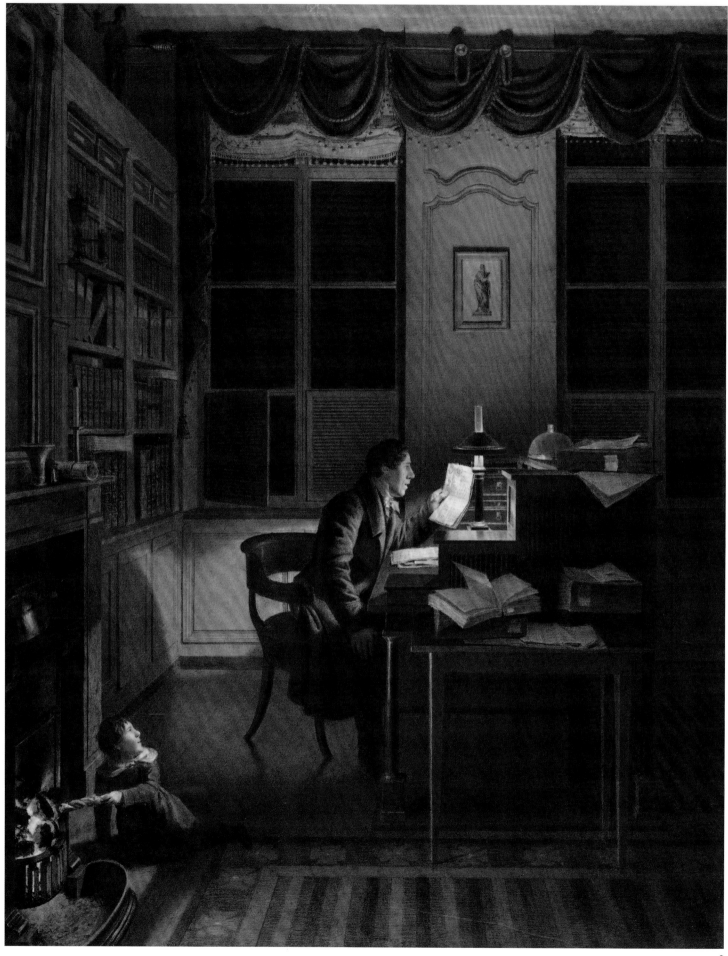

8

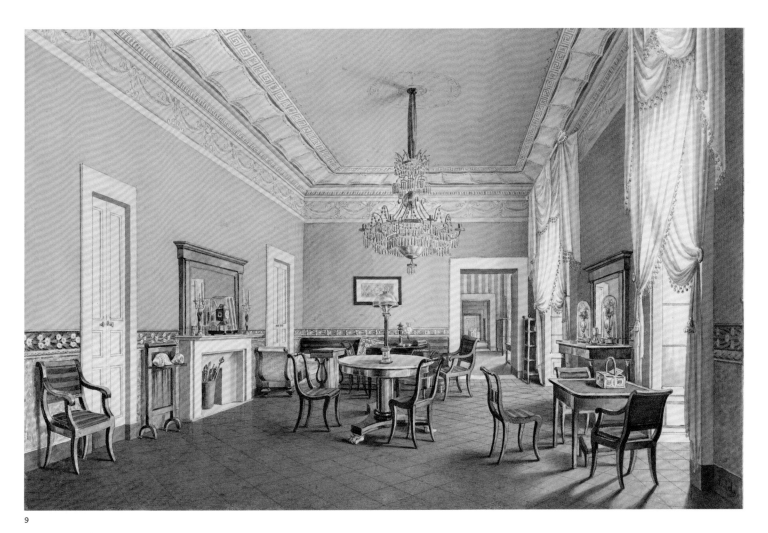

9

8. **A. L. LEROY** (Possibly English, active 1820s–30s)
An Interior with a Man Reading at His Desk, 1827
Charcoal stumped,
black and white chalk on tan wove paper
27 1/16 x 21 7/8 in. (688 x 556 mm)
Cooper-Hewitt, National Design Museum
Smithsonian Institution
Thaw Collection, 2007-27-8

9. **L. IELY** (Possibly French, active 1820s–30s)
A Salon in the Palazzo Satriano, Naples, 1829
Brush and watercolor, graphite on white wove paper
9 1/2 x 14 9/16 in. (241 x 370 mm)
Cooper-Hewitt, National Design Museum
Smithsonian Institution
Thaw Collection, 2007-27-9

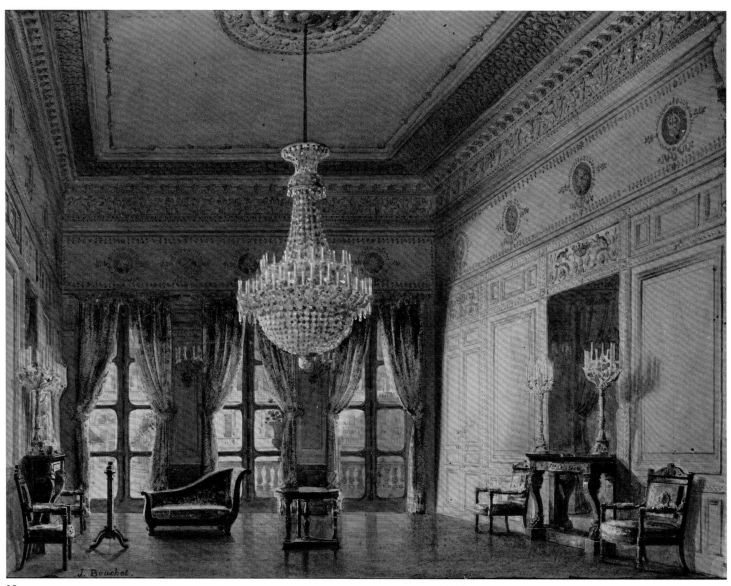

10

10. **JULES-FRÉDÉRIC BOUCHET** (French, 1799–1860)
A Small Salon in the Montpensier Wing, Palais Royal, 1830
Brush and watercolor, white gouache,
graphite on white wove paper
7 ³⁄₁₆ x 9 ⅝ in. (18.2 x 24.4 mm)
Cooper-Hewitt, National Design Museum
Smithsonian Institution
Thaw Collection, 2007-27-10

11. **JULES-FRÉDÉRIC BOUCHET** (French, 1799–1860)
The Salon in the Montpensier Wing, Palais Royal, ca. 1830
Brush and watercolor, white gouache on tan wove paper
6 ½ x 9 ¹⁄₁₆ in. (165 x 230 mm)
Cooper-Hewitt, National Design Museum
Smithsonian Institution
Thaw Collection, 2007-27-11

11

12

12. **UNKNOWN ENGLISH ARTIST**
A Large Salon with Organ, 1830
Brush and watercolor, gouache, graphite
on white wove paper
11 $^{7}/_{16}$ x 16 $^{15}/_{16}$ in. (291 x 431 mm)
Cooper-Hewitt, National Design Museum
Smithsonian Institution
Thaw Collection, 2007-27-12

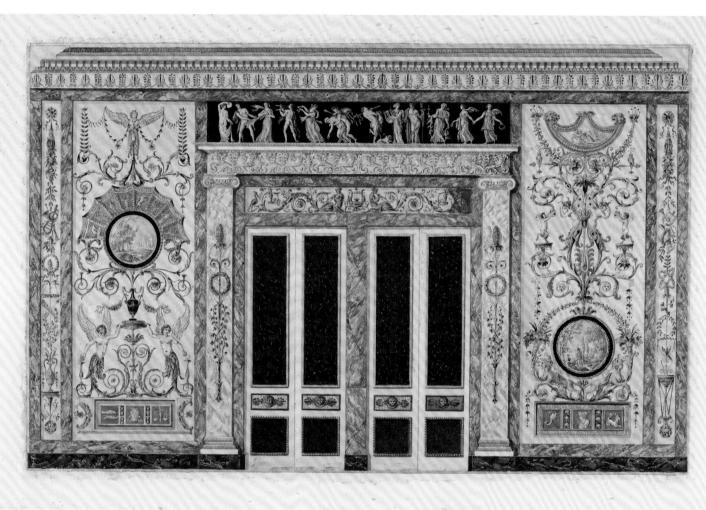

14

13

13. UNKNOWN GERMAN ARTIST
A Prussian Officer's Quarters, 1830
Brush and watercolor, pen and ink, graphite
on white wove paper
5 7/8 x 10 7/8 in. (149 x 277 mm)
Cooper-Hewitt, National Design Museum
Smithsonian Institution
Thaw Collection, 2007-27-13

14. CIRCLE OF FRANÇOIS-JOSEPH BÉLANGER
(French, 1744–1818)
Projet pour un salon de musique
(Design for a Wall Elevation in a Music Room), Paris, 1790–1802
Brush and watercolor, pen and black ink, gouache
on off-white laid paper
13 7/8 x 20 15/16 in. (333 x 532 mm)
Cooper-Hewitt, National Design Museum
Smithsonian Institution
Thaw Collection, 2007-27-14

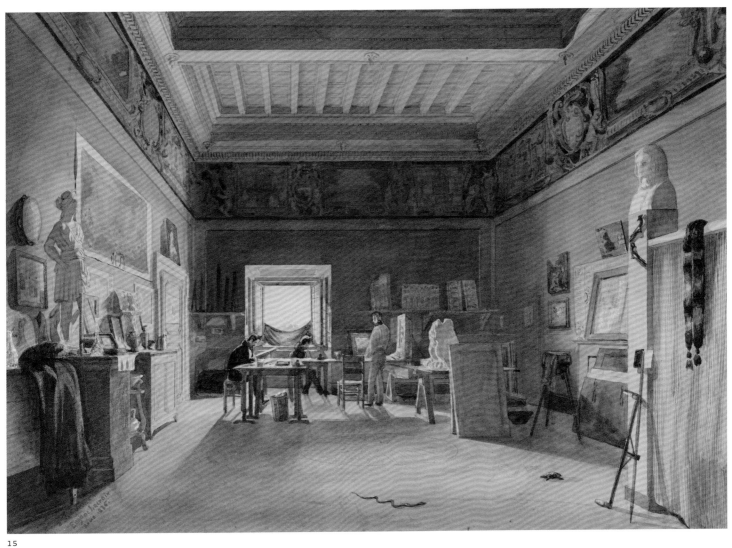

15

15. **EUGÈNE LACROIX** (French, 1814–1873)
A Studio in the Villa Medici, Rome, 1835
Brush and watercolor with scraping for highlights on
white wove paper
9 x 12 ¹⁵⁄₁₆ in. (228 x 329 mm)
Cooper-Hewitt, National Design Museum
Smithsonian Institution
Thaw Collection, 2007-27-15

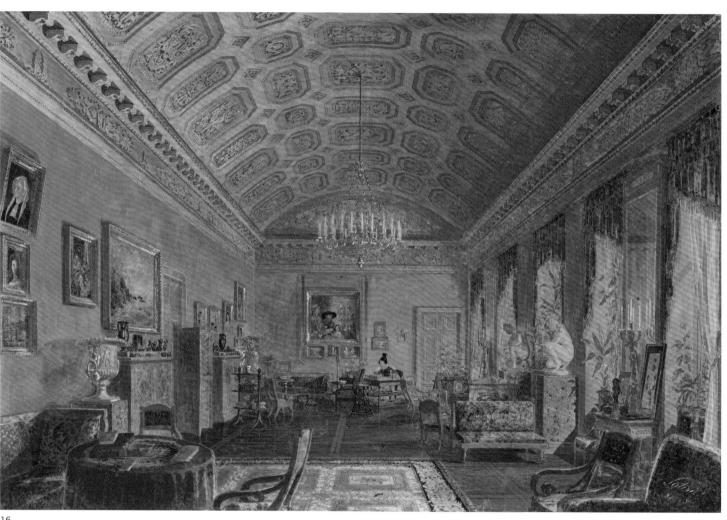

16

16. **JOSEF SOTIRA**
(Austrian, active Austria and Russia, 1830–1840)
The Study of Czarina Alexandra Feodorovna, Russia, 1835
Brush and gray wash, watercolor, gouache,
pen and black ink on off-white wove paper
10 ¹³⁄₁₆ x 16 in. (274 x 407 mm)
Cooper-Hewitt, National Design Museum
Smithsonian Institution
Thaw Collection, 2007-27-16

17. **POSSIBLY C. M. FREDRO** (Polish, active 1830s)
A Room in the Reuss Palace, Dresden, 1835–37
Brush and watercolor, gouache, graphite
on white wove paper
13 x 8 ½ in. (330 x 216 mm)
Cooper-Hewitt, National Design Museum
Smithsonian Institution
Thaw Collection, 2007-27-17

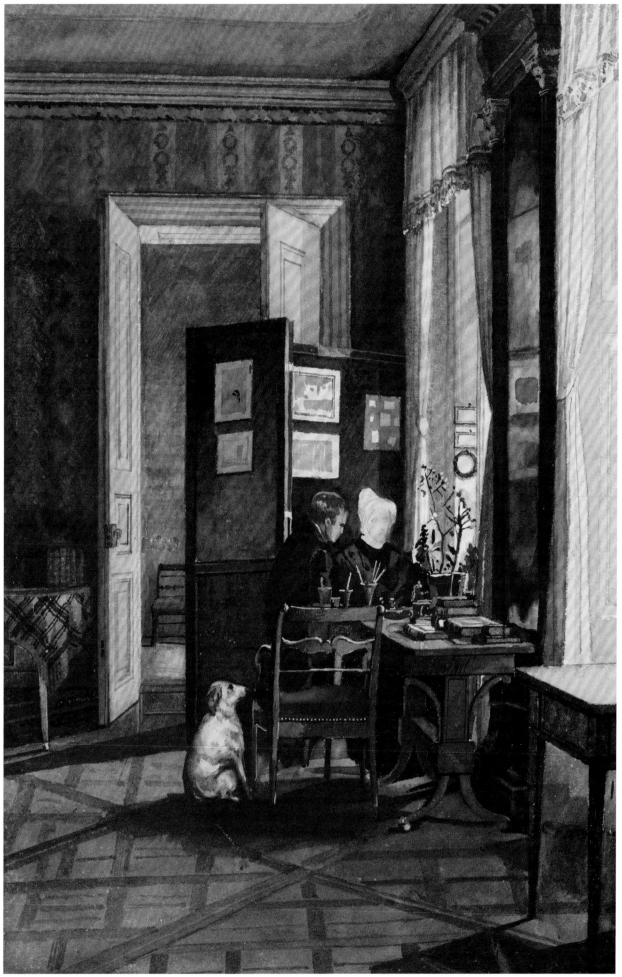

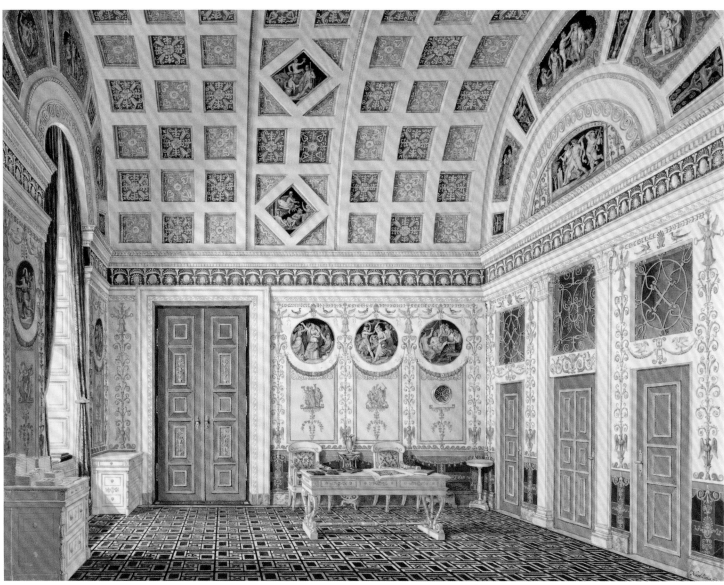

18

18. **FRANZ XAVER NACHTMANN** (German, 1799–1846)
*The Dressing Room of King Ludwig I at the
Munich Residenz*, 1836
Brush and gouache, gold paint, pen and black ink,
graphite on white wove paper
8 ¹¹⁄₁₆ x 11 ¼ in. (221 x 286 mm)
Cooper-Hewitt, National Design Museum
Smithsonian Institution
Thaw Collection, 2007-27-18

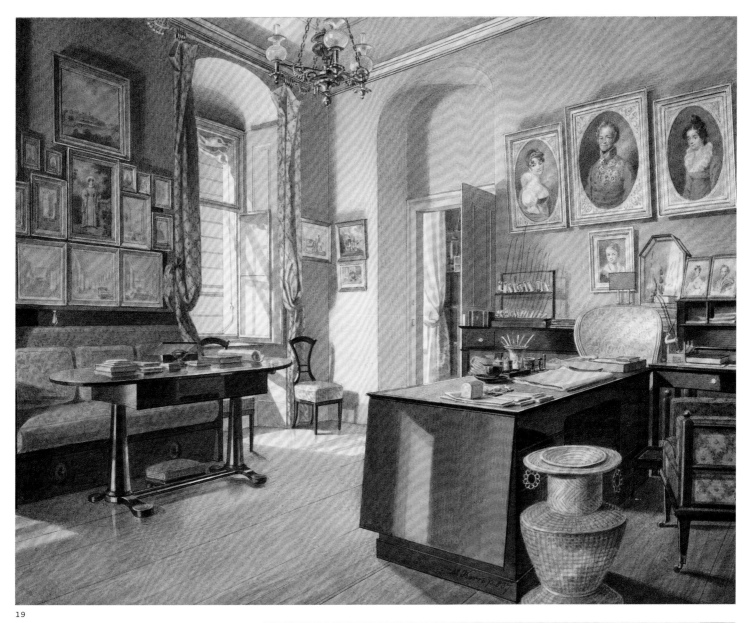

19

19. **MATTHÄUS KERN** (Austrian, 1801–1852)
A Study at St. Polten, 1837
Brush and watercolor on white wove paper
9 11⁄₁₆ x 12 ³⁄₈ in. (246 x 314 mm)
Cooper-Hewitt, National Design Museum
Smithsonian Institution
Thaw Collection, 2007-27-19

20. **AUGUSTUS CHARLES PUGIN**
(French, active England, ca. 1762–1832)
The Library at Cassiobury, before 1816
Brush and watercolor, graphite on white wove paper
14 13⁄₁₆ x 20 ³⁄₈ in. (376 x 517 mm)
Cooper-Hewitt, National Design Museum
Smithsonian Institution
Thaw Collection, 2007-27-20

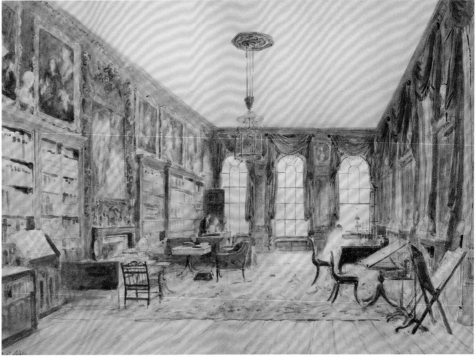

20

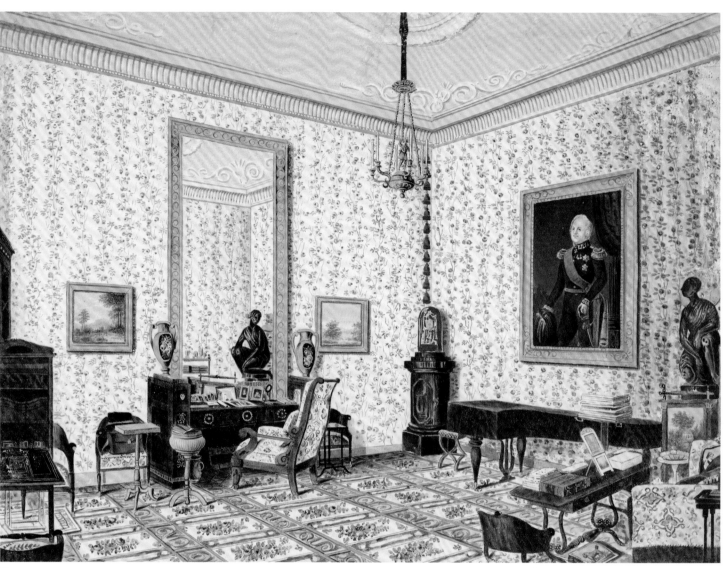

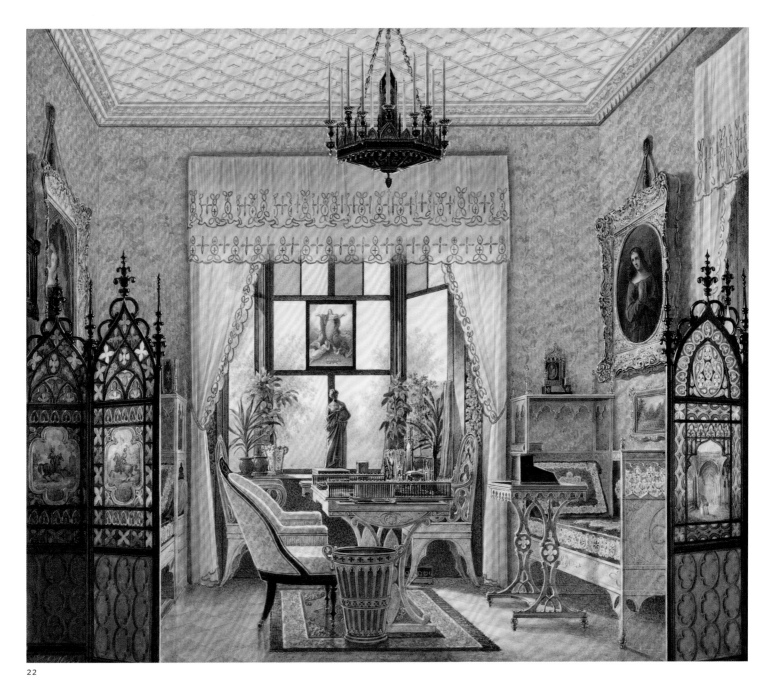

22

22. **EDUARD PETROVICH HAU** (Estonian, 1807–1887)
Petit cabinet de Maman dans le Cottage, 1830–35
Brush and watercolor on white wove paper
8 ⅜ x 9 ⅝ in. (212 x 244 mm)
Cooper-Hewitt, National Design Museum
Smithsonian Institution
Thaw Collection, 2007-27-22

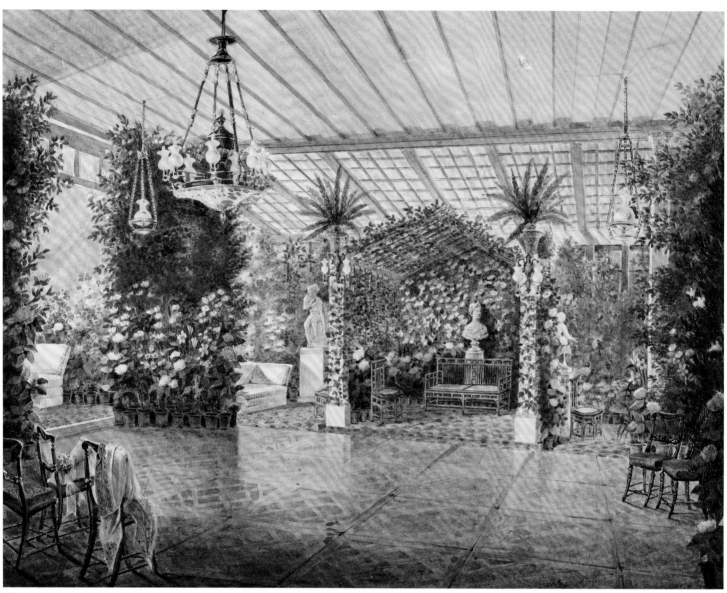

23

23. **ATTRIBUTED TO VASILY SEMENOVIC SADOVNIKOV**
(Russian, 1800–1879)
A Russian Winter Garden, 1835–38
Brush and watercolor, gouache, graphite
on white wove paper
9 ⁷/₁₆ x 11 ¾ in. (239 x 299 mm)
Cooper-Hewitt, National Design Museum
Smithsonian Institution
Thaw Collection, 2007-27-23

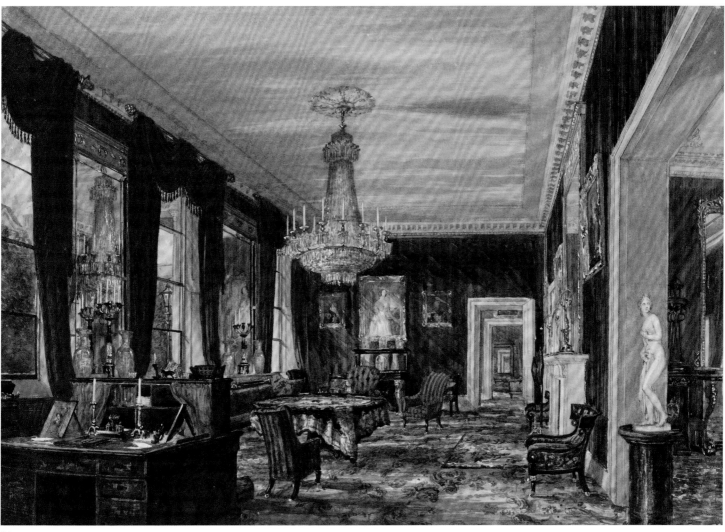

24

24. UNKNOWN FRENCH ARTIST
Second Empire Salon, 1850–60
Brush and watercolor, gouache, graphite
on white wove paper
14 9/16 x 20 3/4 in. (370 x 527 mm)
Cooper-Hewitt, National Design Museum
Smithsonian Institution
Thaw Collection, 2007-27-24

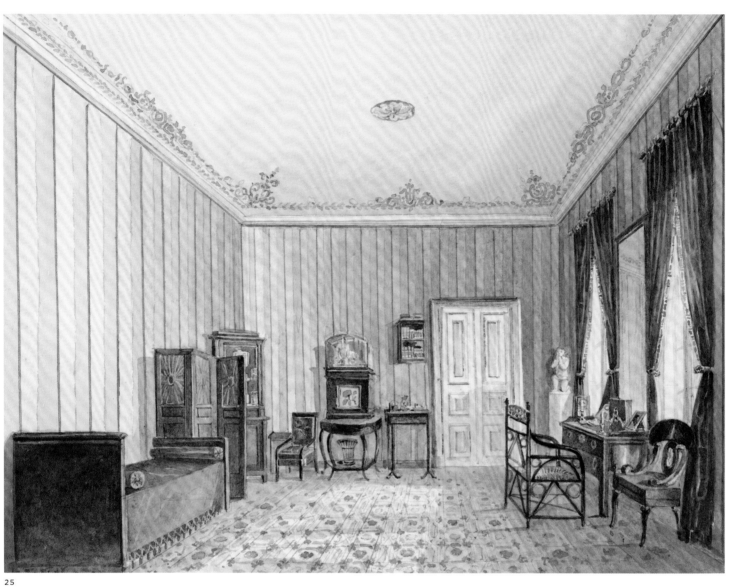

25

25. **UNKNOWN RUSSIAN ARTIST**
Bedroom in a Country Dacha, 1839
Brush and watercolor, pen and blue ink, graphite
on white wove paper
7 ³⁄₁₆ x 9 ⁹⁄₁₆ in. (183 x 243 mm)
Cooper-Hewitt, National Design Museum
Smithsonian Institution
Thaw Collection, 2007-27-25

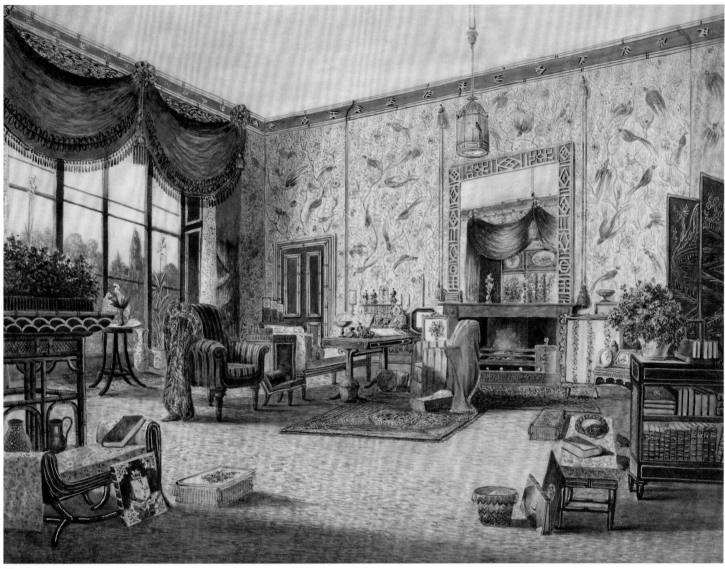

26

26. WILLIAM ALFRED DELAMOTTE
(English, 1775–1863)
*The Chinese Drawing Room at Middleton Park,
Oxfordshire*, 1839
Brush and watercolor, gouache, gold paint,
graphite on white wove paper
11 3/8 x 14 15/16 in. (289 x 380 mm)
Cooper-Hewitt, National Design Museum
Smithsonian Institution
Thaw Collection, 2007-27-26

27. WILLIAM ALFRED DELAMOTTE
(English, 1775–1863)
*The Chinese Drawing Room, Looking towards
the Conservatory, Middleton Park, Oxfordshire*, 1840
Brush and watercolor, gouache, gold paint,
graphite on white paper
9 5/8 x 12 5/16 in. (245 x 313 mm)
Cooper-Hewitt, National Design Museum
Smithsonian Institution
Thaw Collection, 2007-27-27

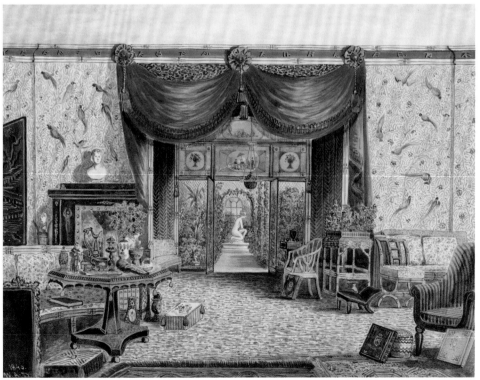

27

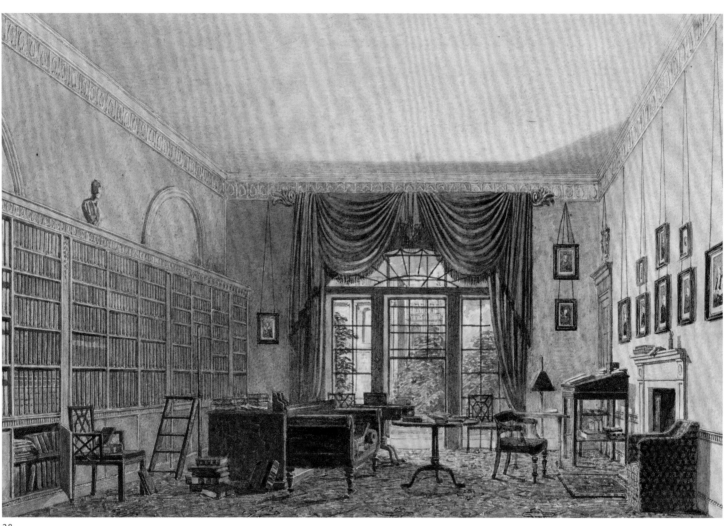

28

28. UNKNOWN ENGLISH ARTIST
Interior of a Library, 1830s–40s
Brush and watercolor, graphite on off-white wove paper
8 ⅜ x 12 ⁷⁄₁₆ in. (213 x 316 mm)
Cooper-Hewitt, National Design Museum
Smithsonian Institution
Thaw Collection, 2007-27-28

29

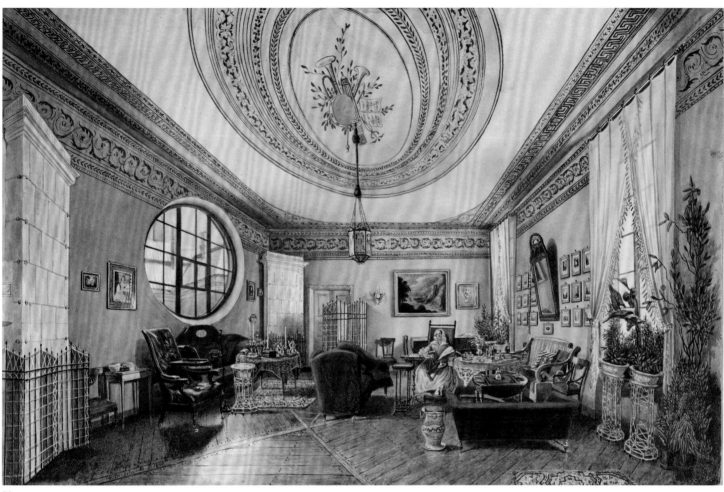

29. **VLADISLAV DMOCHOWSKI**
(Lithuanian, active Poland mid-19th century)
Intérieur de salon, 1840
Brush and watercolor, gouache on white wove paper
8 ⅛ x 12 ¹¹⁄₁₆ in. (206 x 322 mm)
Cooper-Hewitt, National Design Museum
Smithsonian Institution
Thaw Collection, 2007-27-29

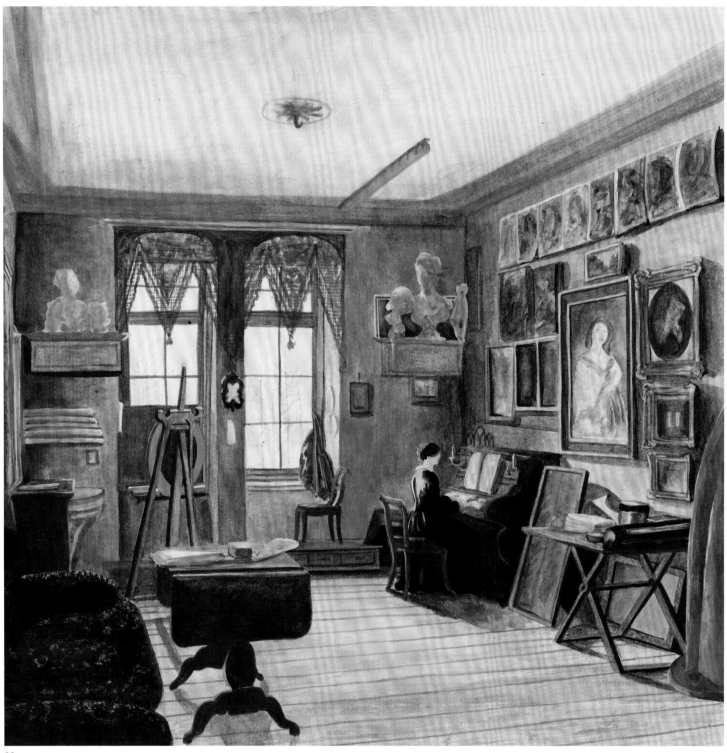

30

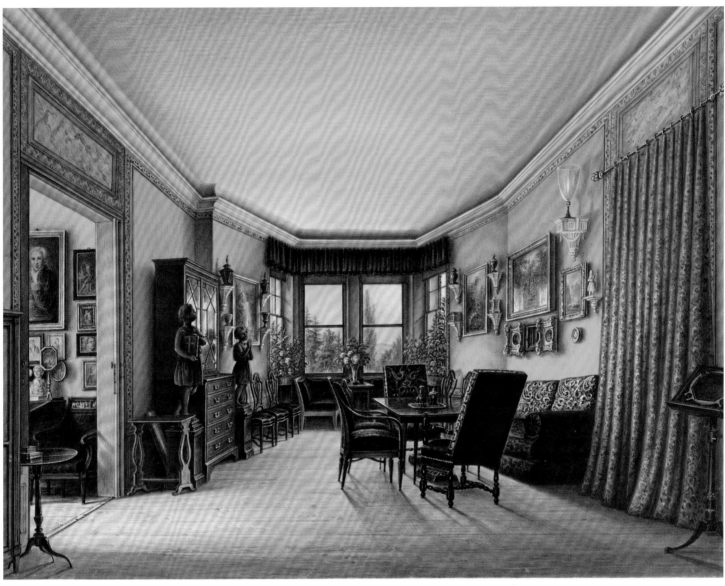

31

30. **KARL WILHELM STRECKFUSS** (German, 1817–1896)
An Artist's Studio in Berlin, 1860s
Brush and gouache on white wove paper
11 5/16 x 11 1/2 in. (287 x 292 mm)
Cooper-Hewitt, National Design Museum
Smithsonian Institution
Thaw Collection, 2007-27-30

31. **ATTRIBUTED TO CARL FRIEDRICH WILHELM KLOSE**
(German, 1804–after 1863)
A Room in Schloss Buchwald, 1840–45
Brush and watercolor, gouache on white wove paper
9 1/16 x 11 7/8 in. (230 x 301 mm)
Cooper-Hewitt, National Design Museum
Smithsonian Institution
Thaw Collection, 2007-27-31

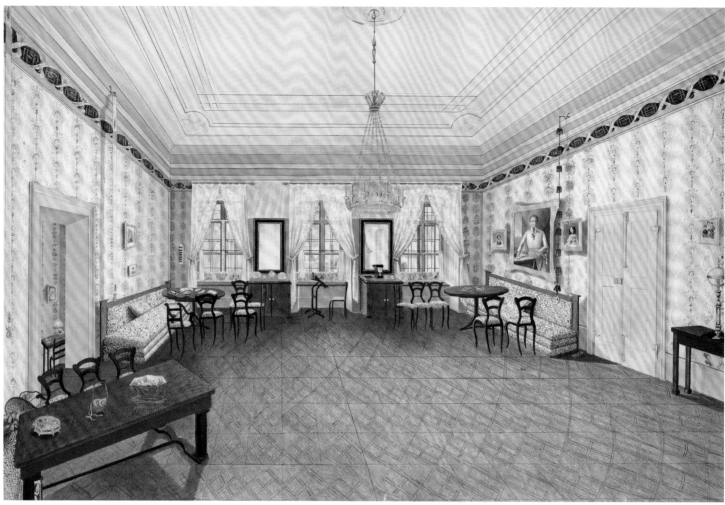

32

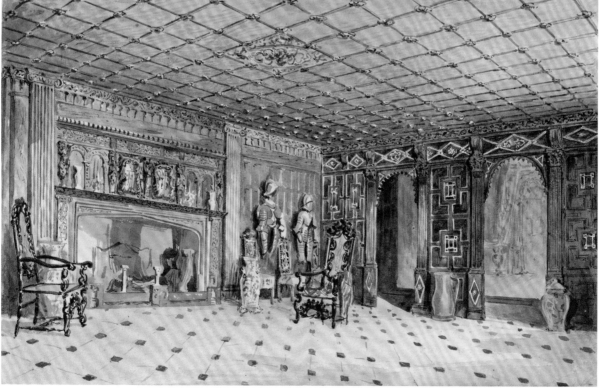

33

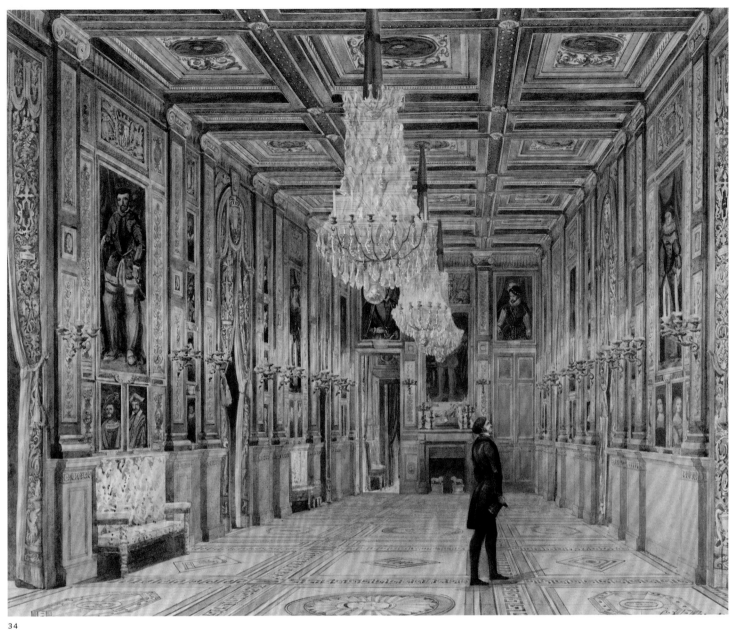

34

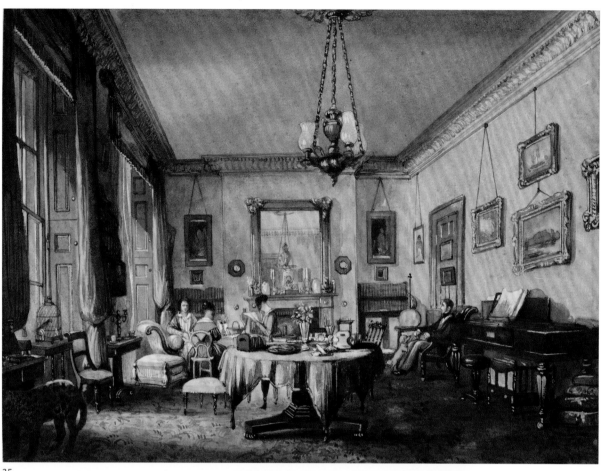

35

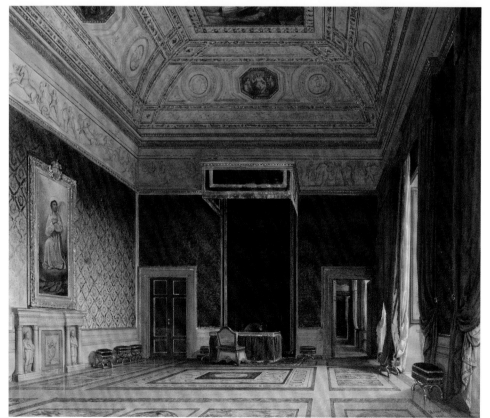

36

35. **UNKNOWN ENGLISH ARTIST**
A Drawing Room, ca. 1842
Brush and watercolor, gouache, gum arabic, graphite
on off-white wove paper
8 1⁄16 x 10 11⁄16 in. (205 x 271 mm)
Cooper-Hewitt, National Design Museum
Smithsonian Institution
Thaw Collection, 2007-27-35

36. **FRANZ HEINRICH** (German, 1802–1890)
Sala del Thorvaldsen, Rome, 1845
Pen and brown ink, brush and watercolor,
gouache, graphite on white paper
10 13⁄16 x 13 3⁄16 in. (275 x 335 mm)
Cooper-Hewitt, National Design Museum
Smithsonian Institution
Thaw Collection, 2007-27-36

37. **JAMES ROBERTS** (English, ca.1800–1867)
The Study of King Louis-Philippe at Neuilly, 1845
Brush and watercolor, gouache on white wove paper
13 1⁄4 x 12 1⁄8 in. (336 x 308 mm)
Cooper-Hewitt, National Design Museum
Smithsonian Institution
Thaw Collection, 2007-27-37

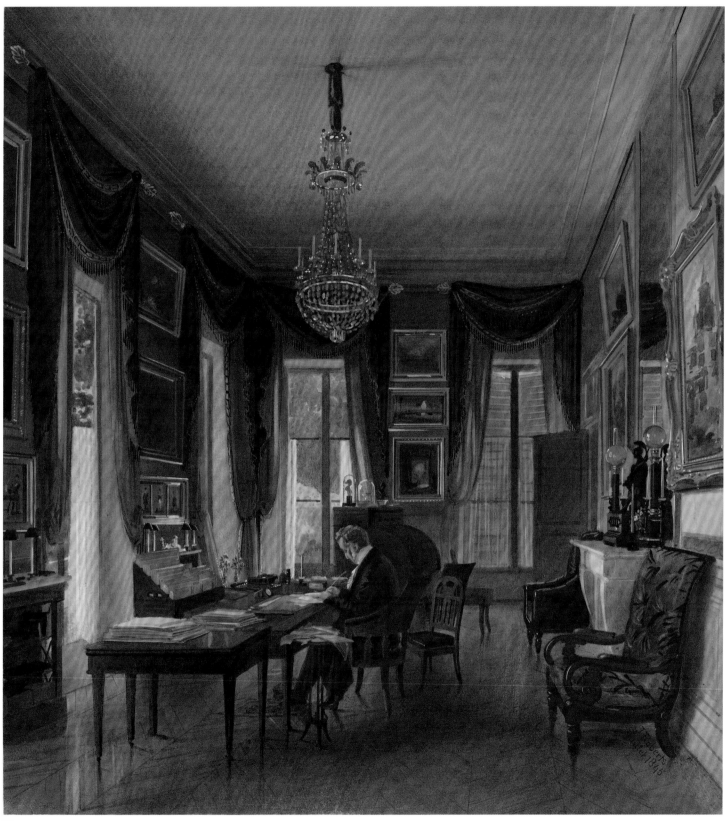

37

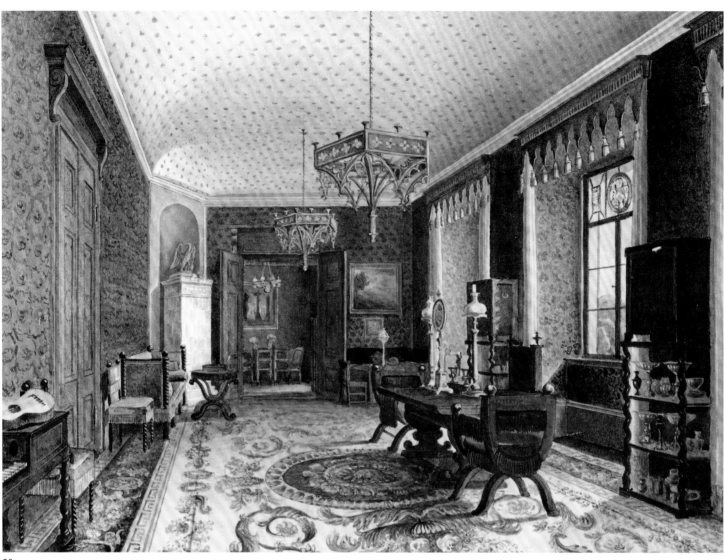

38

38. **CARL FRIEDRICH WILHELM KLOSE**
(German, 1804–after 1863)
The Red Room, Schloss Fischbach, ca. 1846
Brush and watercolor, graphite on white wove paper
6 ½ x 8 ¹³⁄₁₆ in. (165 x 224 mm)
Cooper-Hewitt, National Design Museum
Smithsonian Institution
Thaw Collection, 2007-27-38

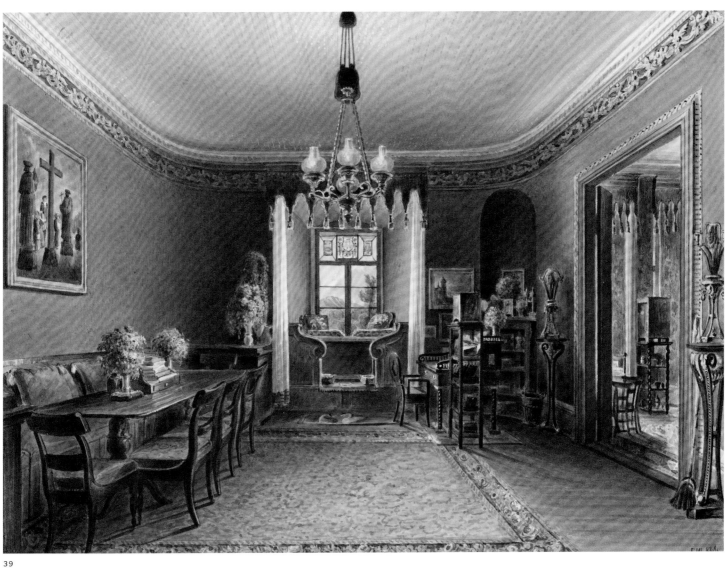

39

39. **CARL FRIEDRICH WILHELM KLOSE**
(German, 1804–after 1863)
The Blue Room, Schloss Fischbach, 1846
Brush and watercolor, graphite on white wove paper
6 ⁹⁄₁₆ x 9 in. (166 x 228 mm)
Cooper-Hewitt, National Design Museum
Smithsonian Institution
Thaw Collection, 2007-27-39

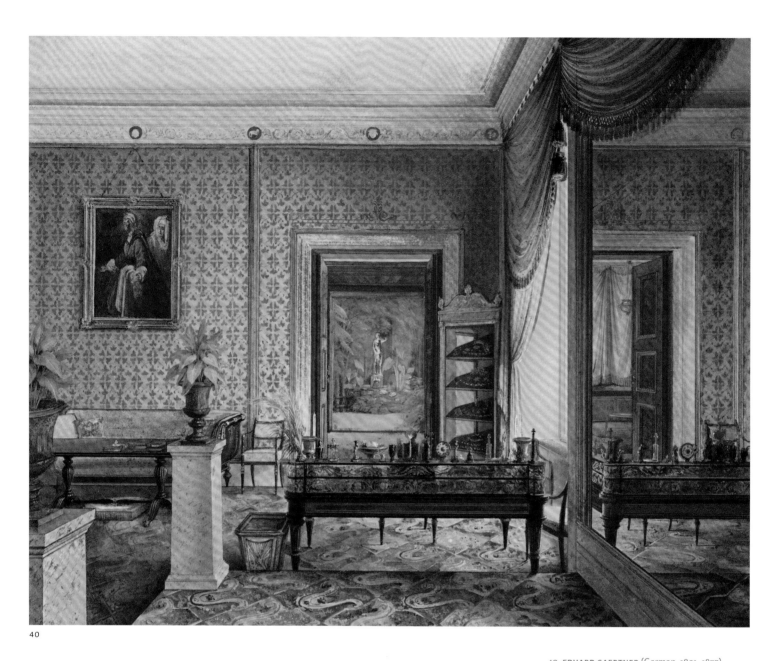

40

40. **EDUARD GAERTNER** (German, 1801–1877)
The Study of Prince Karl of Prussia, 1848
Brush and watercolor, graphite on white wove paper
6 ¹⁵⁄₁₆ x 8 ¾ in. (177 x 222 mm)
Cooper-Hewitt, National Design Museum
Smithsonian Institution
Thaw Collection, 2007-27-40

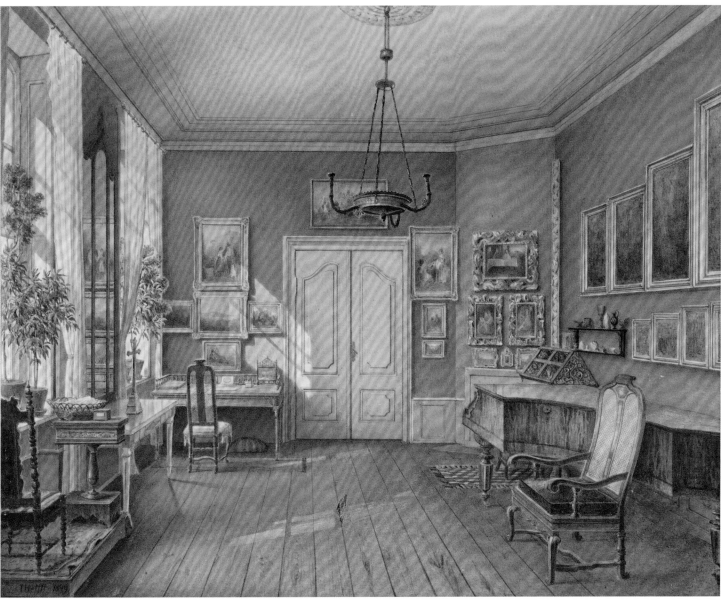

41

41. **JULIUS EDUARD WILHELM HELFFT**
(German, 1818–1894)
The Music Room of Fanny Hensel (née Mendelssohn), 1849
Brush and watercolor, graphite on white wove paper
9 3/16 x 11 13/16 in. (234 x 300 mm)
Cooper-Hewitt, National Design Museum
Smithsonian Institution
Thaw Collection, Gift of Eugene Victor Thaw Art
Foundation, 2007-27-41

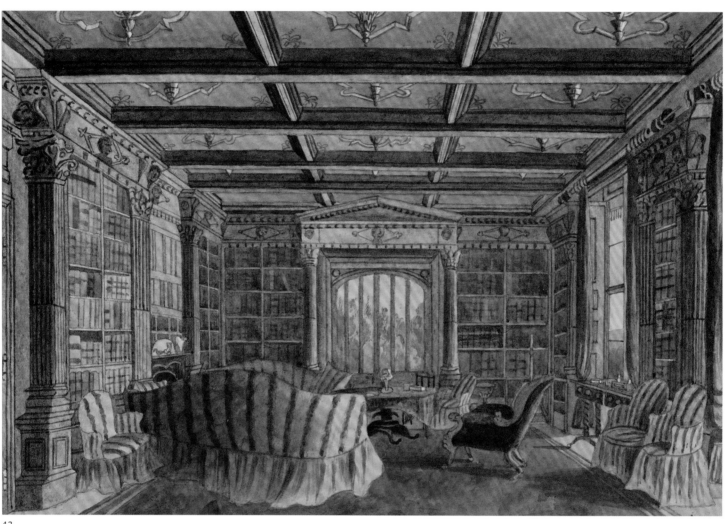

42

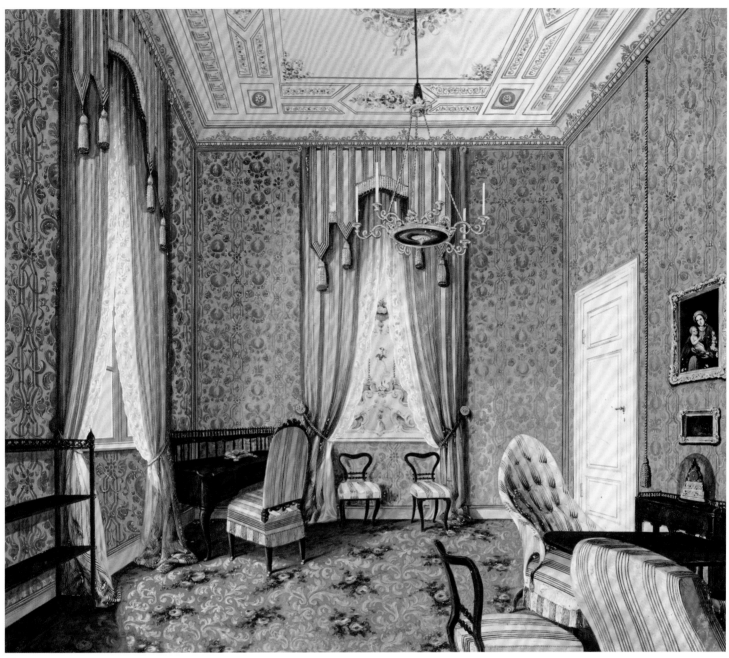

43

43. ATTRIBUTED TO M. SEKIM
(Active Austria and Russia, 1840s)
A Room, possibly in the Governor's Residence,
Hermannstadt, ca. 1840
Brush and watercolor, gouache, gold paint,
gum arabic on white wove paper
13 ⅛ x 16 ⅛ in. (334 x 409 mm)
Cooper-Hewitt, National Design Museum
Smithsonian Institution
Thaw Collection, 2007-27-43

44. JULIE BAYER (German, active 1840s–50s)
An Artist's Studio, ca. 1850
Brush and watercolor, graphite on white wove paper
7 ⅜ x 11 ⁵⁄₁₆ in. (188 x 287 mm)
Cooper-Hewitt, National Design Museum
Smithsonian Institution
Thaw Collection, 2007-27-44

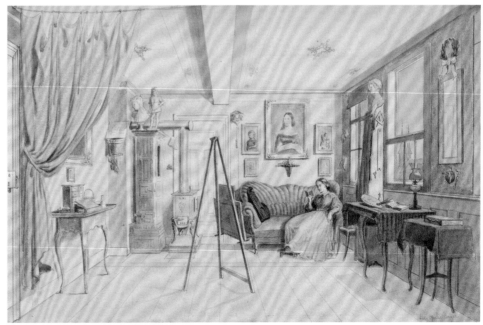

44

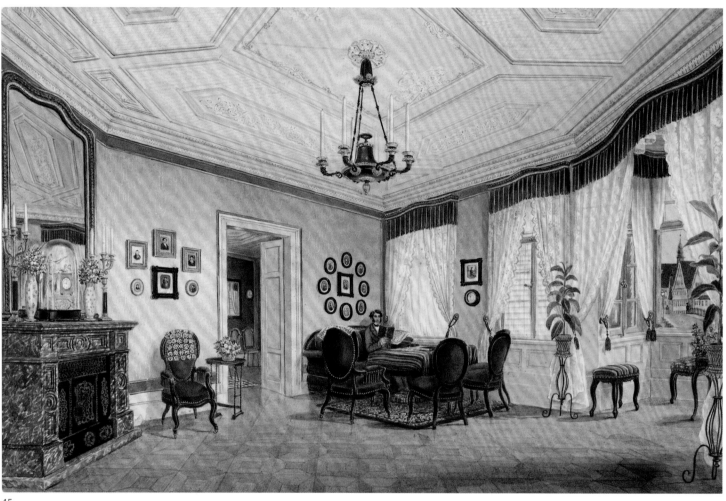

45

45. **CASPAR OBACH** (German, 1807–1868)
A Salon, probably in Stuttgart, 1850s
Brush and watercolor, gold paint,
graphite on white wove paper
10 x 15 ⅛ in. (254 x 384 mm)
Cooper-Hewitt, National Design Museum
Smithsonian Institution
Thaw Collection, 2007-27-45

46. **L. ROSSI** (active Germany and France, 1850s)
The Music Party, ca. 1850
Brush and watercolor, white gouache, graphite
on white wove paper
12 ⅛ x 9 ⁵⁄₁₆ in. (308 x 236 mm)
Cooper-Hewitt, National Design Museum
Smithsonian Institution
Thaw Collection, 2007-27-46

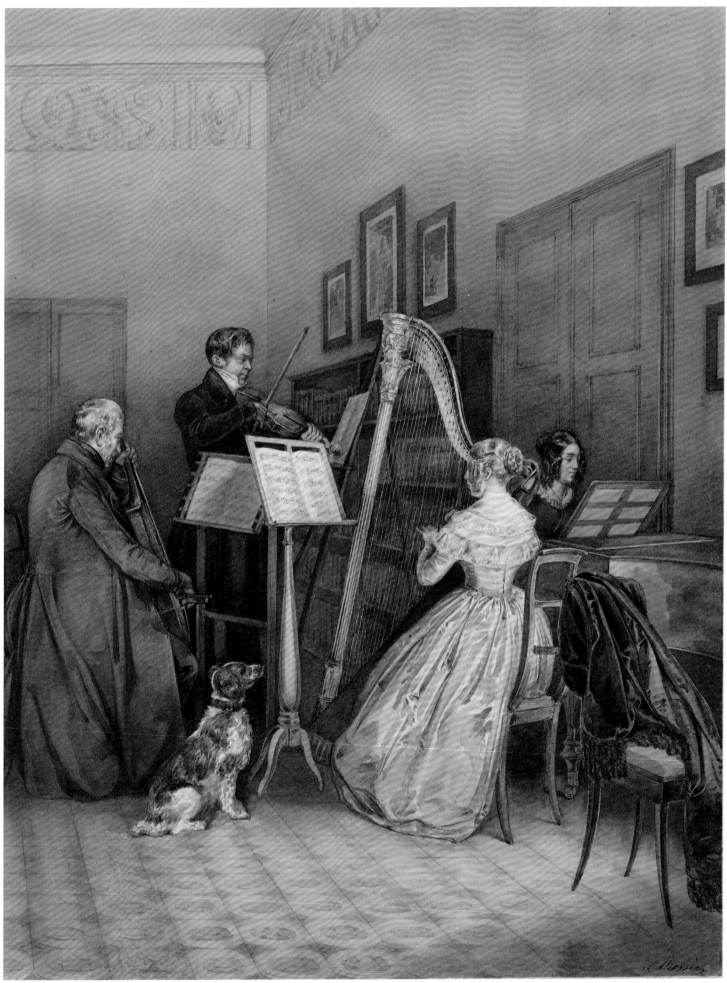

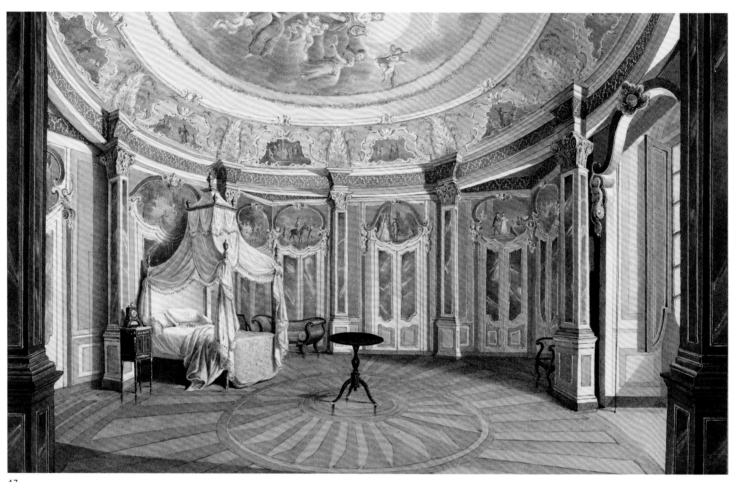

47

47. **FERDINAND LE FEUBURE** (German, 1815–1898)
The Bedroom of the Emperor Dom Pedro I of Brazil,
Palace of Queluz, 1850
Brush and watercolor, graphite, gum arabic
on white wove paper
7 ⅞ x 12 ⅝ in. (200 x 320 mm)
Cooper-Hewitt, National Design Museum
Smithsonian Institution
Thaw Collection, 2007-27-47

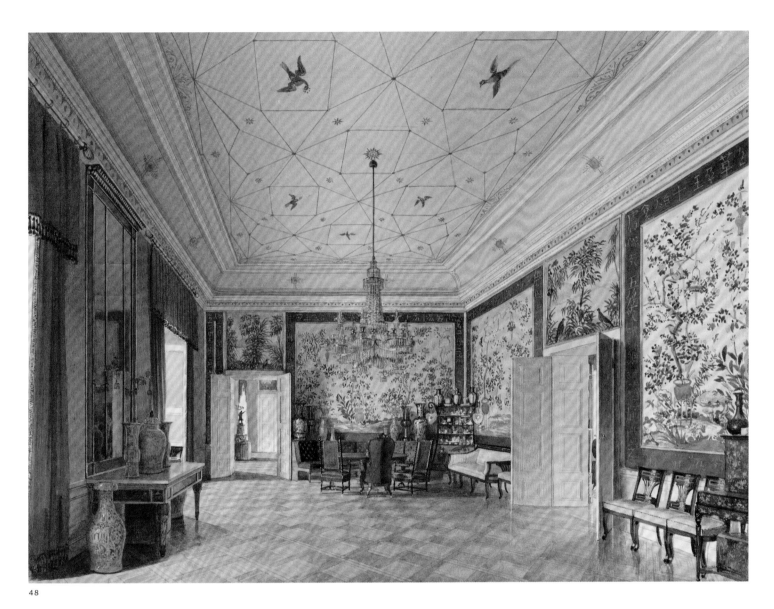

48

48. **EDUARD GAERTNER** (German, 1801–1877)
The Chinese Room at the Royal Palace, Berlin, 1850
Brush and watercolor, gouache, graphite
on white wove paper
10 ¹¹⁄₁₆ x 14 ⁵⁄₁₆ in. (272 x 363 mm)
Cooper-Hewitt, National Design Museum
Smithsonian Institution
Thaw Collection, 2007-27-48

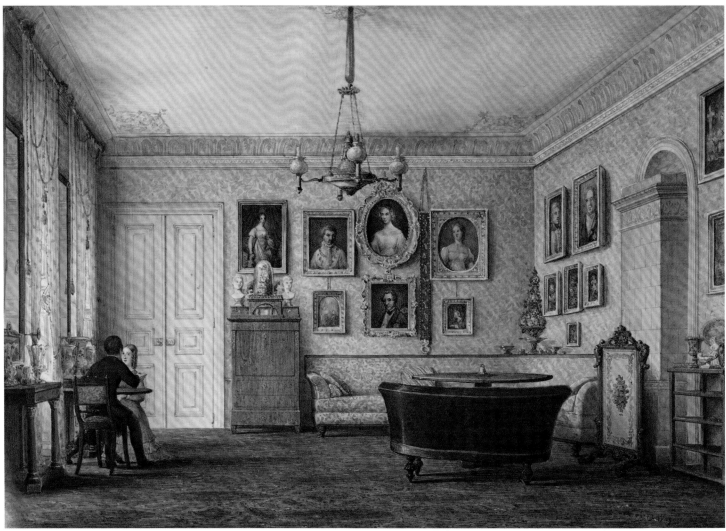

49

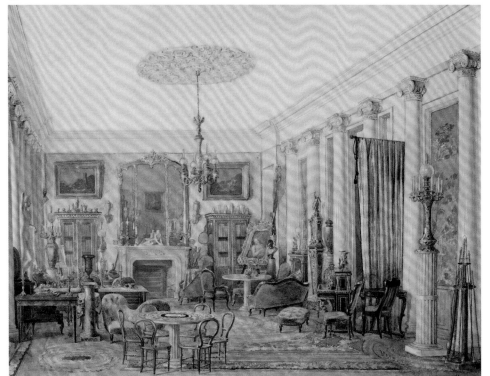

50

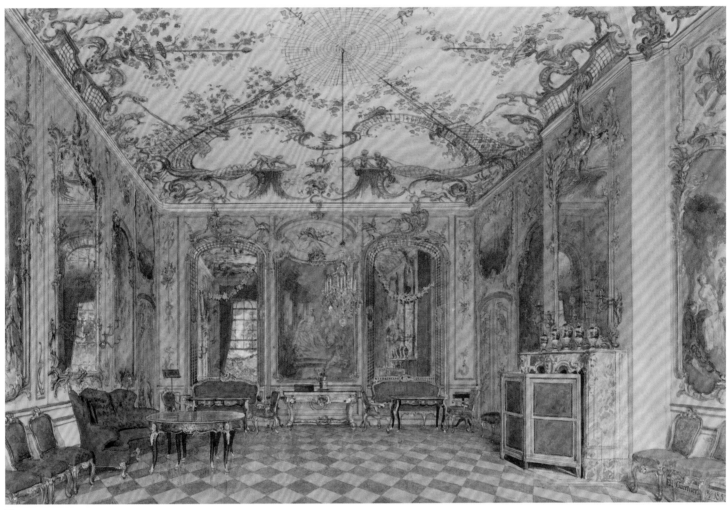

51

51. **EDUARD GAERTNER** (German, 1801–1877)
Concert Room of Sanssouci Palace, Potsdam, Germany, 1852
Brush and gouache, graphite, gum arabic
on white wove paper
6 ¹⁵⁄₁₆ x 10 ⅜ in. (177 x 264 mm)
Cooper-Hewitt, National Design Museum
Smithsonian Institution
Thaw Collection, 2007-27-51

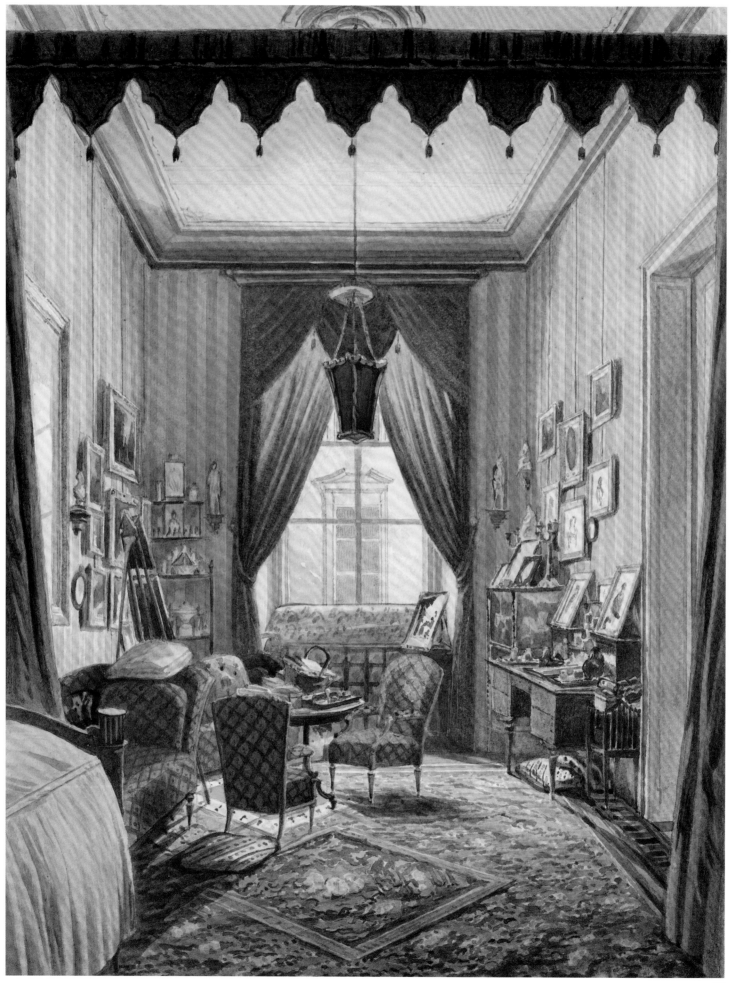

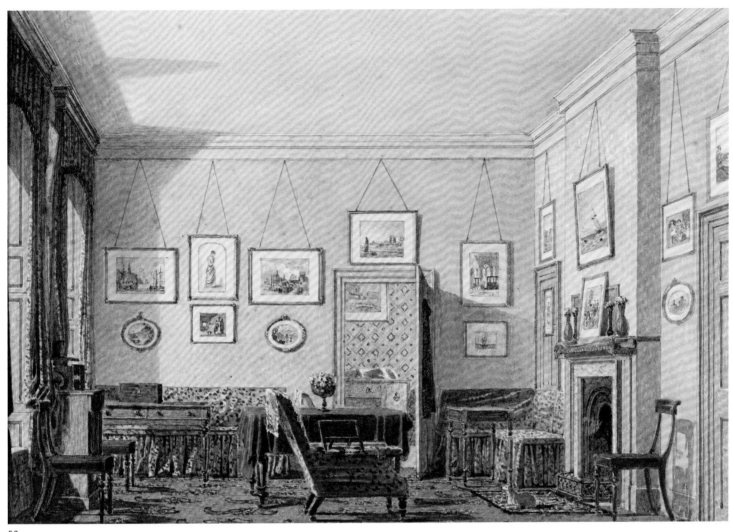

53

52. UNKNOWN AUSTRIAN ARTIST
An Interior with a Curtained Bed Alcove, ca. 1853
Brush and watercolor, gouache, gum arabic, graphite
on Whatman paper
11 5/16 x 8 7/16 in. (288 x 215 mm)
Cooper-Hewitt, National Design Museum
Smithsonian Institution
Thaw Collection, 2007-27-52

53. GEORGE PYNE (English, 1800/01–1884)
George James Drummond's Room at Oxford, 1853
Brush and watercolor, gouache,
graphite on white wove paper
8 3/16 x 11 15/16 in. (208 x 303 mm)
Cooper-Hewitt, National Design Museum
Smithsonian Institution
Thaw Collection, 2007-27-53

54. GEORGE PYNE (English, 1800/01–1884)
George James Drummond's Room at Oxford, 1853
Brush and watercolor, gouache, graphite on
white wove paper
8 7/16 x 12 1/8 in (215 x 308 mm)
Cooper-Hewitt, National Design Museum
Smithsonian Institution
Thaw Collection, 2007-27-54

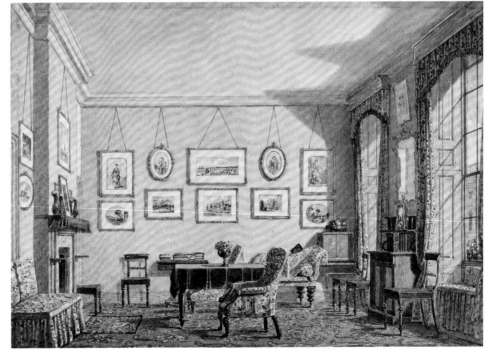

54

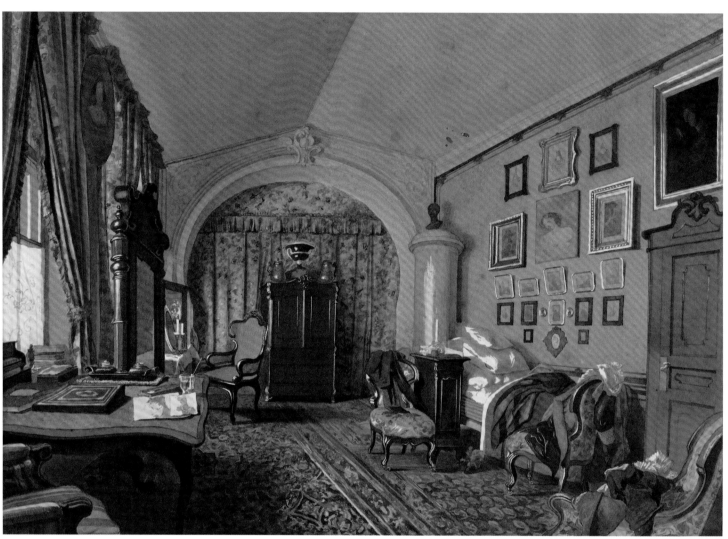

55

55. **S. TOLSTOI** (Russian, active 1850s)
An Interior of a Man's Living Room, 1853
Brush and watercolor on white wove paper
9 ¹³/₁₆ x 13 ⅞ in. (249 x 353 mm)
Cooper-Hewitt, National Design Museum
Smithsonian Institution
Thaw Collection, 2007-27-55

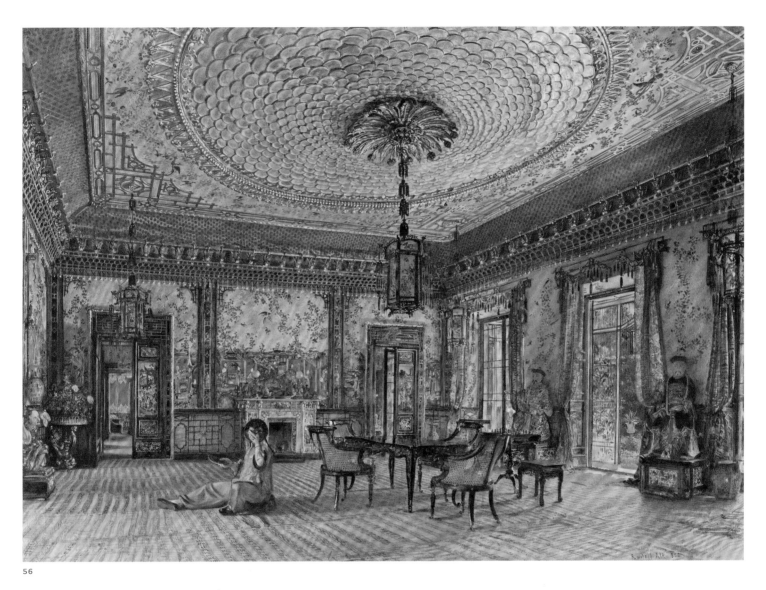

56

56. **RUDOLF VON ALT** (Austrian, 1812–1905)
The Japanese Salon, Villa Hügel, Heitzing, Vienna, 1855
Brush and watercolor, gouache, graphite on
white wove paper
15 ⅛ x 20 ¹⁵⁄₁₆ in. (384 x 532 mm)
Cooper-Hewitt, National Design Museum
Smithsonian Institution
Thaw Collection, 2007-27-56

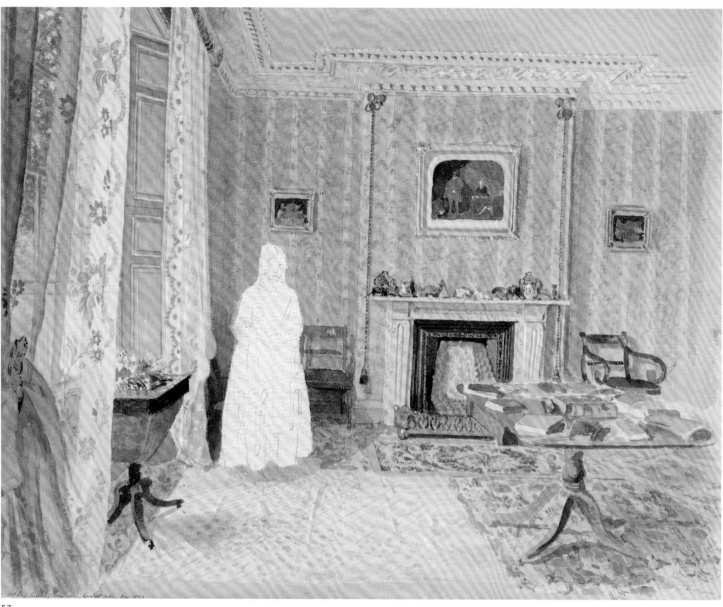

57

57. **RICHARD PARMINTER CUFF**
(English, 1819/20–1876 or later)
Sitting Room at 7 Owen's Row, Islington, 1855
Brush and watercolor and gray wash,
graphite on white wove paper
11 x 13 ⁹/₁₆ in. (280 x 345 mm)
Cooper-Hewitt, National Design Museum
Smithsonian Institution
Thaw Collection, 2007-27-57

58. **EMMANUEL COULANGE-LAUTREC**
(French, 1824–1898)
A Moorish Smoking Room, 1856
Brush and watercolor, gouache on white wove paper
11 ½ x 9 ½ in. (292 x 241 mm)
Cooper-Hewitt, National Design Museum
Smithsonian Institution
Thaw Collection, 2007-27-58

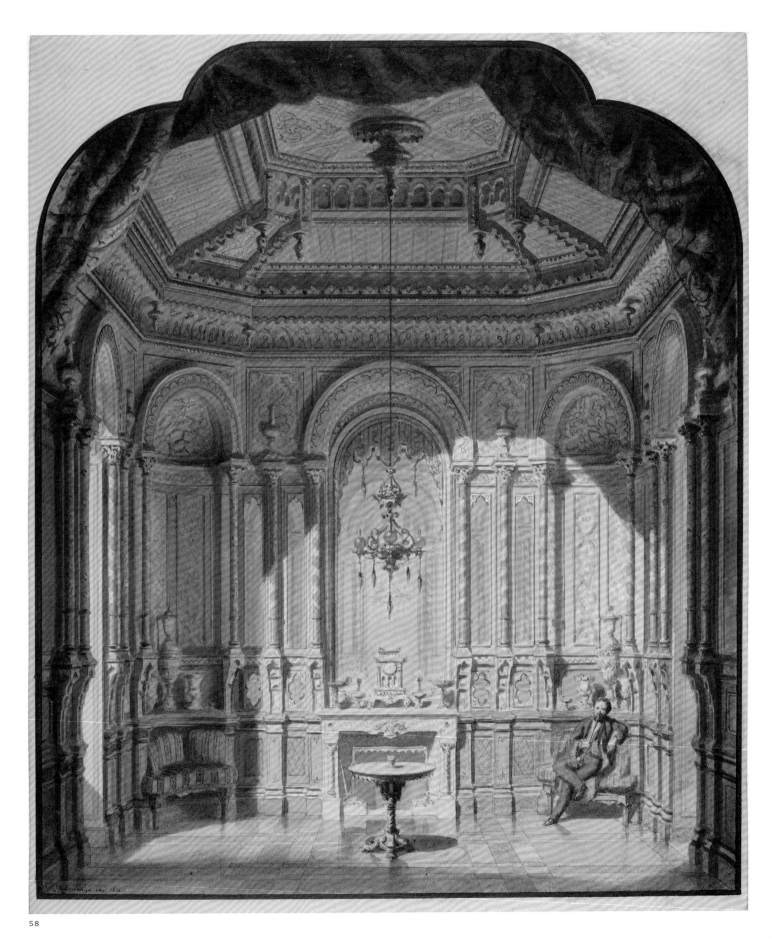

58

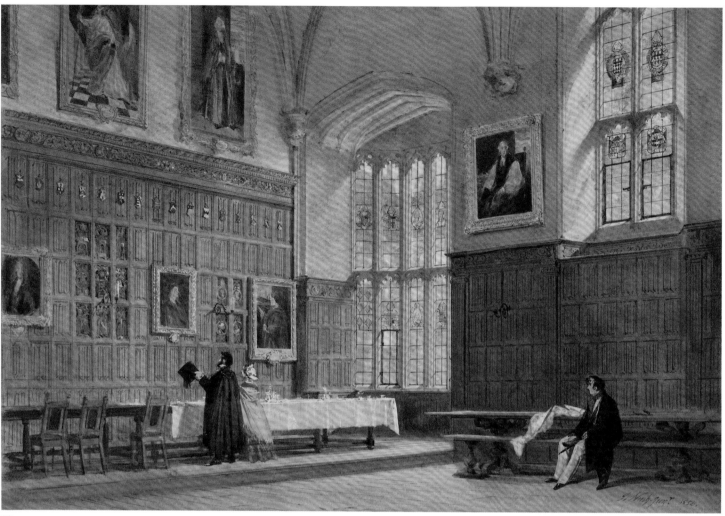

59

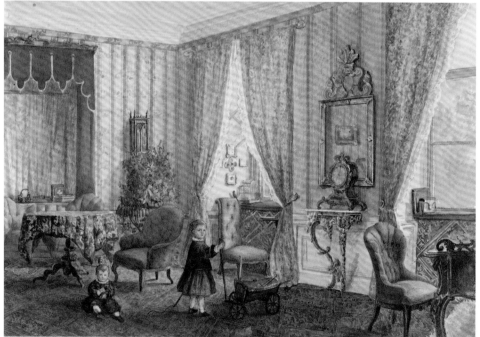

60

59. **JOSEPH NASH, SR.** (English, 1808–1878)
View of the Dining Hall in Magdalen College, Oxford, 1856
Brush and watercolor, gouache, gray wash,
pen and black ink, graphite on off-white wove paper
13 ¼ x 19 ⅛ in. (337 x 485 mm)
Cooper-Hewitt, National Design Museum
Smithsonian Institution
Thaw Collection, 2007-27-59

60. **COUNTESS SCHOENBERG** (German, active 1850s)
A Room at Siebleben, Gotha, 1856
Brush and watercolor, gouache, graphite
on white wove paper
6 ¾ x 9 ¹³⁄₁₆ in. (172 x 249 mm)
Cooper-Hewitt, National Design Museum
Smithsonian Institution
Thaw Collection, 2007-27-60

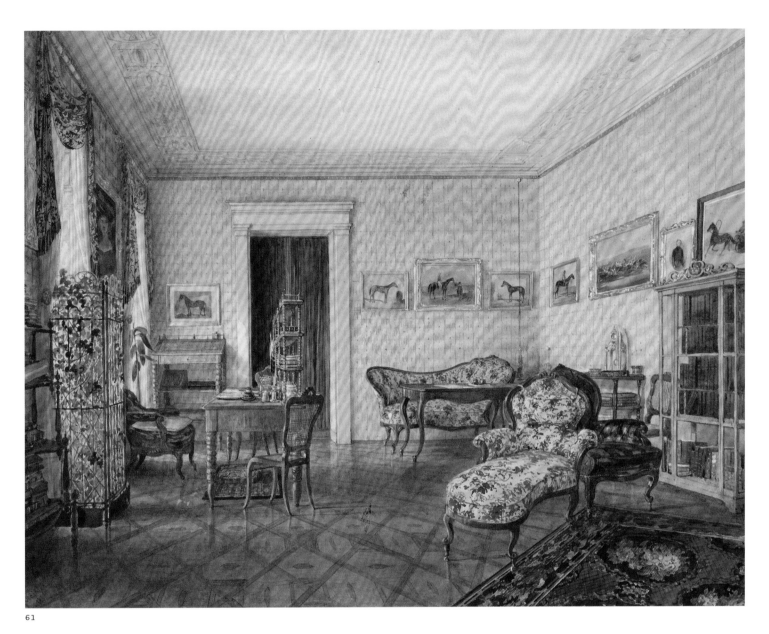

61

61. EMANUEL STÖCKLER
(German, born Czech Republic, 1819–1893)
A Drawing Room of a Sportsman, 1856
Brush and watercolor, white gouache,
graphite on white wove paper
13 13/16 x 17 9/16 in. (351 x 446 mm)
Cooper-Hewitt, National Design Museum
Smithsonian Institution
Thaw Collection, 2007-27-61

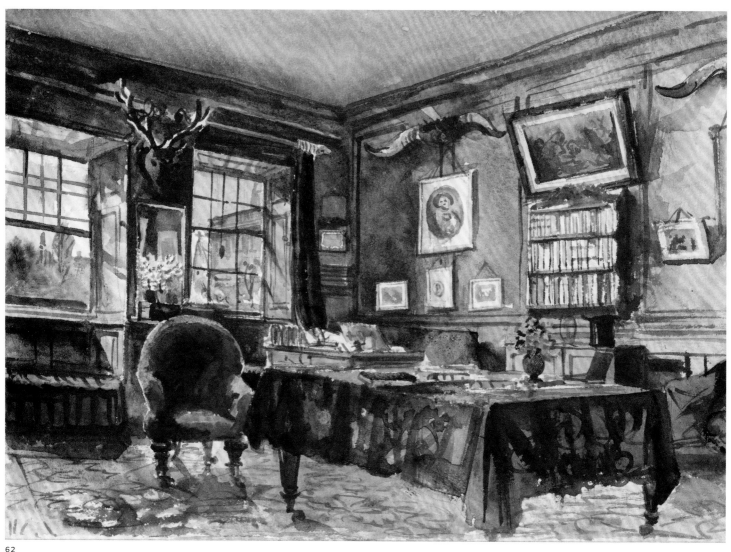

62

62. **ARTHUR FREDERICK PAYNE** (English, 1831/35–1884)
Pynson Wilmot Bennitt's Room, Trinity College, Oxford, 1857
Brush and watercolor, gouache, graphite
on white wove paper
5 ⁷⁄₁₆ x 7 in. (138 x 178 mm)
Cooper-Hewitt, National Design Museum
Smithsonian Institution
Thaw Collection, 2007-27-62

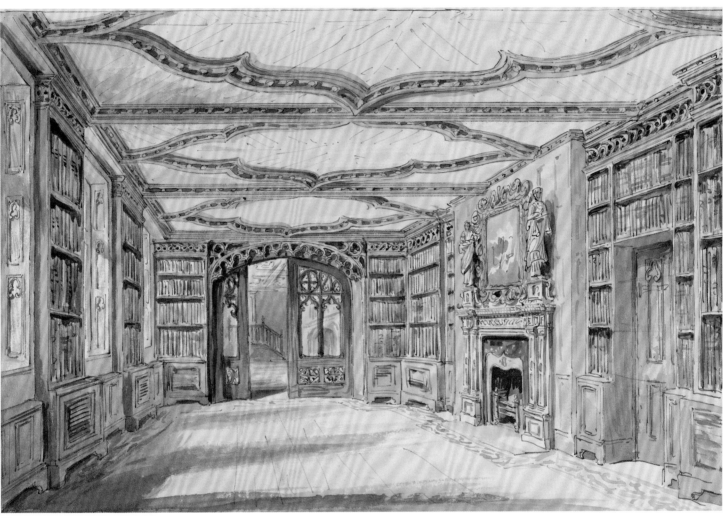

63

63. **CHARLES JAMES RICHARDSON** (English, 1806–1871)
A Library in Gothic Style, ca. 1860
Brush and watercolor, pen and brown ink,
graphite on white wove paper
10 ¹³⁄₁₆ x 15 ¹¹⁄₁₆ in. (274 x 398 mm)
Cooper-Hewitt, National Design Museum
Smithsonian Institution
Thaw Collection, 2007-27-63

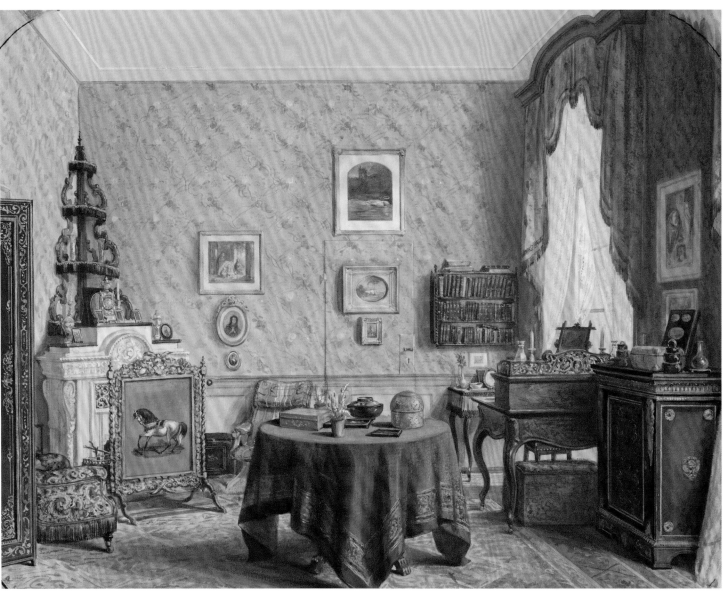

64

64. **WILHELM AMANDUS BEER**
(German, 1837–1907)
A Sitting Room with a Writing Table, 1867
Brush and watercolor, gold paint, graphite on
white wove paper
11 ⅝ x 14 ¾ in. (295 x 375 mm)
Cooper-Hewitt, National Design Museum
Smithsonian Institution
Thaw Collection, 2007-27-64

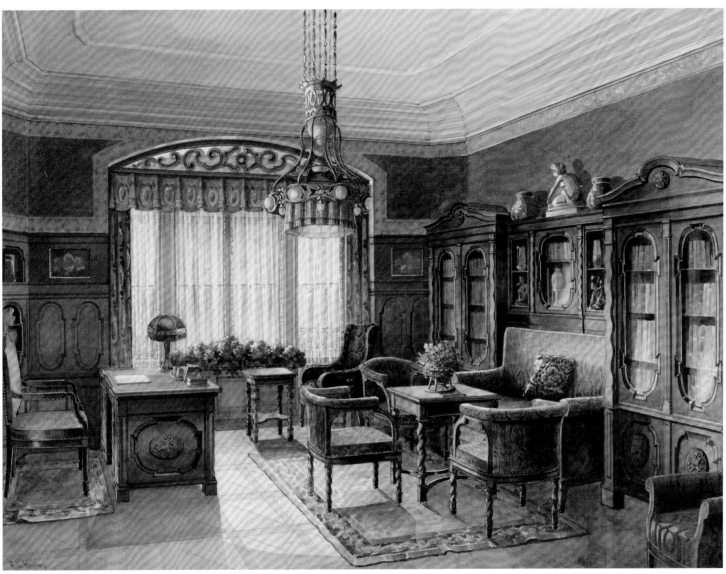

65

65. **EDWARD LAMSON HENRY** (American, 1841–1919)
A Library Interior, 1890–1905
Brush and watercolor, gouache on white wove paper
11 ¾ x 15 ¾ in. (298 x 400 mm)
Cooper-Hewitt, National Design Museum
Smithsonian Institution
Thaw Collection, 2007-27-65

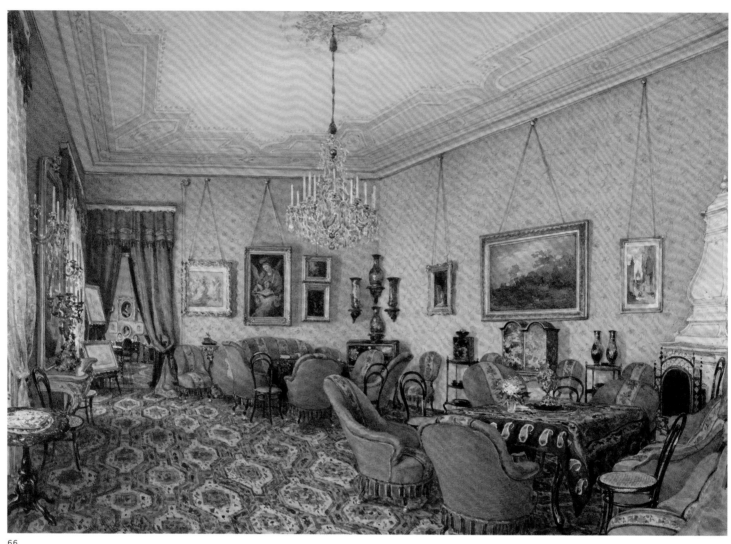

66

66. **FRANZ ALT** (Austrian, 1821–1914)
A Salon in Vienna, 1872
Brush and watercolor, gouache, graphite
on white wove paper
8 ¾ x 12 ⅝ in. (223 x 320 mm)
Cooper-Hewitt, National Design Museum
Smithsonian Institution
Thaw Collection, 2007-27-66

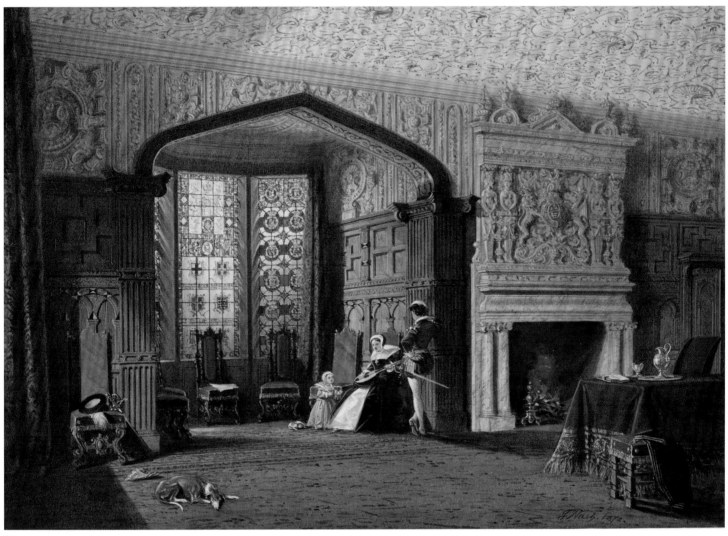

67

67. **JOSEPH NASH, SR.** (English, 1808–1878)
An Elizabethan Room at Lyme Hall, Cheshire, 1872
Brush and watercolor, gouache, graphite
on white wove paper
13 ⅛ x 19 ⅛ in. (333 x 484 mm)
Cooper-Hewitt, National Design Museum
Smithsonian Institution
Thaw Collection, 2007-27-67

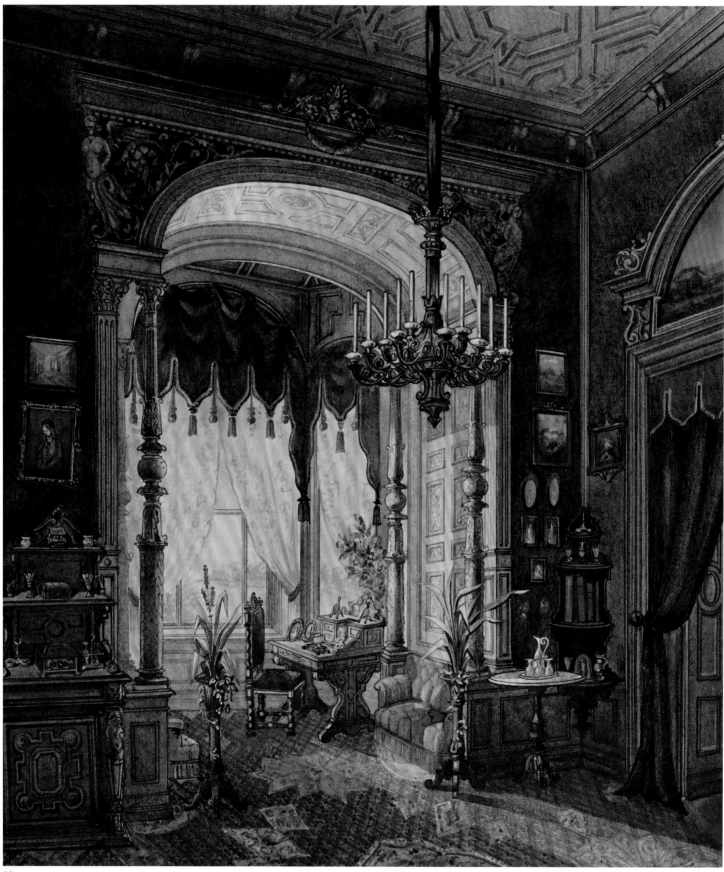

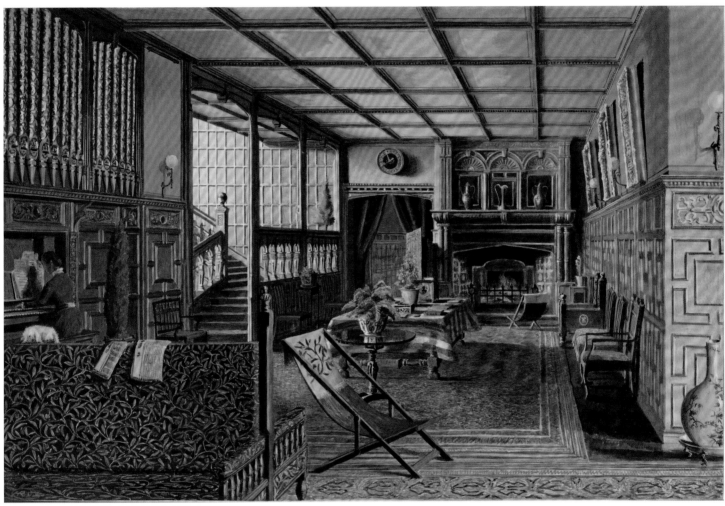

69

68. **C. RATH** (possibly Austrian, active 1870s)
Alcove in the Salon of the Grand Duchess Anna of
Mecklenburg-Schwerin, 1877
Brush and watercolor, gouache, gold paint
on off-white wove paper
11 ¹⁵⁄₁₆ x 10 ⅜ in. (303 x 264 mm)
Cooper-Hewitt, National Design Museum
Smithsonian Institution
Thaw Collection, 2007-27-68

69. **HENRY ROBERT ROBERTSON** (English, 1839–1921)
The Interior of Hall Place at Leigh, near Tonbridge,
Kent, 1879
Brush and watercolor, gouache, graphite
on off-white wove paper
11 ³⁄₁₆ x 16 ¾ in. (284 x 426 mm)
Cooper-Hewitt, National Design Museum
Smithsonian Institution
Thaw Collection, 2007-27-69

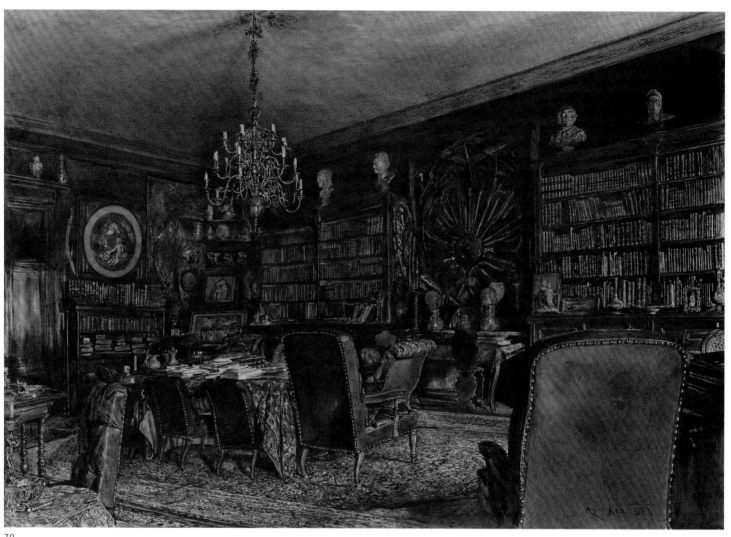

70

70. **RUDOLF VON ALT** (Austrian, 1812–1905)
The Library in the Apartment of Count Lanckoronski
in Vienna, Riemergasse 8, 1881
Brush and watercolor, gouache, graphite
on white wove paper
12 ⅜ x 17 ⅜ in. (315 x 442 mm)
Cooper-Hewitt, National Design Museum
Smithsonian Institution
Thaw Collection, 2007-27-70

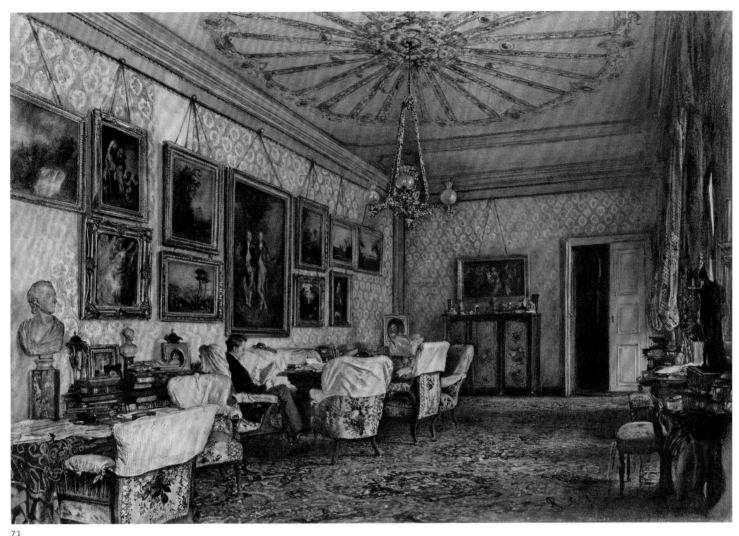

71

71. **RUDOLF VON ALT** (Austrian, 1812–1905)
*The Salon in the Apartment of
Count Lanckoronski in Vienna*, 1881
Brush and watercolor, gouache
on white wove paper
10 7/16 x 15 3/8 in. (265 x 391 mm)
Cooper-Hewitt, National Design Museum
Smithsonian Institution
Thaw Collection, 2007-27-71

72. **ANNA ALMA-TADEMA** (English, 1865–1943)
*Sir Lawrence Alma-Tadema's Library
in Townshend House, London*, 1884
Brush and watercolor, pen and brown and
black ink on white wove paper
13 x 17 11/16 in. (330 x 450 mm)
Cooper-Hewitt, National Design Museum
Smithsonian Institution
Thaw Collection, 2007-27-72

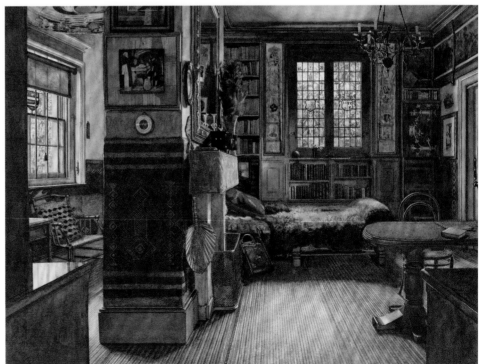

72

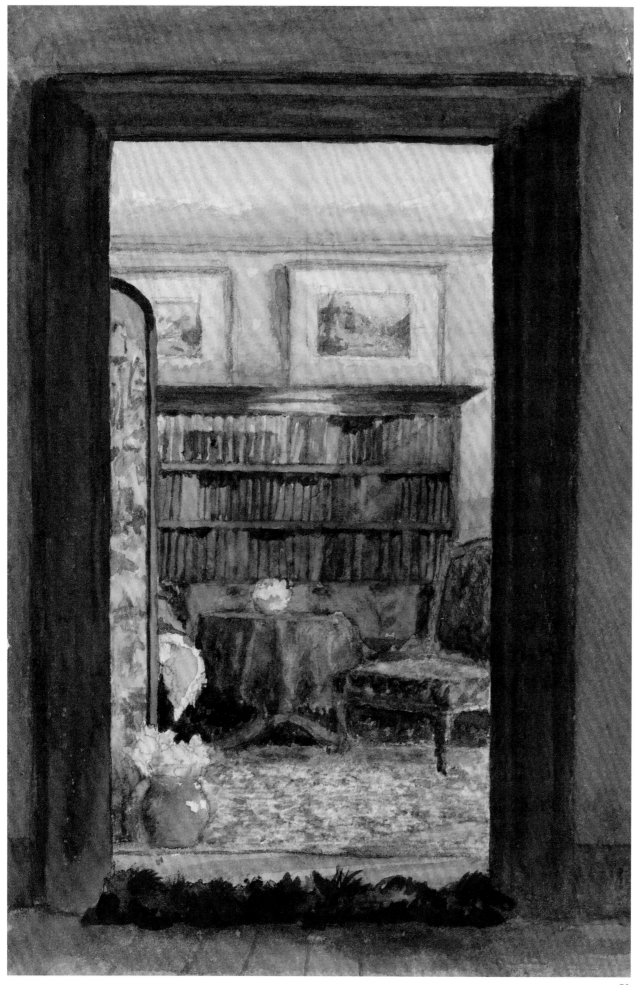

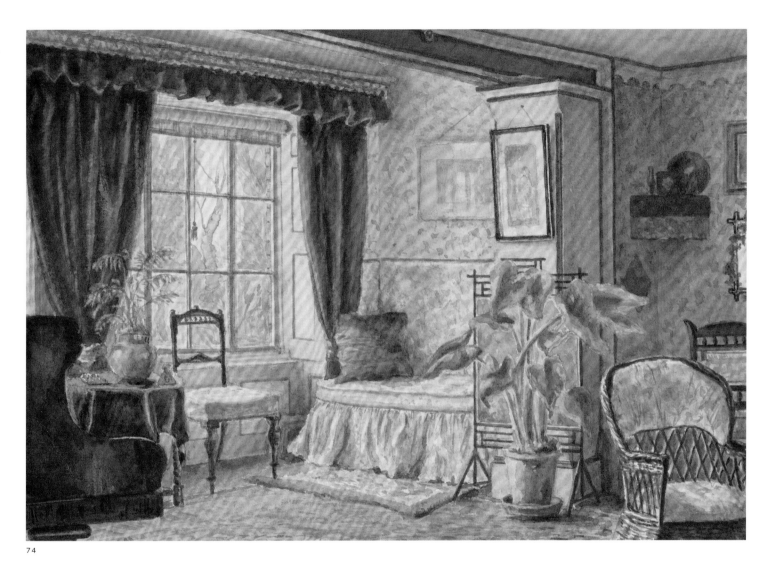

74

73. **M. F. PEARCE** (English, active 1890s)
The Library at Brabourne Vicarage, ca. 1890
Brush and watercolor on white wove paper
8 ⅛₆ x 5 ⁷⁄₁₆ in. (204 x 138 mm)
Cooper-Hewitt, National Design Museum
Smithsonian Institution
Thaw Collection, 2007-27-73

74. **POSSIBLY M. F. PEARCE** (English, active 1890s)
The Drawing Room at Brabourne Vicarage, 1893
Brush and watercolor, graphite on white wove paper
6 ¹⁵⁄₁₆ x 9 ¹⁵⁄₁₆ in. (176 x 252 mm)
Cooper-Hewitt, National Design Museum
Smithsonian Institution
Thaw Collection, 2007-27-74

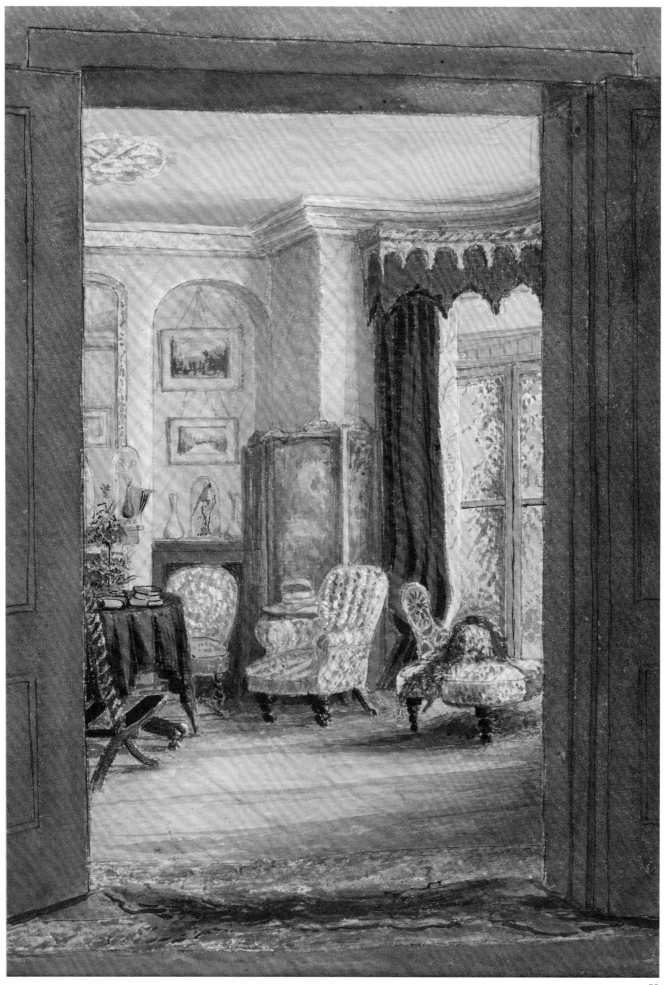

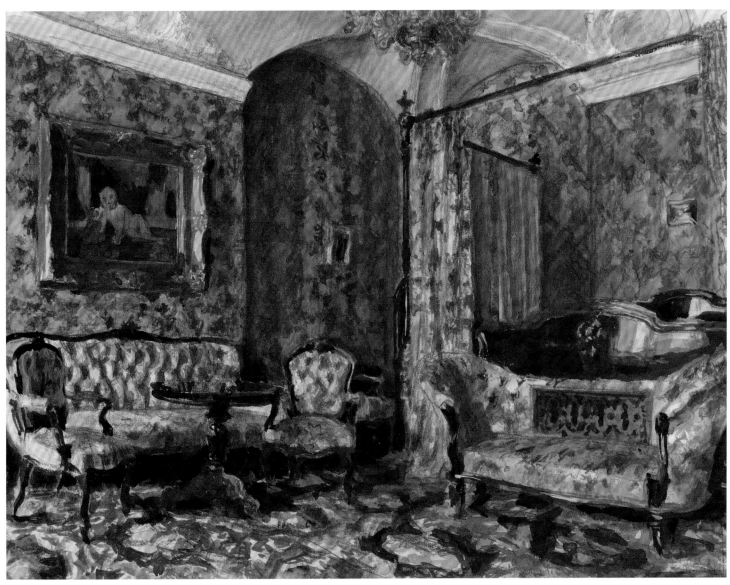

76

75. **MARIA CHEVAL TOOKE** (English, active 1890s)
The Drawing Room at Cosham House, 1892
Brush and watercolor, graphite on white wove paper
9 ¾ x 6 ¾ in. (247 x 172 mm)
Cooper-Hewitt, National Design Museum
Smithsonian Institution
Thaw Collection, 2007-27-75

76. **ALEXANDRE BENOIS** (Russian, 1870–1960)
The Bedroom of Czarina Maria Alexandrovna,
Gatchina Palace, St. Petersburg, ca. 1900
Brush and watercolor, gouache, graphite,
red chalk on white wove paper
12 ⅜ x 16 ¾ in. (315 x 425 mm)
Cooper-Hewitt, National Design Museum
Smithsonian Institution
Thaw Collection, 2007-27-76

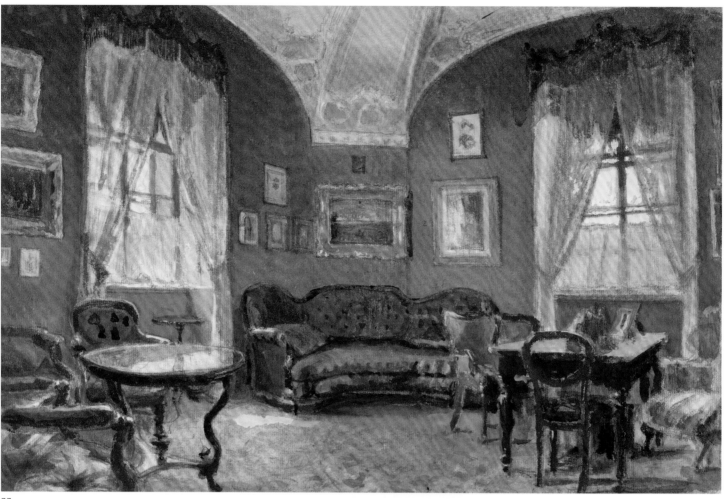

77

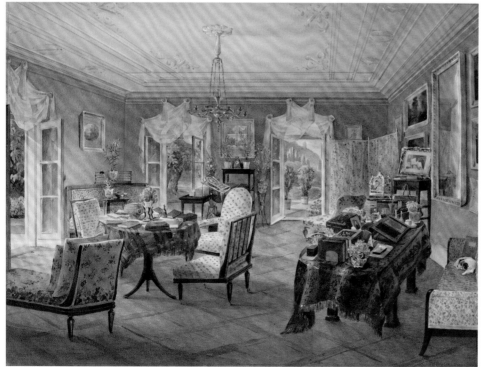

78

77. **ALEXANDRE BENOIS** (Russian, 1870–1960)
The Study of Czar Alexander II at Gatchina Palace,
St. Petersburg, late 19th century
Brush and watercolor, gouache, graphite,
red chalk on white wove paper
12 1/16 x 18 7/16 in. (306 x 468 mm)
Cooper-Hewitt, National Design Museum
Smithsonian Institution
Thaw Collection, 2007-27-77

78. **UNKNOWN (POSSIBLY RUSSIAN) ARTIST**
A Sitting Room, perhaps in a Country Dacha, n.d.
Brush and watercolor, white gouache, graphite
on white wove paper
9 5/8 x 12 3/4 in. (245 x 324 mm)
Cooper-Hewitt, National Design Museum
Smithsonian Institution
Thaw Collection, 2007-27-78

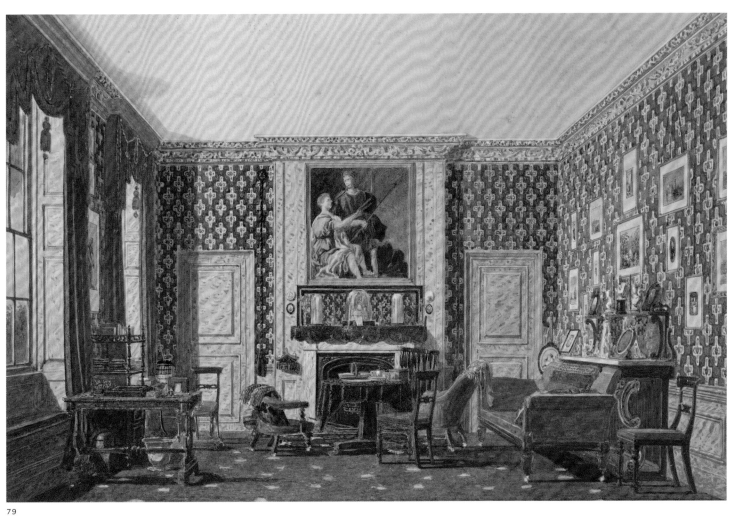

79

79. **MARY ELLEN BEST** (English, 1809–1891)
An Interior, 1837–40
Brush and watercolor, graphite on off-white wove paper
11 ⅞ x 17 ¹⁵⁄₁₆ in. (302 x 455 mm)
Cooper-Hewitt, National Design Museum
Smithsonian Institution
Thaw Collection, 2007-27-79

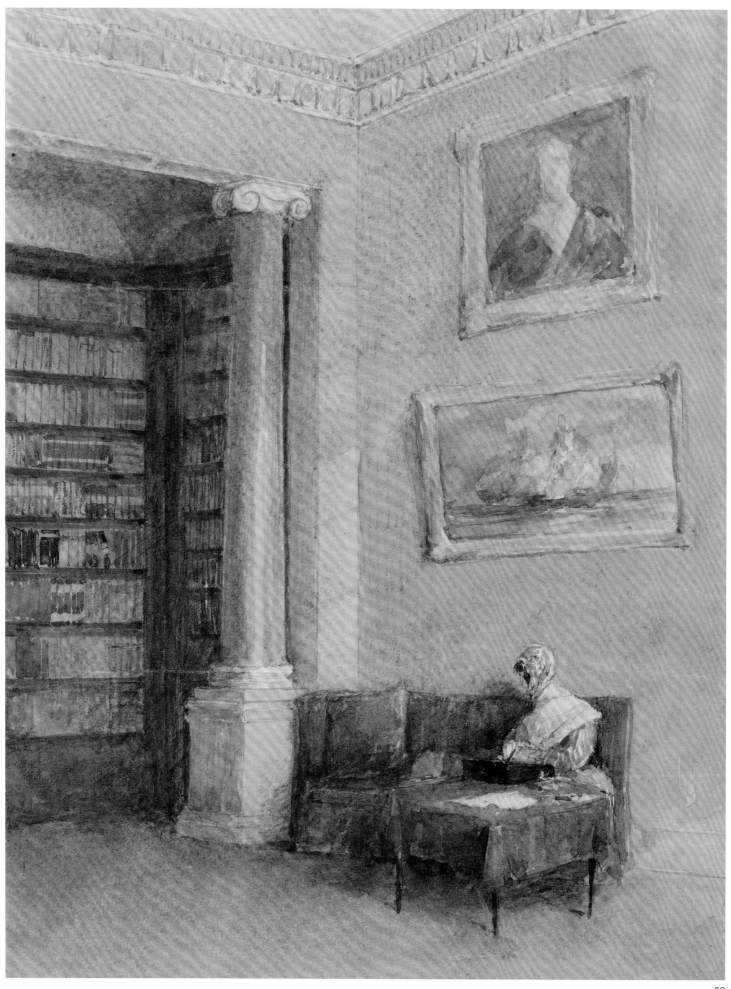

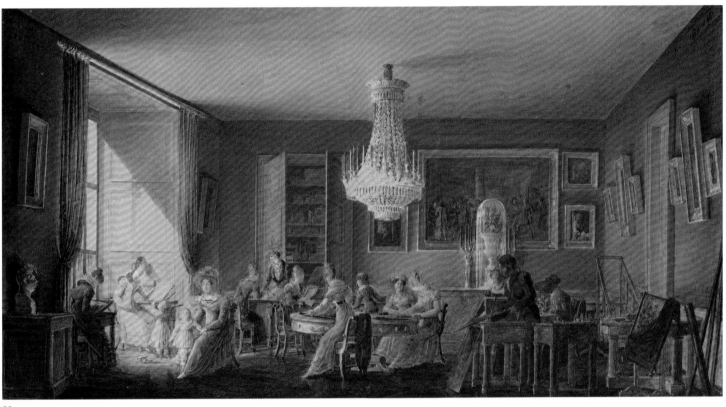

81

80. UNKNOWN ARTIST
A Library Interior, 1850s
Brush and watercolor and graphite on white wove paper
9 ¾ x 7 ³⁄₁₆ in. (248 x 183 mm)
Cooper-Hewitt, National Design Museum
Smithsonian Institution
Thaw Collection, 2007-27-80

81. UNKNOWN FRENCH ARTIST
A Painter's Studio, 1820s
Brush and watercolor, gouache on off-white wove paper
5 ¼ x 9 ¹³⁄₁₆ in. (133 x 250 mm)
Cooper-Hewitt, National Design Museum
Smithsonian Institution
Thaw Collection, 2007-27-81

82. POSSIBLY GARNERAY FAMILY
(French, early 19th century)
A Salon Interior, 1820s
Brush and watercolor, graphite on tan wove paper
5 ⅞ x 8 ⁷⁄₁₆ in. (150 x 214 mm)
Cooper-Hewitt, National Design Museum
Smithsonian Institution
Thaw Collection, 2007-27-82

82

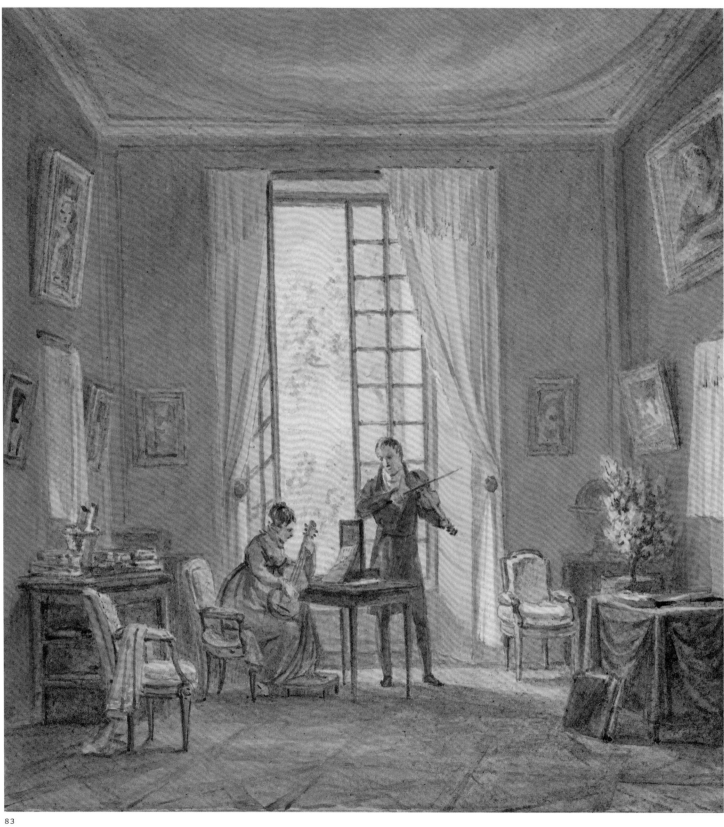

83

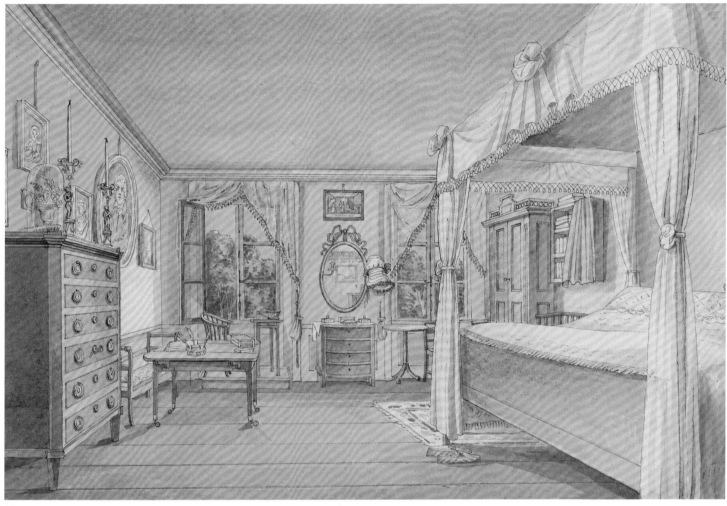

84

83. POSSIBLY ACHILLE-LOUIS MARTINET
(French, 1806–1877)
Salon Interior with Gabriel d'Arjuzon Playing the Violin and
Pascalie Hosten, Comtesse d'Arjuzon, Playing Guitar, 1840s
Brush and watercolor on white wove paper
4 ⅝ x 4 3⁄16 in. (117 x 107 mm)
Cooper-Hewitt, National Design Museum
Smithsonian Institution
Thaw Collection, 2007-27-83

84. UNKNOWN ARTIST
Interior of a Bedroom, n.d.
Brush and watercolor on white wove paper
5 ¼ x 7 ⅞ in. (134 x 200 mm)
Cooper-Hewitt, National Design Museum
Smithsonian Institution
Thaw Collection, 2007-27-84

85. JAMES ROBERTS (English, ca.1800–1867)
Salon Particulier de la Reine au Palais de Buckingham (The
Queen's Sitting Room at Buckingham Palace), August 1848
Brush and watercolor, gouache, gum arabic,
graphite on white wove paper
10 ¾ x 15 3⁄16 in. (273 x 385 mm)
Cooper-Hewitt, National Design Museum
Smithsonian Institution
Thaw Collection, 2007-27-85

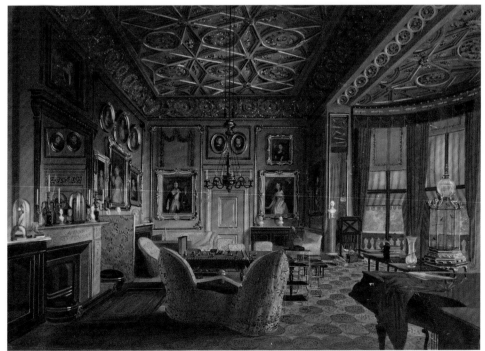

85

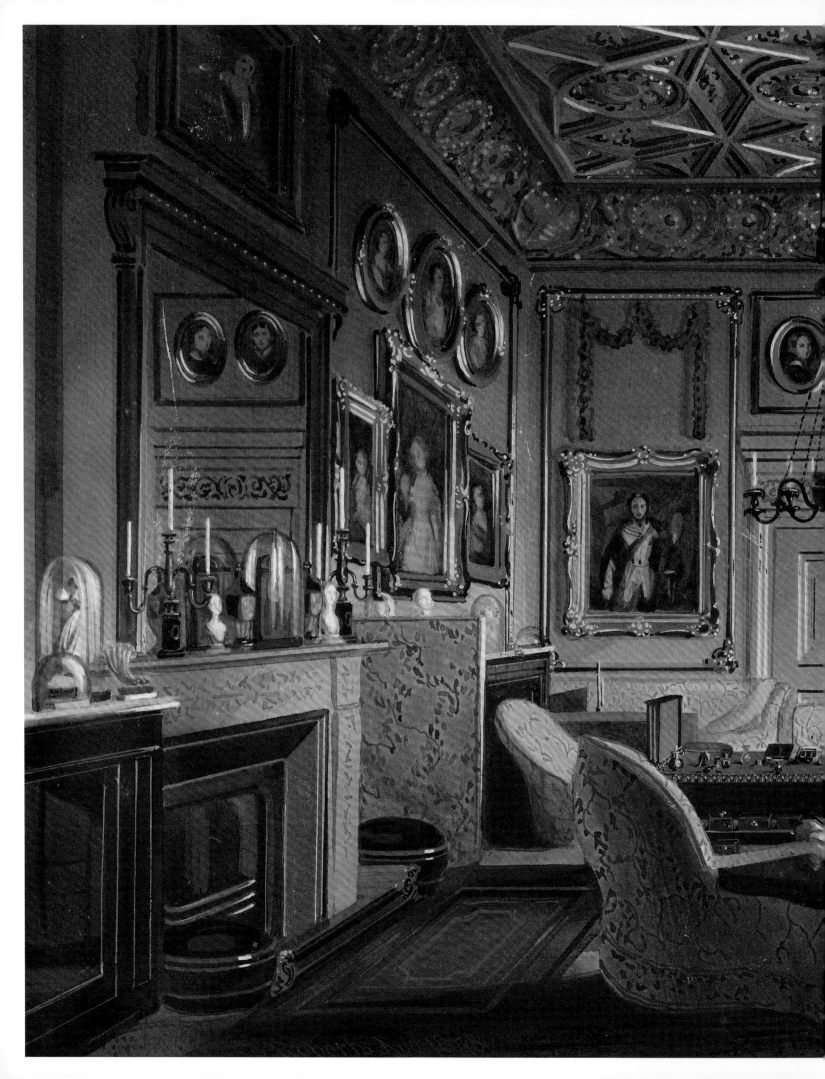

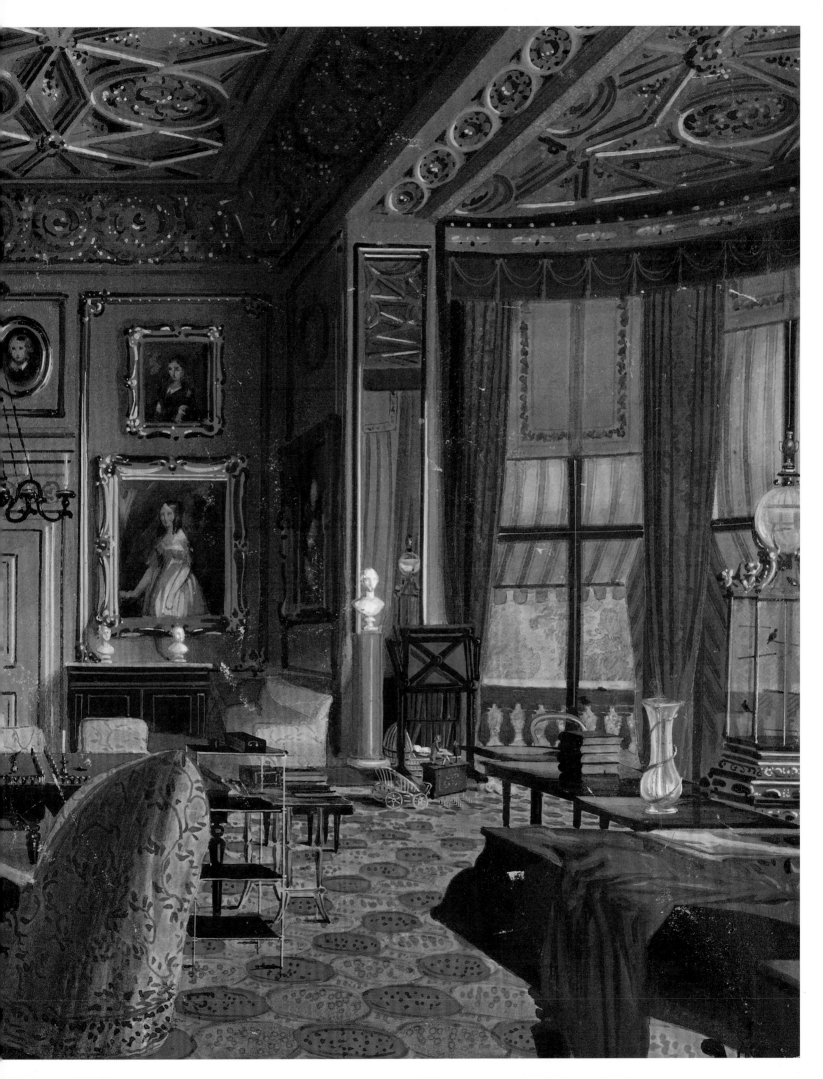

SELECTED ARTIST BIOGRAPHIES

CHARLOTTE GERE WITH JACQUELANN G. KILLIAN

ANNA ALMA-TADEMA
(English, 1865–1943)

Anna Alma-Tadema began her artistic training at a very young age under the tutelage of her father, Dutch-born painter Sir Lawrence Alma-Tadema (1836–1912). Anna was the youngest daughter from her father's first marriage. After his wife's death in 1869, Alma-Tadema married one of his pupils, Laura Theresa Epps, who became a respected artist. Anna Alma-Tadema's debut seems to have been at the Grosvenor Gallery in 1885, where two studies she submitted were "indicative of much promise" (*New York Times*, May 17, 1885). Another view of Townshend House in Regent's Park, London, may have been painted prior to 1885, when Alma-Tadema and his family moved to the house formerly owned by James Tissot in Grove End Road, in St. John's Wood.

FRANZ ALT
(Austrian, 1821–1914)

Franz Alt was the son of watercolor painter and lithographer Jakob Alt (1789–1872) and brother of Rudolf von Alt. Like his brother, Alt began studying art with his father, trained at the Akademie der Bildenden Künste, Vienna, and began his artistic career by about 1844. While based in Vienna throughout his life, Alt traveled widely in the Tyrol, northern Italy, and central Europe, making studies of landscapes and picturesque views of local architecture. One of his first albums of watercolors, commissioned by Count Casimir Esterházy, contained views of the northern Italian town Tarvisio and its vicinity.

RUDOLF VON ALT
(Austrian, 1812–1905)

Rudolf von Alt was from a family of talented and prolific Viennese artists who excelled at architecture and landscape subjects. He studied first with his father, Jakob Alt, and received formal training from 1825 to 1832 at the Akademie der Bildenden Künste, Vienna, where he was later a member. In 1832, his work earned him a prize, which freed him from military service and allowed him to devote himself fully to art. Like his brother, Alt traveled

extensively, visiting areas of Italy and the Austro-Hungarian Empire, and, beginning as early as 1834, exhibited works he had made during these trips in Berlin, Munich, Vienna, Dresden, and Paris. He was commissioned by Czar Alexander II in 1863 to execute views of the imperial residences in the Crimea. The Lanckoronski watercolors are two of a series of ten completed for a commission by Count Karol Lanckoronski (1848–1933) of his residence prior to the construction of the Palais Lanckoronski in 1894–95. A well-known and sought-after artist, Alt was ennobled in 1882, and in 1897 was nominated honorary president of the Vienna Secession by Gustav Klimt.

WILHELM AMANDUS BEER
(German, 1837–1907)

Wilhelm Amandus Beer was born in Frankfurt am Main, where he studied at the Städel Institut under Jacob Becker (1810–1872) and later was a pupil and assistant of the celebrated professor of history painting Edward von Steinle (1810–1886). After some time in Antwerp and Paris, he went to Russia, where he became fascinated with folk traditions. Russian peasant life grew to be his favorite subject matter. He returned to Frankfurt in 1870 and taught at the Städel Institut from 1897 until his death. He worked mainly in oils but also executed painstakingly accurate watercolors.

ALEXANDRE BENOIS
(Russian, 1870–1960)

Alexandre Benois was a painter, watercolorist, illustrator, and writer best known for his stage décor and costume designs for Sergei Diaghilev's Ballets Russes. The son and grandson of court architects, Benois was brought up within the Russian imperial entourage. His father worked at Peterhof and later at Pavlovsk, and was responsible for the Bolshoy Theatre in Moscow and the Mariinsky Theatre in St. Petersburg (Crisp, 1995: 47). Benois first began his study of painting in St. Petersburg between 1887 and 1888, and from 1891 to about 1910 he participated in exhibitions of the Society of Russian Watercolorists. Around 1898, Benois founded the magazine *Mir Iskousstva* (*The World of Art*) with Diaghilev and Léon Bakst. In 1909, at

the same time he was designing for the Ballets Russes, he exhibited a suite of paintings entitled *Promenade de Louis XIV dans le parc de Versailles*. Throughout the 1910s and 1920s, Benois continued to be engaged in the fine arts. He served as director of the Picture Gallery of the Hermitage Museum from 1917 until he left Russia for Paris in 1926.

MARY ELLEN BEST
(English, 1809–1891)

Mary Ellen Best was born in York, England, the younger of two daughters of well-to-do doctor Charles Best and his wife Mary. Her father died when she was eight, and left a bequest to both children, guaranteeing in some measure their freedom to pursue an education and not be forced into marriage for financial support as adults. Mary Ellen and her sister Rosamond attended boarding school and were both likely taught painting privately prior to their lessons with George Haugh (1755–1827), a successful painter who exhibited regularly at the Royal Academy (Davidson, 1985: 16). Best lived with her mother after her schooling, and they often traveled together through England, Germany, and the Netherlands. Family documents indicate that Mary Ellen was actively painting watercolors and selling her works as early as 1831. After the 1850s, she seems to have given up painting. She recorded her career by pasting a number of her best paintings chronologically into albums; nearly all of these albums have now been dispersed.

CHARLOTTE BOSANQUET
(English, 1790–1852)

Charlotte Bosanquet was the daughter of a banker, William Bosanquet, who died in 1800, leaving his family unexpectedly impoverished. She had a talent for watercolor and, in the 1840s, filled two albums with exteriors and interiors of mainly Bosanquet family homes, one being titled *The Bosanqueti – a selection of Several Mansion Houses, Villas, Lodges, Parks, etc., the principal residences of a distinguished Family with descriptive notes* (Cherry, 1993: 131). Bosanquet's large family of Huguenot origin made up an extensive network, and Charlotte built up what amounted to a pictorial diary of her movements from house to house among the many branches of the family, usually depicting the libraries, halls, or drawing rooms of their houses.

JULES-FRÉDÉRIC BOUCHET
(French, 1799–1860)

Jules-Frédéric Bouchet was an architect and engraver who began his career as a student of French architect and designer Charles Percier (1764–1838). In 1822, Bouchet obtained second prize in the Grand Prix of architecture for his design of an opera-house interior. While he lived and worked in Paris, Bouchet was enamored with Italian ruins and antiquities. After a trip to study them from 1825 to 1828, he completed twenty-seven engraved illustrations of the *Maison du poète tragique à Pomp'ei* (*The House of the Tragic Poet at Pompeii*), one of the first major studies of a Pompeiian house. Upon his return to Paris, he was named Inspector of the Works of the Royal Library (later the Bibliothèque Nationale) under Ludovico-Tullio-Giacomo Visconti (1791–1853) (Buschal, 1887: 613-14). Bouchet was also named Inspector of the Tomb of Napoleon, and finally was appointed chief architect of the tomb project after Visconti's death. Bouchet actively showed at numerous salons from the 1830s through the 1850s.

LOUISE COCHELET
(French, 1785–1835)

In addition to being an artist, Louise Cochelet was a Lady-in-Waiting, *lectrice* (reader), and confidant to Queen Hortense of Holland. Cochelet's four-volume *Mémoirs sur la Reine Hortense et la famille impériale* detail the queen's years of exile in Switzerland. In 1817, Cochelet bought Sandegg Castle; after her marriage to Denis-Charles Parquin (1786–1845), an officer in the entourage of the young Prince Louis-Napoleon, Hortense's son and the future Emperor Napoleon III, they lived at Wolfsberg Castle in nearby Ermatingen. Sandegg served as a refuge for members of the Bonaparte family, and Wolfsberg became the center of a lively social circle connected with the exiled court.

EMMANUEL COULANGE-LAUTREC
(French, 1824–1898)

Emmanuel de Coulange, or Coulange-Lautrec, was born in Nîmes, France. He took courses in architecture and decoration in Marseille and returned there in 1877 as a professor of industrial and decorative arts at the Ecole des Beaux-Arts. He exhibited at the Paris Salon from 1856 and also worked as an illustrator of deluxe publications for a firm in Saint-Germain-des-Près. Coulange-Lautrec

completed several designs for mural paintings in churches, mansions, and châteaux in the south of France as well as in the Grand Salon of the Marseille Stock Exchange. He is known for his landscape paintings of Provence and for his still lifes, which show a great admiration for Dutch masters of the seventeenth and eighteenth centuries.

RICHARD PARMINTER CUFF
(English, 1819/20–1876 or later)

Richard Parminter Cuff was born in Wellington in County Somerset. An architect and engraver, he exhibited at the Royal Academy in London from 1860 to 1876. He was one of the illustrators commissioned by John Ruskin (1819–1900) to work on the second edition of his *Stones of Venice*, replacing the original plates made by the author.

WILLIAM ALFRED DELAMOTTE
(English, 1775–1863)

Landscape painter, watercolorist, engraver, and lithographer William Delamotte was born in Weymouth in County Dorset to a French refugee family. He studied at the Royal Academy beginning in 1794 (Wood, 1978: 124). In 1803, he was appointed Second Landscape Drawing Master at the Royal Military College, Sandhurst (Wilson, Feb. 1978: 86-87). Delamotte was a friend of Benjamin West (1738–1820) and consulted with him extensively on the restoration of an altarpiece by William Hogarth (1697–1764) at St. Nicholas Church, Bristol. He actively exhibited at the Royal Academy from 1793 to 1851 and traveled throughout Wales, Belgium, France, northern Italy, and Switzerland. Delamotte is perhaps best known for his illustrated topographical books about Oxford and for his landscape paintings.

ALEXANDRE-DOMINIQUE DENUELLE
(French, 1818–1879)

Alexandre-Dominique Denuelle was a noted decorative painter and pupil of Paul Delaroche (1797–1856) and (Jacques-) Félix Duban (1797–1870) in the 1830s, and later collaborated with Hippolyte Flandrin (1809–1864). He traveled extensively through Italy, recording the ruins of Herculaneum and Pompeii and copying the paintings of thirteenth- and fourteenth-century masters such as Cimabue, Giotto, and Zuccari. He was elected the painter-member of the French Comité des Monuments Historiques and documented the decoration of French cathedrals and churches, often sending these drawings to

the Paris Salon. Denuelle carried out an enormous program of decorative fresco painting in ecclesiastical, public, and private buildings all over France, with specific work known at Saint-Germain-des-Près, the Grand Gallery of the Louvre, and the Abbey of Saint-Denis in Paris. He died in Florence (Kingsley, 1899: 465).

VLADISLAV DMOCHOWSKI
(Lithuanian, active Poland, mid-19th century)

Vladislav Dmochowski was a member of a Lithuanian family of artists active in the capital of Vilnius in the early nineteenth century. He was a painter and draftsman whose subjects frequently included genre and hunting scenes worked in watercolor or oil. He worked in Poland, exhibiting paintings in Warsaw, Krakow, and Lubin, and also completed a sketch for stained glass in Krakow's Church of the Holy Virgin.

C. M. FREDRO
(Polish, active 1830s)

Relatively little is known about C. M. Fredro, a member of a prominent Polish noble family forced into exile during the political upheavals of the nineteenth century. A friend of Charles de Talleyrand, Fredro would have been about sixteen years old in 1836 when *A Room in the Reuss Palace, Dresden* was completed. Another drawing in the Thaw Collection, *A Room in a Florentine Palace*, came from an album which may have been assembled by Fredro's sister and originally contained a number of his drawings. He seemed to have a talent for caricature; comical drawings record a visit that he made in 1848 with Talleyrand to Rochecotte, the French château belonging to the Marquise de Castellane.

EDUARD GAERTNER
(German, 1801–1877)

Born in Berlin to a master cabinetmaker, Eduard Gaertner began his artistic career with drawing lessons at the age of five in Cassel. He returned to Berlin after 1813 and studied painting at the Königliche Porzellanmanufaktur, where he stayed until approximately 1821. Gaertner became an assistant in the studio of theatrical scene painter Karl Wilhelm Gropius (1793–1870) and worked as a painter of stage sets. He first exhibited at the Akademie der Bildenden Künste, Berlin. In 1824–25, he was commissioned to paint interior views of the Berlin Cathedral and the chapel of the Schloss Charlottenburg. He spent three years in Paris, where he studied under Jean-Victor Bertin (1767–

1842), and later mounted an exhibition at the Berlin Akademie of works he had completed there (Betthausen et al. 1988: 130). This exhibition greatly increased his visibility, and King Wilhelm III of Prussia acquired several of his works. Under the patronage of the Prussian royal family, Gaertner launched a career as a painter of Berlin architecture and interiors, developing a specialty in topographic and panoramic views.

DOMINIQUE HAGEN
(Possibly Russian, active second half of 19th century)

The watercolorist Dominique (Dominik) Hagen studied at the Moscow Academy. He worked in Moscow, exhibiting there and in St. Petersburg. He was elected to the St. Petersburg Academy in 1860 on the strength of his watercolor drawing *Blind Ukranian Lute-Players*.

EDUARD PETROVICH HAU
(Estonian, active Russia, 1807–1888)

Eduard Petrovich Hau was first trained in painting by his father, the landscape painter Johannes Hau (1771–1838), and was a student at the Akademie der Bildenden Künste, Dresden, for one year (Dobler, 2004: 263). In 1836, he went to Dorpat, a center of romanticism in the nineteenth century, and worked as a portraitist. There he began a catalogue of portraits of thirty professors at the Imperial Universities of Dorpat known as the *Sammlung von Portraits der Professoren an der Kaiserlichen Universität zu Dorpat seit dem Jahre 1837 nach dem Leben und auf Stein gezeichnet von E. Hau*. Ultimately, Hau moved to St. Petersburg, where he was hired in 1852 to assist with a significant nine-year documentation of the interiors of the New Hermitage, contributing twenty paintings to the total of fifty-five views.

JULIUS EDWARD WILHELM HELFFT
(German, 1818–1894)

Julius Edward wilhelm Helfft, a painter of landscapes and architecture, studied at the Akademie der Bildenden Künste, Berlin, and with the landscape painter Johann Wilhelm Schirmer (1807–1863) of the Düsseldorf Kunstakademie (Clement and Hutton, 1879: 343). Helfft exhibited at the Berlin Akademie from 1844 and later served as Royal Professor. He was commissioned by King Friedrich Wilhelm IV to make a series of views of Florence and its environs in 1843–47. He also traveled to Rome, Naples, and Sicily, and returned to Italy regularly to continue sketching, producing a series of views in the late 1850s.

Later in life, Helfft was forced to stop painting because of an eye injury. He left the Berlin Akademie a number of his sketches and studies as well as money to establish a scholarship for landscape painters.

EDWARD LAMSON HENRY
(American, 1841–1919)

Edward Lamson Henry was born in Charleston, South Carolina; at the age of seven, he was brought to live with relatives in New York. He began studying art at fourteen with Walter Oddie (1808–1865), a landscape painter and early member of the National Academy of Design. Henry furthered his study with Paul Weber (1823–1916) at the Pennsylvania Academy of Fine Arts and in Paris as a student of Joseph-Nicolas Robert-Fleury (1797–1890) at the Ecole des Beaux-Arts. He later traveled through Rome and Florence. In 1859, Henry began exhibiting yearly at the National Academy of Design; two years later he received the status of full Academician. From 1875 to 1879, Henry lived in London and exhibited at the Royal Academy and Suffolk Street Gallery, and exhibited at both the 1878 and 1889 *Expositions Universelles*, receiving an honorable mention for his submission to the latter. After returning to the United States, he spent summers in a small artist/farming community in upstate New York known as Cragsmoor, which frequently appeared as the subject of his landscape and genre paintings from the late 1870s onward.

WILLIAM HENRY HUNT
(English, 1790–1864)

William Henry Hunt began studying with John Varley (1778–1842), draftsman and founding member in 1804 of the Society of Painters in Water Colours. Evidence of this tutelage is apparent in Hunt's early landscapes, genre scenes, and architectural studies (Wood, 1978: 243). In 1806, Hunt showed at the Royal Academy and enrolled for formal study the following year. Early in his career, he found employment by painting views of gentleman's country seats, of which the Cassiobury drawing is one example. Hunt worked primarily in watercolor and first exhibited at the Society of Painters in Water Colours in 1814, joining as a full member in 1826. He is best known for his still lifes, for which the English art critic and theorist John Ruskin called him "the good peach and apple painter" in 1879 (Treble, Aug. 1981: 502).

CARL FRIEDRICH WILHELM KLOSE
(German, 1804–after 1863)

Carl Friedrich Wilhelm Klose was born in Berlin and studied at the Berlin Akademie under the royal theatre painter Karl Wilhelm Gropius, later working in his workshop. He traveled in Rome and Paris, but lived and worked in Berlin throughout his life. Klose made a number of views of the Berlin palaces for the Prussian royal family and contributed a view of the sitting room in Berlin to the Wittgenstein Album (Praz, 1964: 237-38). Many of his interior drawings are in the watercolor collection of Friedrich Wilhelm IV at the Stiftung Preußische Schlösser und Gärten Berlin-Brandenburg, and, like his contemporary Eduard Gaertner, he was considered a specialist of interior architecture painting.

EUGÈNE LACROIX
(French, 1814–1873)

Eugène Lacroix was a painter of landscapes, genre scenes, and still lifes, but little else is known of his activity in Paris. Lacroix published three lithographs of Rome in 1835. He exhibited at the Salon from 1841 onwards and was a recipient of a silver medal at the 1878 *Exposition Universelle*, and subsequently received a Grand Prix at the 1889 *Exposition Universelle* (Hors-Concours). The "M. Constant. D." to whom *A Studio in the Villa Medici* is dedicated may be Lacroix's near-contemporary Henri-Joseph-Constant Dutilleux (1807–1865), a painter, lithographer, and early practitioner of the *cliché-verre* photographic technique.

ACHILLE-LOUIS MARTINET
(French, 1806–1877)

Achille-Louis Martinet was a Parisian watercolor draftsman and engraver who exhibited at the Salon from 1835 to 1876. He twice won the Prix de Rome, obtaining second place in 1826 and first place in 1830. He was made Knight of the Legion of Honor in 1846 and Officer of the Legion in 1867.

FRANZ XAVER NACHTMANN
(German, 1799–1846)

Franz Xaver Nachtmann studied at the Akademie der Bildenden Künste, München from 1814 to 1819, and worked for six years in the Nymphenburg Porcelain Manufactory as a china painter. He was one of the first German professionals engaged to paint interiors for the royal albums that proliferated in the 1830s and 1840s. He was involved from the early 1820s with developing the Wittelsbach Album for Queen Caroline of Bavaria, and made replicas of some of these views for the Hesse family album at Darmstadt.

JOSEPH NASH THE ELDER
(English, 1808–1878)

Born at Great Marlow, Joseph Nash began his drafting career studying Gothic architecture under Augustus Charles Pugin. He went with Pugin to Paris in 1829 to make drawings for *Paris and Its Environs* (1830), and lithographed the plates in Pugin's *Views Illustrative of Examples of Gothic Architecture* (1830). From 1831 to 1879, he exhibited at the Royal Academy; and exhibited at the 1855 Paris *Exposition Universelle*, receiving an honorable mention. His early exhibits at the Society of Painters in Water Colours were mainly illustrations for Shakespeare and contemporary poetry and novels; Tudor and Elizabethan architecture of Knole, Hampton Court, and Speke Hall were also frequent subjects. His published works include *Architecture of the Middle Ages* (1838); *The Mansions of England in the Olden Time*, published in four sets of twenty-six lithographs (1839–49); *Scotland Delineated* (1847–54); and *Views of Windsor Castle* (1848) (Wood, 1978: 338).

AUGUSTUS CHARLES PUGIN
(French, active England, ca. 1762–1832)

Augustus Charles Pugin possibly came to England during the French Revolution, although the exact circumstances and date of his arrival are not known. In 1792, he entered the Royal Academy Schools and worked as a draftsman for John Nash (1752–1835). In 1799, he exhibited a design for a villa at the Royal Academy. His architectural drawings were outstanding for their clarity and accuracy, and he worked frequently as an illustrator of architectural treatises. Some of his most notable contributions are illustrations for *The Microcosm of London* (1808) and two volumes of *Specimens of Gothic Architecture* (1818). After the success of *Specimens*, Pugin worked for Nash between 1819 and 1824, drawing the plates for *The Royal Pavilion at Brighton* (1826). He was not very active as a practicing architect, but probably provided designs for other architects. In 1826–27, he exhibited three designs for cemeteries, and in 1830 he was associated with the layout of the cemetery at Kensal Green, London.

CHARLES JAMES RICHARDSON
(English, 1806–1871)

Charles James Richardson trained as an architect with Sir John Soane (1753–1837) and was later the curator of the Sir John Soane Museum. He was a talented architectural draftsman who owned a large and valuable collection of architects' drawings and designs. His *Observations on the Architecture of England* (1837), a volume extensively illustrated with details of plasterwork, moldings, and woodcarving, was of great value to fellow architects. In the 1840s, Richardson drew and painted the treasures at Goodrich Court for the noted collector Sir Samuel Rush Meyrick, thus feeding his antiquarian inclinations. The studies include specimens of unusual early furniture and objects as well as rooms from ancient houses. He exhibited seventeen works at the Royal Academy, including views of the Chapel Royal, St. James's, Holland House, and Sutton Place (Wood, 1978: 393).

JAMES ROBERTS
(English, ca.1800–1867)

Not a great deal is known about James Roberts, an English painter who was active in Paris throughout his life. Roberts studied there from around 1817 and later worked with Neoclassicist Michel-Martin Drolling (1786–1851). In 1824, he exhibited views of Rouen and Beauvais at the Paris Salon and became a drawing master in the Faubourg St. Germain (Millar, v. 2, 1995: 735). At the beginning of the 1848 Revolution, Roberts went to London, where he painted for Queen Victoria until 1861. The Royal Collection contains six of Roberts's paintings made for Victoria, Princess Royal, as a gift from her brother Albert as mementos to take with her to Berlin upon her marriage. These drawings include views of Balmoral, Buckingham Palace, Osborne, and Windsor Castle. Roberts also colored photographs, including royal portraits.

HENRY ROBERT ROBERTSON
(English, 1839–1921)

Henry Robert Robertson was born in Windsor and exhibited in London from 1861. He was a versatile painter with subjects ranging from landscapes to portraits, genre scenes, and miniatures. He was a member of the Society of Painter-Etchers and of the Royal Society of Miniature Painters.

CHARLES WILD
(English, 1781–1835)

A pupil of the topographical and architectural draftsman Thomas Malton (1726–1801) and an accomplished architectural draftsman himself, Charles Wild was responsible for drawing the interior views of Carlton House for William Henry Pyne's *The History of the Royal Residences*. Twenty-four of the original watercolors are in the Royal Collection at Windsor Castle, including four other views of interiors at Carlton House. They were exhibited at the Society of Painters in Water Colours in 1817 and 1818, and were identified in the handlist as being for Pyne's publication.

SELECTED BIBLIOGRAPHY

Ackermann, Rudolph. "Fashionable Furniture." In Repository of Arts, Literature, Fashions Etc., ser. 3, vol. 10, no. 56 (August 1, 1827): 19.

———. "Gothic Furniture." In Repository of Arts, Literature, Fashions Etc., ser. 3, vol. 10, no. 58 (October 1, 1827): 295.

Adams, Bernard. London Illustrated, 1604–1851: A Survey and Index of Topographical Books and Their Plates. Phoenix: Oryx Press, 1983.

Agius, Pauline. Ackermann's Regency Furniture & Interiors. Marlborough, England: The Crowood Press, 1984.

Aldrich, Megan, ed. The Craces: Royal Decorators, 1768–1899, exh. cat. London: Murray, 1990.

Allibone, Jill. George Devey: Architect, 1820–1886. Cambridge: Lutterworth, 1991.

The American Renaissance 1876–1917, exh. cat. Brooklyn: The Brooklyn Museum, Division of Publications and Marketing Services, 1979.

Anscombe, Isabelle, and Charlotte Gere. Arts & Crafts in Britain and America. New York: Rizzoli, 1978.

Arrowsmith, Henry William, and A. Arrowsmith. The House Decorator and Painter's Guide. London: Thomas Kelly, 1840.

Baarsen, Reinier. Courts and Colonies: The William and Mary Style in Holland, England, and America, exh. cat. New York: Cooper-Hewitt Museum, 1988.

Bader, Walter. Aus Schloss Augustusburg zu Brühl und Falkenlust. Cologne: M. DuMont Schauberg, 1961.

———. The Historie of Life and Death: With Observations Naturall and Experimentall for the Prolonging of Life. London: Printed by I. Okes, for Humphrey Mosley..., 1638.

Bauchal, Charles. Nouveau Dictionnaire Biographique et Critique des Architectes Français. Paris: André, Daly Fils et Cie, 1887.

Bartoschek, Gerd, Helmut Börsch-Supan, and Adelheid Schendel. Blick auf Potsdam: Ansichten aus dem 18. und 19. Jahrhundert; Ausstellung der Staatlichen Schlösser und Gärten Berlin und Potsdam vom 1. Juni bis 24. Juli 1990 im Schloss Glienicke. Potsdam: Die Generaldirektion, 1990.

Beard, Geoffrey. Stucco and Decorative Plasterwork in Europe. London: Thames and Hudson, 1983.

———. The National Trust Book of the English House Interior. London: Viking, 1990.

Benjamin, Walter. The Arcades Project. Translated by Howard Eiland and Kevin McLaughlin, prepared on the basis of the German volume edited by Rolf Tiedemann. Cambridge, MA: Belknap Press, 1999.

Bergdoll, Barry, and Erich Lessing. Karl Friedrich Schinkel: An Architecture for Prussia. New York: Rizzoli, 1994.

Betthausen, Peter, et al. The Romantic Spirit: German Drawings, 1780-1850, from the Nationalgalerie, Staatliche Museen, Berlin and the Kupferstich-Kabinett, Staatliche Kunstsammlungen, Dresden, German Democratic Republic, exh. cat. New York: Pierpont Morgan Library and Oxford University Press, 1988.

Boffrand, Germain. Livre d'architecture... Paris: Guillaume Cavelier, 1745.

Boffrand, Germain, Albert France-Lanord, Jörg Garms, and Michel Gallet. Germain Boffrand, 1667–1754: L'aventure d'architecte independant. Paris: Herscher, 1986.

Boniface, Priscilla. The Garden Room. London: Royal Commission on Historical Monuments England; Her Majesty's Stationary Office, 1982.

Börsch-Supan, Helmut. Marmorsaal und blaues Zimmer: so wohnten Fürsten. Berlin: Mann, 1976.

Börsch-Supan, Helmut, and Lucius Grisebach. Karl Friedrich Schinkel: Architektur, Malerei, Kunstgewerbe. Berlin: Verwaltung der Staatlichen Schlösser und Gärten und Nationalgalerie Berlin, Staatliche Museen Preussischer Kulturbesitz, 1981.

Britton, John. The Union of Architecture, Sculpture and Painting... London: the author, 1827.

Bryan, Michael. Dictionary of Painters and Engravers, Biographical and Critical. Rev. edition edited by Robert Edmund Graves. London: George Bell and Sons, 1886.

Bullock, George, and Clive Wainwright. George Bullock: Cabinet Maker. London: Murray in association with H. Blairman and Sons, 1988.

Carbone, Teresa A. At Home with Art: Paintings in American Interiors, 1780-1920, exh. cat. Katonah, NY: Katonah Museum of Art, 1995.

Carlton House: The Past Glories of George IV's Palace, exh. cat. London: Queen's Gallery, Buckingham Palace, 1991.

Cartwright-Hignett, Elisabeth, and Lili Cartwright. Lili at Aynhoe: Victorian Life in an English Country House. London, Barrie and Jenkins, 1989.

Chenevière, Antoine. Russian Furniture: The Golden Age 1780–1840. London: Vendome Press, 1988.

Cherry, Deborah. Painting Women: Victorian Women Artists. London: Routledge, 1993.

Chippendale, Thomas. The Gentleman and Cabinet-maker's Director. London, 1754.

Clement, Clara Erskine, and Laurence Hutton. Artists of the Nineteenth Century and Their Works. Boston: Houghton, Osgood and Company, 1879.

Clemmensen, Tove. Skæbner og Interiører: Danske Tegninger fra Barok til Klunketid. Copenhagen: Nationalmuseet, 1984.

Clemmensen, Tove, and Mogens B. Mackeprang. Kina og Danmark 1600–1950: Kinafart og Kinamode. Copenhagen: Nationalmuseet, 1980.

Clifford, Timothy. Designs of Desire: Architectural and Ornament Prints and Drawings, 1500–1850. Edinburgh: National Galleries of Scotland, 1999.

Cochelet-Parquin, Louise, and Frédéric Lacroix, ed. Mémoirs sur la Reine Hortense et la famille impériale, 4 vols. Paris, 1836–38.

Cohen, Deborah. Household Gods: The British and Their Possessions. New Haven: Yale University Press, 2006.

Cohn, Marjorie B. Wash and Gouache: A Study of the Materials of Watercolor. Cambridge, MA: The Center for Conservation and Technical Studies, Fogg Art Museum, Harvard University, 1977.

Cohn-Wiener, Ernst. Potsdam mit den Königlichen Schlössern und Gärten: 120 Bilder nach Naturaufnahmen, mit Einleitendem Text. Berlin: Verlag für Kunstwissenschaft, 1920s.

Collard, Frances. Regency Furniture. Woodbridge, England: Antique Collectors' Club, 1985.

Cornforth, John. English Interiors 1790–1848: The Quest for Comfort. London: Barrie and Jenkins, 1978.

———. Pyne's Royal Residences. London: Michael Joseph, 1976.

Cosnac, Gabriel Jules, comte de. Les Richesses du Palais Mazarin. Paris: Renouard, 1884.

Crisp, Clement. "Alexandre Nikolaevich Benois." In Dance Research: The Journal of the Society for Dance Research 13, no. 2 (1995): 47–48.

Cust, Lionel. "Notes on the Collections Formed by Thomas Howard, Earl of Arundel and Surrey, K. G.-II." In The Burlington Magazine for Connoisseurs 20, no. 104 (Nov. 1911): 97–100.

Davidson, Caroline. The World of Mary Ellen Best. London: Chatto and Windus, 1985.

Davidson, Gail S. "Ornament of Bizarre Imagination: Rococo Prints and Drawings from Cooper-Hewitt's Léon Decloux Collection." In Sarah D. Coffin, Gail S. Davidson, Ellen Lupton, Penelope Hunter-Stiebel, et al. Rococo: The Continuing Curve, 1730–2008, exh. cat. New York: Cooper-Hewitt, National Design Museum, Smithsonian Institution, 2008: 40-71.

Dayot, Armand. *Napoleon I in Bild und Wort* Leipzig: H. Schmidt & C. Günther, 1897.

Dewing, David, ed. *Home and Garden: Paintings and Drawings of English, Middle-Class, Urban Domestic Spaces; 1675 to 1914,* exh. cat. London: Geffrye Museum, 2003.

Dinkel, John. *The Royal Pavilion Brighton.* London: Philip Wilson, 1983.

Dobler, Andreas. *Interieurs Der Biedermeierzeit: Zimmeraquarelle aus Fürstlichen Schlössern im Besitz des Hauses Hessen,* exh. cat. Petersberg, Germany: M. Imhof; Eichenzell, Germany: Hessische Hausstiftung Museum Schloss Fasanerie, 2004.

Drawings from the Collection of Mr. and Mrs. Eugene Victor Thaw: Part II, exh. cat. New York: Pierpont Morgan Library, 1985.

Drossaers, Sophie Wilhelmina Albertine, and Theodoor Herman Lunsingh Scheurleur. *Inventarissen van de Inboedels in de Vrblijven van de Oranjes...1567–1795.* The Hague: M. Nijhoff, 1974-76.

Ducamp, Emmanuel, et al. *Imperial Palaces in the Vicinity of Saint Petersburg: Watercolours, Paintings and Engravings from the XVIIIth and XIXth Centuries,* 4 vols. Paris: Alain de Gourcoff, 1992.

Ducamp, Emmanuel, et al. *The Winter Palace, Saint Petersburg.* Saint Petersburg: State Hermitage Museum, 1995.

Duff, David. *Victoria Travels: Journeys of Queen Victoria between 1830 and 1900.* New York: Taplinger, 1971.

Eastlake, Charles. *Hints on Household Taste in Furniture, Upholstery and Other Details.* London: Longmans, Green, 1868.

Eriksen, Svend. *Early Neo-Classicism in France: The Creation of the Louis Seize Style in Architectural Decoration, Furniture and Ormolu, Gold and Silver, and Sèvres Porcelain in the Mid-Eighteenth Century.* London: Faber, 1974.

Evans, Robin. *Translations from Drawing to Building.* Cambridge, MA: MIT Press, 1997.

von Falke, Jacob. *Art in the House: Historical, Critical, and Aesthetical Studies.* Boston: L. Prang, 1879.

Feulner, Adolf. *Das Residenzmuseum in München.* Munich: F. Bruckmann, 1922.

Finch, Christopher. *Nineteenth-Century Watercolors.* New York: Abbeville Press, 1991.

Flanders, Judith. *Inside the Victorian Home: A Portrait of Domestic Life in Victorian England.* New York: W. W. Norton, 2004.

Fontaine, Pierre-François. *Journal: 1799–1853,* 2 vols. Paris: Ecole Nationale Supérieure des Beaux-Arts, Institut Français d'Architecture, Société de l'Histoire de l'Art Français, 1987.

———. *Histoire du Palais-Royal.* Paris, 1834.

Foskett, Douglas John. *The New Encyclopaedia Britannica,* 15th ed., vol. 22. Chicago: Encyclopaedia Britannica, 1989.

Fowler, John, and John Cornforth. *English Decoration in the 18th Century.* London: Barrie and Jenkins, 1974.

Frémy, Elphège. *Histoire de la Manufacture Royale des Glaces au 17è et 18è Siècle.* Paris: Plon-Nourrit et Cie, 1909.

Fuhring, Peter. *François-Joseph Bélanger, 1744–1818.* Paris: de Bayser, 2006.

———. *Juste-Aurèle Meissonnier: Un Génie du Rococo; 1695–1750,* 2 vols. Turin: Umberto Allemandi, 1999.

Gaertner, Eduard, Dominik Bartmann, and Gundula Ancke. *Eduard Gaertner: 1801–1877.* Berlin: Nicolai, 2001.

Garnier, Athanase. *Manuel du Tapissier, Décorateur, et Marchand de Meubles...* Paris: Libr. encyclopédique de Roret, 1830.

Gautier, Jean-Jacques. "Le Gout du Prince, Part III, Décor et Ameublement de Bagatelle." In Daniel Alcouffe et al. *La Folie d'Artois,* exh. cat. Levallois-Perret, France: L'Objet d'Art, 1988.

Gere, Charlotte. *An Album of Nineteenth-Century Interiors: Watercolors from Two Private Collections,* exh. cat. Edited by Joseph Focarino. New York: The Frick Collection, 1992.

———. *Nineteenth-Century Decoration: The Art of the Interior.* London: Weidenfeld and Nicholson, 1989.

Gere, Charlotte, and Lesley Hoskins. *The House Beautiful: Oscar Wilde and the Aesthetic Interior.* London: Lund Humphries in association with the Geffrye Museum, 2000.

Gibbs, Jenny. *Curtains and Draperies: History, Design, Inspiration.* Woodstock, NY: Overlook Press, 1994.

Gloag, John. *Victorian Comfort: A Social History of Design from 1830–1900.* Newton Abbott, England: David and Charles, 1973.

Gore, Alan, and Ann Gore. *English Interiors: An Illustrated History.* New York: Thames and Hudson, 1991.

Grandjean, Serge. *Empire Furniture, 1800 to 1825.* London: Faber, 1966.

Grier, Katherine C. *Culture and Comfort: People, Parlors, and Upholstery; 1850–1930.* Rochester, NY: Strong Museum; Amherst, MA: distributed by the University of Massachusetts Press, 1988.

Guimard, exh. cat. Paris: Éditions de la Réunion des Musées Nationaux, 1992.

Guimard, Hector, David Dunster, Gillian Naylor, and Yvonne Brunhammer. *Hector Guimard.* London: Academy Editions, 1978.

Günther, R. T., and Sir Roger Pratt. *The Architecture of Sir Roger Pratt...* Oxford: Oxford University Press, 1928.

Hapgood, Marilyn Oliver. *Wallpaper and the Artist: From Dürer to Warhol.* New York: Abbeville, 1992.

Harris, John. "Inigo Jones and His French Sources." In *The Metropolitan Museum of Art Bulletin* 19, no. 9 (May 1961): 253–64.

Havard, Henry. *Dictionnaire de l'Ameublement et de la Décoration depuis le XIIIe Siècle jusqu'à nos Jours.* Paris: Ancienne Maison Quantin, Librairies-imprimeries réunies, May et Motteroz, 1888–90.

Himmelheber, Georg. *Biedermeier, 1815–1835: Architecture, Painting, Sculpture, Decorative Arts, Fashion.* Munich: Prestel, 1989.

———. *Biedermeier Furniture.* Translated by Simon Jervis. London: Faber and Faber, 1974.

———. *Deutsche Möbelvorlagen, 1800-1900: Ein Bilderlexikon der Gedruckten Entwürfe und Vorlagen im Deutschen Sprachgebiet.* Munich: C. H. Beck, 1988.

Holtzman, Joseph, ed. *Every Room Tells a Story: Tales from the Pages of* Nest *Magazine.* New York: Distributed Art Publishers, 2001.

Honour, Hugh. "Canova's Statues of Venus." In *The Burlington Magazine* 114, no. 835 (Oct. 1972): 658–71.

———. "From the House of Life." In *The New York Review of Books* 30, no. 3 (March 3, 1983).

Hope, Thomas. *Household Furniture and Interior Decoration: Classic Style Book of the Regency Period.* New York: Dover Publications, 1971.

Hortense, Queen Consort of Louis, King of Holland. *The Memoirs of Queen Hortense,* 2 vols. Edited by Jean Adolphe Hanoteau, translated by Arthur Kingsland Griggs. New York: Cosmopolitan Book Corporation, 1927.

Hübner, Paul Gustav. *Schloss Sanssouci.* Berlin: Deutscher Kunstverlag, 1926.

Hutchison, Jane Cambell. Review of Celeste Brusati, *Artifice and Illusion: The Art and Writing of Samuel van Hoogstraten.* In *Sixteenth Century Journal* 28, no. 3. (Autumn, 1997): 1040–41.

Inventaires des Merveilles du Monde rencontreés dans le Palais du Cardinal Mazarin, Paris, 1649. Paris: Le Comte de Laborde, Le Palais Mazarin..., 1846.

Jervis, Simon. *Printed Furniture Designs before 1650.* Leeds: W. S. Maney and Son for the Furniture History Society, 1974.

Jervis, Simon. "A Tortoiseshell Cabinet and Its Precursors." In *Victoria and Albert Museum Bulletin* 4, no. 4 (October 1968): 133–43.

Joy, Edward Thomas. *English Furniture 1800-1851.* London: Sotheby Parke Bernet, 1977.

Kerr, Robert. *The Gentleman's House...* London: Murray, 1864.

Kier, Hiltrud. *Schmuckfussböden in Renaissance und Barock.* Munich: Deutscher Kunstverlag, 1976.

Kimball, Fiske. *The Creation of the Rococo.* Philadelphia: Philadelphia Museum of Art, 1943.

Kingsley, Rose G. *A History of French Art, 1100–1899.* New York: Longmans, Green, and Co., 1899.

Kühn, Margarete. *Schloss Charlottenburg.* Berlin: Deutscher Verein für Kunstwissenschaft, 1955.

Kühn, Margarete, and Helmut Börsch-Supan. *Charlottenburg Palace,* rev. ed. Berlin: Brüder Hartmann, 1976.

Kurth, Willy. *Die Raumkunst im Kupferstich des 17. und 18. Jahrhunderts.* Stuttgart. J. Hoffmann, 1923.

———. *Sanssouci: Ein Beitrag zur Kunst des Deutschen Rokoko.* Berlin: Henschelverlag Kunst und Gesellschaft, 1962.

Lasdun, Susan. *Victorians at Home.* London: Weidenfeld and Nicolson, 1981.

Le Rouge. *Les curiositez de paris, de Versailles...* Paris: Chez Saugrain, 1723.

Lilley, Ed. "The Name of the Boudoir." In *Journal of the Society of Architectural Historians* 53, no. 2 (June 1994): 193–98.

Londonderry, Frances Anne Vane, Marchioness of, W. A. L. Seaman, and James Reid Sewell. *Russian Journal of Lady Londonderry, 1836–37.* London: J. Murray, 1973.

Louw, H. J. "The Origin and Development of the Sash-Window in the Seventeenth and Eighteenth Centuries with Special Reference to England." Ph.D. diss., Oxford University, 1981.

Lukatis, Christiane. *Mein Blauer Salon: Zimmerbilder der Biedermeierzeit.* Nuremburg: Verlag des Germanischen Nationalmuseums, 1995.

Lynn, Catherine. *Wallpaper in America: From Seventeenth Century to World War I.* New York: W. W. Norton, 1980.

Macaulay, Thomas Babington, Baron. *History of England from the Accession of James II.* London: Longman, Brown, Green, and Longmans, 1849.

Macquoid, Percy, and Ralph Edwards. *The Dictionary of English Furniture, from the Middle Ages to the Late Georgian Period,* 2nd ed. London: Country Life Limited, 1954.

Manguel, Alberto. *A History of Reading.* New York: Viking, 1996.

Marie, Alfred. *Naissance de Versailles: Le Château, les Jardins...* Paris: Vincent, Fréal et Cie, 1968.

Marie, Alfred, and Jeanne Marie. *Mansart à Versailles.* Paris: J. Fréal, 1972.

Marshall, John, and Ian Willox. *The Victorian House.* London: Sidgwick and Jackson in association with Channel Four Television, 1986.

Mayhew, Edgar de Noailles, and Minor Myers. *A Documentary History of American Interiors: From the Colonial Era to 1915.* New York: Scribner, 1980.

Meier, Burkhard. *Potsdam: Palaces and Gardens,* 2nd ed. Translated by Gertrude Daus. Berlin: Deutscher Kunstverlag, 1927.

Meissonnier, Juste-Aurèle. *Oeuvre de Juste-Aurèle Meissonnier.* Introduction by Dorothea Nyberg. New York: Benjamin Blom, 1969.

de Mézières, Nicolas Le Camus. *Le Génie de l'Architecture...* Paris: L'Auteur [et] Chez B. Morin, 1780.

Millar, Delia. *Queen Victoria's Life in the Scottish Highlands: Depicted by Her Watercolour Artists.* London: Philip Wilson, 1985.

———. *The Victorian Watercolours and Drawings in the Collection of Her Majesty the Queen,* 2 vols. London: Philip Wilson, 1995.

Millar, Oliver, ed. "The Inventory and Valuation of the King's Goods, 1649–51." In *Walpole Society Journal* 43 (1972): vii–xxviii, 1–450.

Mitford, William. *Principles of Design in Architecture...,* 2nd ed. London: printed for Rodwell and Martin, 1824.

Montgomery, Florence M. *Textiles in America 1650–1870.* New York: W. W. Norton, 1984.

Morley, John. "Early Chinoiserie Interiors at Brighton." In *Apollo* 116, no. 247 (September 1982): 156–62.

———. *The Making of Royal Pavilion Brighton: Designs and Drawings.* London: Published for Sotheby Publications by Philip Wilson, 1984.

Musgrave, Clifford. "The Royal Pavilion, Brighton, Part 1: The Building and Its Decoration." In *The Magazine Antiques* 90 (July 1966): 74–79.

Nash, John, and Gervase Jackson-Stops. *Views of the Royal Pavilion.* London: Pavilion, 1991.

Nicholson, Peter, and Michael Angelo Nicholson. *The Practical Cabinet Maker, Upholsterer, and Complete Decorator.* London: H. Fisher, Son, 1826.

Nouvel-Kammerer, Odile, et al. *Symbols of Power: Napoleon and the Art of the Empire Style, 1800–1815.* New York: American Federation of the Arts/Abrams; Paris: Musée des Arts Décoratifs, 2007.

d'Orléans, Charlotte-Elisabeth, Duchesse. *Letters from Liselotte: Elisabeth Charlotte, Princess Palatine and Duchess of Orléans, 'Madame', 1652-1722.* Edited by Maria Kroll. London: Gollancz, 1970.

d'Orléans, Henri-Eugène-Philippe-Louis. *Inventaire de Tous les Meubles du Cardinal Mazarin...* London, 1861.

Österreichisches Museum für Angewandte Kunst. *153 Sesselmodelle aus Danhauser's k. k. priv. Möbel Fabrik, Alte Wieden Maierhof Gasse No. 302.* Vienna: Österreichisches Museum für Angewandte Kunst, 1987.

Ottomeyer, Hans. *Das Wittelsbacher Album: Interieurs königlicher Wohn- und Festräume 1799–1848.* Munich: Prestel, 1979.

Ottomeyer, Hans, Klaus Albrecht Schröder, and Laurie Winters. *Biedermeier: The Invention of Simplicity.* Milwaukee: Milwaukee Art Museum; Ostfildern, Germany: Hatje Cantz, 2006.

Le Palais Royal, exh. cat. Paris: Musée Carnavalet, 1988.

Parker, K. T. *Catalogue of Drawings in the Ashmolean Museum.* Oxford: Clarendon Press, 1938.

Parry, Linda. *The Victoria and Albert Museum's Textile Collection: British Textiles from 1850 to 1900.* London: Victoria and Albert Museum, 1993.

———. *William Morris and the Arts and Crafts Movement: A Design Source Book.* London: Studio Editions, 1989.

———. *William Morris Textiles.* London: George Weidenfeld and Nicolson Limited, 1983.

Percier, Charles, and Pierre-François-Léonard Fontaine. *Recueil de Décorations Intérieures...* Paris: chez les auteurs, 1812.

Perrot, Michelle, ed. *From the Fires of Revolution to the Great War,* vol. 4 of *A History of Private Life.* Translated by Arthur Goldhammer. Cambridge, MA: Belknap Press of Harvard University Press, 1990.

Peterson, Harold L. *American Interiors from Colonial Times to the Late Victorians: A Pictoral Source Book of American Domestic Interiors with an Appendix on Inns and Taverns.* New York: Scribner, 1971.

Pfeil, Christoph, Graf von. *Die Möbel der Residenz Ansbach.* Munich and New York: Prestel, 1999.

Pick, Michael. *Inside Out: Historic Watercolour Drawings, Oil Sketches and Paintings of Interiors and Exteriors 1770–1870.* London: Charles Plante Stair and Company, 2000.

Pionniers du xxe Siècle: Guimard, Horta, Van de Velde, exh. cat. Paris: Musée des Arts Décoratifs, 1971.

———. *An Illustrated History of Interior Decoration: From Pompeii to Art Nouveau.* New York: Thames and Hudson, 1964, 1994.

Pyne, William Henry. *The History of the Royal Residences of Windsor Castle, St. James Palace, Carlton House, and Frogmore.* London: A. Dry, 1819.

Pyne, William Henry, William Combe, Thomas Rowlandson, and Augustus Pugin. *The Microcosm of London: Or, London in Miniature,* 3 vols. London: Methuen, 1904.

de Réaux, Gédéon Tallemant. *Histoirettes....* III. Paris: Levasseur, 1834.

Reed, Sue Welsh. *French Prints from the Age of the Musketeers,* exh. cat. Boston: Museum of Fine Arts, 1998.

The Royal Pavilion: The Palace of George IV. Brighton: Royal Pavilion, Art Gallery and Museums, Brighton Borough Council, 1995.

Rutherford, Jessica M. F. *The Royal Pavilion: The Palace of George IV*. Brighton: Royal Pavilion, Art Gallery and Museums, 1995.

Rybczynski, Witold. *Home: A Short History of an Idea*. New York: Viking, 1986.

Rykwert, Joseph. *The Necessity of Artifice*. New York: Rizzoli, 1982.

Sanderson, William, William Faithorne, and Wenceslaus Hollar. *Graphice: The Use of the Pen and Pensil...* London: Printed for Robert Crofts, at the signe of the Crown in Chancery-Lane, under Serjeant's Inne, 1658.

Sauval, Henri. *Histoire et Recherches des Antiquités de la Ville de Paris*, vol. 2. Paris: Chez C. Moette, etc., 1724.

Scott, Katie. *The Rococo Interior: Decoration and Social Spaces in Early Eighteenth-Century Paris*. New Haven: Yale University Press, 1995.

Sheraton, Thomas. *Cabinet Dictionary*, 2 vols. introduction by Wilford P. Cole and Charles F. Montgomery. New York: Praeger, 1970.

Sherrill, Sarah B. *Carpets and Rugs of Europe and America*. New York: Abbeville, 1996.

Snodin, Michael, ed. *Karl Friedrich Schinkel: A Universal Man*. New Haven: Yale University Press in association with the Victoria and Albert Museum, London, 1991.

Sotheby Parke Bernet & Co. *Part I: Architectural and Decorative Drawings, Part II: Important XIXth Century European Drawings and Watercolours*, auction cat. Uxbridge, England: The Hillingdon Press, 1981.

Sparke, Penny. *As Long as It's Pink: The Sexual Politics of Taste*. London: Pandora, 1995.

Spink: Autumn Catalogue 1994. London: White Bros. (Printers) Ltd., 1994.

Stern, Jean. *A l'Ombre de Sophie Arnould: François-Joseph Bélanger, Architecte des Menus Plaisirs, Premier Architecte du Comte d'Artois*. Paris: Plon, 1930.

Stevens, Kimberly. "Picture, Picture on the Wall...Whose is the Fairest House of All?" In *The New York Times*, 21 Feb. 2008, sec. F, House & Home.

Stroud, Dorothy. *Henry Holland: His Life and Architecture*. London: Country Life Limited, 1966.

Taylor, Judith G. "Original Proposal and Final Gallery Guide for 'Evolution to Revolution: Nineteenth-century Lighting Devices in America.'" MA thesis, Cooper-Hewitt, National Design Museum and Parsons School of Design, 1990.

Taylor, Mark, and Julieanna Preston, eds. *Intimus: Interior Design Theory Reader*. Chichester, England: Wiley-Academy, 2006.

Tessin, Nicodemus, Daniel Cronström, Karl Hernmarck, and Roger Armand Weigert. *Les Relations Artistiques entre la France et la Suède, 1693-1718*. Stockholm: Egnellska boktr., 1964.

Teynac, Françoise, Pierre Nolet, and Jean-Denis Vivien. *Wallpaper: A History*. London: Thames and Hudson, 1982.

Theilmann, Rudolf. *Nineteenth Century German Drawings from the Grand Duchy of Baden*, exh. cat. Translated by Robert E. Lewis. Cincinnati: Cincinnati Art Museum, 1983.

Theilmann, Rudolf, et al. *Deutsche Zeichnungen des 19. Jahrhunderts*. Karlsruhe : Müller, 1978.

Thornton, Peter. *Authentic Décor: The Domestic Interior, 1620–1920*. New York: Viking, 1984.

———. *Seventeenth-Century Interior Decoration in England, France and Holland*. New Haven, CT: Published for the Paul Mellon Centre for Studies in British Art by Yale University Press, 1978.

Thornton, Peter, and Maurice Tomlin. *The Furnishing and Decoration of Ham House*. London: The Furniture History Society, 1980.

Treble, Rosemary. "Hastings. William Henry Hunt." In *The Burlington Magazine* 123, no. 941 (Aug. 1981): 502–07.

Verlet, P. *The Savonnerie: Its History; The Waddesdon Collection*. Fribourg, Switzerland: Published for the National Trust by Office du Livre, 1982.

Victoria, Queen of Great Britain. *Further Letters of Queen Victoria, from the Archives of the House of Brandenburg-Prussia*. Edited by Hector Bolitho. Translated by J. Pudney and Arthur Paul John Charles James Gore Sudley, Viscount. London: T. Butterworth, 1938.

Victoria, Queen of Great Britain, and Raymond Mortimer. *Queen Victoria, Leaves from a Journal: Record of the Visit of the Emperor and Empress of the French to the Queen and of the Visit of the Queen and HRH the Prince Consort to the Emperor of the French, 1855*. London: Andre Deutsch, 1961.

Vigne, Georges. *Hector Guimard: Architect Designer, 1867–1942*. New York: Delano Greenidge Editions, 2003.

Voorsanger, Catherine Hoover, and John K. Howat. *Art and Empire City: New York 1825–1861*. New York: The Metropolitan Museum of Art, 2000.

Voronikhina, Anna Nikolaevna. *Views of the Hermitage and Winter Palace*. Moscow: Iskusstvo, 1983.

Wainwright, Clive. *The Romantic Interior: The British Collector at Home, 1750–1850*. New Haven and London: published for the Paul Mellon Centre for Studies in British Art by Yale University Press, 1989.

Waissenberger, Robert, ed. *Vienna in the Biedermeier Era, 1815–1848*. New York: Rizzoli, 1986.

Watkin, David. *Royal Interiors of Regency England: From Watercolours First Published by W.H. Pyne in 1817–1820*. London: Dent, 1984.

———. *Thomas Hope (1769–1831) and the Neo-classical Idea*. London: Murray, 1968.

Weigert, Roger Armand. *Louis XIV: faste et décors: [exposition au] Musée des Arts Décoratifs, mai-octobre 1960*, exh. cat. Paris: Musée des Arts Décoratifs, 1960.

Weissenbacher, Gerhard. *In Hietzing gebaut: Architektur und Geschichte eines Wiener Bezirkes*, 2 vols. Vienna: Holzhausen, 1998.

Wharton, Edith, and Odgen Codman. *The Decoration of Houses*. New York: Norton, [1902] 1978.

White, Roger, and Robin Darwall-Smith. *The Architectural Drawings of Magdalen College, Oxford: A Catalogue*. Oxford; New York: Oxford University Press, 2001.

Wiese, Erich. *Biedermeierreise durch Schlesien*. Darmstadt: Bläschke, 1966.

Wilson, Arnold. "St. Nicholas Church Museum." In *The Burlington Magazine* 120, no. 899 (February 1978): 86–87.

Wirth, Irmgard. *Eduard Gaertner: Der Berliner Architekturmaler*. Frankfurt am Main, Berlin, and Vienna: Propyläen Verlag, 1979.

Wood, Christopher. *The Dictionary of Victorian Painters*, 2nd ed. Woodbridge, Suffolk, England: Antique Collectors' Club, 1978.

ACKNOWLEDGMENTS AND PHOTOGRAPHIC CREDITS

Cooper-Hewitt, National Design Museum and the curators are grateful to the following individuals and organizations for their help with this exhibition and catalogue.

EXHIBITION LENDERS
Smithsonian Institution Libraries:
 Nancy E. Gwinn; Vanessa Haight
University of Pennsylvania,
 Annenberg Rare Book and Manuscript
 Library: Lynne Farrington
David Scott Parker
Ellen and Bill Taubman

OTHER SUPPORT
Louis de Bayser
Cabinet Le Fuel, Paris:
 Marie de la Chevardière
Florida State University Libraries:
 Lucia Patrick
Fogg Art Museum, Harvard Art Museum:
 Marjorie B. Cohn, Miriam Stewart
Peter Fuhring
Großherzoglich Hessisches Familienarchiv
 at the Hessian State Archives,
 Darmstadt: Eckhart G. Franz
Mary Ann Hoag
Houghton Library, Harvard University:
 Eleanor Garvey
Hans P. Kraus, Jr., New York: Russell Lord
Leven Betts Studio: David Leven,
 Stella Betts, Lucas Echeveste Lacy,
 Rachel Johnston
Barbara Lloyd
Magdalen College, University College,
 Oxford: Robin Darwall-Smith
Metropolitan Museum of Art:
 Jamieson Bunn, Mary Zuber
Derek Ostergard
Royal Academy of Arts, London:
 Laura Valentine
Royal Institute of British Architects,
 Drawings and Archives Collections,
 London: Catriona Cornelius,
 Laura Whitton
Schloss Fasanerie, Potsdam:
 Christine Klössel
Stiftung Preussische Schlösser und Gärten
 Berlin-Brandenburg: Sibylle Michel
Tsang Seymour Design:
 Catarina Tsang, Patrick Seymour,
 Laura Howell, Thomas Ryun,
 Loren Flaherty, Ellen Zhao
Victoria & Albert Museum: Tessa Murdoch

AT COOPER-HEWITT
Communications and Marketing:
Jennifer Northrop, William Berry,
Laurie Olivieri, Mara Sorkin;
Conservation: Lucy Commoner,
Perry C. Choe, Sarah Scaturro;
Curatorial: Susan Brown, Nurit Einik,
Jackie Killian, Kimberly Randall,
Caroline Krause;
Development and External Affairs:
Caroline Baumann, Sophia Amaro,
Joanna Broughton, Deborah Fitzgerald,
Kelly Mullaney, Anne Shisler-Hughes;
Education: Caroline Payson, Mei Mah,
and staff;
Exhibitions: Ciara McKeown, Matthew
O'Connor, Mathew Weaver, and staff;
Finance: Christopher Jeannopoulos;
Image Rights and Reproduction:
Jill Bloomer, Annie Chambers;
Registrar: Steven Langehough,
Melanie Fox, Wendy Rogers, Larry Silver;
Library: Stephen Van Dyk,
Elizabeth Broman

Cooper-Hewitt fellows, interns, and
volunteers: Judith Bergoffen and Susan
Hermanos, as well as Talia Avisar,
Emma Bowen, Caroline Cole, Alexandra
Gilbert, Mary Hermes, Caroline LeFevre,
Diane Pierce, Renata Rutledge, Emily
Segal, Nava Sutter

SELECTED INDEX OF ARTISTS AND WORKS

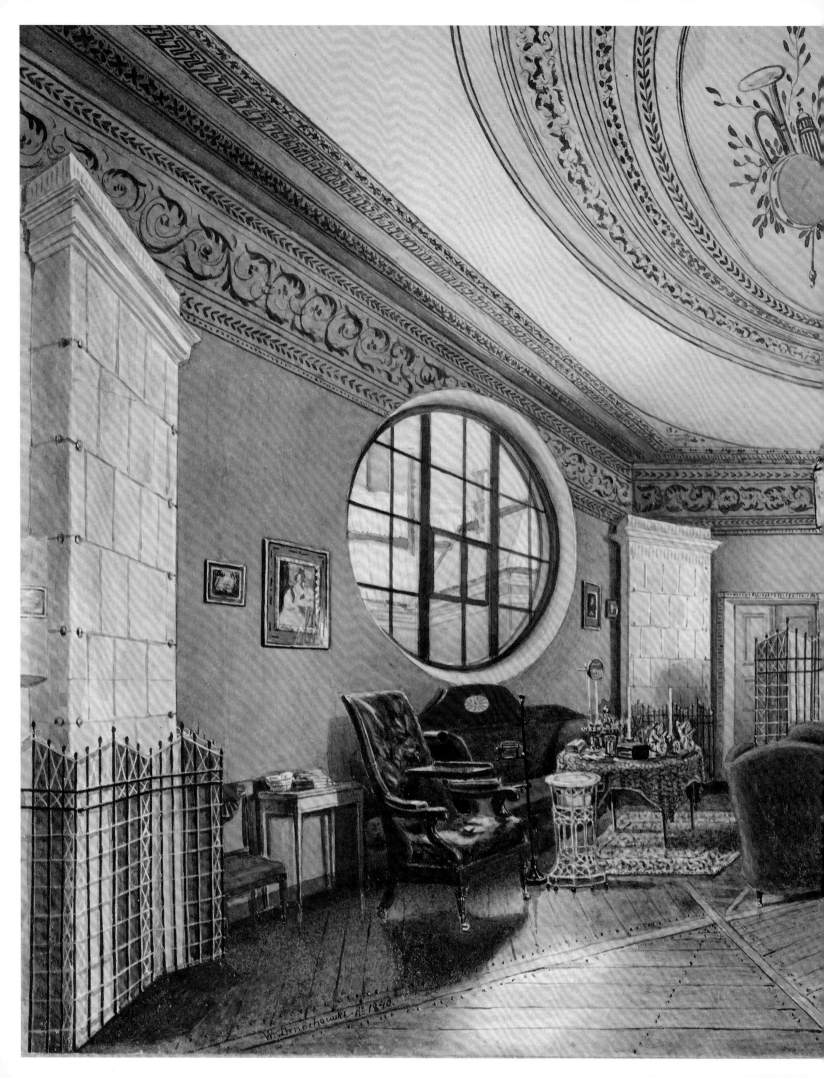

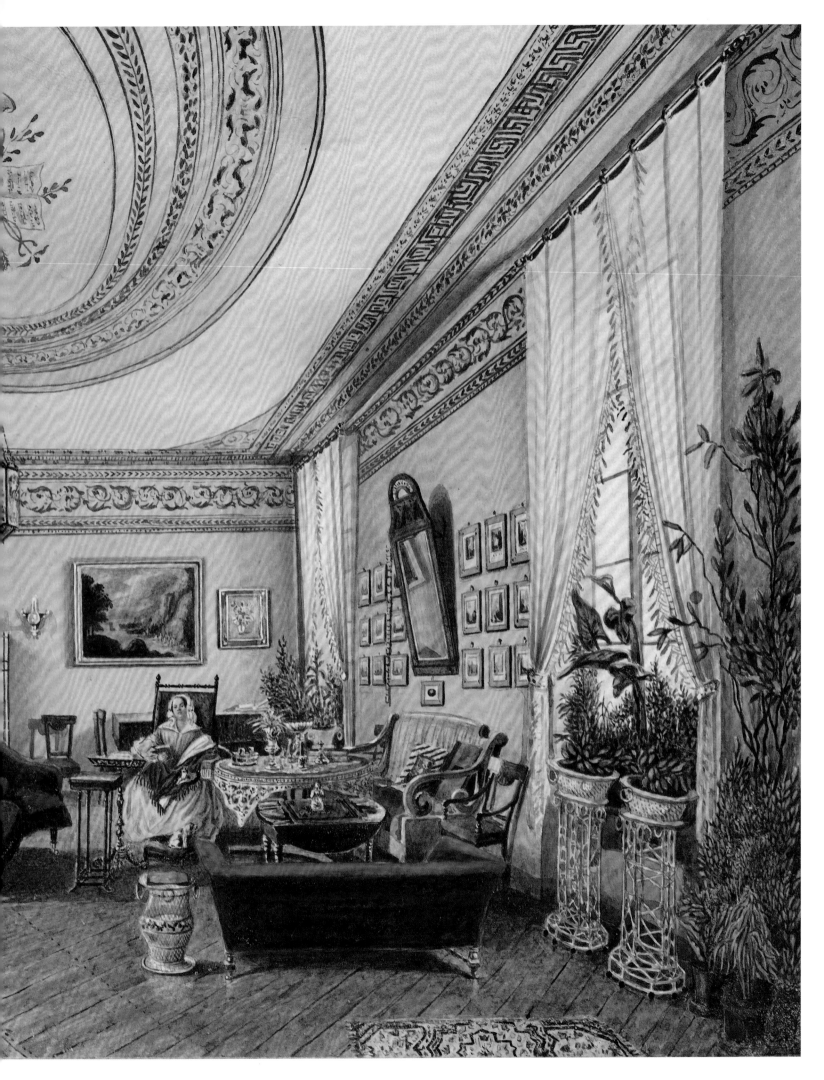

**HOUSE PROUD: NINETEENTH-
CENTURY WATERCOLOR INTERIORS
FROM THE THAW COLLECTION**

Gail S. Davidson, Floramae McCarron-
Cates, and Charlotte Gere
© 2008 Smithsonian Institution

Published by
Cooper-Hewitt, National Design Museum
Smithsonian Institution
2 East 91st Street
New York, NY 10128, USA
www.cooperhewitt.org

Published on the occasion of the exhibition

*House Proud: Nineteenth-century Watercolor
Interiors from the Thaw Collection*

at Cooper-Hewitt, National Design
Museum, Smithsonian Institution,
August 12, 2008–January 25, 2009.

*House Proud: Nineteenth-century Watercolor
Interiors from the Thaw Collection* is made
possible in part by the Arthur Ross
Foundation. Support is provided by the
Esme Usdan Exhibition Endowment Fund,
Jan and Warren Adelson, Jamie Drake,
The Felicia Fund, Albert Hadley, Inc.,
and Mr. and Mrs. Frederic A. Sharf.

Additional support is provided by
Barbara R. Munves, Oceanic Graphic
Printing (USA), Inc., and the Fifth Floor
Foundation.

This publication is made possible in part
by The Andrew W. Mellon Foundation.

Distributed to the trade worldwide by
Assouline Publishing
601 West 26th Street, 18th floor
New York, NY 10001, USA
www.assouline.com

Some research in this catalogue was
originally published in Charlotte Gere,
*An Album of Nineteenth-Century Interiors:
Watercolors from Two Private Collections*
(New York: The Frick Collection, 1992),
and is reprinted by permission of The
Frick Collection.

First edition: September 2008

ISBN: 978-0-910503-90-7

Library of Congress CIP data available
from the publisher.

Museum Editor:
Chul R. Kim, Director of Publications

Image Editors:
Jill Bloomer, Annie Chambers

Design: Tsang Seymour Design, Inc.

Printed in China by
Oceanic Graphic Printing